GRAPHIS PHOTO 96

GRAPHIS PHOTO 96

· ·

GRAPHIS INC.

THE INTERNATIONAL ANNUAL OF PHOTOGRAPHY

DAS INTERNATIONALE JAHRBUCH ÜBER PHOTOGRAPHIE

LE RÉPERTOIRE INTERNATIONAL DE LA PHOTOGRAPHIE

EDITED BY · HERAUSGEGEBEN VON · EDITÉ PAR:

B. MARTIN PEDERSEN

PHOTO OPPOSITE · KATHRYN KLEINMAN

GRAPHIS INC.

CONTENTS

INHALT

SOMMAIRE

REMARKS

WE EXTEND OUR HEARTFELT THANKS TO CONTRIBUTORS THROUGHOUT THE WORLD WHO HAVE MADE IT POSSIBLE TO PUBLISH A WIDE AND INTERNATIONAL SPECTRUM OF THE BEST WORK IN THIS FIELD.

ENTRY INSTRUCTIONS FOR NEXT YEAR'S ANNUAL MAY BE REQUESTED FROM:
GRAPHIS INC.
141 LEXINGTON AVENUE
NEW YORK, NY 10016-8193

ANMERKUNGEN

UNSER DANK GILT DEN EINSENDERN AUS ALLER WELT, DIE ES UNS DURCH IHRE BEI-TRÄGE ERMÖGLICHT HABEN, EIN BREITES, INTERNATIONALES SPEKTRUM DER BESTEN ARBEITEN ZU VERÖFFENTLICHEN.

TEILNAHMEBEDINGUNGEN FÜR DAS NÄCHSTE JAHRBUCH SIND ERHÄLTLICH BEIM:
GRAPHIS INC.
141 LEXINGTON AVENUE
NEW YORK, NY 10016-8193

REMERCIEMENTS

NOUS REMERCIONS LES PARTICIPANTS DU MONDE ENTIER QUI ONT RENDU POSSIBLE LA PUBLICATION DE CET OUVRAGE OFFRANT UN PANORAMA COMPLET DES MEILLEURS TRA-VAUX RÉALISÉS DANS CE DOMAINE.

LES MODALITÉS D'INSCRIPTION PEUVENT ÊTRE OBTENUES AUPRÈS DE:
GRAPHIS INC.
141 LEXINGTON AVENUE
NEW YORK, NY 10016-8193

Photo opposite: Terry Heffernan • Photo following spread: Lizzie Himmel

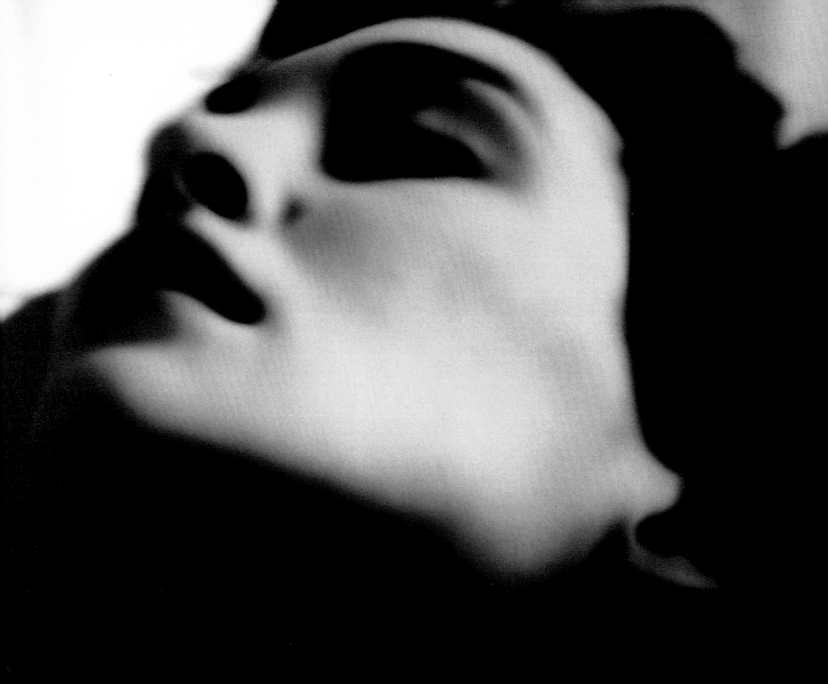

LIKE ALL PHOTOGRAPHERS, DESIGNERS, PRINTERS, AND PREPRESS PROFESSIONALS,

GRAPHIS AND AGFA CONTINUE TO SEARCH FOR THE MOST VIABLE AND REALISTIC MEANS OF REPRODUCING ART.

THIS COOPERATIVE EFFORT IS ONE MORE STEP TOWARD THAT GOAL.

AGFA ◆ *Agfa*

SPECIAL RECOGNITION GOES TO MICHAEL PAIGE, PETER BRODERICK, AND

BRIAN ALTERIO FROM AGFA AND SANJAY SAKHUJA OF DIGITAL PRE-PRESS INTERNATIONAL

FOR THEIR DEDICATION TO THE INNOVATIVE PRODUCTION OF THIS BOOK.

PRODUCTION NOTES

SCANNER: CROSFIELD 646 • INPUT RES: 300 DPI • IMAGESETTER: SELECTSET 5000 WITH ON-LINE BRIDGE

RIP: AGFA STAR 400 WITH HALFTONE ACCELERATOR • MEDIA: AGFA HN 712 • CHEMISTRY: CG 101 RAPID ACCESS

APPLICATIONS: QUARKXPRESS 3.32, PHOTOSHOP 2.51 • PLATFORM: MACINTOSH QUADRA 950 • PROOFING: AGFA PROOF,

EURO STANDARD FOILS • PRESS: AURELIA 700 • INK SEQUENCE: KCMY • PAPER: BURGO R 400

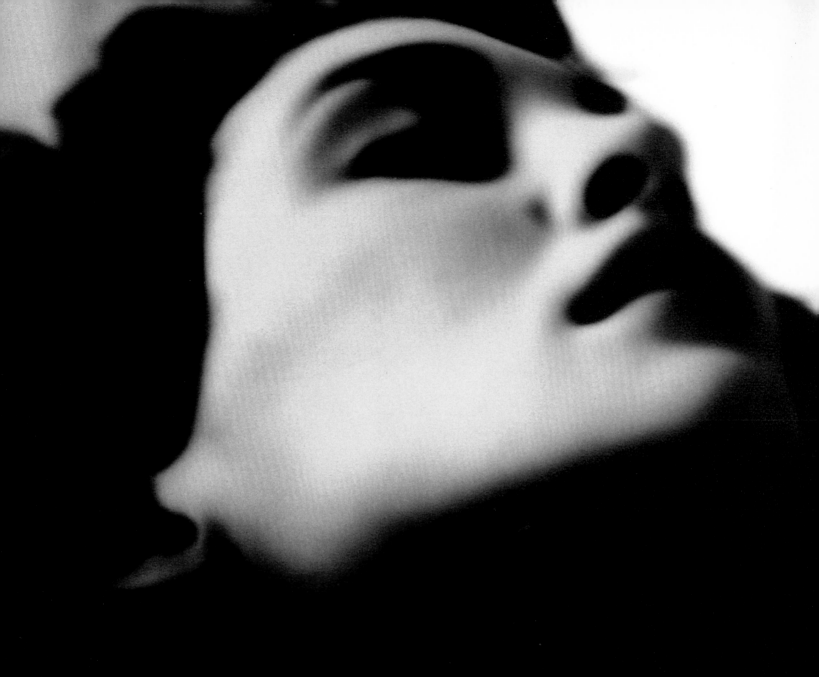

ACKNOWLEDGMENTS

...

PRODUCTION OF THE GRAPHIS PHOTO '96 ANNUAL HAS BEEN MADE POSSIBLE BY AGFA,

A WORLDWIDE MANUFACTURER OF DIGITAL IMAGING SOLUTIONS.

AGFA *Agfa*

FOR THE THIRD YEAR RUNNING, THIS BOOK WAS PRODUCED ENTIRELY IN A

POSTSCRIPT™ ENVIRONMENT WITH AGFA CRISTALRASTER™ TECHNOLOGY. AGFA'S IMAGESETTERS,

RIPS, FILM, CHEMISTRY, CRISTALRASTER TECHNOLOGY AND PROOFING SYSTEMS HAVE BEEN TEAMED WITH

LEADING DESKTOP PLATFORMS AND APPLICATIONS TO RAISE POSTSCRIPT COLOR

IMAGING BEYOND THAT OF TRADITIONAL PREPRESS SYSTEMS.

AS AN INDUSTRY INNOVATOR IN IMAGING TECHNOLOGY, AGFA

DRAWS ON ITS COMBINED EXPERIENCE IN PHOTOCHEMISTRY, ELECTRONICS AND

PRINTING TO DELIVER THE FAITHFUL REPRODUCTION OF IMAGES YOU SEE ON THESE PAGES. AGFA

CRISTALRASTER TECHNOLOGY, THE LEADING STOCHASTIC SCREENING TECHNIQUE, WAS USED

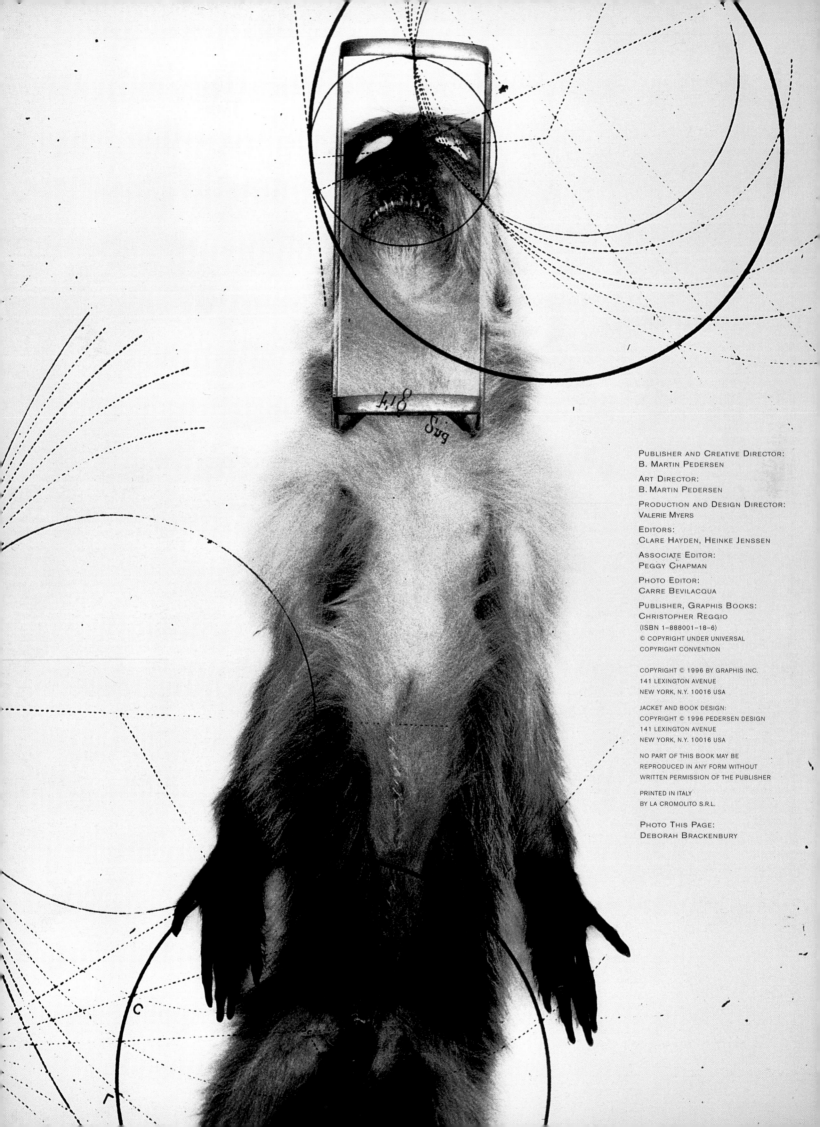

PUBLISHER AND CREATIVE DIRECTOR:
B. MARTIN PEDERSEN

ART DIRECTOR:
B. MARTIN PEDERSEN

PRODUCTION AND DESIGN DIRECTOR:
VALERIE MYERS

EDITORS:
CLARE HAYDEN, HEINKE JENSSEN

ASSOCIATE EDITOR:
PEGGY CHAPMAN

PHOTO EDITOR:
CARRE BEVILACQUA

PUBLISHER, GRAPHIS BOOKS:
CHRISTOPHER REGGIO
(ISBN 1–888001–18–6)

PRINTED IN ITALY
BY LA CROMOLITO S.R.L.

PHOTO THIS PAGE:
DEBORAH BRACKENBURY

COMMENTARIES

KOMMENTARE

COMMENTAIRES

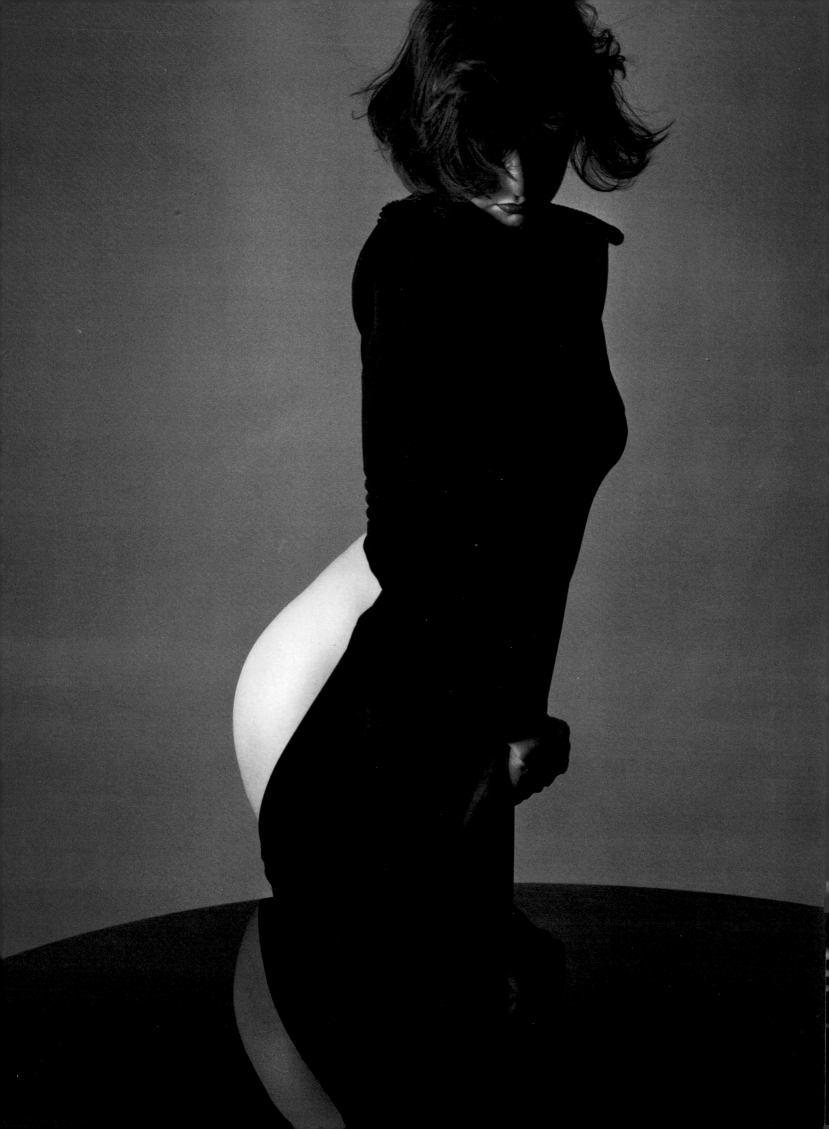

Jeanloup Sieff

"How did you become a believer?" someone once asked André Frossard, the Christian author and journalist. "By entering a church," was his disarming reply, to which he added: "Thank goodness I didn't enter a train station, or I probably would have become a train conductor!" This goes to show that the most clear-cut destinies can originate in the most improbable circumstances. ✦ I myself have often—all too often in fact—been asked: "Why did you become a photographer?" "Because I was given a camera," was my frank and ingenuous reply. There is truth to this, for had I not received a Phorax in black plastic for my fourteenth or fifteenth birthday, I might have become an actor, film director, writer or gigolo (alas, an impossible dream shared over the years with Tristan Bernard)! ✦ But simple questions should not be granted replies that are too obvious, or people won't take you seriously. As interview after interview loomed upon the horizon, I took to providing a more metaphysical motivation, such as "to arrest the flight of time"—a quite honest answer given my nostalgic nature, but representing more of a realization on my part than a primary cause. ✦ Today, as I rummage through the history of my images, seeking the where and why behind their creation, I find myself reverting to what has been my only true motivation as a photographer—besides the need to redeem the value of my birthday gift—the sheer pleasure of it. I know that doesn't sound very serious and I'm almost ashamed to say so, but think what you might, it has been pleasure, and pleasure alone, that has guided my aspirations—the physical pleasure of expressing certain forms, the pleasure of lights that craze, the pleasure of composing and of experiencing spaces and encounters. Of course every activity begins with a cause,

JEANLOUP SIEFF WAS BORN TO POLISH PARENTS IN PARIS ON NOVEMBER 30, 1933. IN 1953 HE BEGAN HIS CAREER AS A PROFESSIONAL PHOTOGRAPHER; IN 1955 HE WAS HIRED BY *ELLE* MAGAZINE, FIRST AS A REPORTER, LATER AS A FASHION PHOTOGRAPHER. FROM 1958-1959 HE WAS A MEMBER OF MAGNUM. FROM 1961-1966 HE LIVED AND WORKED IN NEW YORK, AND HAD EIGHTY EXHIBITIONS WORLDWIDE INCLUDING A RETROSPECTIVE IN 1986 AT THE MUSÉE D'ART MODERNE IN PARIS. SIEFF CURRENTLY WORKS FREELANCE FOR MAGAZINES SUCH AS *RÉALITÉ, JARDIN DES MODES, VOGUE, QUEEN, NOVA* AND *HARPER'S BAZAAR*. SIEFF HAS PUBLISHED A NUMBER OF BOOKS, BOTH AS WRITER AND PHOTOGRAPHER, AND SEVERAL MORE ARE IN PREPARATION.

spontaneous and absent of thought, followed by deliberation as to the finality of it all. But the latter is not meant to eclipse, or even replace, whatever generated it in the first place. A whole lifetime in pursuit of time gone by, years of looking back to what had been: if I claimed to do so to remember, that was, if not altogether untrue, at the very least premature, for I photographed only for my pleasure, even if afterwards I bemoaned the fleeting pleasure my pictures threw back at me. ✧ "Is photography an art?" Bearded and trench-coated members of suburban photography clubs learnedly discuss the question, becalming their existential uncertainties by inventing "creative photography". This name is merely a derisory rhinestone which confers a certain order of distinction on their buttonholes. I have always maintained that art is inexistent, that only the artist exists. Artists, moreover, do not just create art, but create it for their own pleasure, and because they can't help doing so—even if some give birth in pain, happy masochists they are! ✧ All creation involves some sort of technique—more or less difficult to master (and photography is a simple technique)—pressed into the service of a result that satisfies the senses and captures the joy of forms, colors, words, hearing, or touching. "A sculpture one doesn't feel like caressing is no successful sculpture," Brancusi used to say, and there are photographs one would want to caress with the eye. ✧ There is a lazy bent to my photography, and my only wish is for these images to yellow slowly until they leave only the memory of moments gone by. ✧ As long as a living person remembers a loved one who died, that remembered person is never truly dead. As long as a moment of life subsists in the memory of an image once glimpsed, that moment will create a desire to live out other moments and will, perhaps, surpass the nostalgia that is my own.

«Wie haben Sie zu Ihrem Glauben gefunden?» wurde André Frossard, der christliche Schriftsteller und Journalist, eines Tages gefragt. «Indem ich eine Kirche betrat», war seine entwaffnende Antwort, und er fügte hinzu: «Zum Glück habe ich keinen Bahnhof betreten, sonst wäre ich wahrscheinlich Lokomotivführer geworden!» Somit können schicksalhafte Entscheidungen die unwahrscheinlichsten Ursachen haben. ✧ «Warum photographieren Sie?» hat man mich oft, viel zu oft, gefragt. ✧ «Weil ich einen Photoapparat geschenkt bekam» war meine offene und naive Antwort. Es stimmt, wenn ich nicht zum 14. oder 15. Geburtstag eine Photax bekommen hätte – sie war aus schwarzem Kunststoff –, wäre ich vielleicht Schauspieler, Filmemacher, Schriftsteller oder Gigolo (leider ein unmöglicher Traum, den ich lange Zeit mit Tristan Bernard teilte) geworden. ✧ Aber auf einfache Fragen sollte man keine zu eindeutigen Antworten geben, sonst riskiert man, nicht ernst genommen zu werden. ✧ Als immer mehr Interviews drohten, entschied ich mich für eine eher metaphysische Motivation, wie etwa, «um die Zeit festzuhalten», was übrigens, so nostalgisch, wie ich bin, keine falsche Antwort war, es war eher eine Feststellung als eine echte Begründung. ✧ Und heute, wenn ich in der Vergangenheit meiner Bilder wühle, komme ich wieder auf das, was – abgesehen von der Amortisation meines Geburtstags geschenkes – meine einzig wirkliche Motivation für das Photographieren ist: reines VERGNÜGEN. ✧ Ich weiss, dass das nicht seriös klingt, und ich schäme mich fast ein bisschen, aber es ist nichts als das Vergnügen, das mich lenkt: das physische Vergnügen, bestimmte Formen auszudrücken, das Vergnügen am Licht, das einen verrückt macht, das Vergnügen, Räume und Begegnungen zu entwerfen und zu erleben. Und es gibt ein Adjektiv, das ich in diesem Zusammenhang immer wieder in mich hinein sage: «befriedigend», was für mich «unsäglich» bedeutet, also sprechen wir nicht mehr davon! ✧ Natürlich gibt es für jede Tätigkeit einen ursprünglichen Antrieb, der spontan und unreflektiert ist, erst dann folgt die Reflexion über ihren Zweck. Aber sie darf das, was überhaupt erst zu ihr führte, nicht verdecken oder gar ersetzen. ✧ Mein ganzes Leben werde ich nach der verlorenen Zeit suchen, lange Jahre des Rückblickens auf das, was war – wenn ich behauptete, ich täte es, um mich zu erinnern, so wäre das, wenn nicht falsch, so doch zumindest verfrüht, weil ich nur aus Freude photographiere, auch wenn ich vielleicht das Entschwinden der Freude, zu der mich meine Bilder zurückführen, beweine. ✧ «Ist Photographie Kunst?» Die bärtigen Trenchcoat-Träger aus den Vororts-Photoclubs befassen sich sehr gelehrt mit dieser Frage, und zu ihrer eigenen Bestätigung haben sie die «kreative Photographie» erfunden, um so ihr Knopfloch mit diesem Tant einer wertenden Anerkennung schmücken zu können. ✧ Ich habe immer behauptet, dass Kunst nicht existiert, sondern nur die Künstler, die übrigens keine Kunst machen, sondern Dinge, die ihnen Vergnügen bereiten, weil sie nicht anders können, auch wenn sie unter Schmerzen gebähren – glückliche Masochisten. ✧ Jede Kreation erfolgt durch eine Technik, die mehr oder weniger schwer zu beherrschen ist (und das Photographieren ist eine leichte Technik), eingesetzt im Dienste eines befriedigenden Resultats für die Sinne. Das Glück der Formen, der Farben, der Worte, des Hörens, des Fühlens... ✧ «Eine Skulptur, die man nicht streicheln möchte, ist keine gelungene Skulptur», hat Brancusi gesagt, und es gibt Photographien, die man streicheln möchte – mit dem Auge! ✧ Meine Photo-graphie ist von einer gewissen Faulheit geprägt, und mein einziger Wunsch ist, dass diese Photos langsam vergilben, bis sie nichts zurücklassen als die Erinnerung. ✧ Solange sich ein Lebender an einen Verstorbenen erinnert, ist dieser nicht tot. Solange ein Augenblick in einem flüchtig geschauten Bild fortdauert, weckt dieser Augenblick die Sehnsucht nach anderen solchen Augenblicken und überwindet vielleicht die Nostalgie, die ich empfinde.

«Comment la foi vous est-elle venue?», demanda-t-on un jour à André Frossard, l'écrivain-journaliste chrétien. «En entrant dans une église», fut sa réponse désarmante, et il ajouta: «Heureusement, je ne suis pas entré dans une gare, je serais probablement devenu conducteur de train!» ✧ Comme quoi les destins les plus définitfs peuvent avoir les causes les plus improbables. ✧ «Pourquoi faites-vous des photographies?», m'a-t-on souvent, trop souvent, demandé. ✧ «Parce qu'on m'a donné un appareil photographique» était ma réponse franche et naive. Et c'est vrai que si je n'avais pas reçu en cadeau d'anniversaire pour mes quatorze ou quinze ans un Photax de plastique noir, je serais peut-être devenu comédien, cinéaste, écrivain ou gigolo (rêve, hélas impossible, longtemps partagé ave Tristan Bernard!). ✧ Mais, aux questions simples, il faut éviter les réponses trop évidentes, car on risque fort de ne pas être pris au sérieux. ✧ Alors, au fil des interviews comminatoires, j'ai proposé une motivation plus métaphysique, du genre «pour arrêter la fuite du temps», qui n'était d'ailleurs pas une réponse fausse, nostalgique que je suis, mais représentait plus un constat qu'une raison première. ✧ Et aujourd'hui, alors que je refouille le passé de mes images et le pourquoi de leur réalisation, j'assume à nouveau ce qui aura été ma seule véritable motivation à faire des photographies, en

JEANLOUP SIEFF WURDE AM 30. NOVEMBER 1933 ALS SOHN POLNISCHER ELTERN IN PARIS GEBOREN. 1953 BEGANN ER ALS PROFESSIONELLER PHOTOGRAPH ZU ARBEITEN; 1955 WURDE ER VON DER ZEITSCHRIFT ELLE ZUERST ALS REPORTER, DANN ALS MODEPHOTOGRAPH EINGESTELLT. ER WAR KURZ MITGLIED DER AGENTUR MAGNUM (1958/1959) UND IST SEITDEM VÖLLIG UNABHÄNGIG. ZEITSCHRIFTEN WIE RÉALITÉS, JARDIN DES MODES, VOGUE, QUEEN, NOVA UND HARPER'S BAZAAR GEHÖREN ZU SEINEN AUFTRAGGEBERN. VON 1961-1966 LEBTE UND ARBEITETE ER IN NEW YORK. ER HATTE HIER U.A. ZAHLREICHE AUSSTELLUNGEN (INSGESAMT WAREN ES CA. 80 IN ALLER WELT, DARUNTER 1986 EINE GROSSE RETROSPEKTIVE IM MUSÉE D'ART MODERNE, PARIS). JEANLOUP SIEFF HAT ALS AUTOR UND PHOTOGRAPH ZAHLREICHE BÜCHER VERÖFFENTLICHT; WEITERE SIND IN VORBEREITUNG.

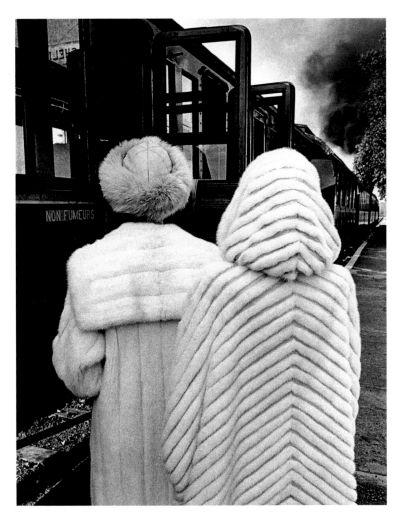

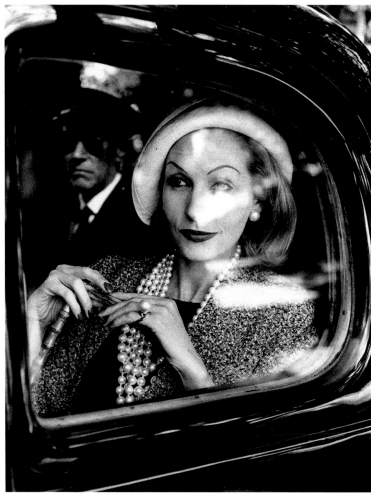

dehors de l'amortissement de mon cadeau d'anniversaire, c'est le PLAISIR. ◇ Eh oui, ce n'est pas sérieux et j'en ai presque honte, mais seul le plaisir a guidé mes envies: plaisir physique d'exprimer certaines formes, plaisir des lumières qui rendent fou, plaisir de composer et de vivre des espaces et des rencontres, et l'adjectif que j'aurai le plus utilisé, à voix basse, fut «satisfaisant», qui pour moi signifiait «ineffable», donc n'en parlons plus! ◇ Evidemment, dans toute activité, il y a la raison première, spontanée, irréfléchie, puis la réflexion sur sa finalité . Mais il ne faut pas que cette dernière vienne occulter, voire remplacer, ce qui l'engendra. ◇ Toute ma vie j'aurai recherché le temps perdu, longtemps je me serai retourné sur ce qui fut, mais si j'ai prétendu faire pour me souvenir, c'était, sinon faux, du moins prématuré, car je ne photographiais que pour me faire plaisir, même si je pleurais ensuite ce plaisir enfui auquel mes images me renvoyaient. ◇ «La photographie est-elle un Art?» se demandent doctement les barbus à imperméables mastic des photo-clubs de banlieue, et pour justifier leur existence incertaine ils ont inventé la «photographie créative» qui leur permet de s'accrocher à la boutonnière ce colifichet dérisoire d'une reconnaissance valorisante. ◇ J'ai toujours prétendu que l'Art n'existait pas et que seuls existaient des artistes, qui d'ailleurs ne font pas de l'Art mais font des choses, pour se faire plaisir, et parce qu'ils ne peuvent pas faire autrement, même si certains enfantent dans la douleur, masochistes heureux! ◇ Toute création passe par une technique, plus ou moins difficile à maîtriser (et la photographie est une technqiue simple) mise au service d'un résultat satisfaisant pour les sens. Bonheur des formes, des couleurs, des mots, de l'oreille, du toucher... ◇ «Une sculpture qu'on n'a pas envie de caresser n'est pas une sculpture réussie», disait Brancusi, et il y a des photographies qu'on a envie de caresser, de l'œil! ◇ J'ai la photographie paresseuse, et mon seul souhait est que ces images j'aunissent doucement pour ne laisser que le souvenir de moments qui furent. ◇ Tant qu'un vivant se souviendra d'un mort aimé, celui-ci ne sera pas totalement mort. Tant qu'un moment d'une vie subsistera dans la mémoire d'une image entr'aperçue, ce moment donnera envie d'en vivre d'autres et permettra, peut-être, de dépasser la nostalgie qui est mienne.

JEANLOUP SIEFF D'ORIGINE POLONAISE, NÉ À PARIS LE 30 NOVEMBRE 1933, DÉBUTE SA CARRIÈRE DE PHOTOGRAPHE PROFESSIONNEL EN 1953. EN 1955 IL EST ENGAGÉ PAR LE MAGAZINE ELLE, DANS UN PREMIER TEMPS EN QUALITÉ DE REPORTER, PUIS COMME PHOTOGRAPHE DE MODE. DE 1958 À 1959, IL EST MEMBRE DE L'AGENCE MAGNUM. DE 1961 À 1966, IL VIT ET TRAVAILLE À NEW YORK. QUELQUE 80 EXPOSITIONS À L'ÉCHELLE INTERNATIONALE ONT ÉTÉ CONSACRÉES À SON ŒUVRE PHOTOGRAPHIQUE, DONT UNE RÉTROSPECTIVE EN 1986 AU MUSÉE D'ART MODERNE DE PARIS. ACTUELLEMENT, SIEFF TRAVAILLE À SON COMPTE POUR DIVERS MAGAZINES, TELS QUE RÉALITÉ, JARDIN DES MODES, VOGUE, QUEEN, NOVA ET HARPER'S BAZAAR. IL A PUBLIÉ DE NOMBREUX OUVRAGES AUSSI BIEN EN TANT QU'ÉCRIVAIN QUE PHOTOGRAPHE. D'AUTRES LIVRES SONT EN PRÉPARATION.

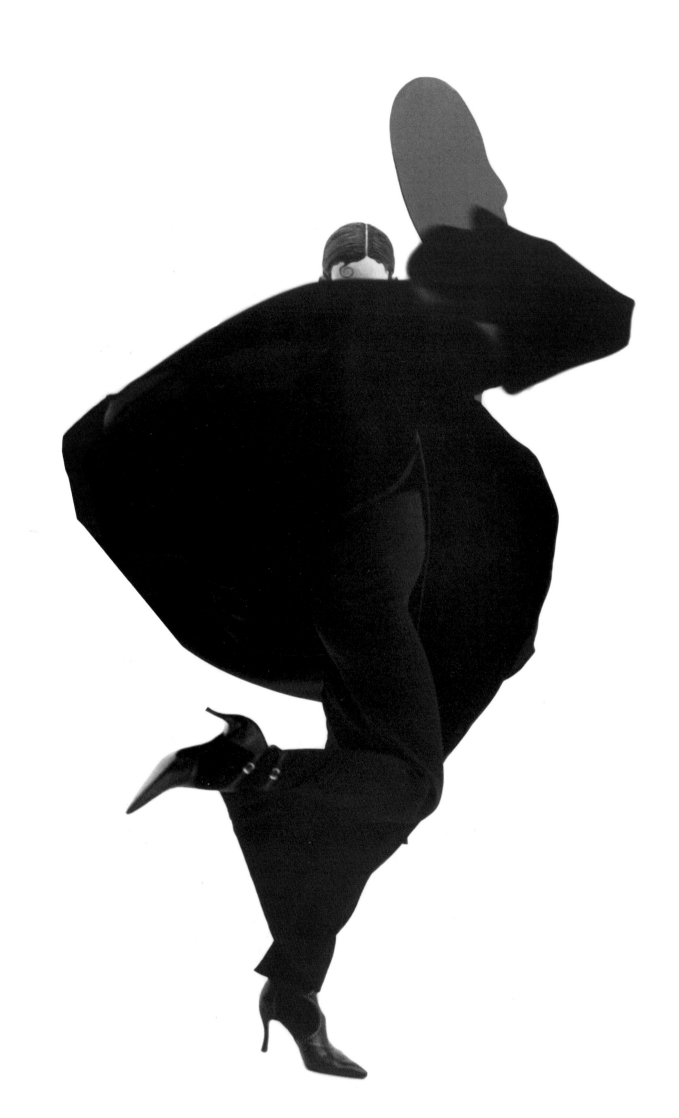

Ruven Afanador

Most people wouldn't find beauty in the aftermath of a devastating volcanic eruption that wiped out an entire town and killed 25,000 people. But then again, from the minute you meet him, you realize that Ruven Afanador isn't like most people. Tall and willowy, bald, pale as the moon, with long Beardsleyesque fingers, enormous ears, and dark, heavy-lidded eyes, the 37-year-old Colombian-born photographer almost looks as if he's from another dimension: a mythological figure who's risen from the depths to disseminate his own form of madness into the world. Luckily for us average earthlings, this madness translates into the kind of artistry that draws beauty out of the murky depths of volcanic craters, that celebrates the texture of an enormous tobacco leaf, and that captures the complex but fundamental mystery in the palm of a hand. ✦ The volcanic eruption that leveled the Colombian town of Almedo in 1985 served as artistic fodder for Afanador, who, upon seeing some obscure TV footage of bodies being pulled from the lava, decided to shoot a series of photographs that explores the fossil-like, primal appeal of the human figure covered in elemental substances such as mud and salt. ✦ The models for the photographs, which were originally intended to commemorate the tenth anniversary of the disaster, are members of a Colombian dance troupe, Athanor Danza. The black-and-white images are textured and sensual, harkening back to the photographer's early training as a sculptor at Notre Dame University. But there's more than just interesting shapes and textures here. ✦ In all his photographs, whether fashion, portraits, or the more "artistic" exhibition-related endeavors, Afanador seems to have summoned up a pantheon of mythological, symbolic, or totemic figures that resonate with an otherworldly—at times, almost sacred—majesty. ✦ Indeed, when one thinks of Catholic countries

RYNN WILLIAMS IS A NEW YORK-BASED FREELANCE WRITER AND A FORMER ASSOCIATE EDITOR AT GRAPHIS.

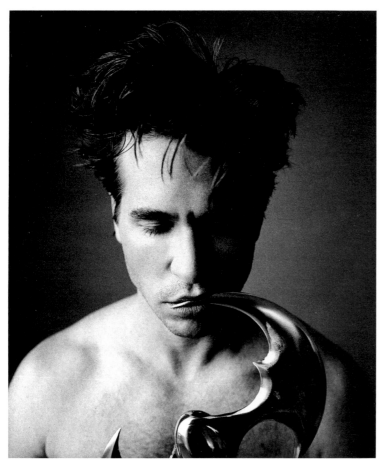
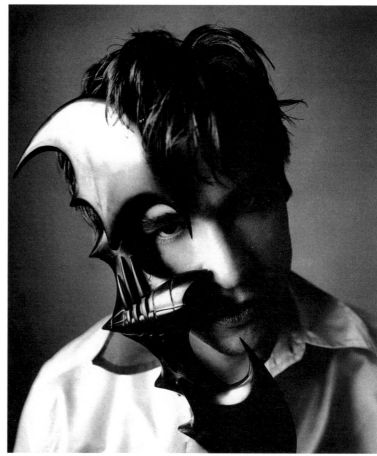

such as Colombia or Italy, death always seems just a little bit closer to life than it does in the United States. With this undercurrent, this acknowledgement of death, comes a rich sensuality and a lack of guile—characteristics present in Afanador's work since he began his career, testing with his first fashion models in Milan. ✧ With no studio, no money, nothing but a bachelor's degree and an affinity with what he calls "a certain soulfulness" that he found there, the young photographer shot against the raw walls of the Italian city. It was there, he says, he "discovered the whole thing—the black and white, the graphic thing, the sculptural elements. I felt a certain association working there with how things looked, the ancientness of everything, something that would never have happened here." ✧ These elements now pervade the portraits and fashion assignments which, Afanador says, make up the lion's share of his work. Since his return to the United States in 1990, he has amassed *Vanity Fair*, *Vogue*, *Time*, *GQ*, *Life*, *Rolling Stone*, and *Vibe* as well as many other editorial credits, and subjects of his portraits have included such luminaries as Al Pacino, Antonio Banderas, Gary Oldman, Diana Ross, Susan Sontag, James Michener, and Gabriel Garcia Marquez. There is a deeply sensual, mythic feel to a portrait of musician Lenny Kravitz, kneeling in profile, nude but for an elaborate loincloth. The fashion photographs have an enigmatic quality—at once straightforward, even confrontational, they conjure an aura of mystery through the use of texturally interesting backgrounds, offbeat camera angles, graphic lighting, and techniques such as shooting the model reflected in a mirror to elongate her image. ✧ The format of choice, not surprisingly, is black and white. It's all he would shoot if given a choice—"There's no banality in black and white," he says.

Yet while in his younger, more idealistic days, Afanador even turned down color assignments, he's been working in the medium recently in order to broaden his range. "I think that if you want to grow you're going to have to do color," he says. If not, he says, "It might take much longer to achieve what you're after, you might not be able to do the things that give you the freedom to do the other projects." Afanador admits that he's become known for black and white, and that he's "trying to break away from that. It's still my favorite," but color is "a change. I think it's progress." ✧ Afanador maintains that there is no hard and fast division between his fashion photography and his portraiture: "The portraits have a fashion quality to them, a certain stylized fashion influence," he says, reclining on the red velvet tufted sofa in the reception area of his Manhattan studio, surrounded by exotic flowers and heavy brass candelabrum. Even a series of portraits of Diana Ross, in which the photographer convinced her to return to her childhood neighborhood, "are primarily fashion, it just happens to be on her," he says. "It's about her clothing, her look, the way it's placed and the feeling that is given to it. Fashion is the most important thing, it goes through all the photos." ✧ Yet Afanador's fashion work is deepened by the kind of exploration inherent in portraiture. "I like feeling," he says. "In the fashion photos—they're not something you look at quickly, there's depth there, there's a reason, a connection. Whether it's with an object or with the feeling of the set." ✧ A recent project featuring the work of Mexican fashion designer Victor Alfaro for the magazine *Si*—in which the only prop was a simple rectangular bed (albeit covered in satin and fishnet)—was inspired by a nineteenth century Mexican photograph of a woman lying on a daybed before a bare wall. "I love the minimal quality of it," Afanador

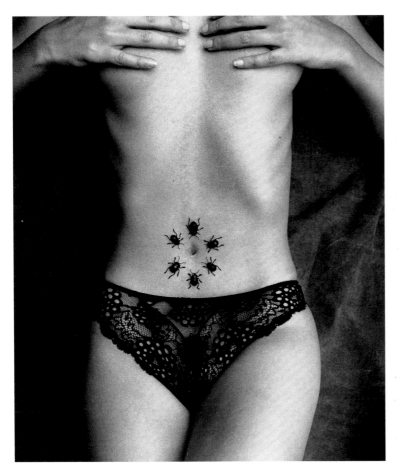
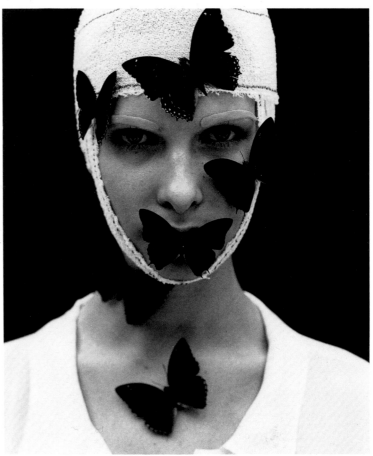

says, "but I love what it says at the same time because it's about a Mexican designer who lives in the United States and is very modern and simple in his clothing, but it's about this bed and the seductiveness of that. I wanted something that could be connected to the Latin American feeling," while emulating the simplicity, the "very real, beautiful, portrait lighting," of the nineteenth century photograph. "It's honest," Afanador says, and reflects "the comfort of the subject I love." ✦ While Afanador feels an affinity with the honesty of a nineteenth century Mexican image, as well as the openness and sensuality of his South American homeland, he says he finds a model of simplicity in the portraits of Irving Penn, and the ideal of sculptural, black and white elegance in the photographs of Spanish photographer Javier Vallhonrat. ✦ Indeed, one can trace the influence of these two masters in Afanador's current projects—one, a book of celebrity portraits

which center on the subjects' hands, called *Palms*, is due to be published this fall in conjunction with the photographer's first New York exhibition. Another show, featuring the Colombian volcano photographs, has traveled to Hong Kong and Germany, and a book centered on the dance troupe will be published in Colombia. Other projects include a book of Afanador's dance photography for the American market, as well as a book called *Home*, in which celebrities (such as Ross) revisit their birthplaces. ✦ One might include the photographer himself in the *Home* roster. While born in Colombia, Afanador moved to Michigan at age fourteen, and did not not return for eighteen years. What he found there—the openness, the mythic symbolism, the voluptuousness—rejuvenated his work, he says. The evidence is here: honest, sensual images that seem to transcend time. Thomas Wolfe was wrong. You can go home again.

Die meisten Menschen werden in den verheerenden Verwüstungen eines Vulkanausbruchs, der eine ganze Stadt auslöschte und 25'000 Menschen das Leben kostete, kaum Schönheit entdecken. Wenn man Ruven Afanador kennenlernt, weiss man allerdings bereits nach einer Minute, dass er nicht wie die meisten Menschen ist. ✦ Von grosser, schlaksiger Gestalt, kahlköpfig und blass wie der Mond mit langen Beardsleyesken Fingern, enormen Ohren und dunklen Augen unter schweren Lidern, sieht der vor 37 Jahren in Kolumbien geborene Photograph fast so aus, als wäre er nicht von dieser Welt: eine mythologische Gestalt, emporgestiegen aus der Tiefe, um ihre eigene Form von Verrücktheit in der Welt zu verbreiten. Zum Glück für alle normalen Sterblichen lebt er diese Verrücktheit in einer Art von Kunst aus, die Schönheit in den finsteren Tiefen vulkanischer Krater findet, die die Textur eines riesigen Tabakblattes zelebriert

und die das komplexe und doch elementare Geheimnis einer Handfläche ergründet. ✦ Der Vulkanausbruch, der die kolumbianische Stadt Almedo 1985 dem Erdboden gleichmachte, diente Afanador als künstlerische Nahrung. Nachdem er im Fernsehen gesehen hatte, wie man Leichen unter den Lavamassen herauszog, beschloss er, sich in einer Photoserie mit der fossilienhaften ursprünglichen Wirkung der mit so elementaren Substanzen wie Schlamm und Salz bedeckten Körper auseinanderzusetzen. ✦ Die Aufnahmen waren eigentlich als Erinnerung an den zehnten Jahrestag des Desasters gedacht, und die dafür eingesetzten Modelle sind Mitglieder einer kolumbianischen Tanzgruppe, der Athanor Danza. Die schwarzweissen Bilder sind strukturiert und sinnlich, sie lassen die bildhauerische Ausbildung des Photographen an der Notre Dame University erkennen. Aber hinter den Aufnahmen steckt

mehr als interessante Formen und Strukturen. ❖ In all seinen Arbeiten, ob es Modeaufnahmen, Porträts oder die eher künstlerischen Studien für Ausstellungen sind, scheint Afanador einen Pantheon mythologischer, symbolischer oder totemartiger Wesen vereint zu haben, die eine ausserirdische, manchmal fast sakrale Majestät ausstrahlen. ❖ In katholischen Ländern wie Kolumbien oder Italien scheint der Tod dem Leben ein bisschen näher zu sein als anderswo. Und dieser Unterton, dieses Bewusstsein des Todes, verleiht den Bildern eine reiche Sinnlichkeit ohne Hintergedanken – etwas, das Afanodars Arbeit seit Beginn seiner Karriere kennzeichnet, als er Versuche mit Modeaufnahmen in Mailand machte. ❖ Ohne Atelier, ohne Geld, nichts als ein Bakkalaureat in den Händen und einer starken Neigung zum «Seelenvollen», das er in dieser italienischen Stadt fand, wo er als junger Photograph vor dem Hintergrund roher Wände photographierte. Hier in Mailand entdeckte er, wie er sagt, «die ganze Sache – die Schwarzweissphotographie, die graphische Wirkung, das skulpturale Element. Ich empfand dort eine bestimmte Assoziation zwischen meiner Arbeit und dem Aussehen der Dinge, der Altertümlichkeit von allem, etwas, was hier nie stattgefunden hatte.» ❖ Diese Elemente prägen heute seine Porträts und Modeaufnahmen, die gemäss Afanador den Löwenanteil seiner Arbeit ausmachen. Seit seiner Rückkehr in die Vereinigten Staaten im Jahre 1990 arbeitet er für Vanity Fair, Vogue, Time, GQ, Life, Rolling Stone und Vibe sowie für viele andere Zeitschriften, und er hat Prominente wie Al Pacino, Antonio Banderas, Gary Oldman, Diana Ross, Susan Sontag, James Michener und Gabriel Garcia Marquez photographiert. Sein Porträt des Musikers Lenny Kravitz, ein von der Seite aufgenommener kniender Halbakt mit kunstvollem Lendenschurz, hat eine zutiefst sinnliche, mythische Ausstrahlung. Die Modeaufnahmen haben etwas Rätselhaftes – einerseits sind sie geradeheraus, fast angriffig, und gleichzeitig umgibt sie eine Aura des Geheimnisvollen, eine Wirkung, die mit verschiedenen Mitteln erreicht wird: durch die Oberflächenbeschaffenheit der Hintergründe, durch ungewöhnliche Aufnahmewinkel, graphisch eingesetztes Licht und durch Techniken wie das Photographieren des Modells im Spiegel, wodurch die Gestalt in die Länge gezogen wird. ❖ Es überrascht kaum, dass Afanador die Schwarzweissphotographie bevorzugt. Wenn er die Wahl hätte, würde er nur in Schwarzweiss arbeiten: «Bei Schwarzweiss gibt es keine Banalität.» Als junger Mann voller Idealismus hat er Farbaufnahmen sogar abgelehnt, aber heute macht er sie, um sein Spektrum zu erweitern. «Ich glaube, wenn man wachsen möchte, muss man auch in Farbe photographieren», sagt er. Wenn man das nicht tut, so Afanador, «wird es wahrscheinlich viel länger dauern, sein Ziel zu erreichen, und man wäre nicht in der Lage, die Sachen zu machen, die einem wiederum die Freiheit geben, andere Projekte zu machen.» Afanador gibt zu, dass er sich als Schwarzweiss-Photograph einen Namen machte und dass er versucht, «von diesem Image wegzukommen. Nach wie vor, ziehe ich Schwarzweiss vor», aber Farbe ist «eine Abwechslung. Ich glaube, es ist ein Fortschritt.» ❖ Afanador behauptet, es gäbe zwischen seinen Modeaufnahmen und den Porträts keine klare Trennung: «Die Porträts haben etwas von den Modeaufnahmen, einen bestimmten stylisierten Modeeinfluss.». Er macht es sich auf dem roten Plüschsofa im Empfangsbereich seines Studios in Manhattan bequem, umgeben von exotischen Blumen und schweren Messingkandelabern. Sogar die Porträtreihe von Diana Ross, die er überredete, für diese Aufnahmen an den Ort ihrer Kindheit zurückzukehren, habe «in erster Linie mit Mode zu tun, die zufällig von ihr getragen wird. Es geht um das, was sie trägt, um ihr Aussehen, darum, wie sie die Kleider trägt und um die Ausstrahlung. Mode ist das Wichtigste und zieht sich durch alle Aufnahmen.» Afanadors Modeaufnhamen haben jedoch dank der eindringlichen Sehweise, die die Porträts charakterisiert, eine gewisse Tiefe. «Ich mag stimmungsvolle Bilder», sagt er. «Die Modeaufnahmen sind keine Photos, die man schnell ansieht, sie haben Tiefe, haben einen Sinn, eine Verbindung, sei es zu einem Gegenstand oder zum gesamten Umfeld.» ❖ Bei einem kürzlichen Projekt, bei dem er die Kreationen des mexikanischen Mode-Designers Victor Alfaro für die Zeitschrift Si photographierte, war das einzige Dekorationsstück ein einfaches, rechteckiges Bett, das allerdings mit Satin und Fischernetzen bedeckt war. Die Inspiration dazu kam von einem mexikanischen Photo aus dem 19. Jahrhundert, das eine Frau liegend auf einem Tagesbett vor einer kahlen Wand zeigt. «Mir gefällt der Minimalismus der Aufnahme», sagt Afanador, «und gleichzeitig gefällt mir die Aussage, denn hier geht es um einen mexikanischen Modeschöpfer, der in den USA lebt und sehr moderne, schlichte Kleider entwirft, aber es geht auch um dieses Bett und das Verführerische. Ich wollte etwas, das einen Bezug zur lateinamerikanischen Mentalität hat», und dabei die Schlichtheit bewahren, das sehr «reale, schöne Porträtlicht» der Photographie aus dem 19. Jahrhundert. «Es ist ehrlich», sagt Afanador, «und ich liebe die sinnliche Ausstrahlung der Frau.» ❖ Afanador liebt die Ehrlichkeit wie auch die Offenheit und Sinnlichkeit seiner südamerikanischen Heimat. Die Porträts von Irving Penn sind für ihn Vorbild in ihrer Schlichtheit, während die Bilder des spanischen Photographen Javier Vallhonrat in ihrer skulpturalen, schwarzenweissen Eleganz seiner Idealvorstellung entsprechen. ❖ Der Einfluss dieser beiden Meister macht sich in der Tat in Afanadors gegenwärtigen Projekten bemerkbar: das eine ist ein Buch mit dem Titel Palms. Es enthält Porträts der Hände von Prominenten und wird im Herbst 1996 zur ersten Ausstellung des Photographen in New York erscheinen. Eine andere Ausstellung mit den kolumbianischen Vulkanbildern war in Hongkong und Deutschland zu sehen, und ein Buch über die Tanztruppe wird in Kolumbien herauskommen. Weitere Projekte sind ein Buch über Afanadors Tanz-Photographie für den amerikanischen Markt und ein Buch mit dem Titel Home, das Bilder von Prominenten an den Orten ihrer Kindheit zeigt (wie Diana Ross). ❖ Der Photograph selbst hätte gut in das Buch Home gepasst. Er wurde in Kolumbien geboren, kam aber bereits im Alter von 14 Jahren nach Michigan und sah seine Heimat erst nach 18 jahren wieder. Was er dort vorfand – die Offenheit, den mythische Symbolismus, die Üppigkeit – habe seiner Arbeit neue Impulse gegeben, sagt er. Der Beweis liegt vor: ehrliche, sinnliche Bilder, die die Zeit zu überwinden scheinen. Thomas Wolfe hat sich geirrt: Man kann nach Hause zurückkehren.

Trouver une forme de beauté à un paysage ravagé par une éruption volcanique qui a coûté la vie à 25'000 personnes et dévasté une ville tout entière, voilà qui n'est pas donné à tout le monde. Mais lorsque l'on rencontre Ruven Afanador, on sait après une minute déjà que cet homme n'est justement pas comme tout le monde. ❖ Grand et élancé, le teint blafard et le crâne dégarni comme la lune, avec de longs doigts à la Beardsleye, d'énormes oreilles et des yeux foncés enfouis sous de lourdes paupières, ce photographe colombien âgé de 37 ans semble être un personnage venu d'ailleurs: une figure mythologique surgie des abysses pour répandre sa folie de par le monde. Mais heureusement pour nous, commun des mortels, il vit cette folie à travers une forme d'art qui tire sa beauté des sombres abîmes d'un cratère volcanique, célèbre la texture d'une gigantesque feuille de tabac ou encore sonde le mystère complexe mais fondamental de la paume d'une main. ❖ L'éruption volcanique qui rasa la ville d'Almedo en 1985 devint sujet d'inspiration artistique pour Afanador. Après avoir vu à la

télévision l'extraction de cadavres engloutis par de la lave, il décida de faire une série de photographies vouées à l'exploration du corps humain dans sa forme primaire, semblable à un fossile et recouvert de substances aussi élémentaires que la boue et le sel. ✧ Destinées dans un premier temps à commémorer le dixième anniversaire du drame, ses photographies en noir et blanc mettent en scène des danseurs de la troupe colombienne Athanor Danza. Sensuelles et structurées, elles témoignent de la formation qu'Afanador suivit à l'Université Notre Dame, la sculpture. Mais ses images recèlent bien plus que des formes et des structures intéressantes. ✧ Dans tous ses travaux, photos de mode, portraits ou encore études plus artistiques pour des expositions, Afanador semble avoir réuni un panthéon de figures mythologiques, symboliques ou totémiques desquelles émane une majesté d'un autre monde, par moments presque sacrée. ✧ Lorsque l'on pense à des pays catholiques comme l'Italie ou la Colombie, il semblerait que là-bas, la mort soit un peu plus proche de la vie que nulle part ailleurs. Et cette impression sous-jacente, cette conscience de la mort s'accompagne d'une grande sensualité exempte de toute fausseté – caractéristiques présentes dans le travail d'Afanador depuis le début de sa carrière à Milan où il fit ses premiers pas dans la photographie de mode. ✧ C'est sans atelier ni argent, avec un baccalauréat pour seul bagage et une grande affinité pour tout ce qui touche à l'âme – affinité qu'il put entièrement satisfaire dans cette ville italienne – que le jeune photographe prit ses premières photos avec pour unique décor les murs nus de la capitale industrielle. C'est là, selon lui, qu'il a tout découvert, «la photo en noir et blanc, les effets graphiques, les éléments sculpturaux. J'ai senti une sorte d'union entre mon travail et l'aspect des choses, l'ancienneté du tout, quelque chose qui ne serait jamais arrivé ailleurs.» ✧ Aujourd'hui, ces éléments prévalent dans ses portraits et ses photos de mode qui, selon Afanador, représentent la part du lion dans son travail. Depuis son retour aux Etats-Unis en 1990, il a travaillé pour Vanity Fair, Vogue, Time, GQ, Life, Rolling Stone, Vibe – liste non exhaustive – et a réalisé des portraits de nombreuses célébrités, telles que Gary Oldman, Al Pacino, Antonio Banderas, Diana Ross, Susan Sontag, James Michener et Gabriel Garcia Marquez. De son portrait de profil du musicien Lenny Kravitz, pris agenouillé et vêtu d'un simple pagne savamment drapé, se dégagent une grande sensualité, une atmosphère mythique. Ses photos de mode renferment leur part de mystère: bien que directes et sans détours, presque proches de la confrontation, elles sont enveloppées d'une aura énigmatique rendue grâce à l'utilisation de fonds à la texture intéressante, d'angles de prises de vues inhabituels, d'un éclairage graphique ou encore de miroirs qui reflètent le modèle et allongent son image. ✧ Qu'Afanador préfère la photographie en noir et blanc ne surprendra personne. S'il avait le choix, il travaillerait uniquement en noir et blanc: «Avec le noir et blanc, il n'y pas de banalité», explique-t-il. Tandis qu'il était encore un jeune homme pétri d'idéaux, il allait jusqu'à refuser de prendre des photographies en couleur. Aujourd'hui, il a revu sa position pour élargir son horizon: «Je crois que si l'on veut évoluer, il faut aussi photographier en couleur. Si on y renonce, il faut sans doute beaucoup plus de temps pour aboutir dans sa recherche, et il est possible que l'on ne puisse pas faire certaines choses qui à leur tour nous donnent la liberté de réaliser d'autres projets.» ✧ Afanador concède qu'il s'est fait

un nom dans la photographie en noir et blanc et qu'il essaie de se «défaire de cette image». «Je préfère toujours le noir et blanc, mais la couleur représente un changement. Je crois que c'est un progrès.» ✧ Il estime qu'il n'y a pas de séparation distincte entre ses photos de mode et ses portraits: «Les portraits ont quelque chose de la mode, une certaine influence stylisée de la mode», explique-t-il, allongé sur un sofa en velours rouge dans son atelier de Manhattan, entouré de fleurs exotiques et de lourds chandeliers en cuivre. Même la série de portraits de Diana Ross – pour laquelle il l'avait convaincue de retourner sur les lieux de son enfance – a «en premier lieu trait à la mode, avec ce qu'elle portait par hasard ce jour-là», explique-t-il. «Cela tient à ses vêtements, à son look, à la façon dont tout est arrangé et au feeling qui est donné. La mode est ce qu'il y a de plus important, elle transparaît à travers toutes les photos.» ✧ Les photos de mode d'Afanador gagnent en profondeur grâce au genre d'exploration inhérent au portrait. «J'aime sentir», dit-il. «Les photos de mode, ce ne sont pas des images qui se regardent rapidement, comme ça, il y a une profondeur, une raison, une relation, que ce soit avec un objet ou avec tout un environnement.» ✧ Lors d'un récent projet consacré aux réalisations du créateur de mode mexicain Victor Alfaro pour le magazine Si, le décor se résumait à un simple lit rectangulaire recouvert de satin et d'un filet de pêche. Afanador a trouvé son inspiration dans une image datant du 19e siècle prise par un photographe mexicain, laquelle montrait une femme alanguie sur une banquette devant un mur nu. «J'aime la qualité minimaliste de cette photo», déclare Afanador, «en même temps, j'aime aussi le message véhiculé, car il s'agit d'un designer mexicain qui vit aux Etats-Unis et crée des vêtements modernes et simples, mais c'est aussi ce lit et l'idée de séduction qui s'en dégage. Je voulais quelque chose qui ait un rapport avec la sensibilité latino-américaine», tout en conservant une certaine simplicité, «l'éclairage très réel et très beau du portrait» propre à la photographie du 19e siècle. «C'est authentique», remarque Afanador, «et j'adore le côté sensuel du sujet.» ✧ Afanador apprécie autant l'authenticité d'une photographie mexicaine du 19e siècle que l'ouverture et la sensualité de son pays natal. Pour lui, la simplicité des portraits d'Irving Penn tient lieu d'exemple tandis que l'élégance sculpturale des prises de vues noir et blanc du photographe espagnol Javier Vallhonrat rejoint son idéal. L'influence de ces deux maîtres se traduit dans les réalisations plus récentes d'Afanador comme dans le livre Palms illustrant les mains de célébrités – lequel paraîtra en automne 1996 à l'occasion de sa première exposition à New York – ou l'exposition consacrée au volcan colombien qui s'est tenue à Hong Kong et en Allemagne, ou encore dans le livre sur la troupe de danse qui sera publié en Colombie. D'autres projets sont également en cours: un livre sur la danse destiné au marché américain et un autre intitulé Home qui montre des célébrités sur le lieu de leur enfance (comme Diana Ross). ✧ Le photographe lui-même aurait eu sa place dans le livre Home. Né en Colombie, il quitte son pays à l'âge de 14 ans pour le Michigan et ne retourne sur sa terre natale que 18 ans plus tard. Ce qu'il trouve là-bas – l'ouverture, le symbolisme mythique, la volupté – lui fait l'effet d'une cure de jouvence. La preuve: ses images honnêtes, sensuelles, qui semblent transcender le temps. L'auteur américain Thomas Wolfe avait tort: un retour est toujours possible.

Rynn Williams, ehemallge Redaktionsassistentin von Graphis, arbeitet heute als freie Autorin und Redakteurin in New York.
Autrefols rédactrice chez Graphis **Rynn Williams** travaille aujourd'hui en tant que rédactrice indépendante à New York.

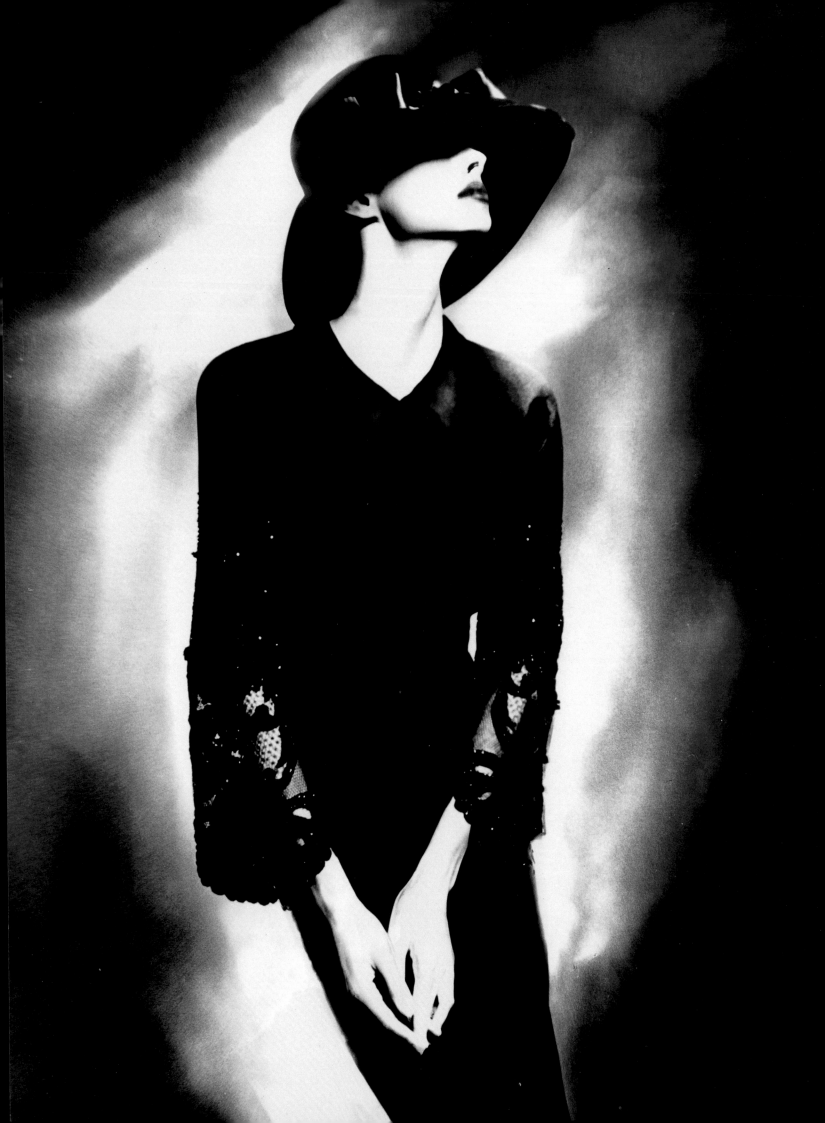

Lillian Bassman

Lillian Bassman is considered one of the finest photographers of the twentieth century. An innovator in experimental photography, Bassman's early training as an artist is reflected in her approach. Lillian Bassman's style transcends technique in its visionary quality, and her earliest work continues to be progressive by today's standards. Bassman was last honored by a retrospective of her work at the Louvre in 1994, and continues to set new standards in both commercial and fine art photography. ▪

Lillian Bassman ist eines der grössten photographischen Talente des zwanzigsten Jahrhunderts. Ihre frühere Ausbildung in bildender Kunst hat ihre innovative, experimentelle Photographie geprägt. Das Visionäre ihrer Arbeit ist unabhängig von technischen Aspekten, und selbst ihre frühsten Arbeiten sind auch nach heutigen Kriterien progressiv. 1994 wurde Lillian Bassman durch eine Retrospektive ihres photographischen Werkes im Louvre geehrt. In der Auftragsphotographie wie in der künstlerischen Photographie setzt sie nach wie vor neue Massstäbe. ▪ *Lillian Bassman compte parmi les plus grands talents de la photographie du 20e siècle. Son approche de la photographie expérimentale porte la marque de ses années de formation dans une école d'arts. La qualité visionnaire de ses images transcende sa technique, et ses premiers travaux restent, aujourd'hui encore, résolument novateurs. En 1994, l'œuvre de Lillian Bassman a été honorée par une rétrospective au Louvre. Cette photographe hors pair n'a de cesse d'ouvrir de nouvelles brèches, que ce soit dans le domaine de la photographie d'art ou de la photographie commerciale.*

—CARRE BEVILACQUA, DIRECTOR OF PHOTOGRAPHY, GRAPHIS

Award Winners

FASHION/HELMUT NEWTON

PHOTOJOURNALISM/SIMON NORFOLK

STILL LIFE/KENRO IZU

FOOD/STEPHAN ABRY

PEOPLE/LIZZIE HIMMEL

PRODUCTS/ALAN RICHARDSON

LANDSCAPE/DEBORAH BRACKENBURY

ARCHITECTURE/DUDLEY DENADOR

WILDLIFE/LUCIANO MORINI

SPORTS/JOHN HUET

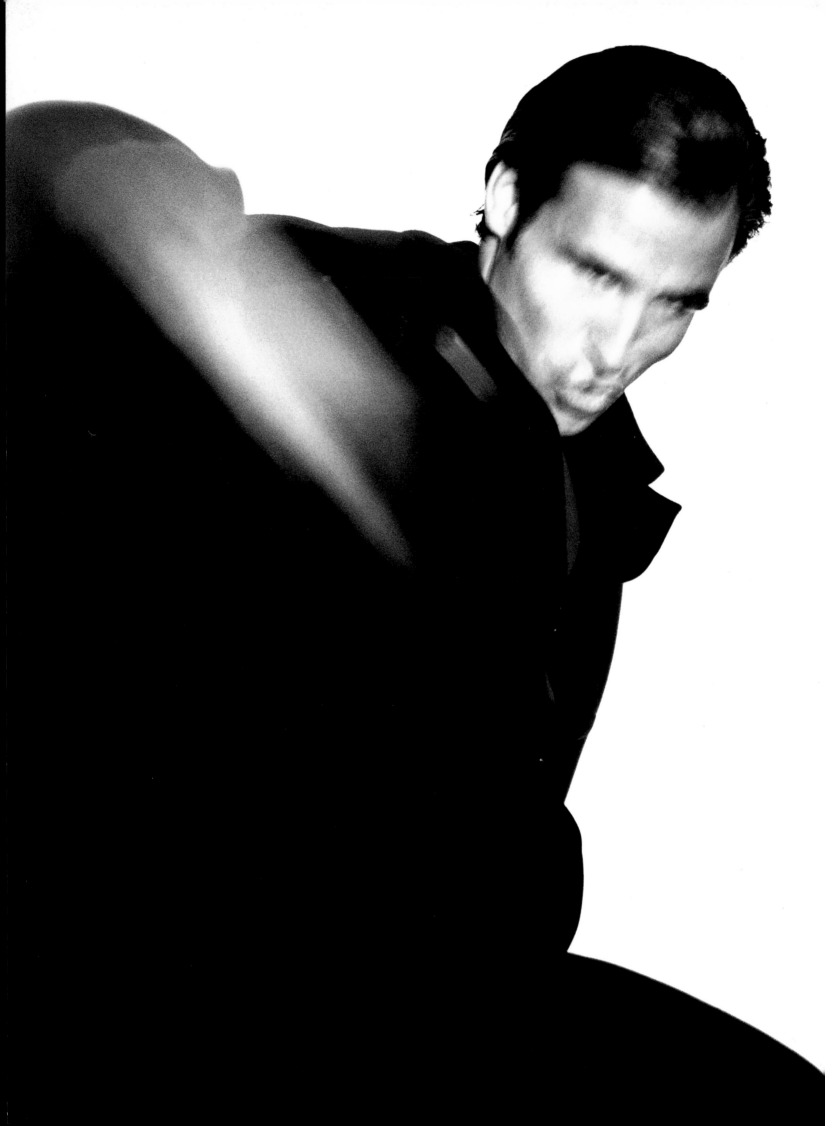

FASHION

MODE

MODE

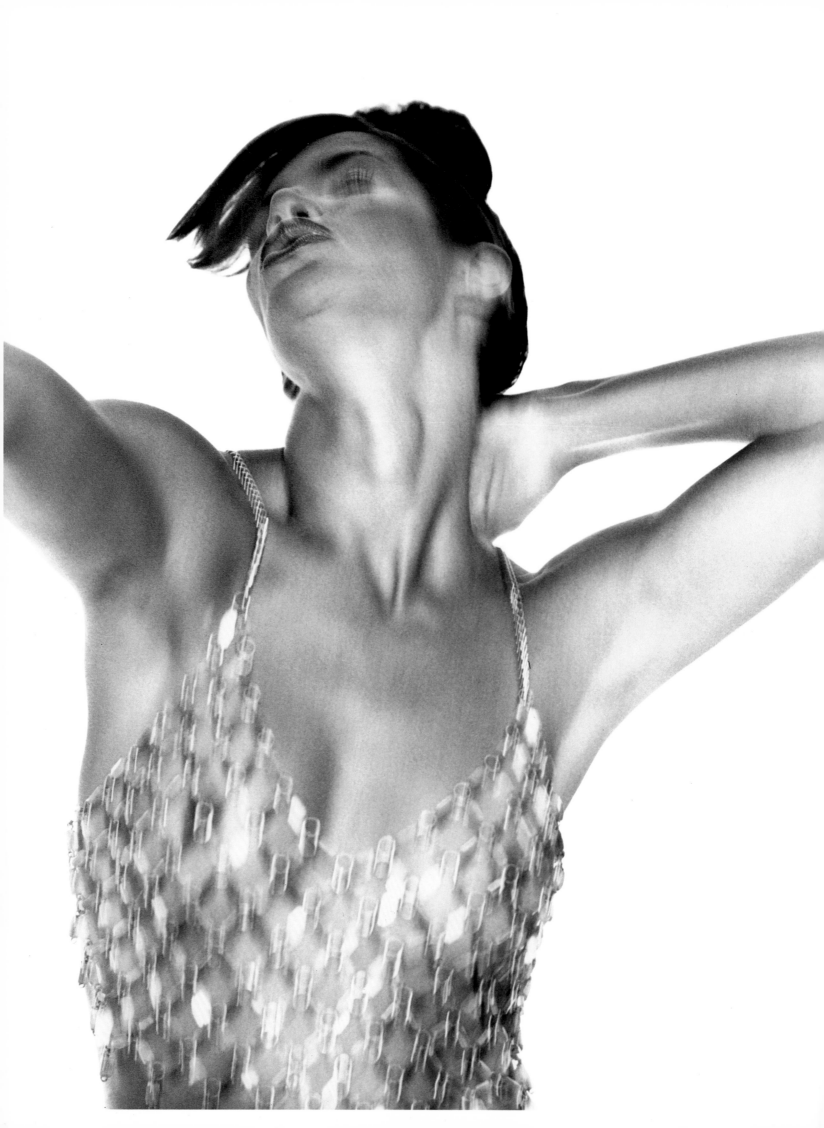

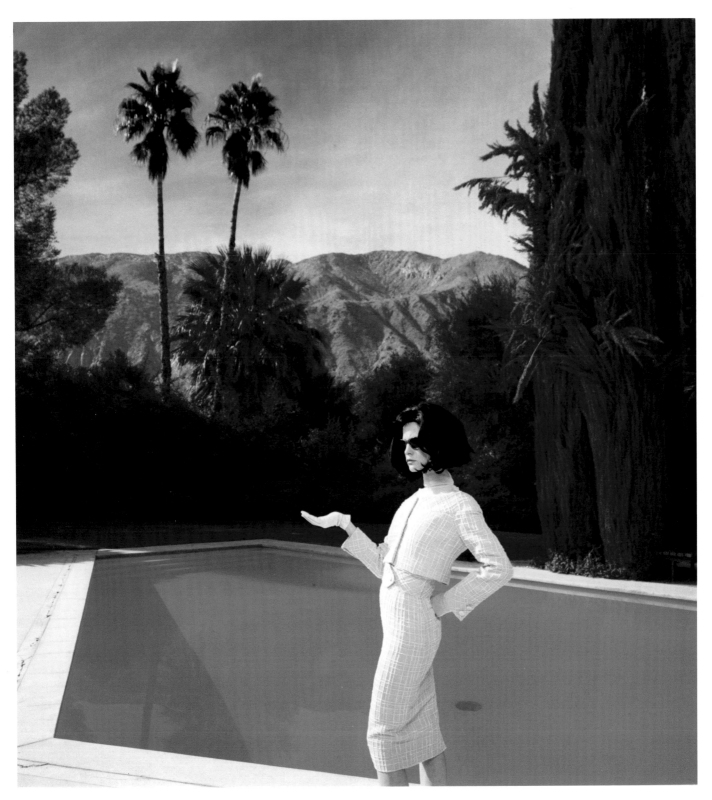

Preceding Spread and Opposite: Man · Above: Annie Leibovitz

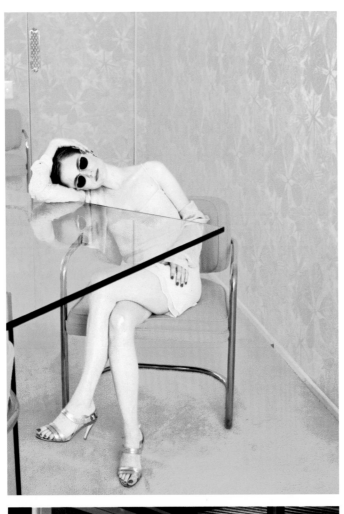
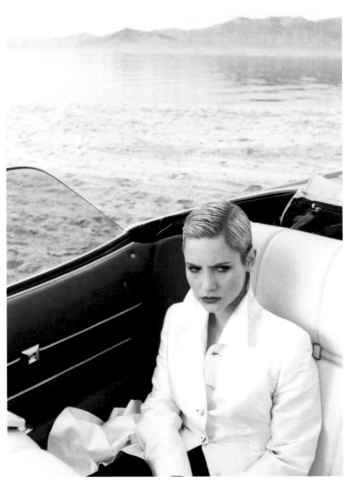
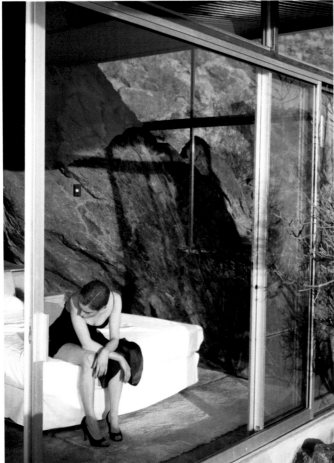
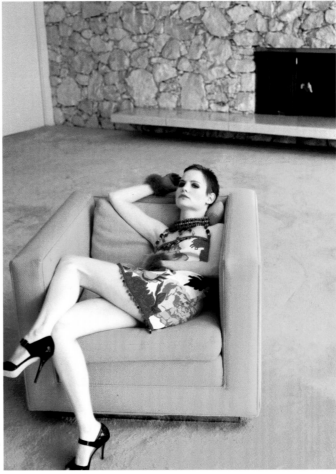

Annie Leibovitz

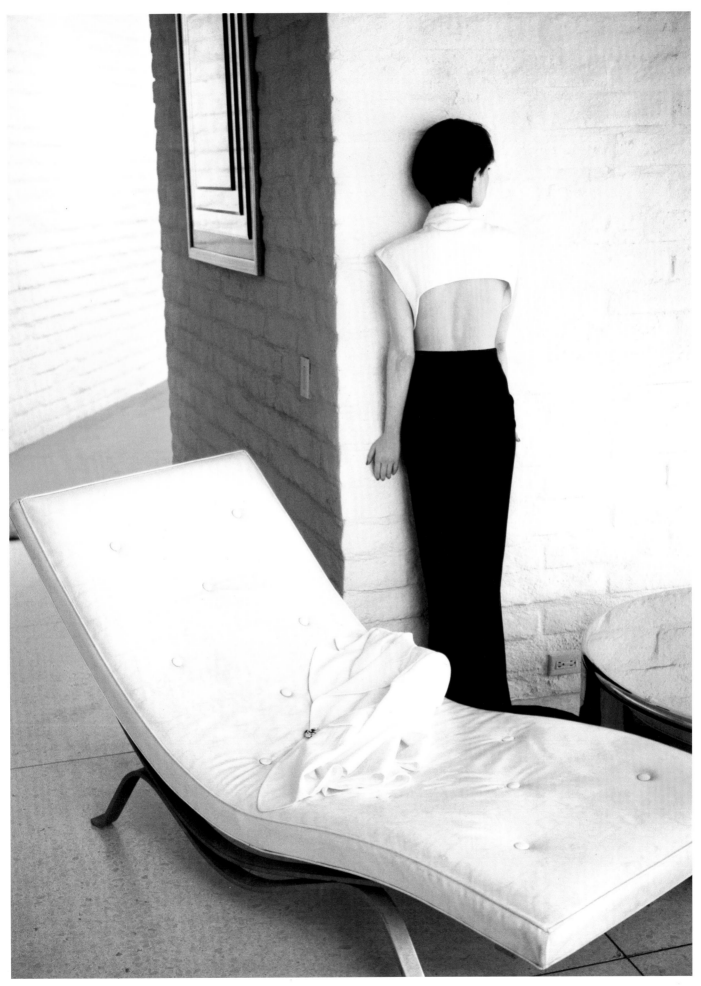

Annie Leibovitz

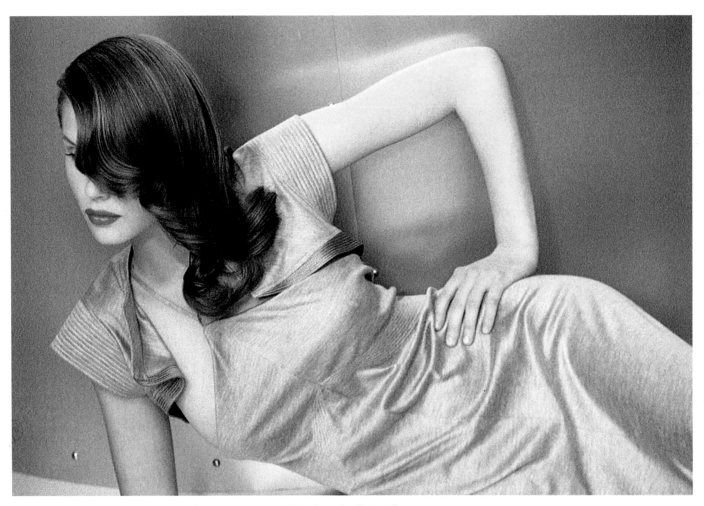

This Spread: Sheila Metzner

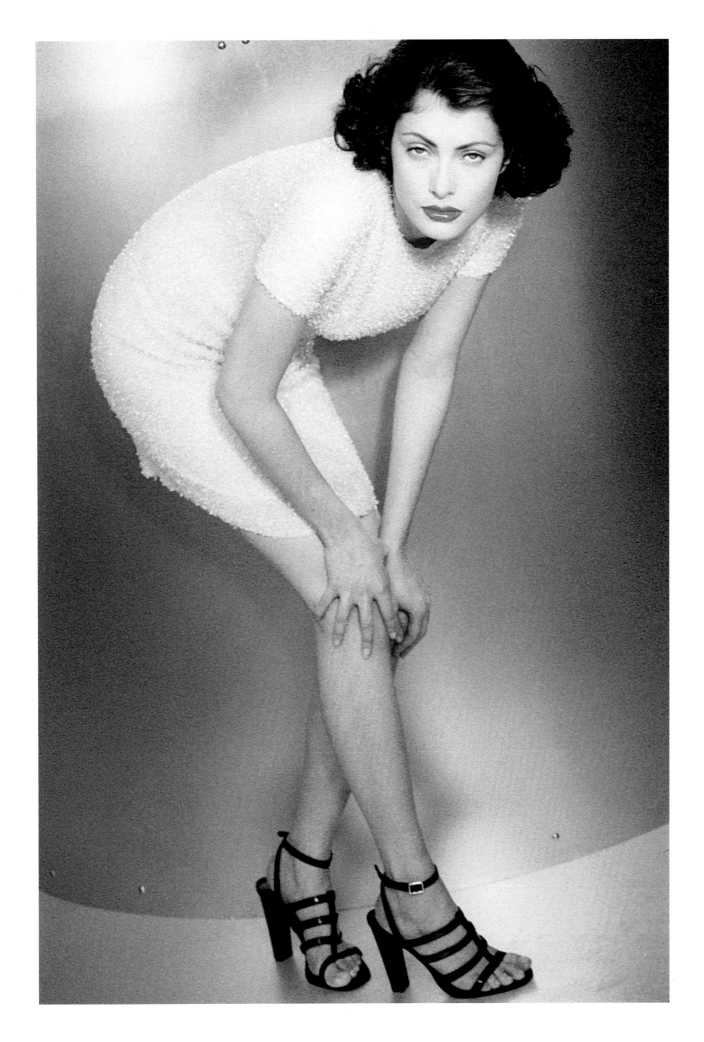

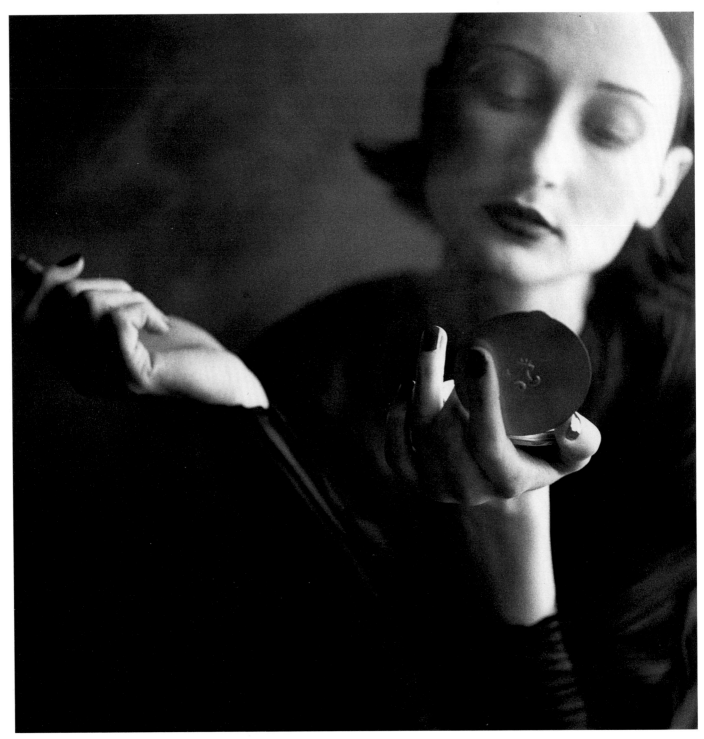

Rodney Smith

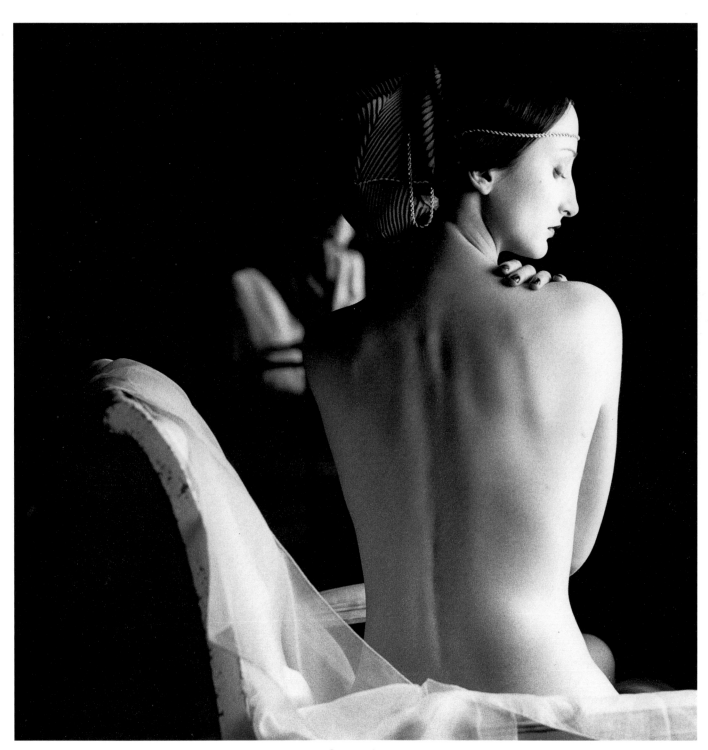

Rodney Smith

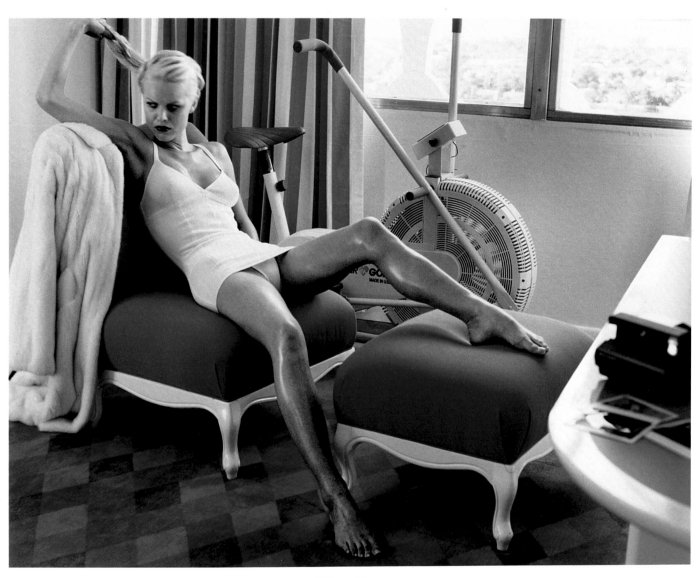

Helmut Newton

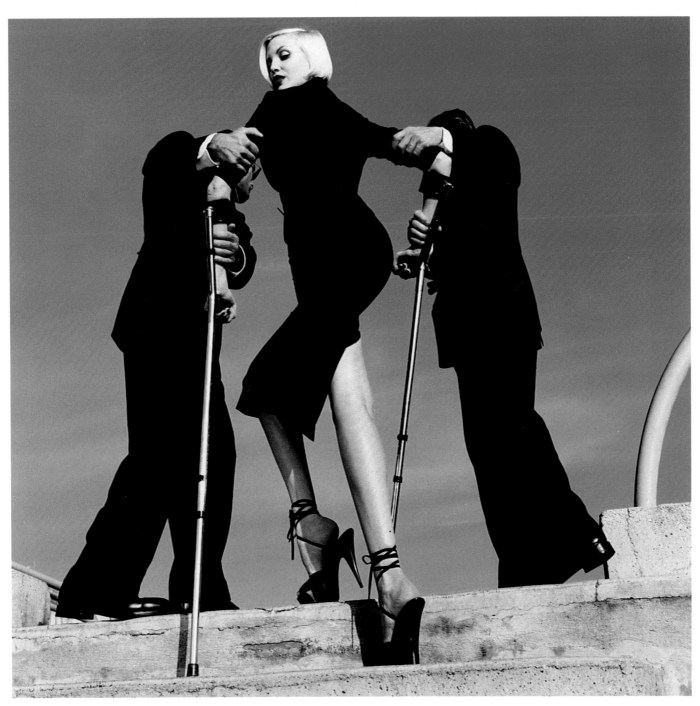

Helmut Newton

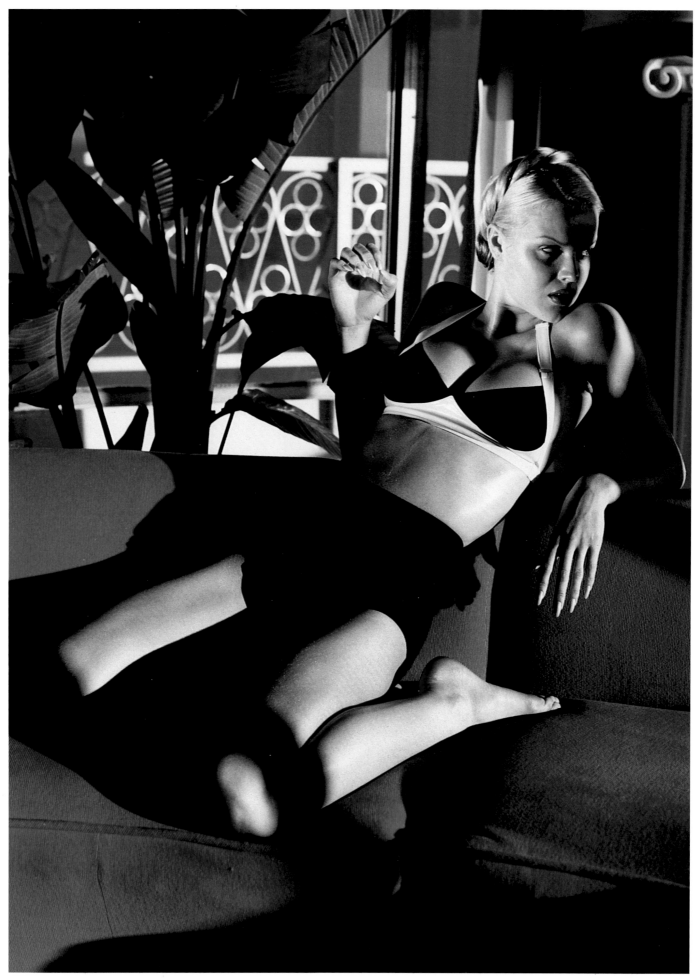

Helmut Newton

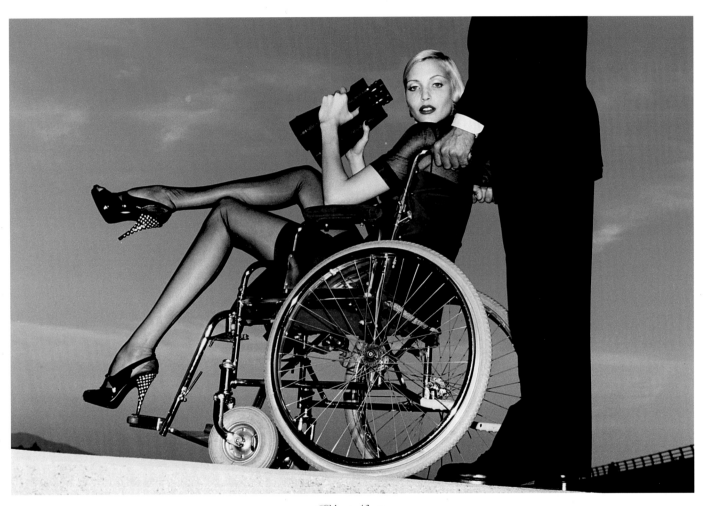

Helmut Newton
BEST OF CATEGORY

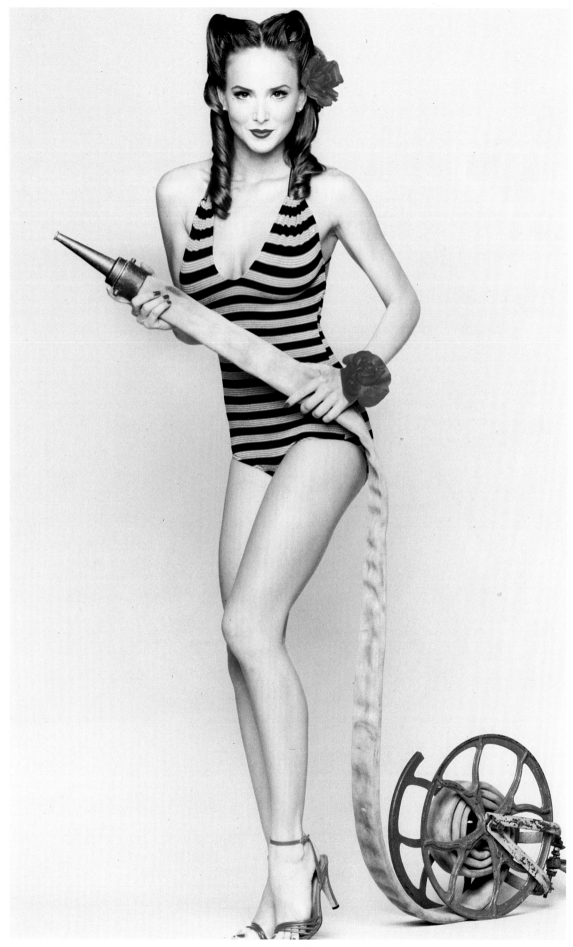

TC Reiner

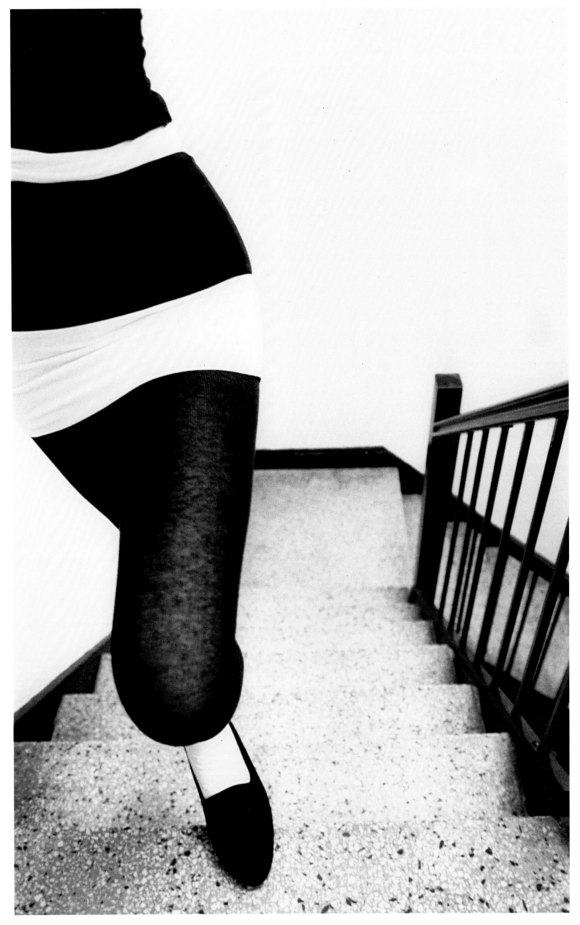

Lizzie Himmel

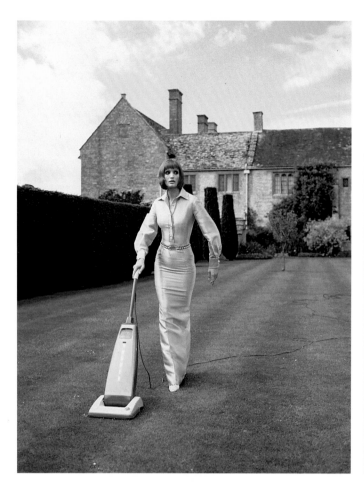

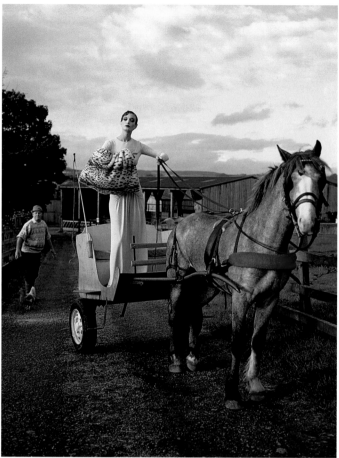

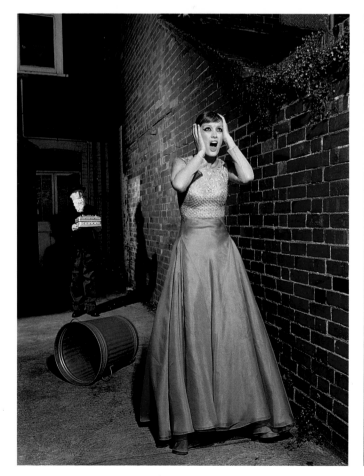

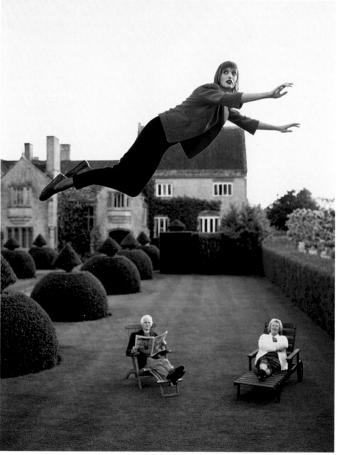

Geof Kern

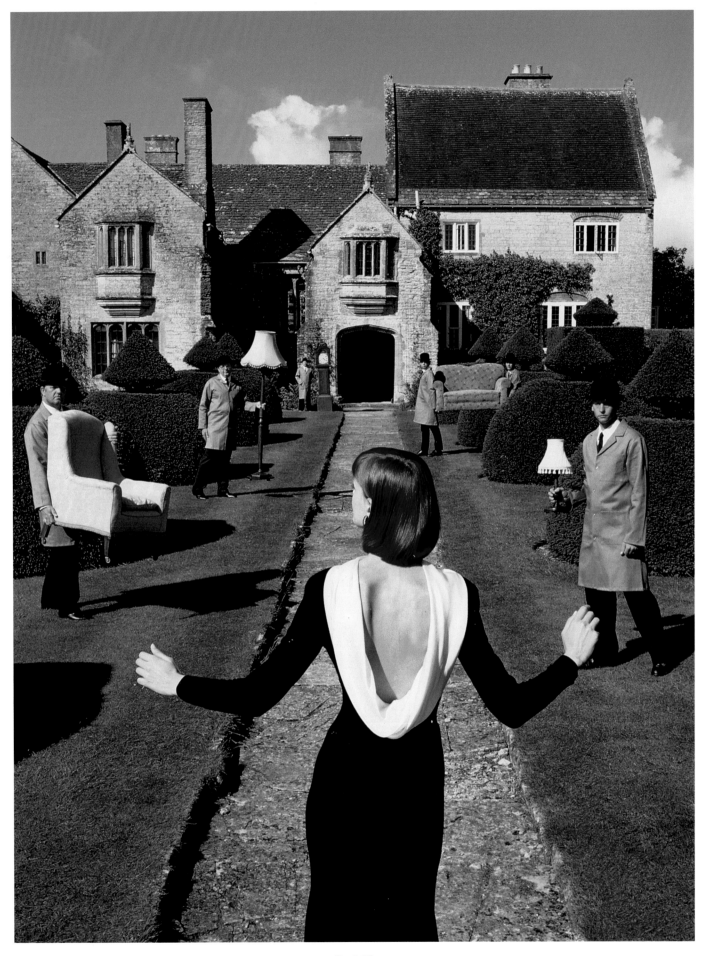

Geof Kern

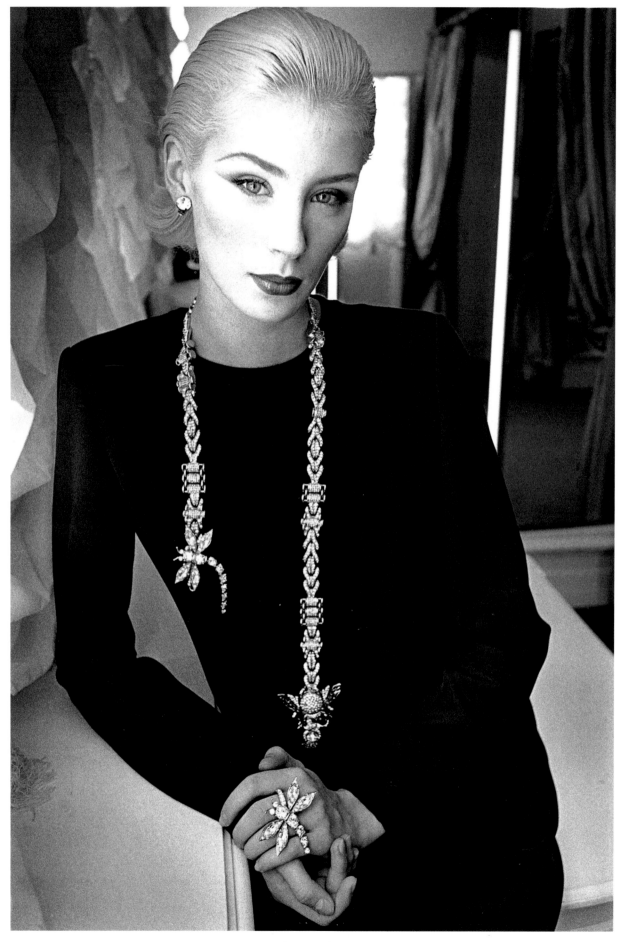

Jeanloup Sieff

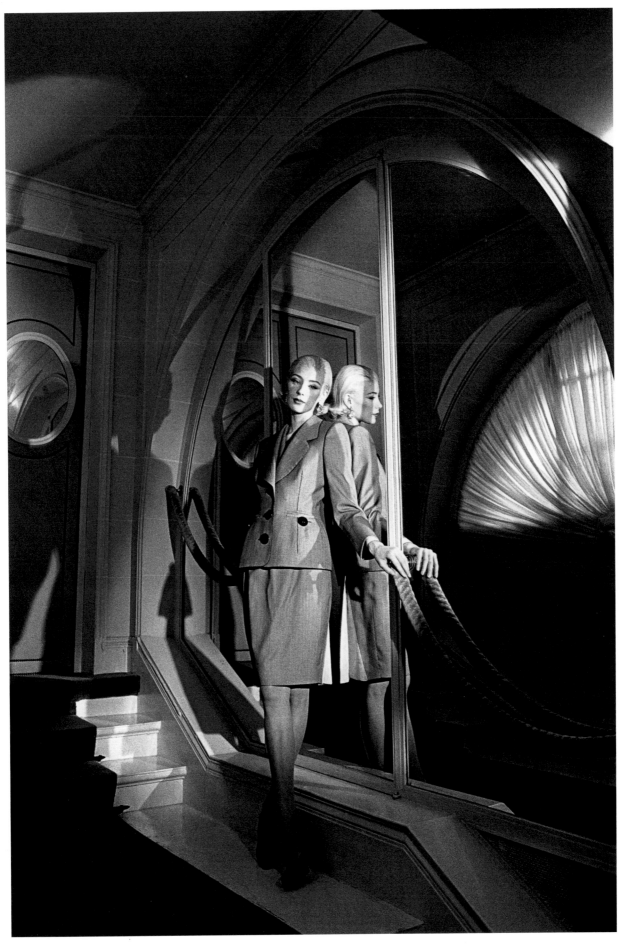

Jeanloup Sieff

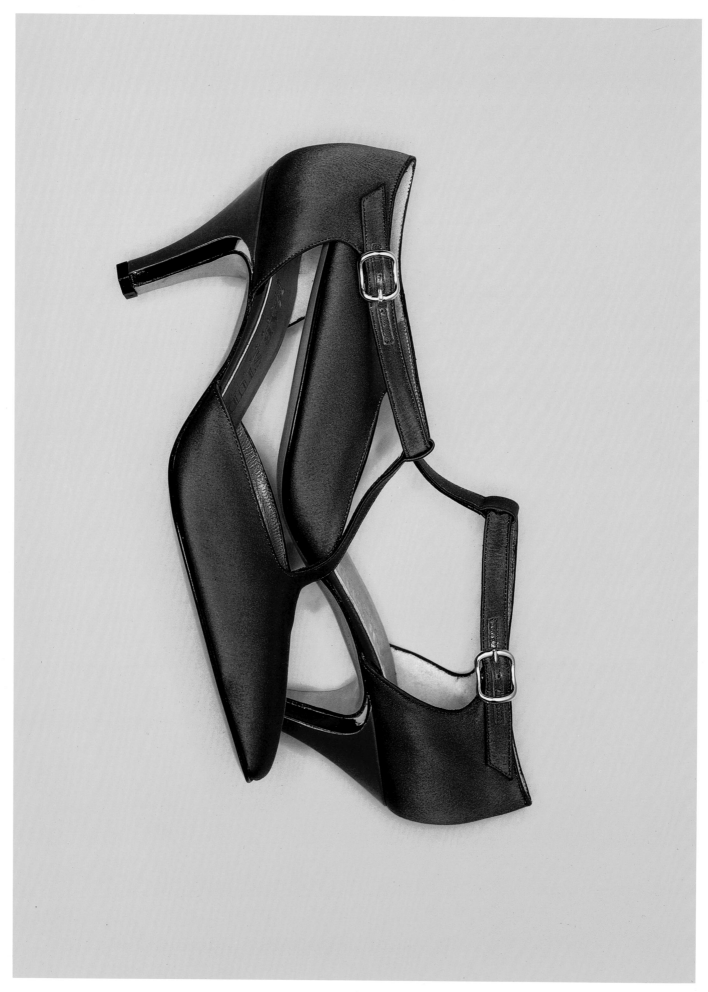

Piero Gemelli

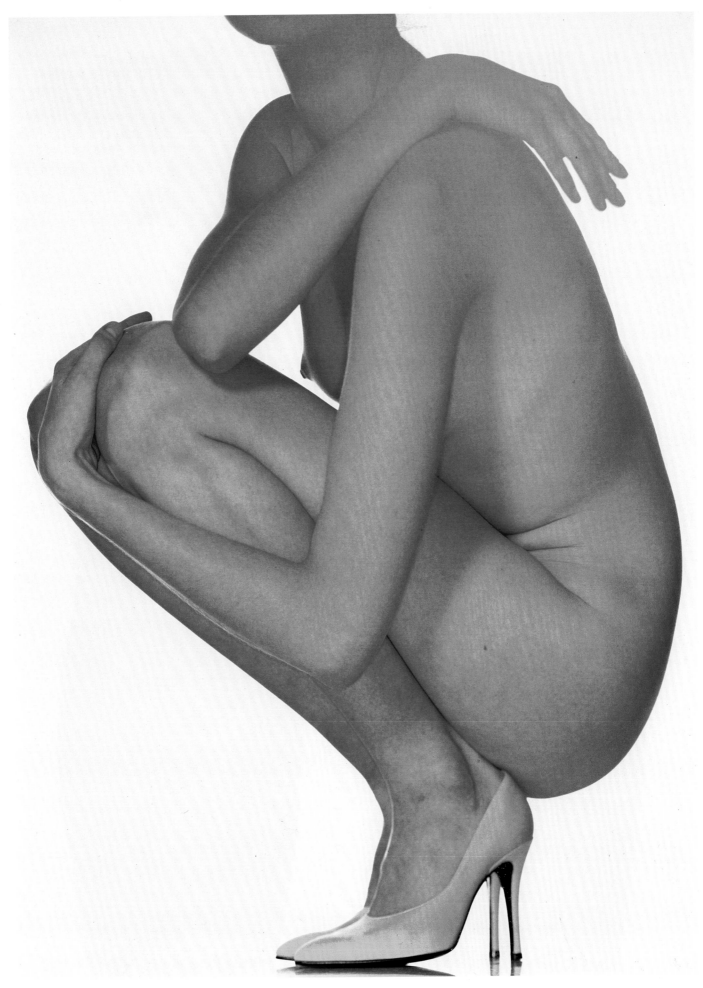

Albert Watson

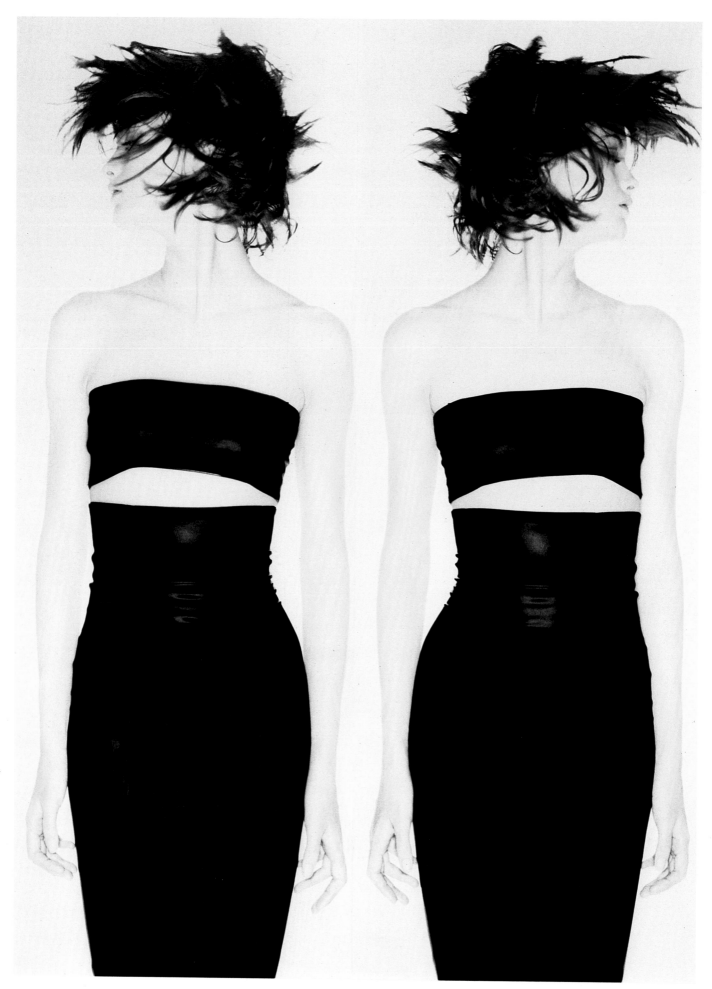

Nick Knight

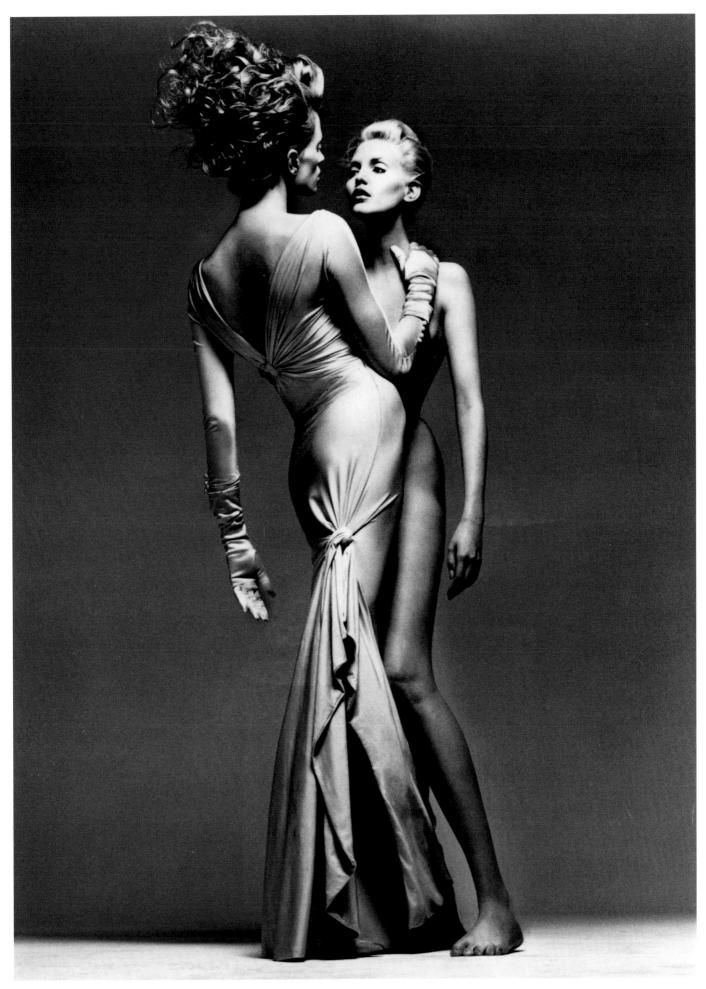

Above: Richard Avedon · Following Spread: Nick Knight

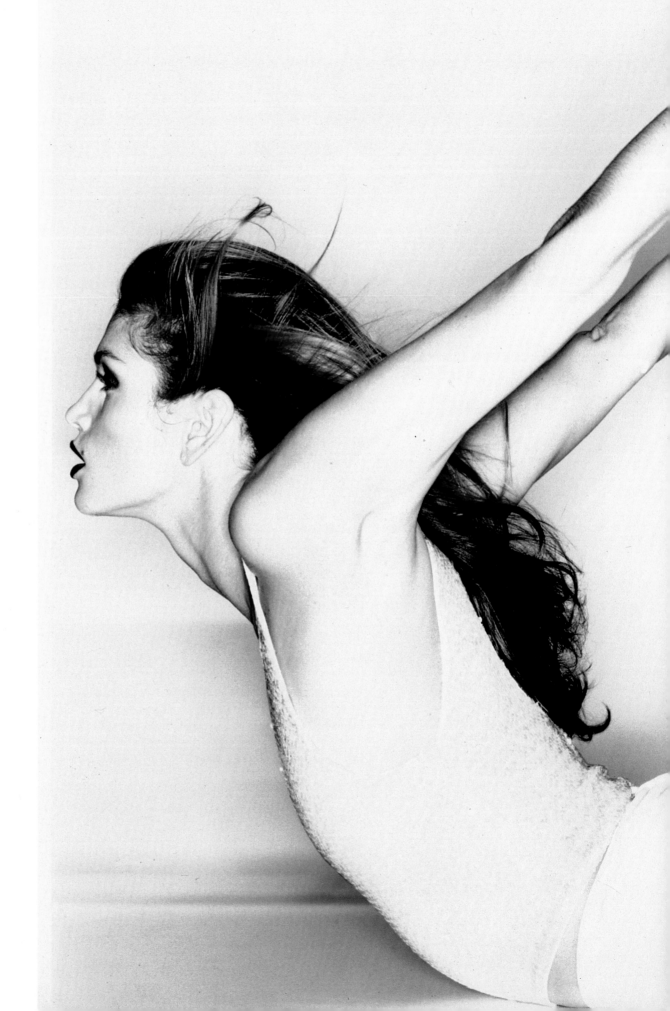

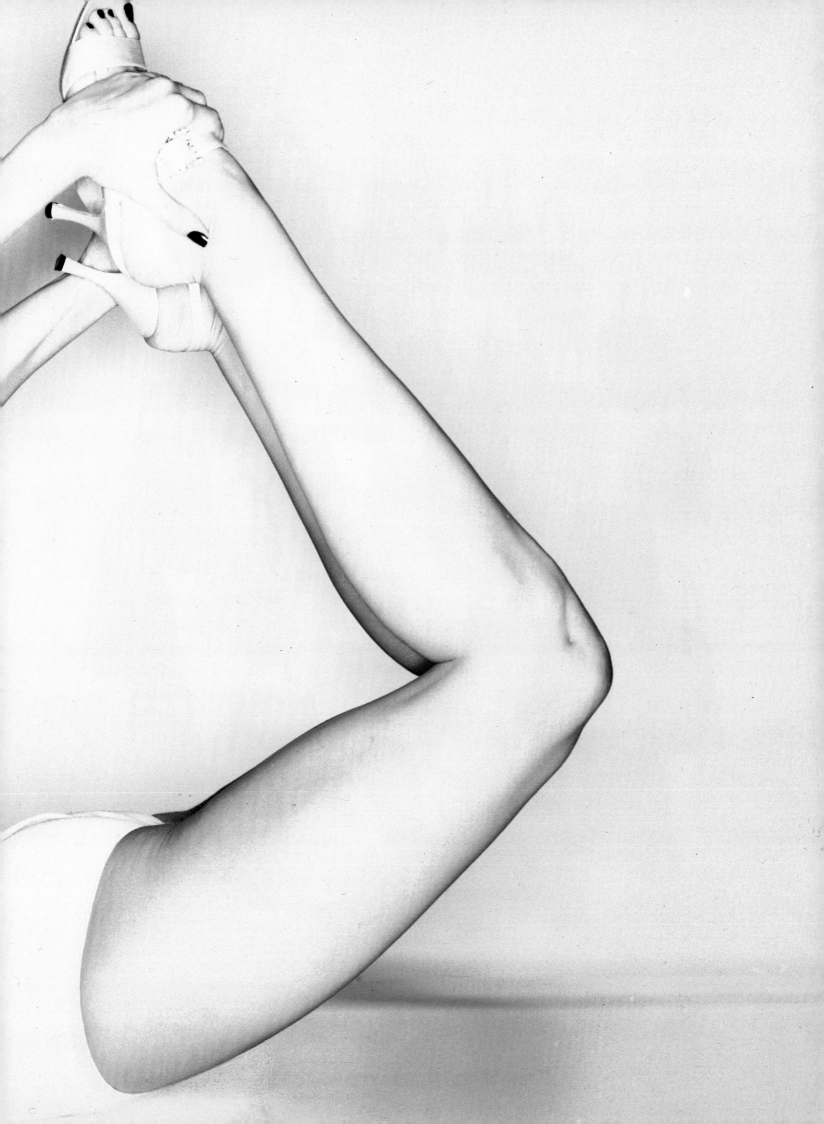

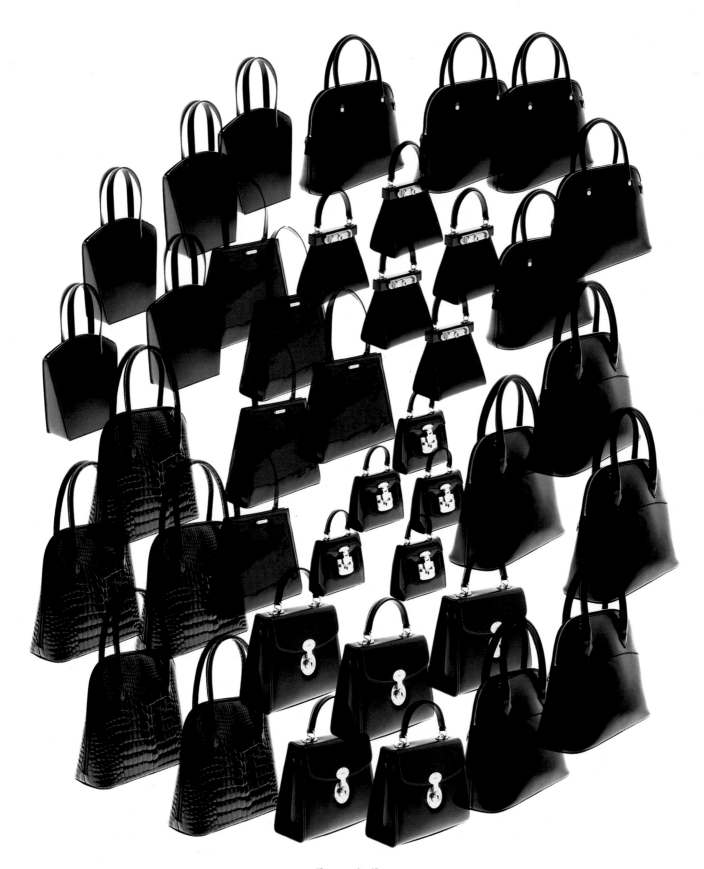

Raymond Meier

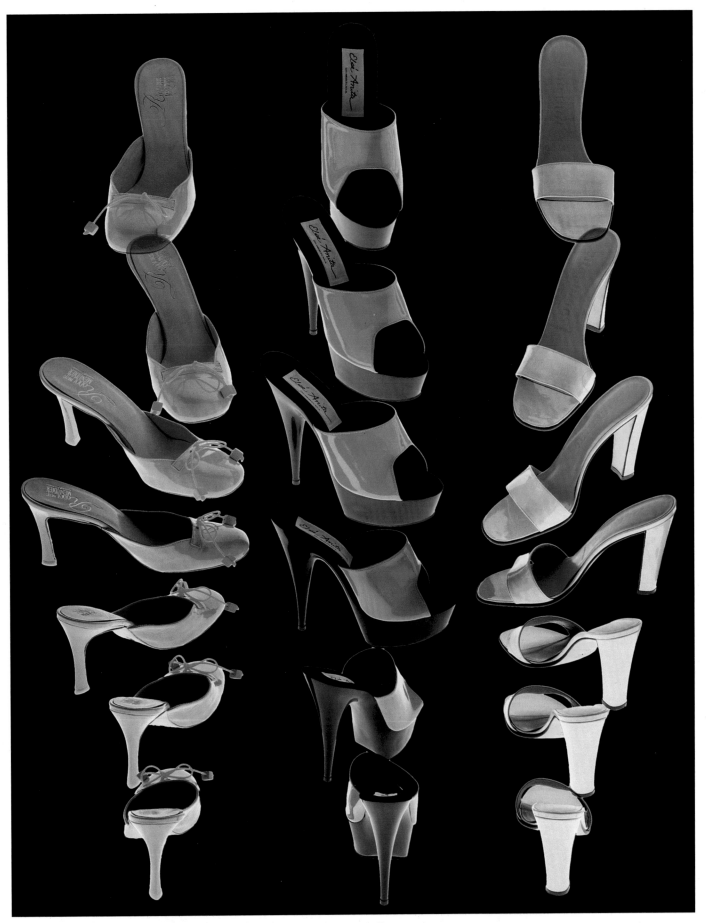

Raymond Meier

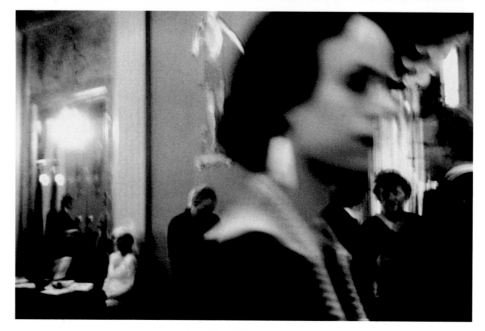

Daniel Proctor

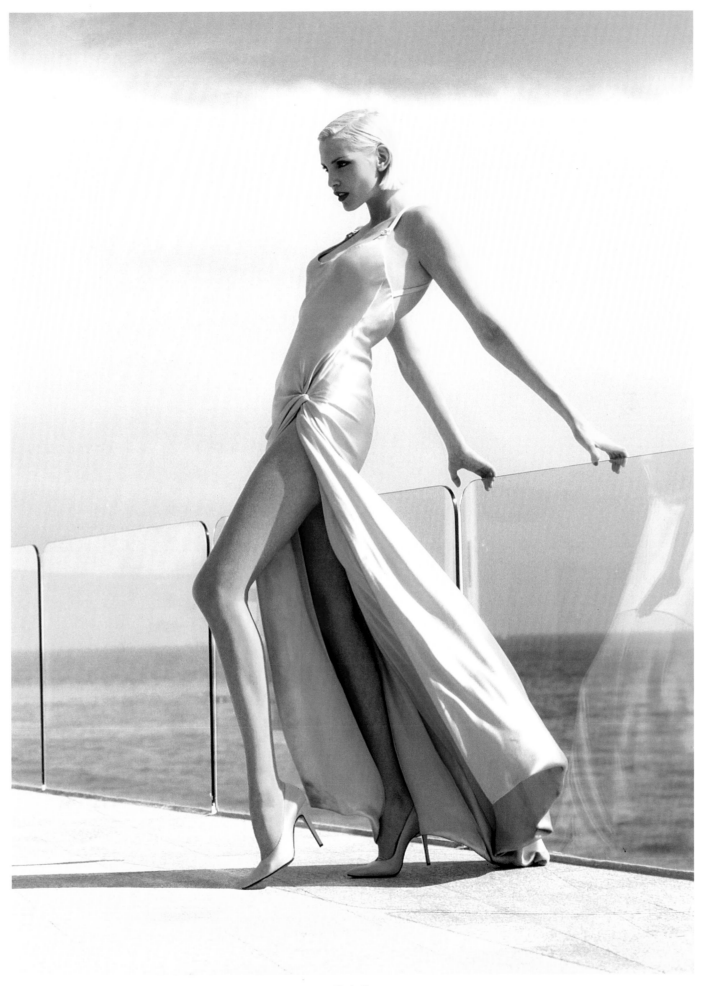

Herb Ritts

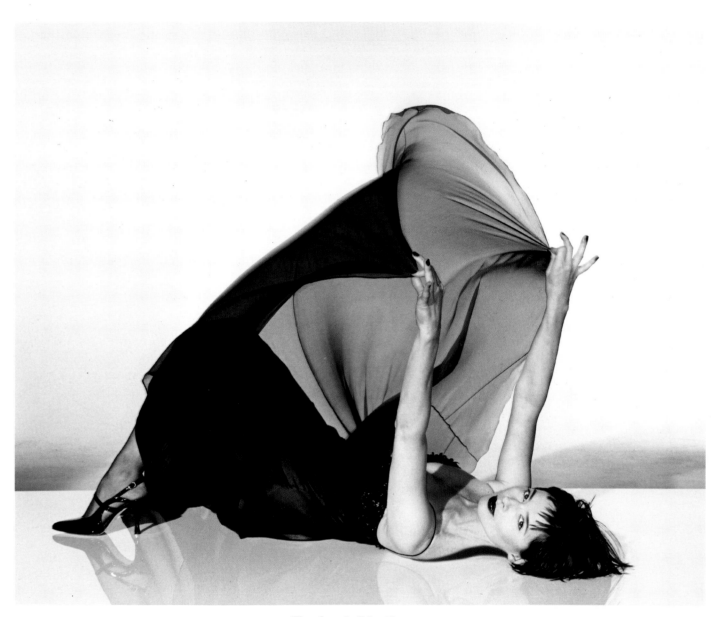

This Spread: Gilles Bensimon

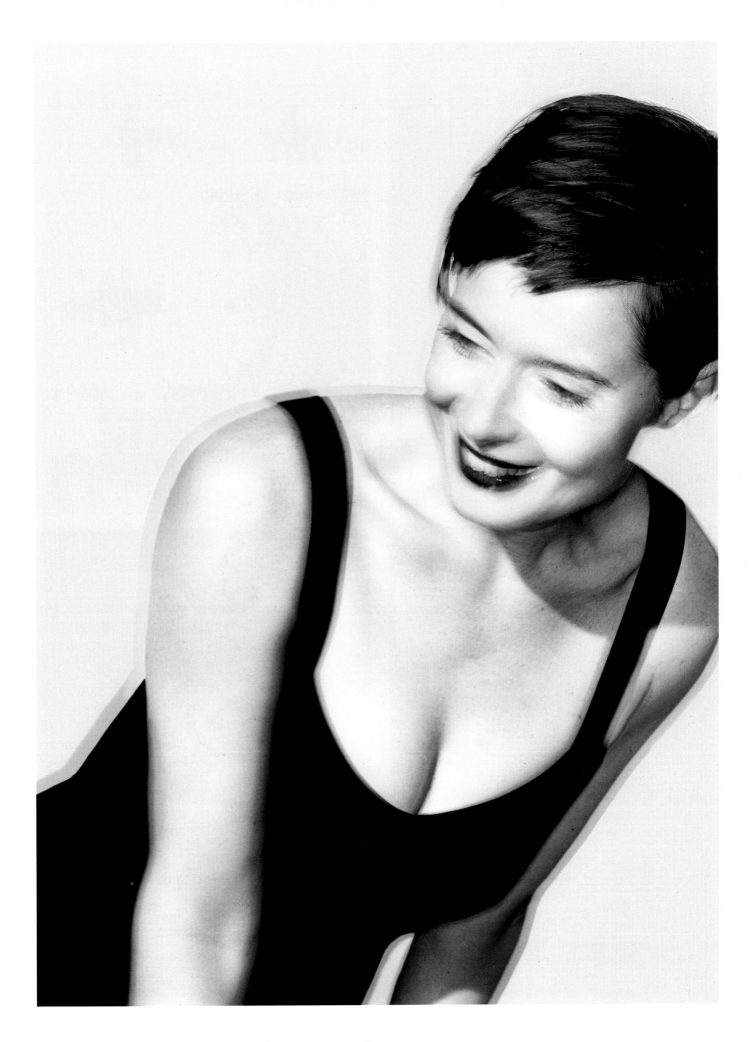

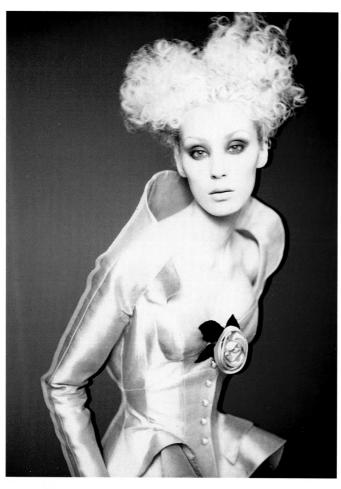

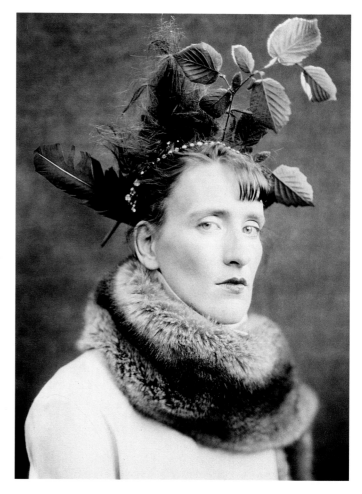

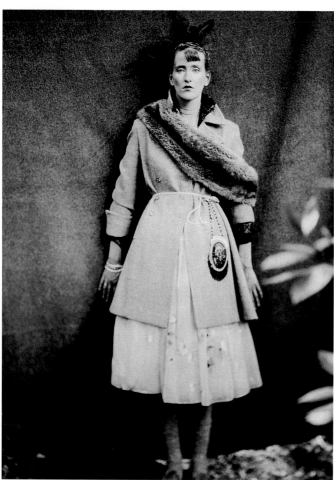

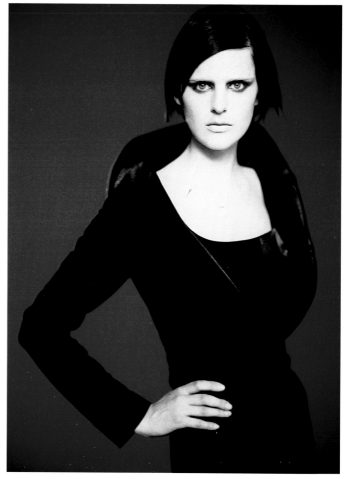

Paolo Roversi

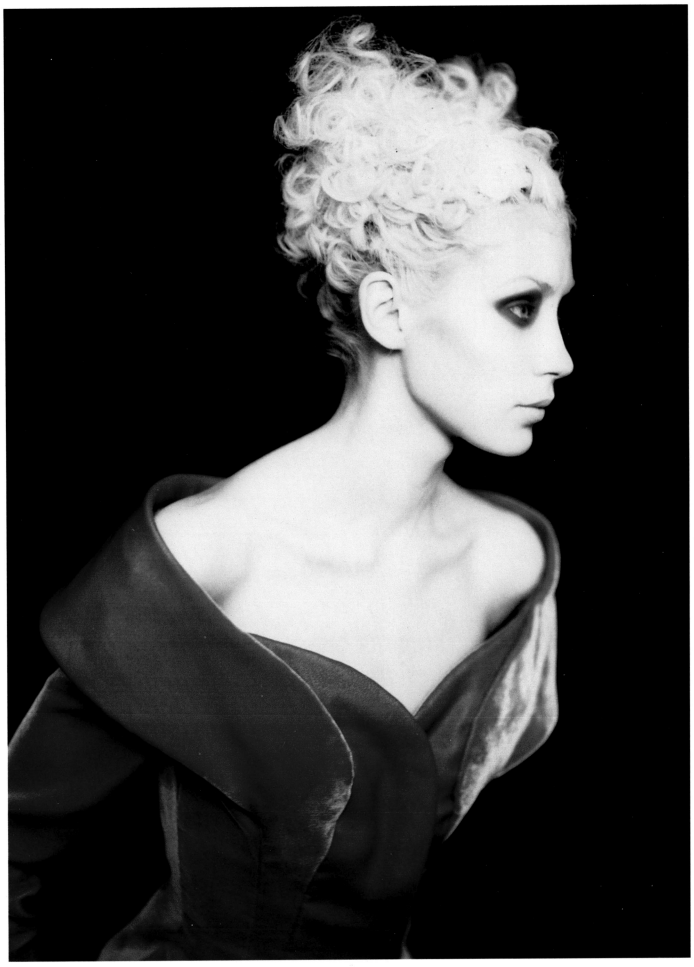

Paolo Roversi

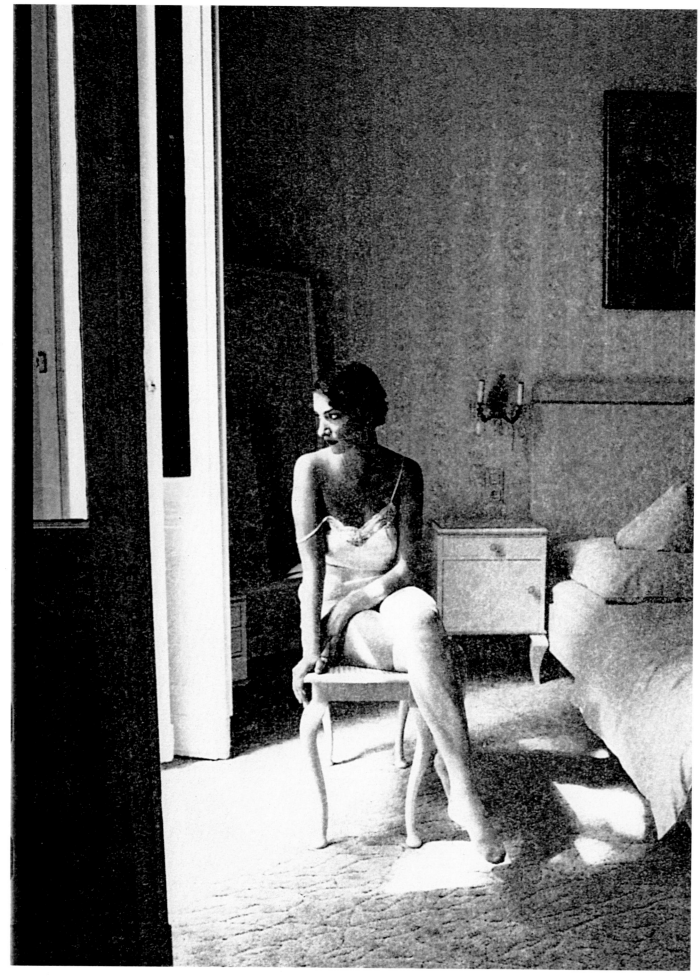

Andrej Glusgold

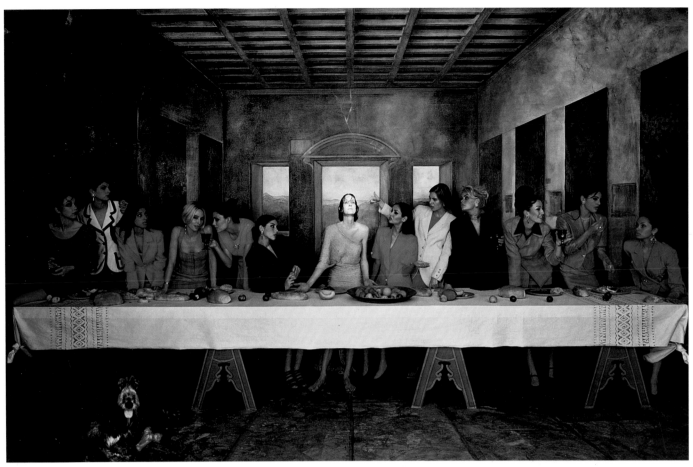

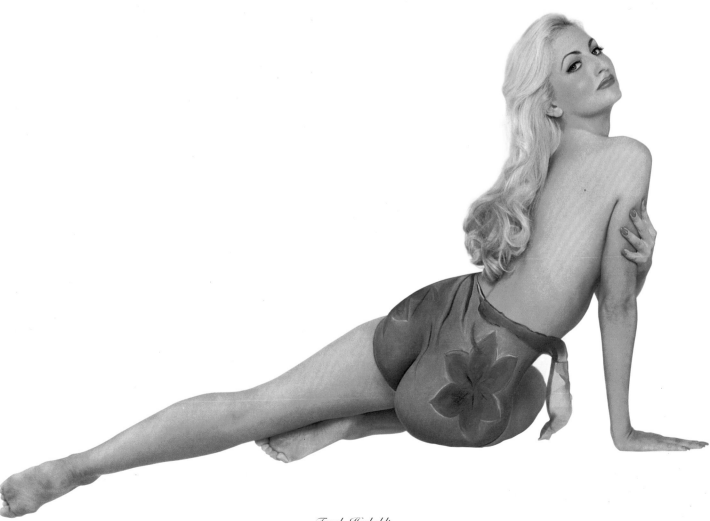

Frank Herholdt

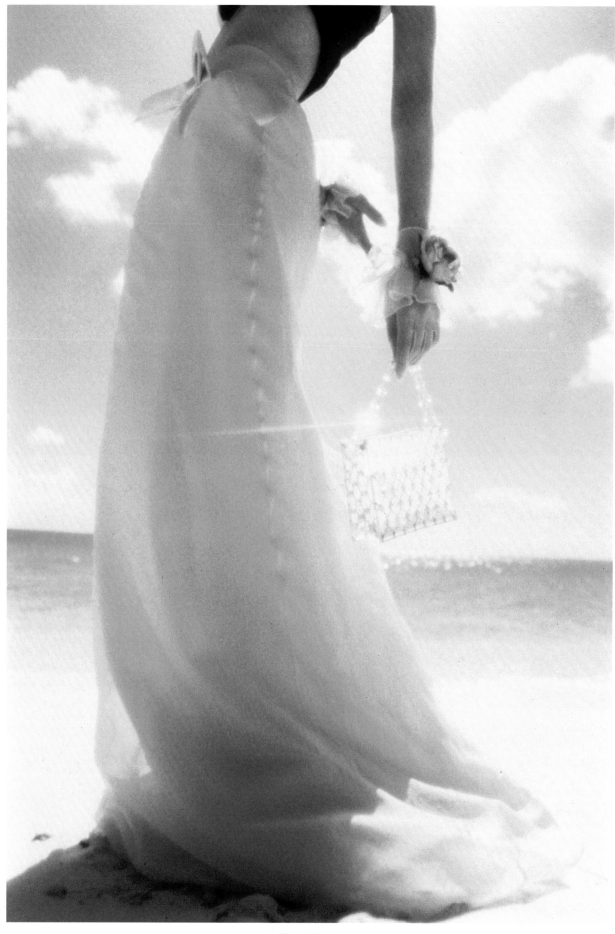

Nick Knight

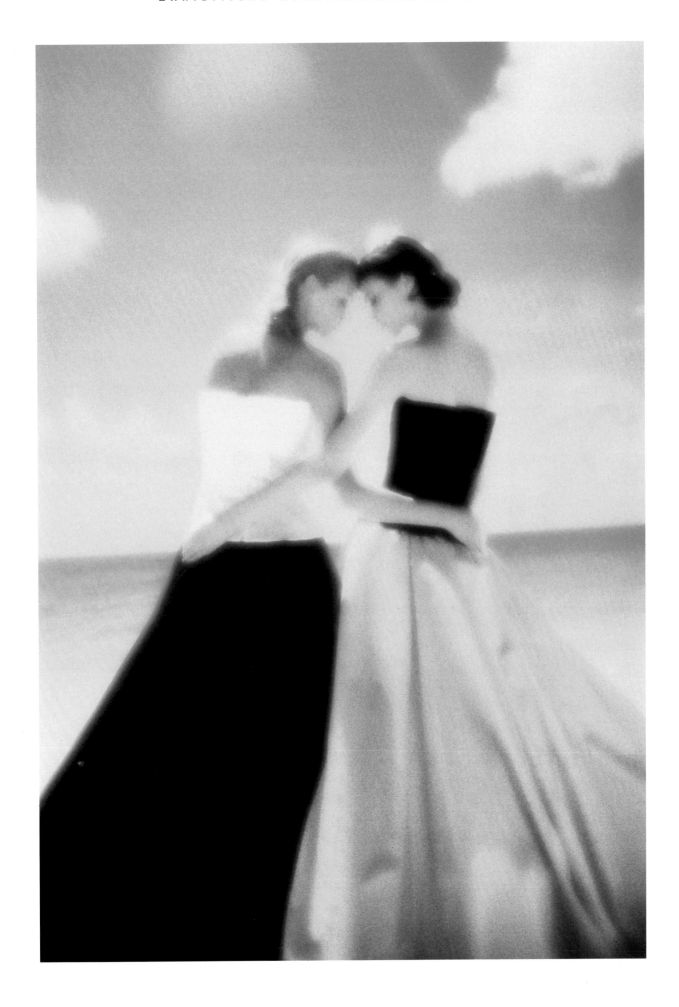

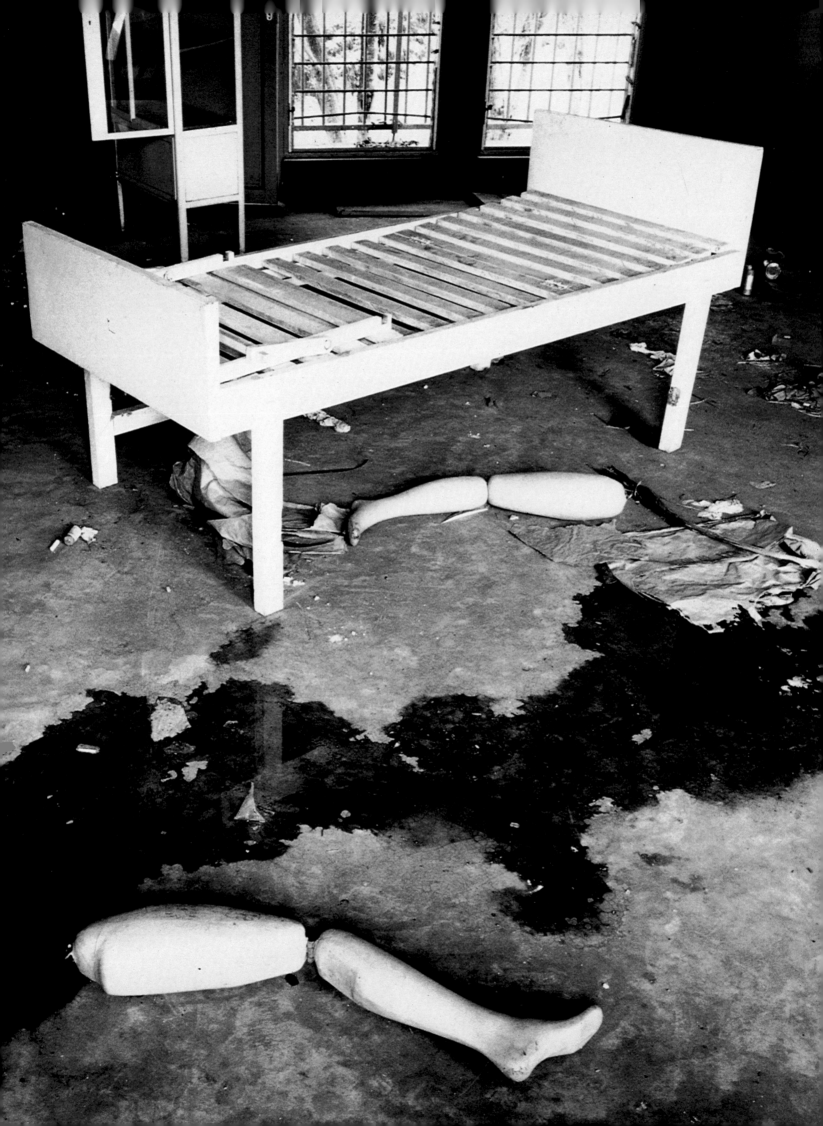

JOURNALISM

JOURNALISMUS

JOURNALISME

This page: ■ When the last soldiers of the Russian Berlin brigade left on September 1, 1994, the photographer captured this image at the Lichtenberg station. He had been trying to capture a symbolic photograph for nearly a year. Focus published the image on September 5, 1994, as "Photograph of the Week." ● Beim Abzug der letzten Soldaten der soujetischen Berliner Brigade am September 1994 am Bahnhof Lichtenberg gelang dem Photographen das symbolische Bild, nach dem er ein Jahr lang gesucht hatte. Am 5. September 1994 erschien es in Focus als «Photo der Woche». ▲ Lors du retrait des derniers soldats de la brigade soviétique à Berlin le 1er septembre 1994, le photographe – après une année de reportage dans la capitale – trouva finalement le lieu idéal pour prendre cette photo symbolique: la gare de Lichtenberg. Image publiée dans Focus le 5 septembre 1994 comme «Photo de la semaine». Opposite: ■ This series was shot at the Sewa-Kendra leprosy station in Kathmandu, Nepal. The people portrayed are

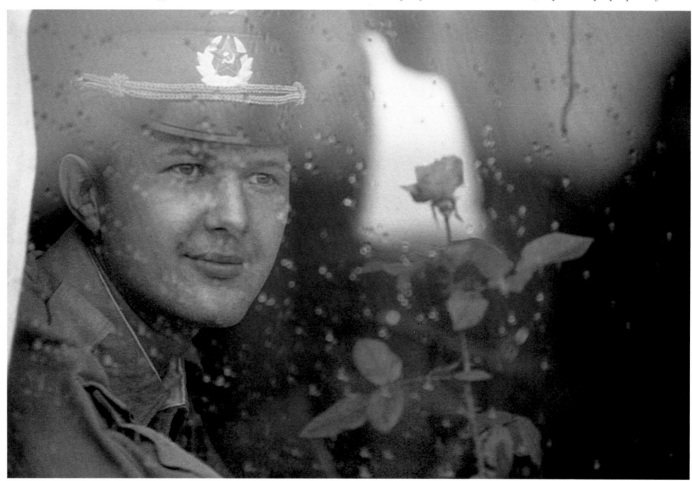

Previous Spread: Simon Norfolk · This Page: Pierre Adenis

former leprosy patients who have made Sewa-Kendra their home, and as much as possible, their workplace. The photographer wanted to draw attention to the fact that enormous numbers of people are suffering from leprosy, despite the fact that care of the disease is very easy and inexpensive. ● Diese Aufnahmen wurden in der Sewa-Kendra Lepra-Station in Katmandu, Nepal, gemacht. Die hier gezeigten Menschen sind ehemalige Lepra-Patienten, für die Sewa-Kendra ein neues Zuhause und im Rahmen ihrer Möglichkeiten auch Arbeitsplatz wurde. Der Photograph wollte darauf aufmerksam machen, dass eine grosse Anzahl von Menschen unter dieser Krankheit leidet, obgleich die Behandlung einfach und billig ist. ▲ Série sur l'hospice de lépreux Sewa-Kendra, Népal. Ces portraits montrent d'anciens lépreux qui ont fait de l'hospice leur maison et, dans la mesure du possible, leur lieu de travail. Le photographe a voulu sensibiliser l'opinion au fait qu'un grand nombre de personnes souffrent de cette maladie, même si elle peut être soignée facilement et à bas prix.

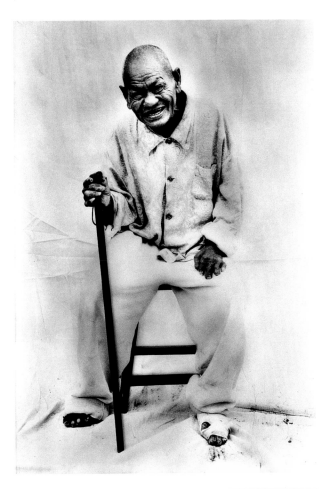

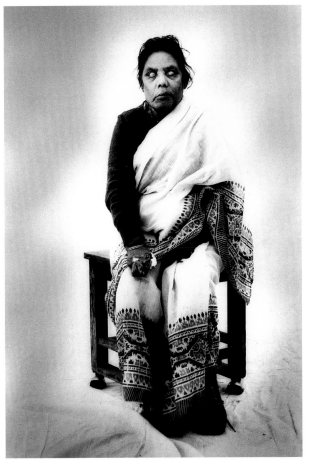

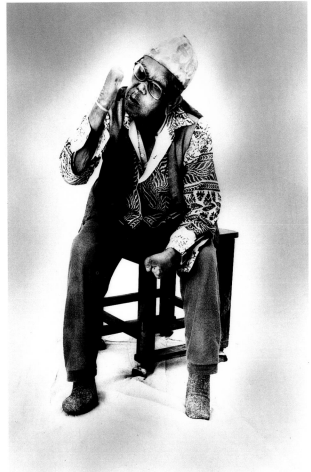

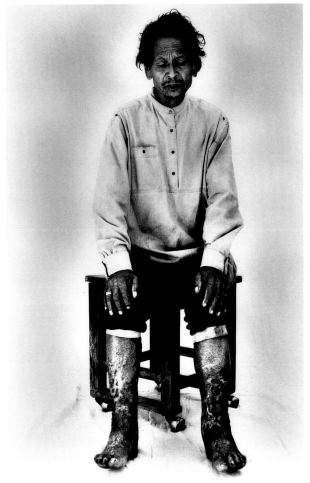

Christopher Thomas

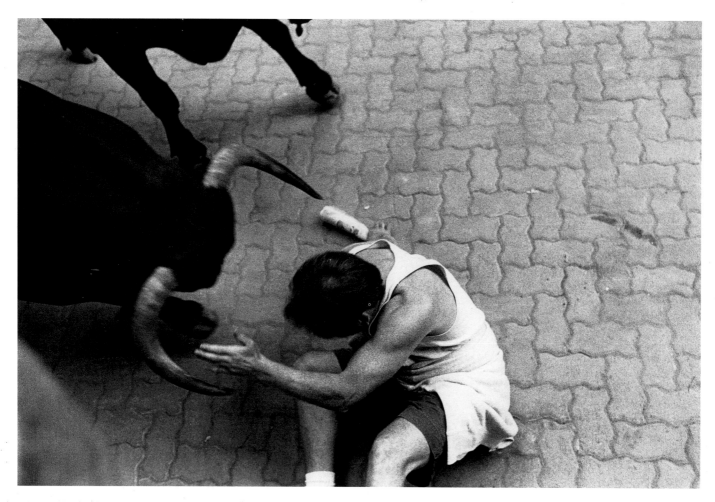

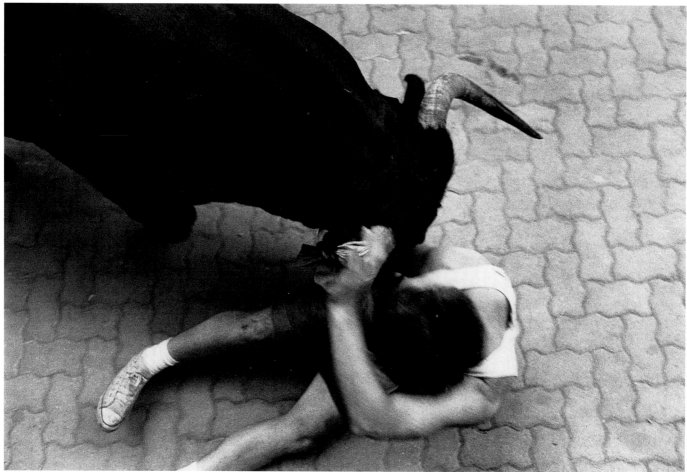

Juan Ignacio Delgado Santamaria

Opposite page: ■ *The "Fiesta San Fermin," during which young bulls are chased through the streets of town, takes place in Spain every summer between July 7 and 14. This man was killed by the bull.* ● *Die «Fiesta San Fermin» ist ein traditionelles Fest, das alljährlich zwischen dem 7. und 14. Juli in Spanien stattfindet. Junge Stiere werden dabei durch die Strassen der Stadt gejagt. Der Mann kam dem Stier zu nah und wurde von ihm getötet.* ▲ *La traditionnelle «Fiesta San Fermin» se déroule chaque année entre le 7 et le 14 juillet en Espagne. A cette occasion, de jeunes taureaux sont lâchés dans les rues. L'homme sur ces images s'est trop approché du taureau et a été tué. This page:* ■ *In this image for TIME, Senad Medanovic, 25, returns to Prhvo, Bosnia, the scene of a massacre by Serbs in 1992. He's the only survivor of a village of 69 people. He cries in front of his*

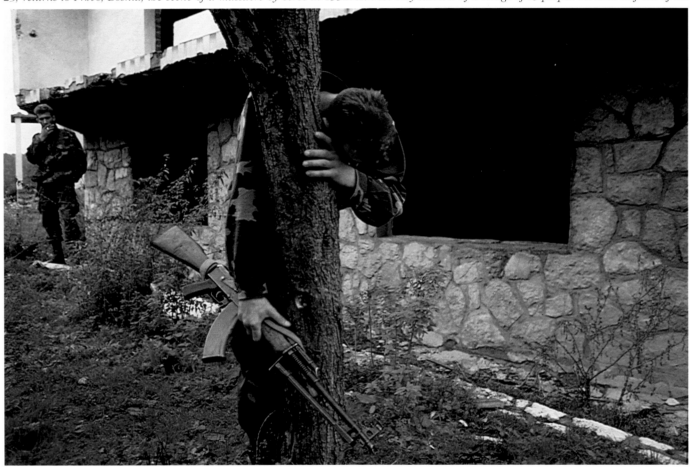

Ron Haviv

destroyed house, where people are buried in a mass grave in his yard. ● *Aufnahme aus einem Bericht in TIME über die verheerenden Folgen einer Offensive im Nordwesten Bosniens. Senad Medanovic, 25, ist in das bosnische Dorf Prhvo zurückgekehrt, wo die Serben 1992 ein Massaker anrichteten. Als einziger Überlebender des Dorfes, in dem zuvor 69 Menschen lebten, weint er vor seinem zerstörten Haus, dessen Hof zum Massengrab wurde.* ▲ *Photos documentaires pour TIME illustrant les ravages de l'offensive déclenchée dans le nord-ouest de la Bosnie. Sur cette image, Senad Medanovic, 25 ans, retourne dans Prhvo en Bosnie, théâtre d'un massacre perpétré par les Serbes en 1992. Seul survivant du village habité autrefois par 69 personnes, il pleure devant les décombres de sa maison dont la cour sert de fosse commune aux victimes de la guerre.*

This spread: ■ *Documents of the mass murders in Rwanda: (A) Looted infirmary, St. André's College, Nyamirambo, Kigali. Thousands fled to the college hoping for safety. The Interahamwe slaughtered hundreds of people there. (B) Classroom filled with corpses, Nyarubuye, eastern Rwanda. Thousands died in the church and adjoining buildings, and the bodies were not buried. (C) Skulls on the altar of Ntarama church. It was impossible to walk on the floor of the church because there were so many corpses. This picture was taken by walking on the pews. (D) Desiccated legs of a victim, Nyarubuye. The bodies remain unburied at this site because so many of the population were killed that there was no one left to do the burying. (E) Exhumation of a mass grave at Kigali Central Hospital. Throughout the genocide, the Interahamwe would come to the hospital looking to finish off those who had been injured or may have been hiding there. (F) Amputated Christ in a classroom at Nyarubuye. (G) Felicien Ntamaharane, who lost both legs when he walked on a mine. Orphaned children foraging for food were particularly susceptible to landmines. The French charity Handicap*

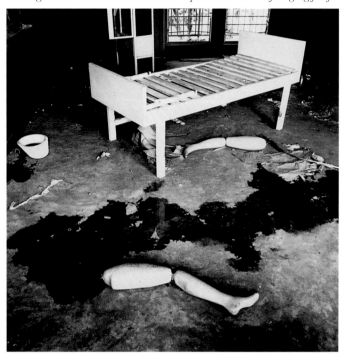

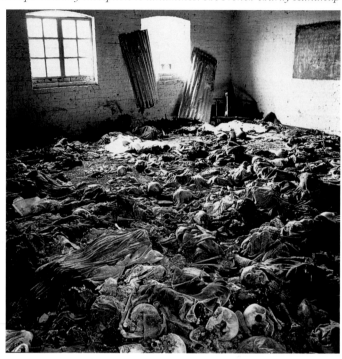

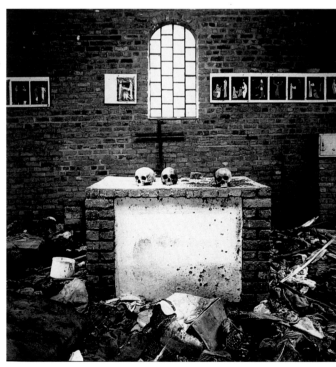

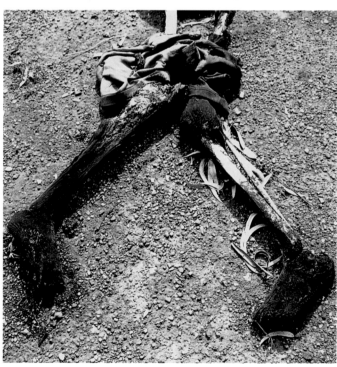

Simon Norfolk
BEST OF CATEGORY

International is doing physiotherapy work in Kigali Central Hospital and training local craftsmen in the manufacture of cheap prosthetic limbs. (H) Bullet-ridden advertisement in Kigali near the Parliament, the scene of fierce fighting between the Rwandan Army and the Rwanda Patriotic Front. ● *Dokumente der entsetzlichen Massenmorde in Rwanda. (A) Das verwüstete Krankenzimmer des St. André's College, Nyamirambo, Kigali. Tausende flohen hierher in der Hoffnung auf einen sicheren Zufluchtsort. Die Interahamwe ermordeten hier Hunderte von Menschen. (B) Ein mit Leichen gefülltes Schulzimmer, Nyarubuye, im Osten Rwandas. Tausende starben in der Kirche und den angrenzenden Gebäuden; ihre Leichen wurden nicht begraben. (C) Schädel auf dem Altar der Kirche in Ntarama. Man kann den Boden der Kirche wegen der vielen Leichen nicht betreten. Der Photograph benutzte die Kirchenbänke, um seine Aufnahme zu machen. (D) Vertrocknete Beine eines Opfers in Nyarubuye. Von der Bevölkerung war niemand übriggeblieben, um die Toten zu begraben. (E) Exhumierung eines Massengrabes beim Kigali Central Hospital, Opfer des*

Völkermorders durch die Interahamwe. Sie kamen immer wieder und ermordeten Verletzte oder Menschen, die sich hier versteckt hielten. (F) Ein beschädigter Christus am Kreuz in einem Klassenzimmer in Nyarubuye. (G) Felicien Ntamaharane verlor beide Beine durch eine Mine. Besonders Waisenkinder waren auf ihrer Suche nach Nahrung durch Minen gefährdet. Die französische Hilfsorganisation Handicap International hat eine physiotherapeutische Station im Hospital von Kigali eingerichtet und bildet ausserdem lokale Handwerker in der Fertigung einfacher Prothesen aus. (H) Von Kugeln durchlöcherte Reklametafel in Kigali in der Nähe des Parlamentsgebäudes, wo sich die Rwandische Armee und die Rwandische Patriotische Front erbitterte Gefechte lieferten. ▲ *Documents des abominables massacres perpétrés au Rwanda. (A) Chambre d'hôpital dévastée du Collège St. André, Nyamirambo, Kigali. Des milliers de personnes sont venues se réfugier dans ce collège. C'est là que les Interahamwe ont tué des centaines de personnes. (B) Une classe d'école jonchée de cadavres, Nyarubuye, à l'est du Rwanda. Des milliers de personnes sont mortes dans l'église*

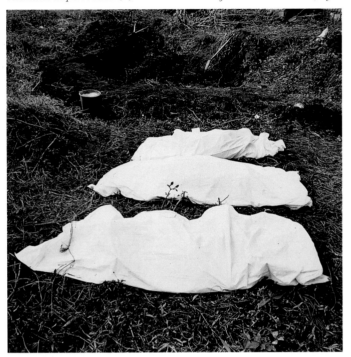

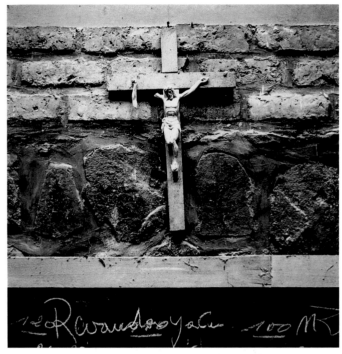

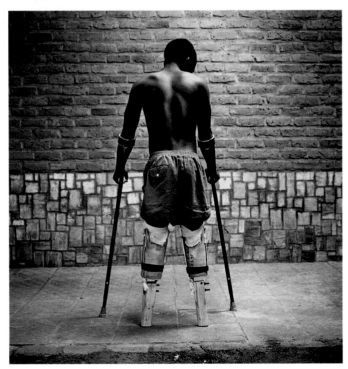

Simon Norfolk

et les bâtiments adjacents; les corps n'ont pas été enterrés. (C) Crânes sur l'autel de l'église de Ntarama où il était devenu impossible de fouler le sol jonché de cadavres. Le photographe a dû se jucher sur les bancs de l'église pour prendre cette image. (D) Jambes desséchées d'une victime à Nyarubuye. Les morts n'ont pu être enterrés, la population locale ayant été décimée. Aujourd'hui, à cet endroit, se dresse un camp militaire dont l'accès est strictement interdit. (E) Exhumation d'un charnier à l'hôpital central de Kigali. Les Interahamwe revenaient régulièrement sur le lieu du génocide pour y massacrer des blessés ou des personnes qui s'étaient réfugiées en cet endroit. (F) Crucifix endommagé dans une classe d'école de Nyarubuye. (G) Félicien Ntamaharane a perdu ses deux jambes dans l'explosion d'une mine. Les mines représentaient surtout un grand danger pour les orphelins en quête de nourriture. L'organisation humanitaire française Handicap International a installé un centre de physiothérapie dans l'hôpital de Kigali et forme les artisans locaux à la fabrication de prothèses. (H) Panneaux publicitaires troués par des balles à Kigali, non loin du Parlement, théâtre de luttes sanglantes entre l'armée ruandaise et le front patriotique ruandais.

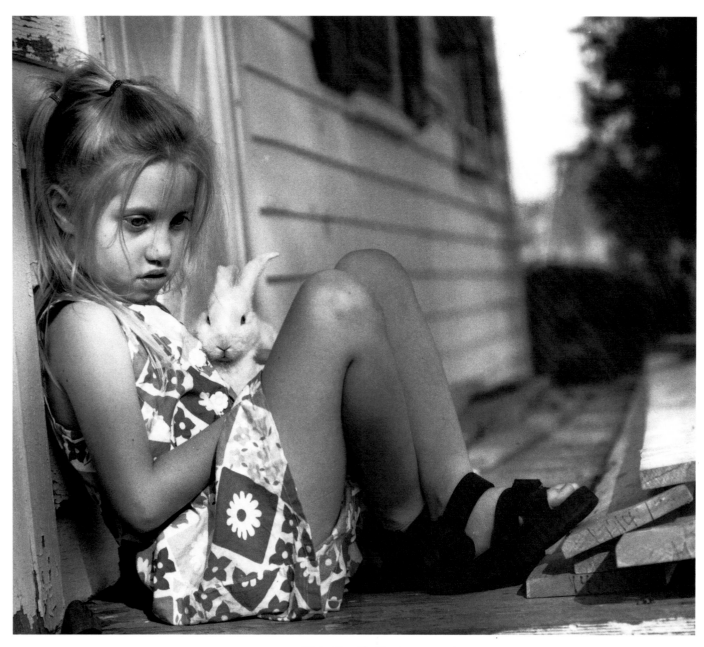

Christopher L. Morris

This spread: ■ From "The Savannah Series," an ongoing photographic essay on the photographer's young cousin, Savannah, her family, and her surroundings in the Shenandoah Valley. These photos are of Savannah, her mother Jo Anne, and her grandmother Ruth Ann. ● Aufnahmen aus einem photographischen Essay über die junge Cousine des Photographen, Savannah, ihre Familie und ihre Umgebung im Shenandoah Valley. Gezeigt sind Savannah, ihre Mutter Jo Anne und ihre Grossmutter Ruth Ann. ▲ Extraits de «The Savannah Series», un essai photographique sur Savannah, la jeune cousine du photographe, sa mère Jo Anne et sa grand-mère Ruth Ann.

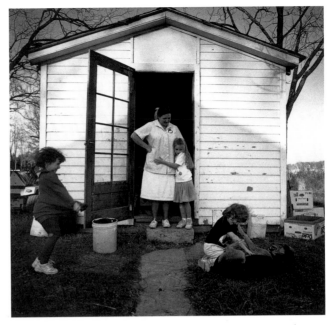

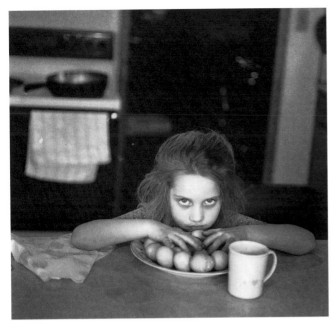

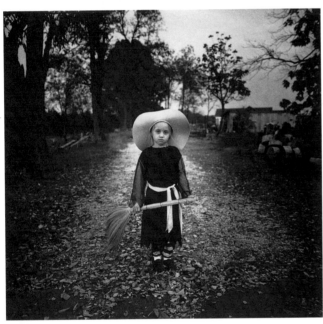

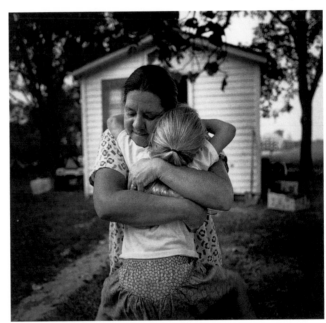

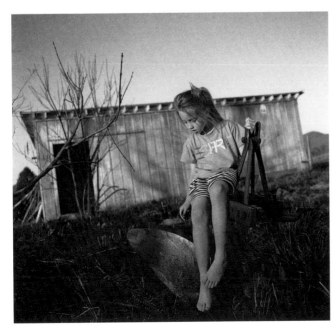

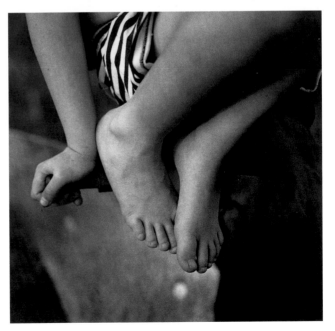

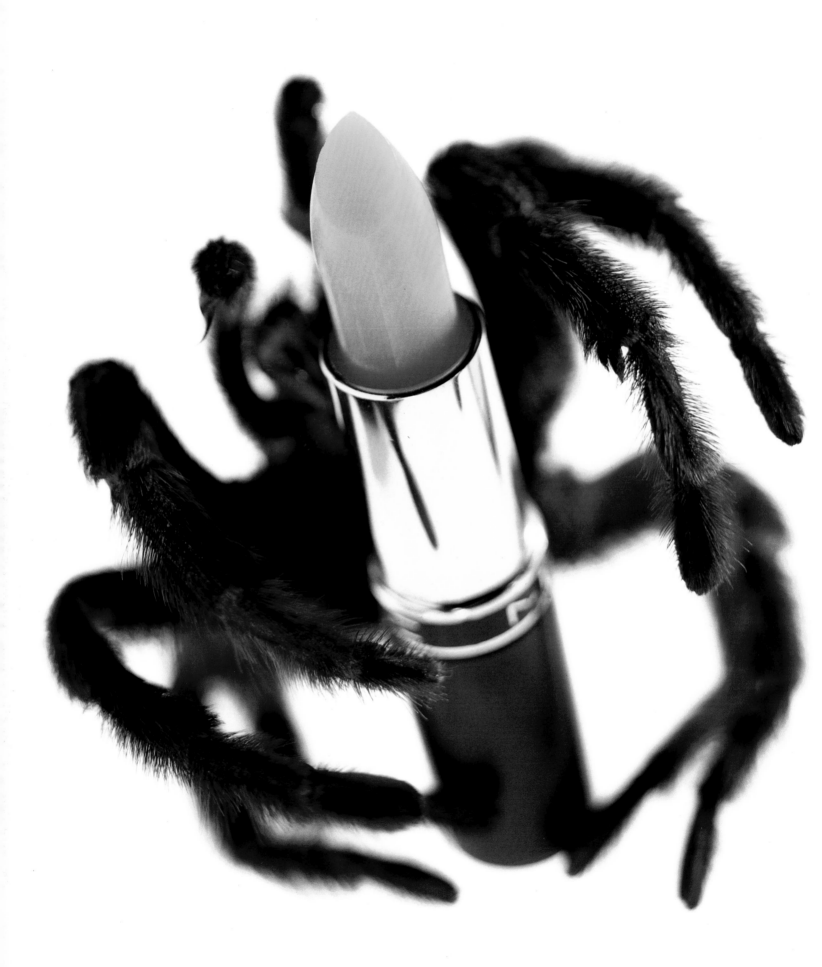

STILL LIFE

STILLEBEN

NATURE MORTE

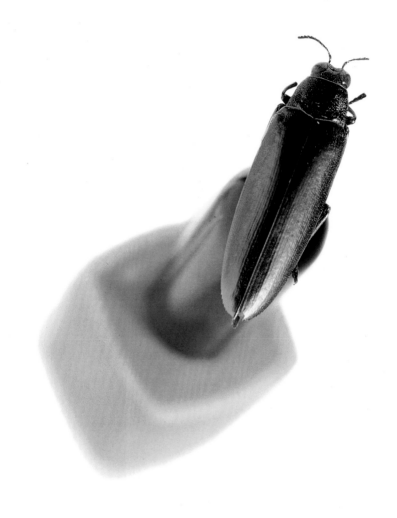

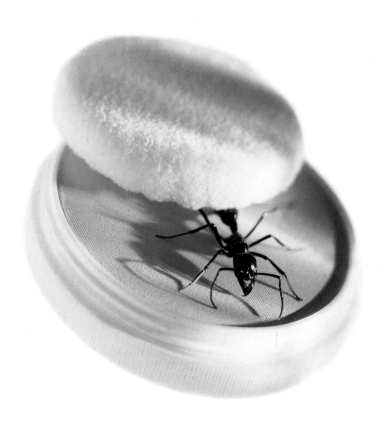

Preceding Spread · This page: David Sacks

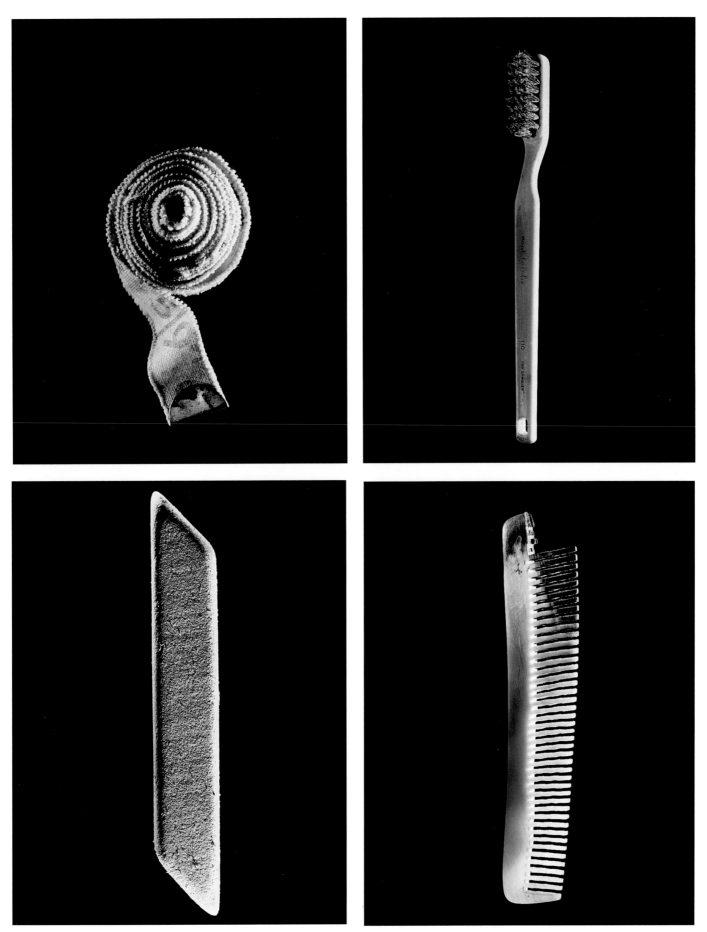

Craig Cutler

Colin Faulkner

Colin Faulkner

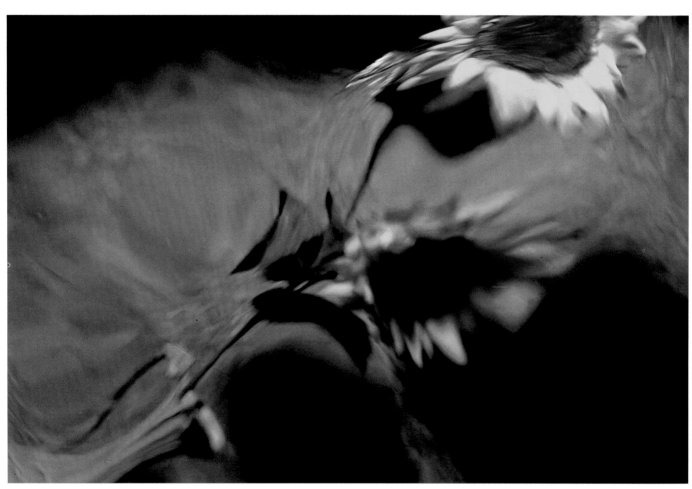

Joseph Keller

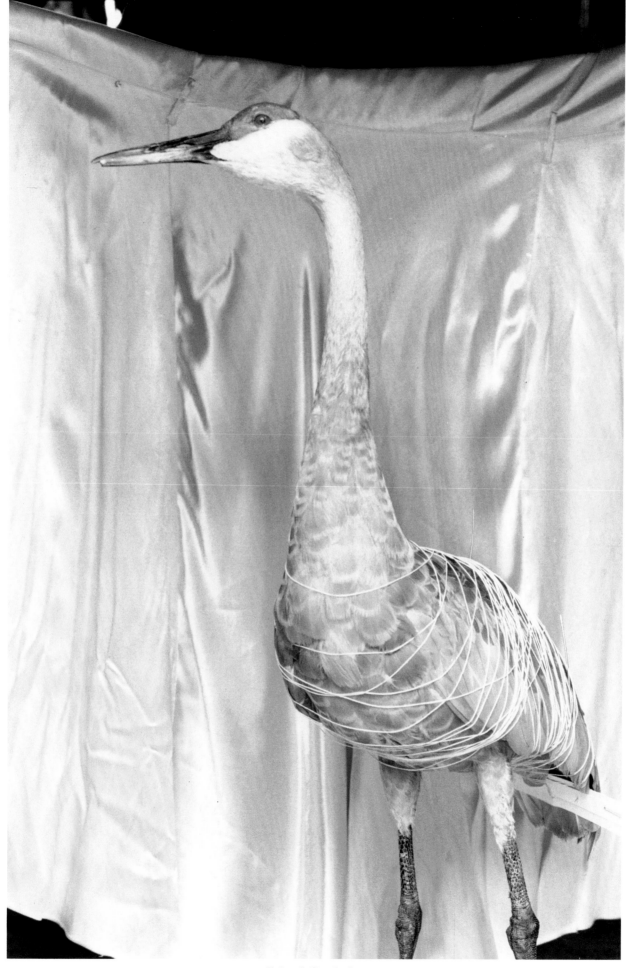

Deborah Brackenbury

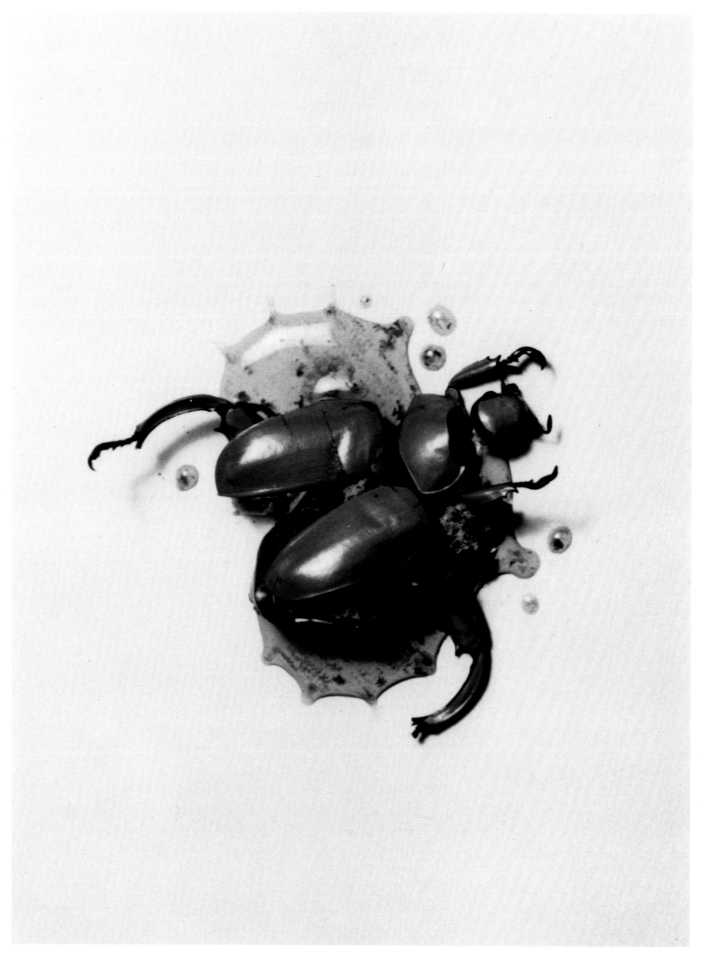

Markku Lahdesmaki

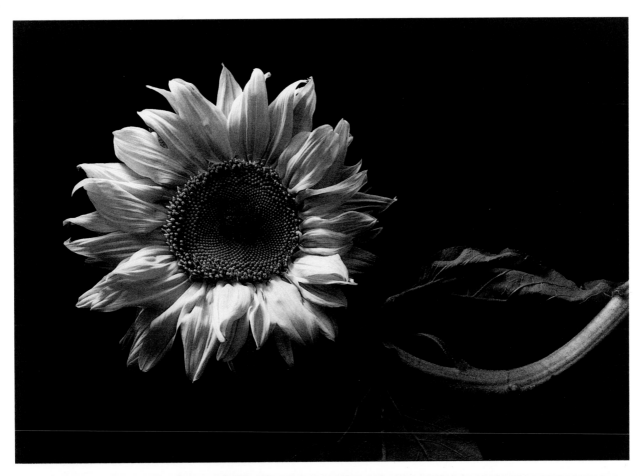

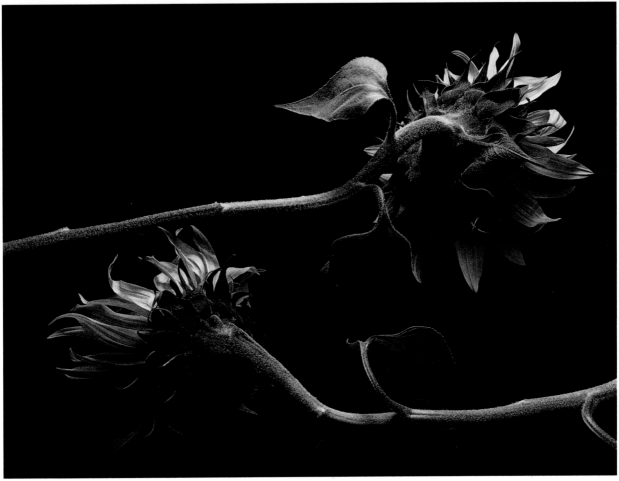

Kenro Izu
BEST OF CATEGORY

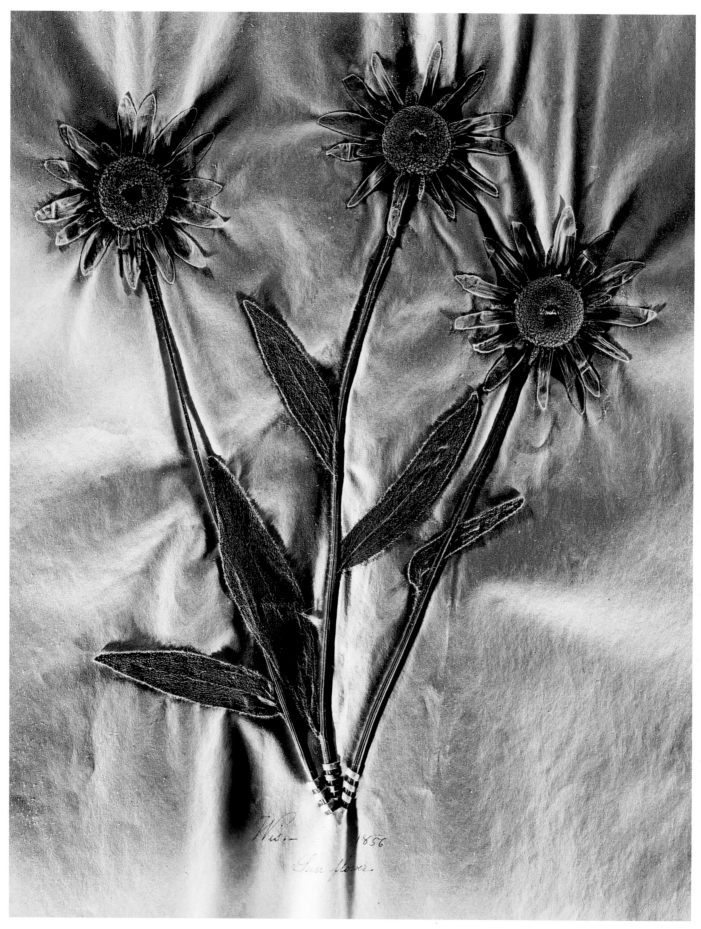

Hans Neleman

Paolo Marchesi

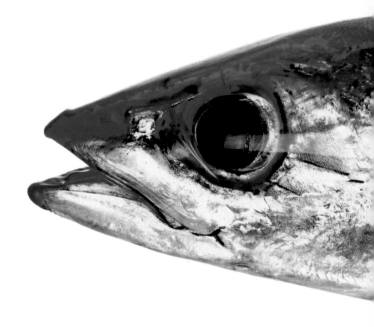

S T I L L L I F E · S T I L L E B E N · N A T U R E M O R T E

Paolo Marchesi

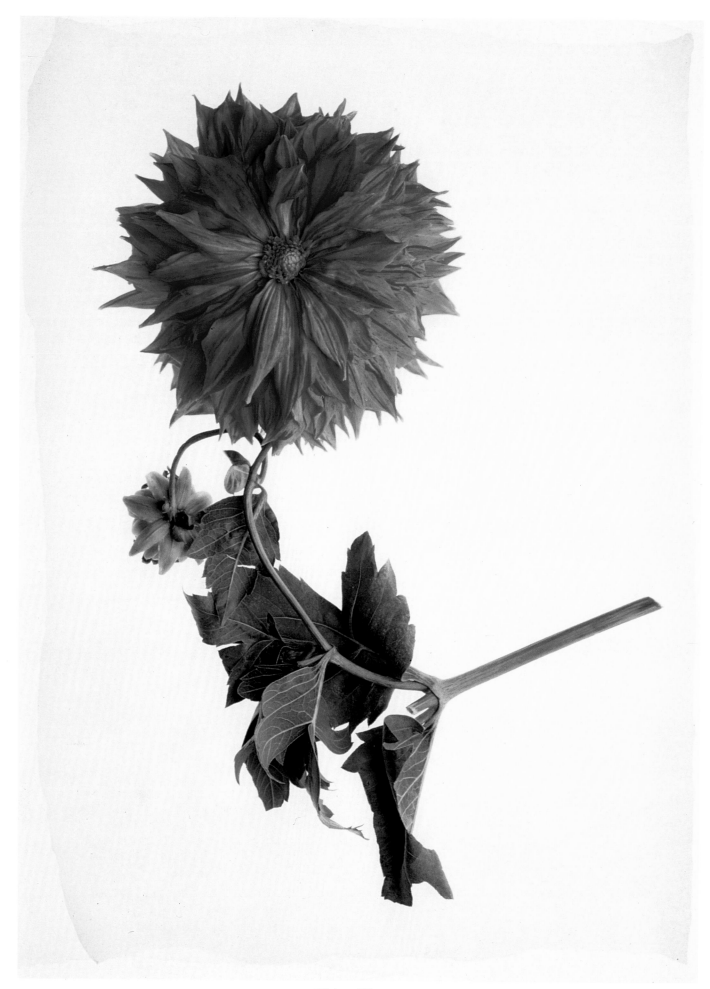

Kathryn Kleinman

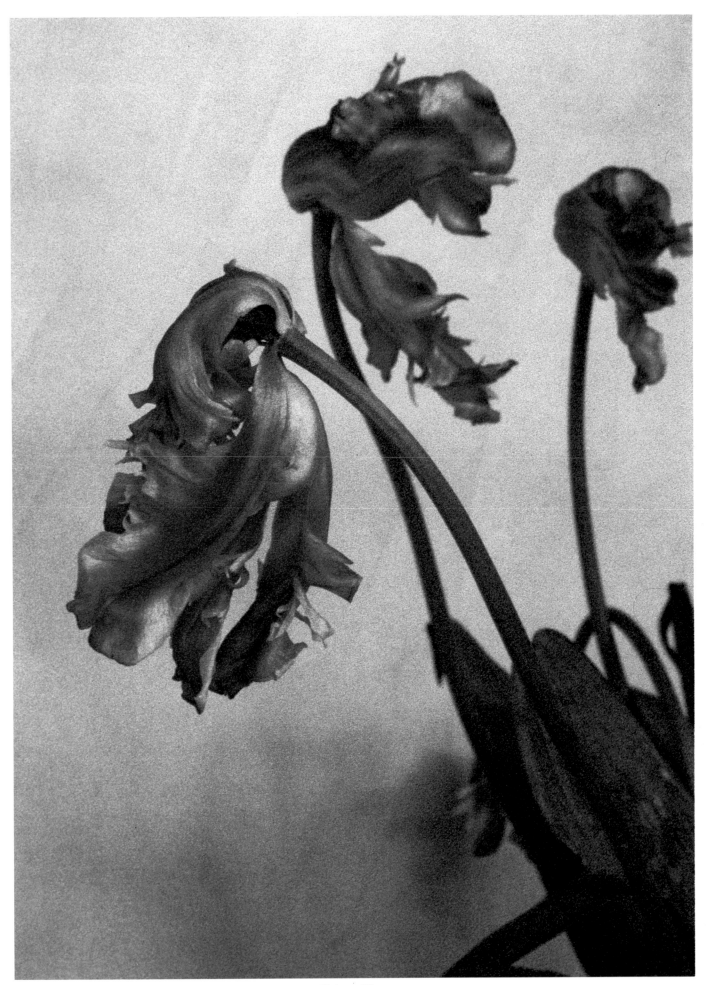

Kathryn Kleinman

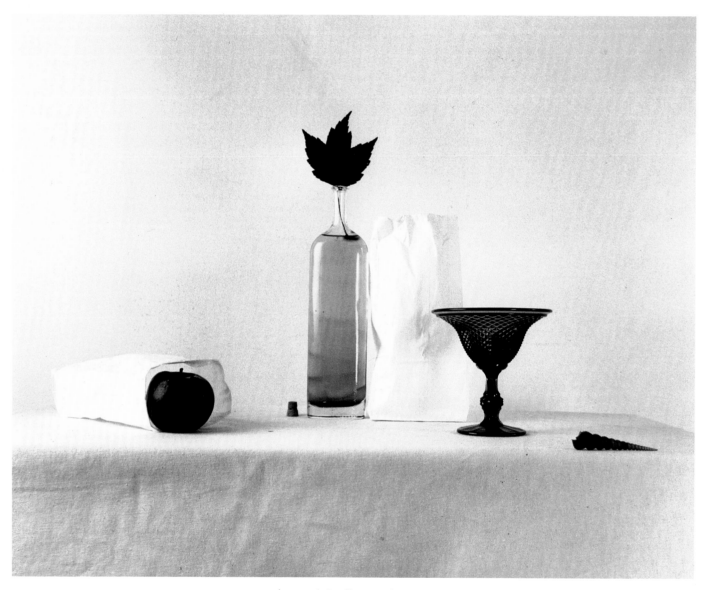

Andre Baranowski

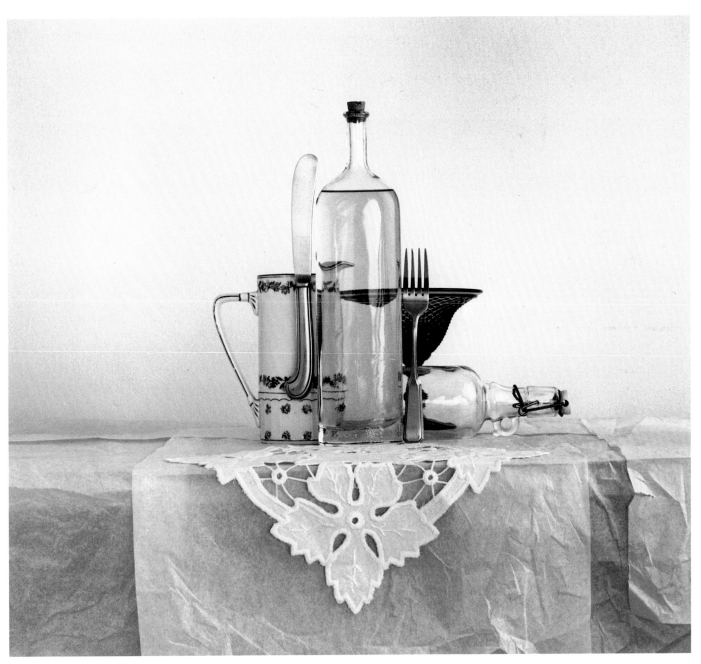

Andre Baranowski

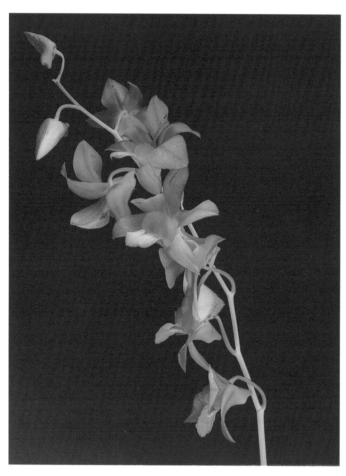
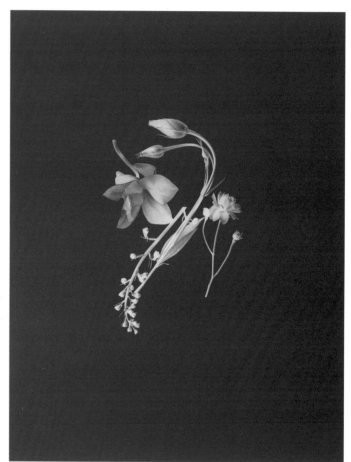

Craig Cutler

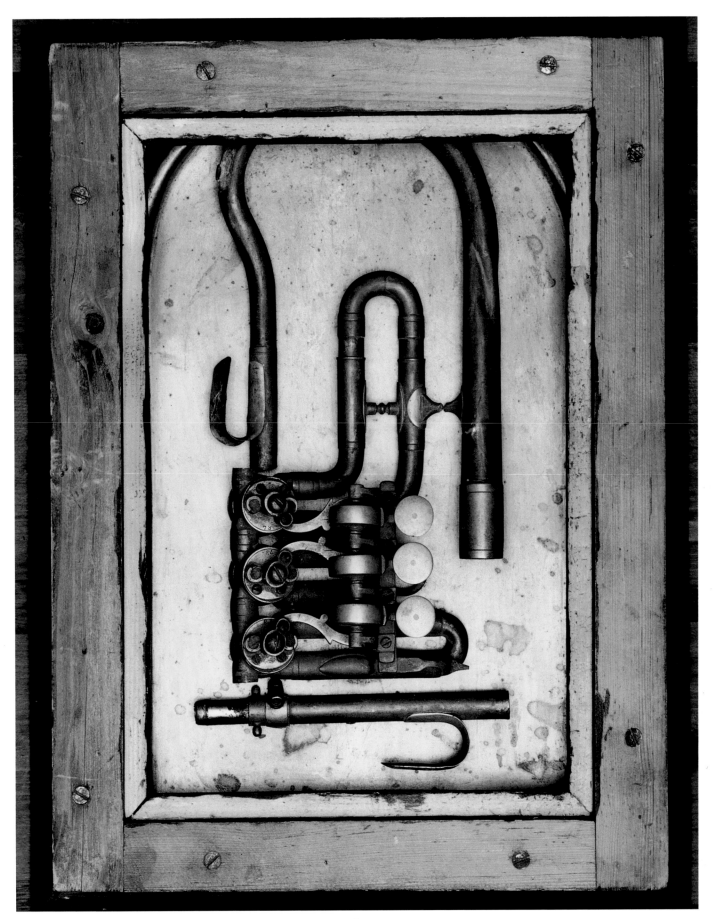

Imre Gabor Eck

Lynn Sugarman

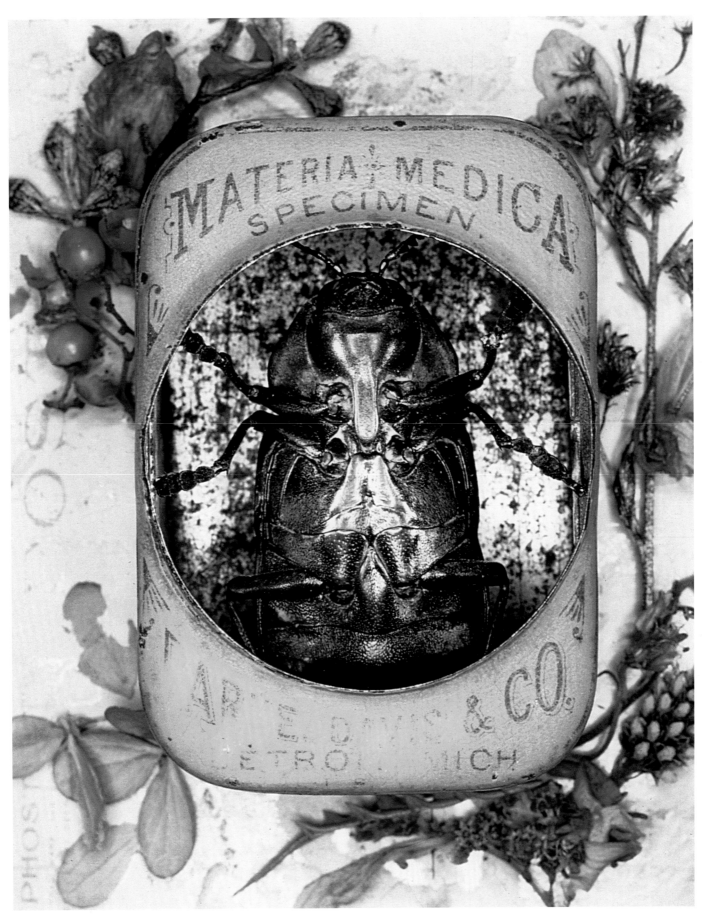

Hans Neleman

FOOD

LEBENSMITTEL

CUISINE

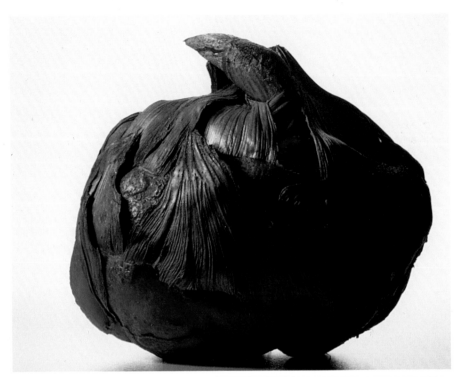

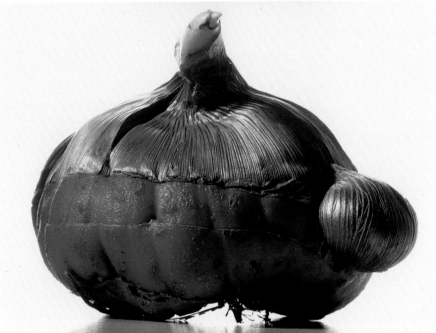

Terry Heffernan

Preceding Spread: Paul Sanders

Stephan Abry
BEST OF CATEGORY

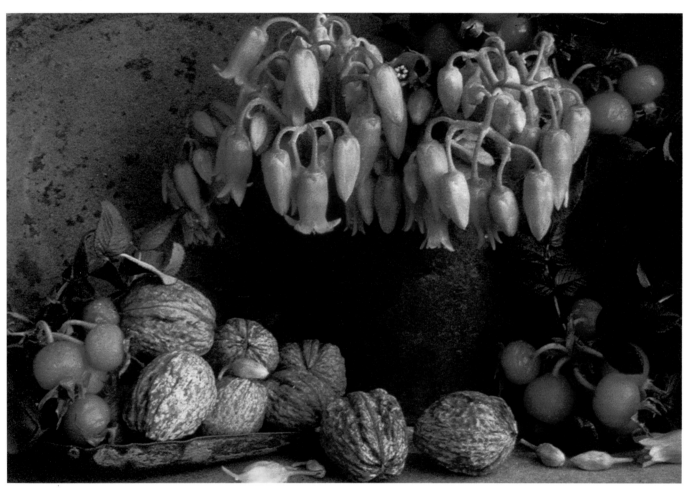

Eivind Lindberget

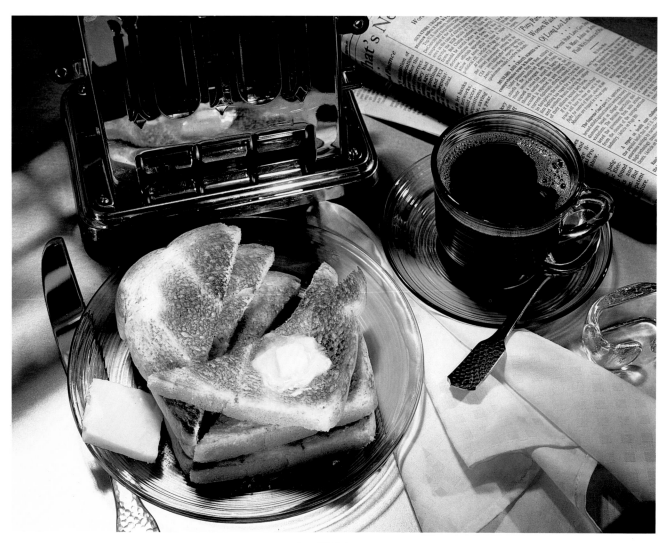

Alan Blakely

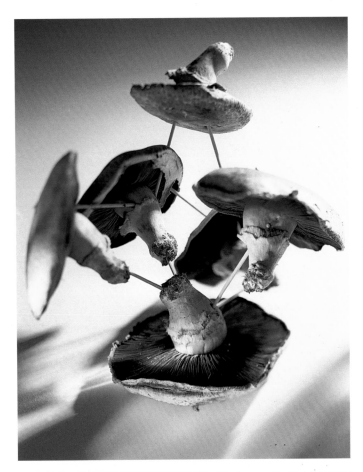

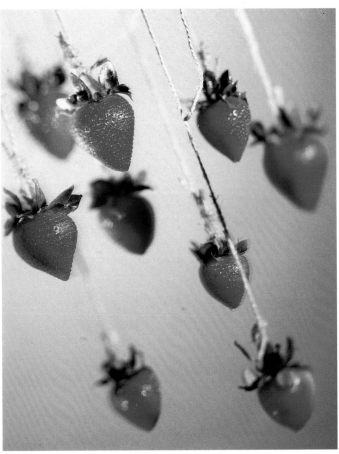

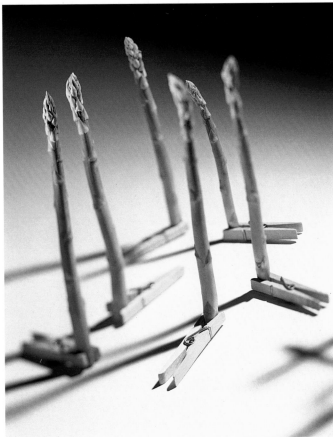

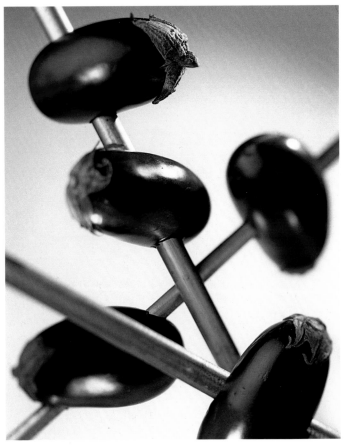

Patrick Tregenza

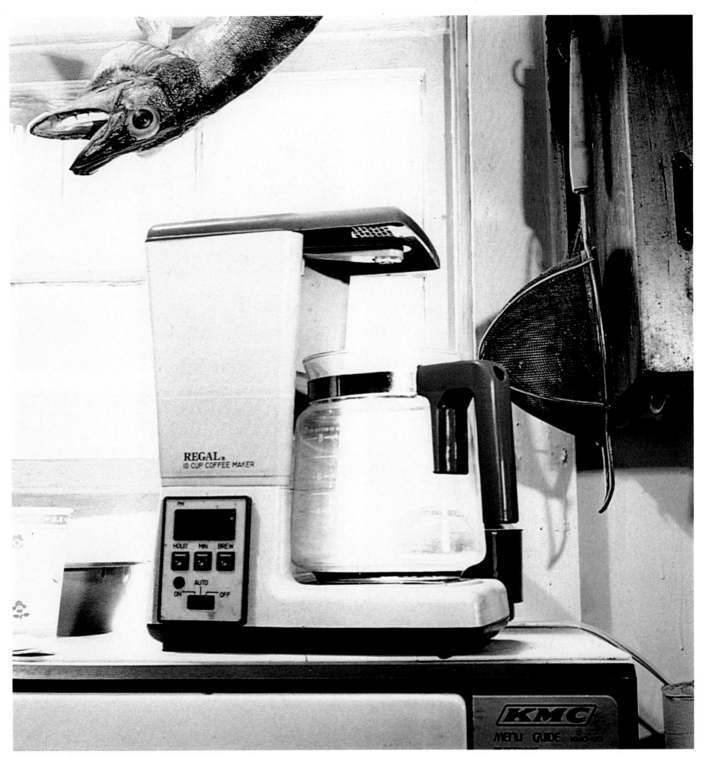

Deborah Brackenbury

Steve Tregeagle

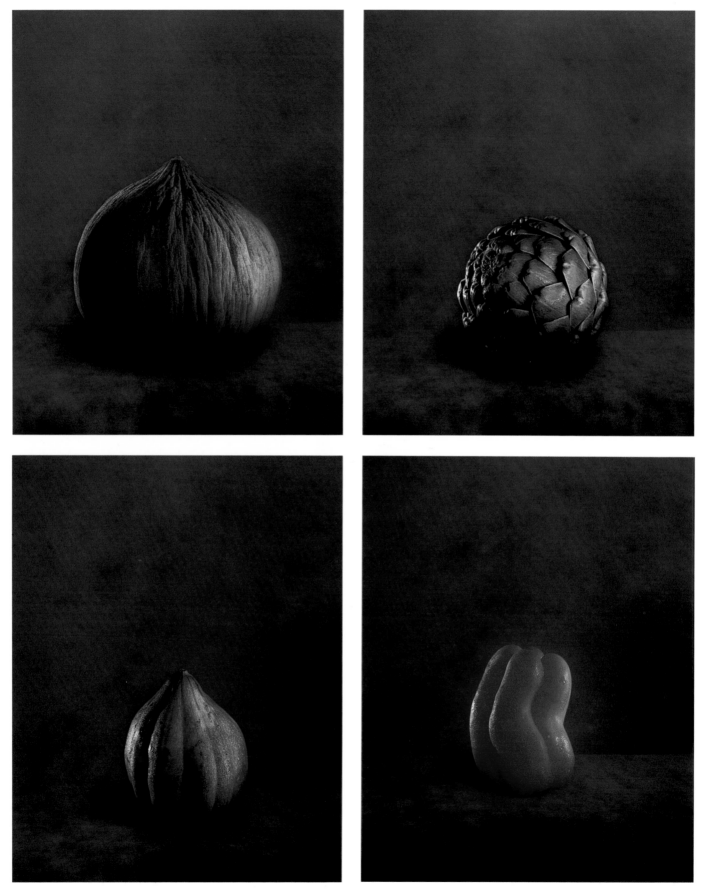

Steve Tregeagle

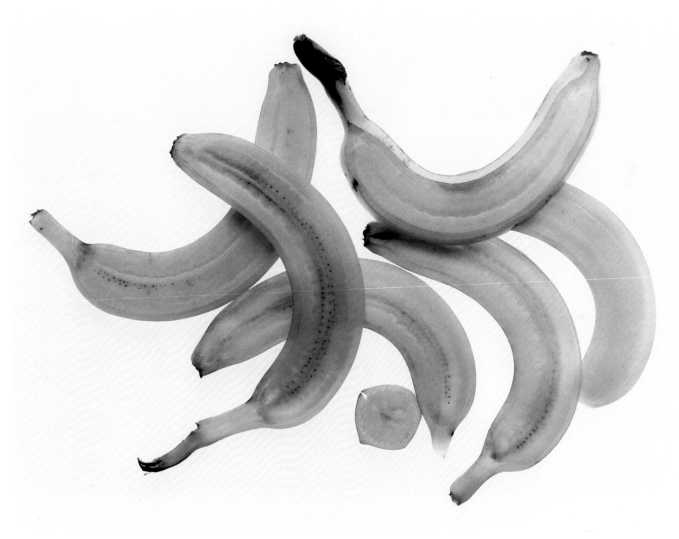

Achim Falkenthal

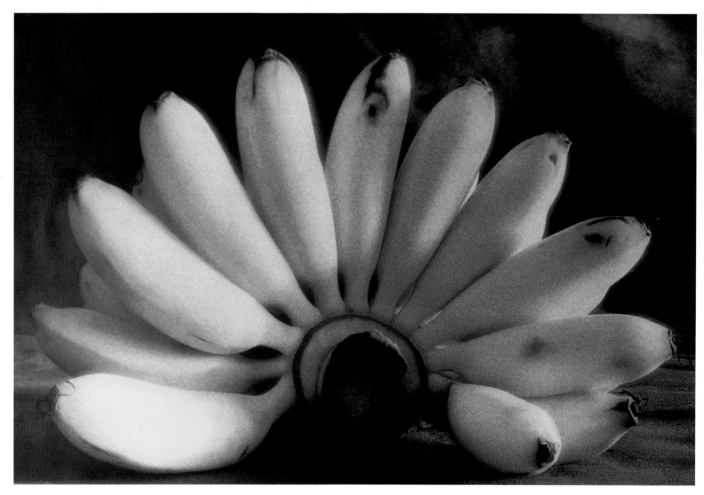

Pamela Strauss

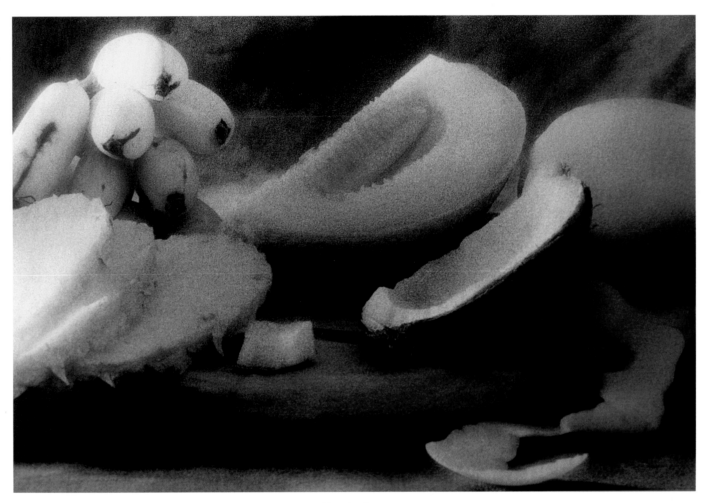

Pamela Strauss

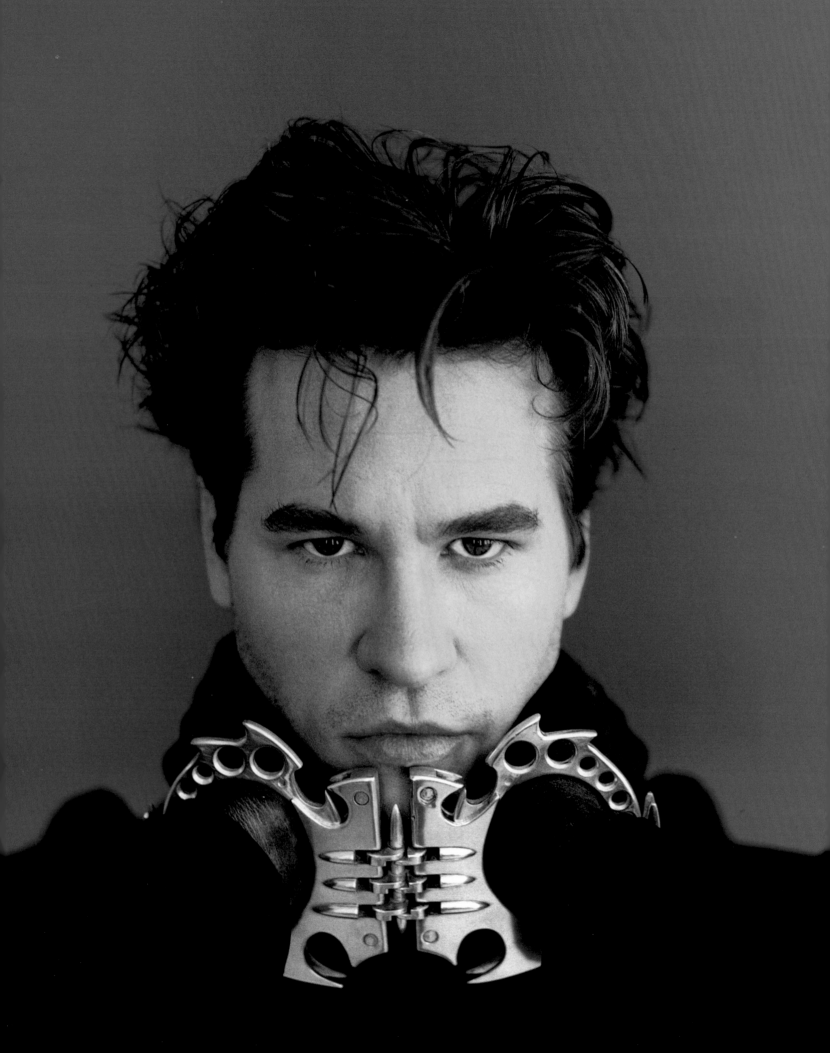

PEOPLE

MENSCHEN

PERSONNES

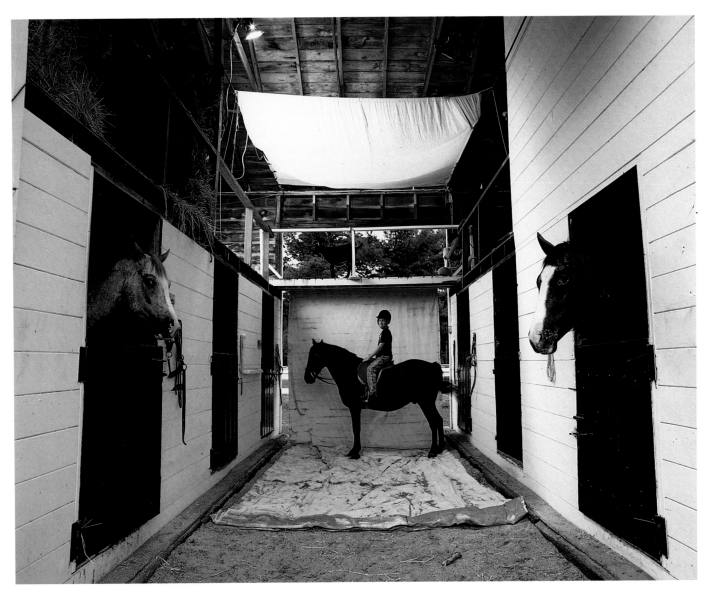

John Madere

Preceding Spread: Ruven Afanador

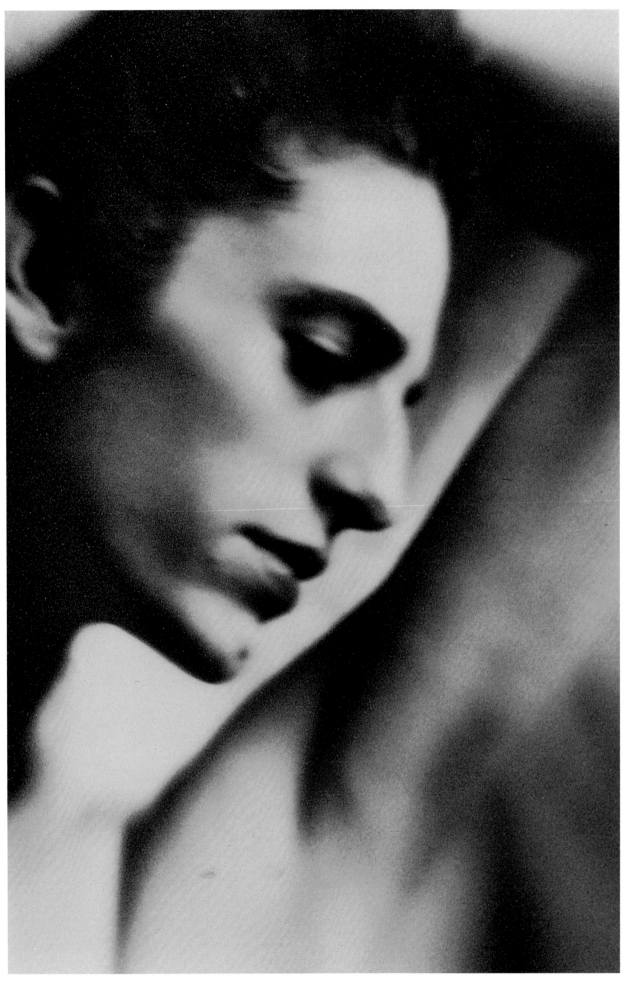

Raymond Allbritton

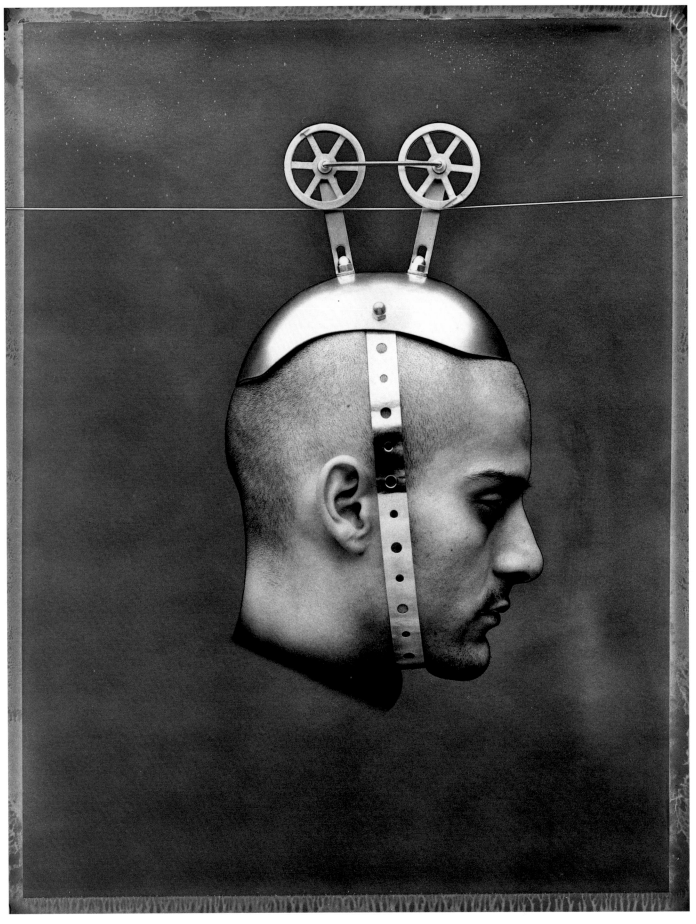

Colin Faulkner

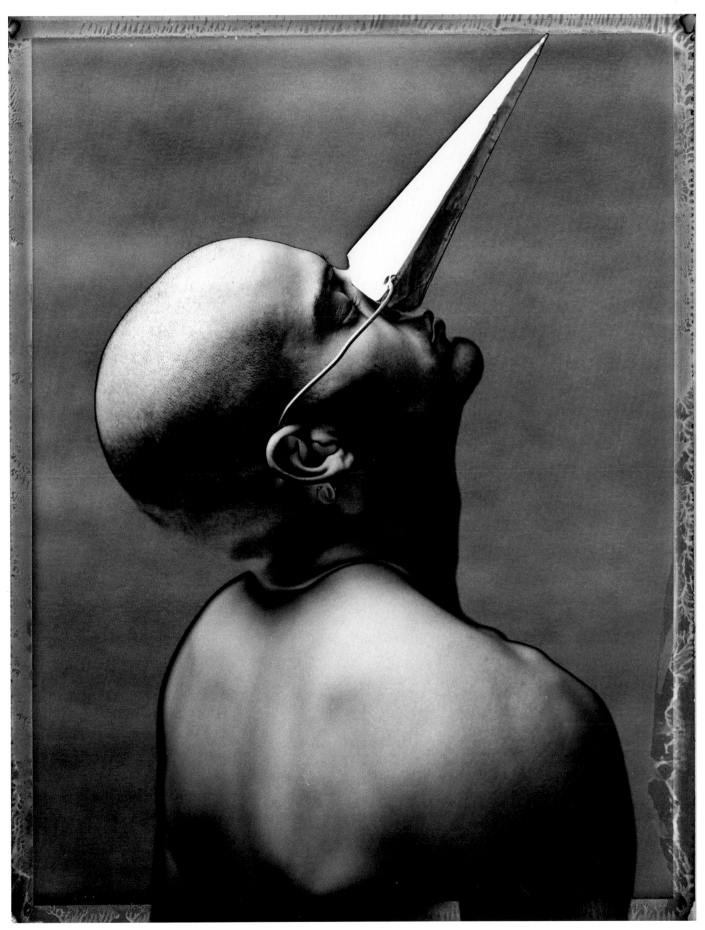

Colin Faulkner

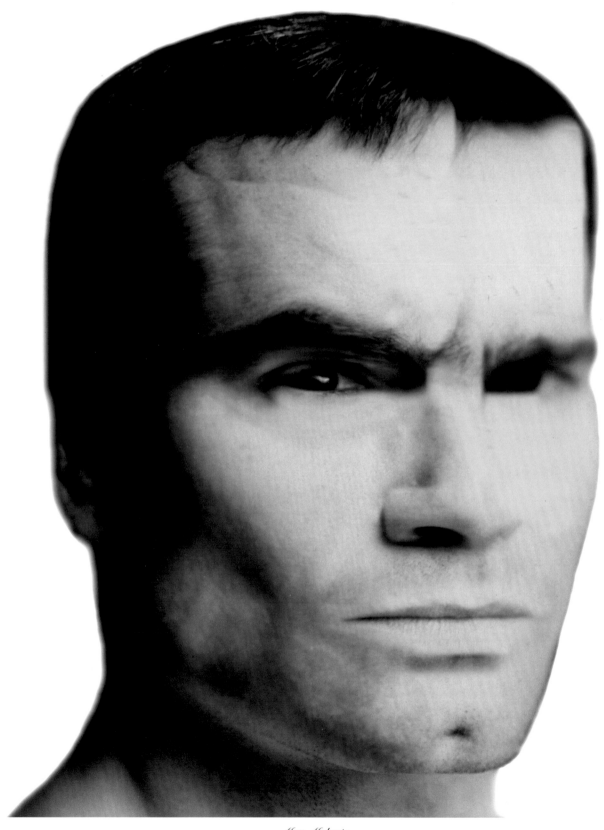

Matt Mahurin

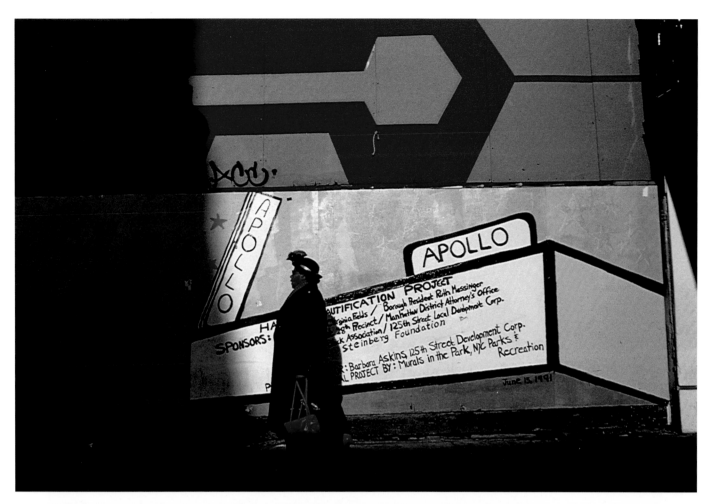

Kiyoko Horvath

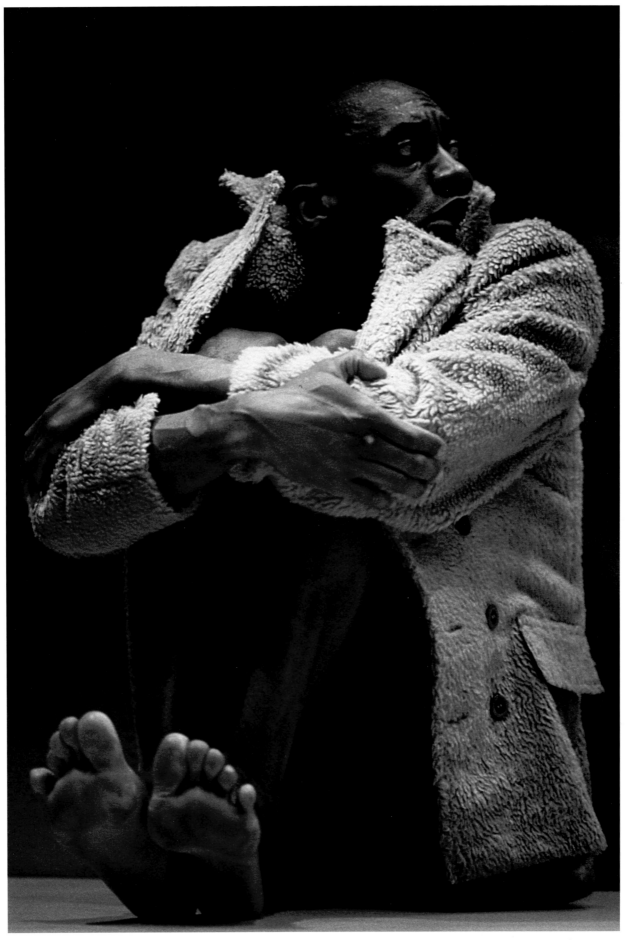

Dieter Blum

Liz Hampton

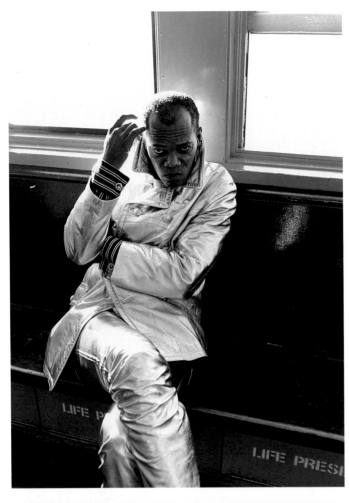

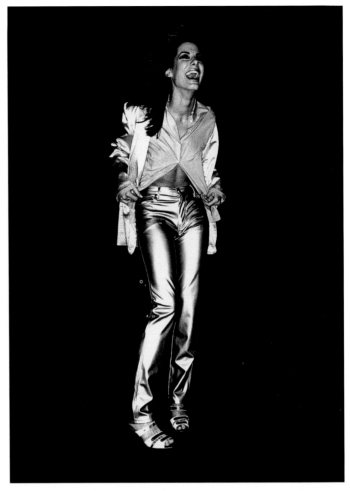

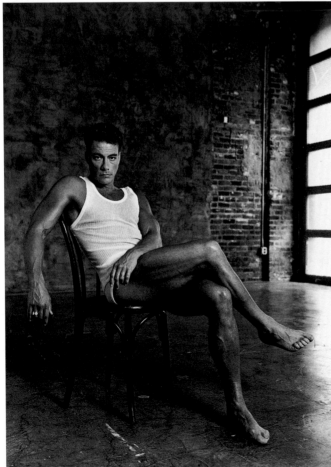

Top Row: Stephanie Pfriender · Bottom Left: Mary Ellen Mark · Bottom Right: Michael Norton

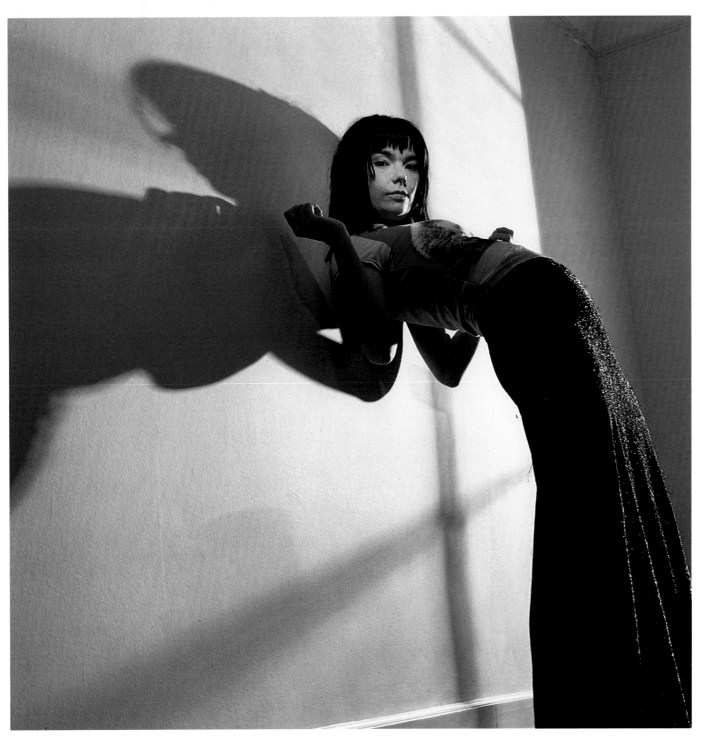

David Strick

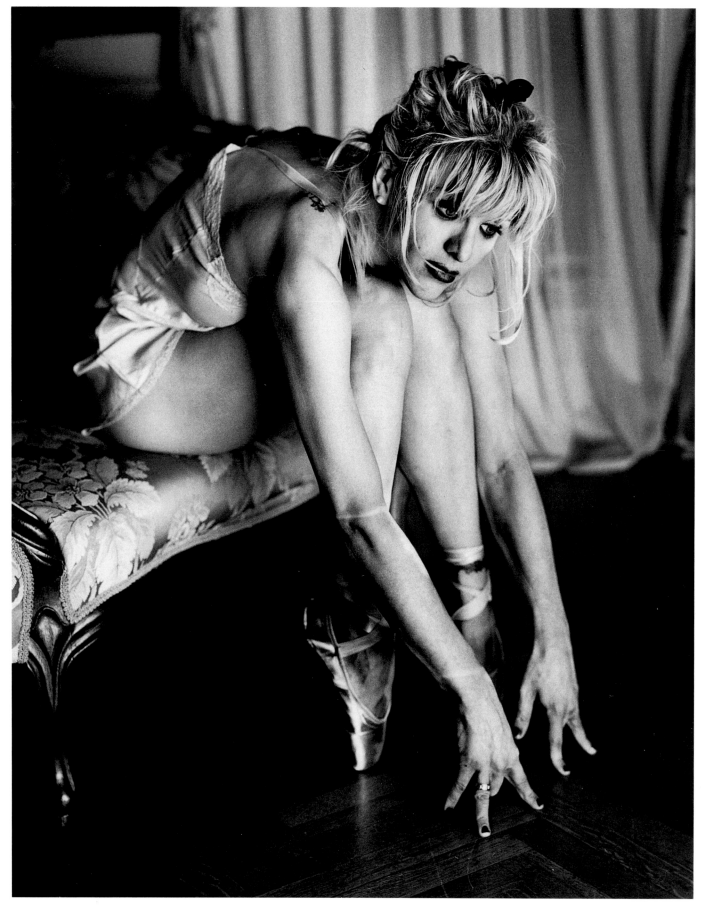

Mark Seliger

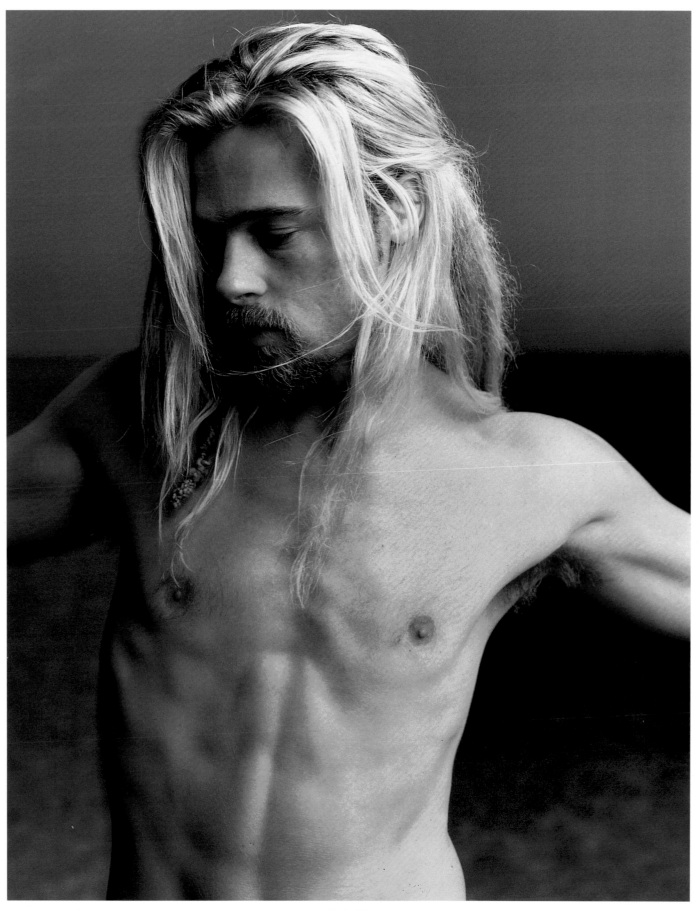

Mark Seliger

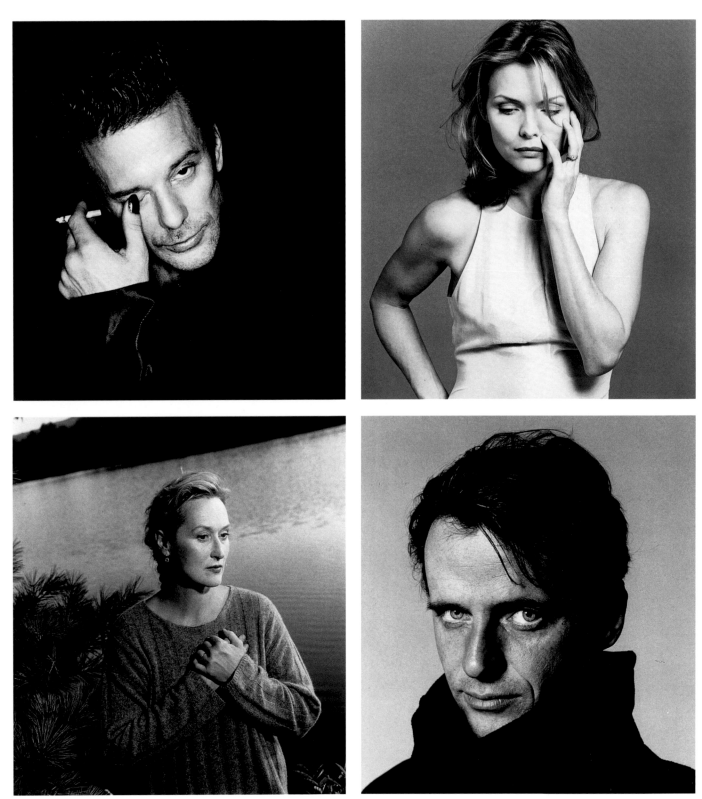

Top Left: Stephanie Pfriender · Top Right: Brigitte LaCombe
Bottom Left: Mary Ellen Mark · Bottom Right: David Bailey

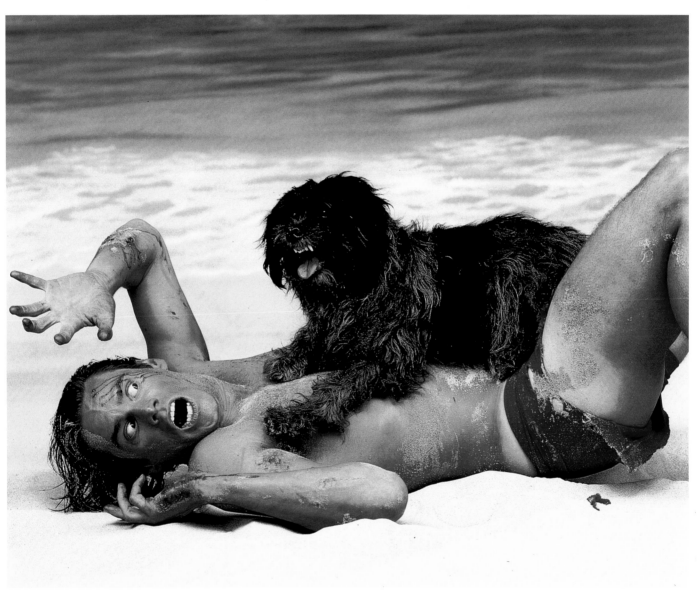

Herb Ritts

John Huet

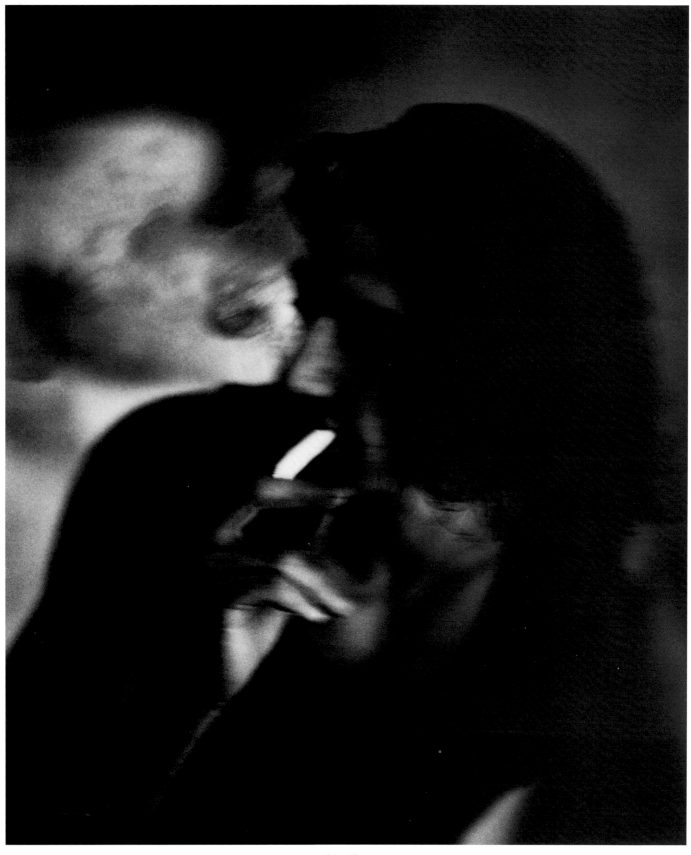

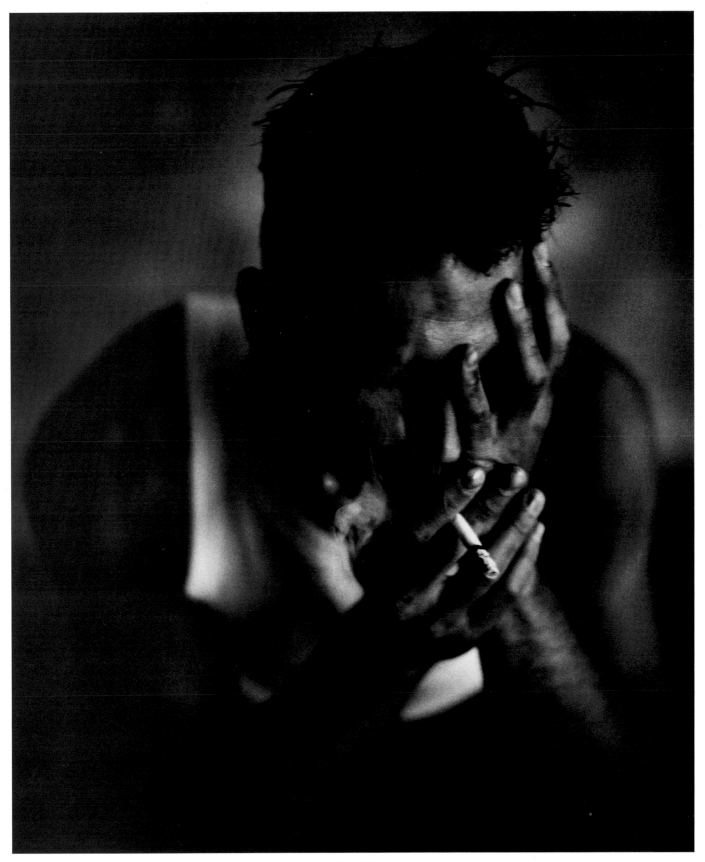

John Huet

John Huet

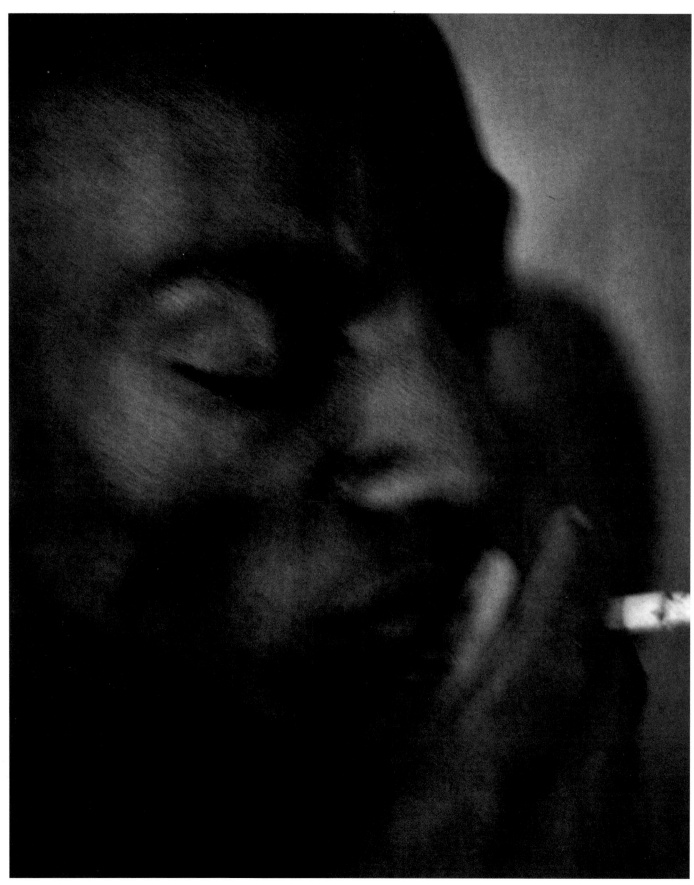

John Huet

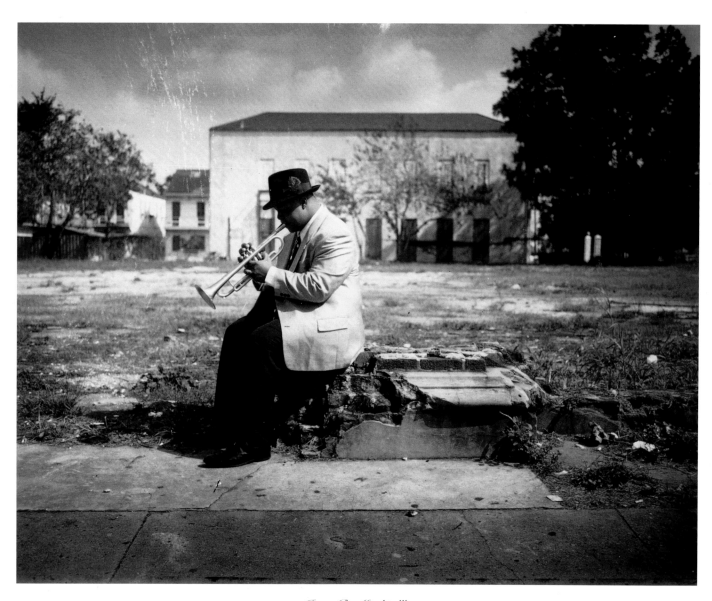

James R. Minchin III

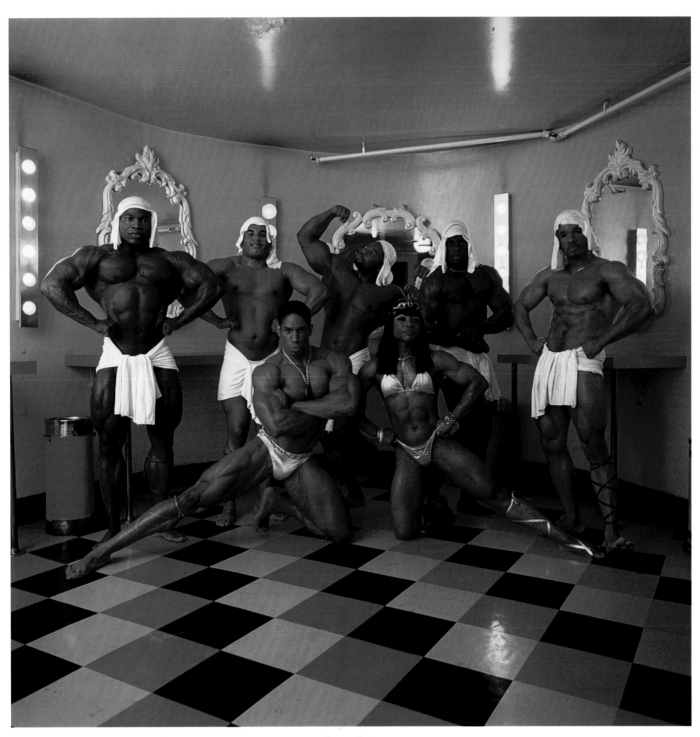

James Salzano

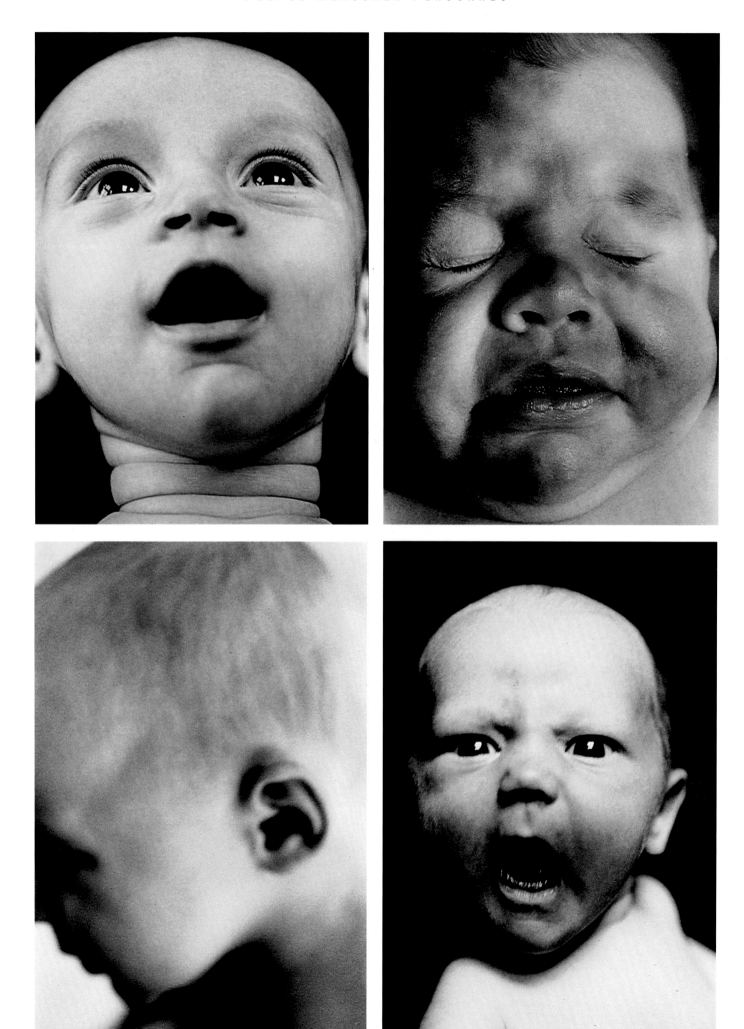

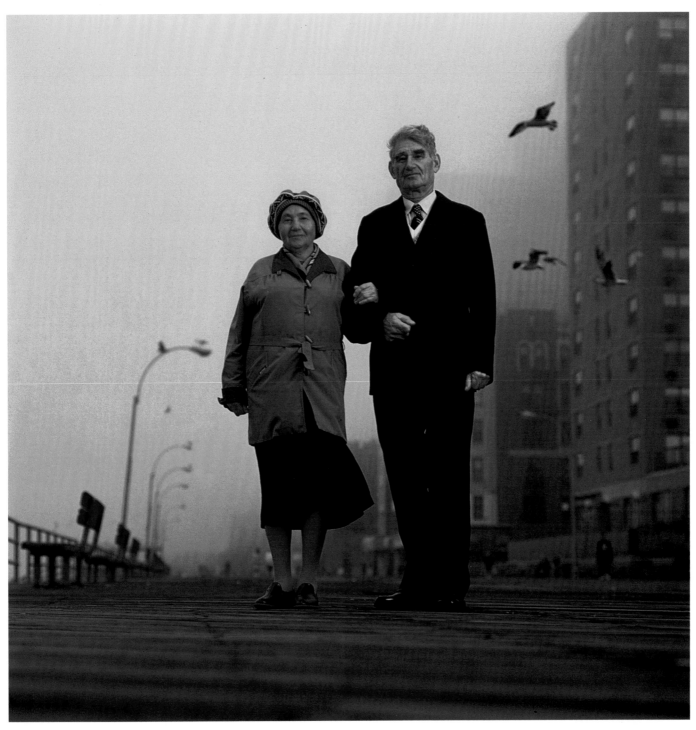

Opposite: Amy Arbus · Above: James Salzano

Paul Mobley

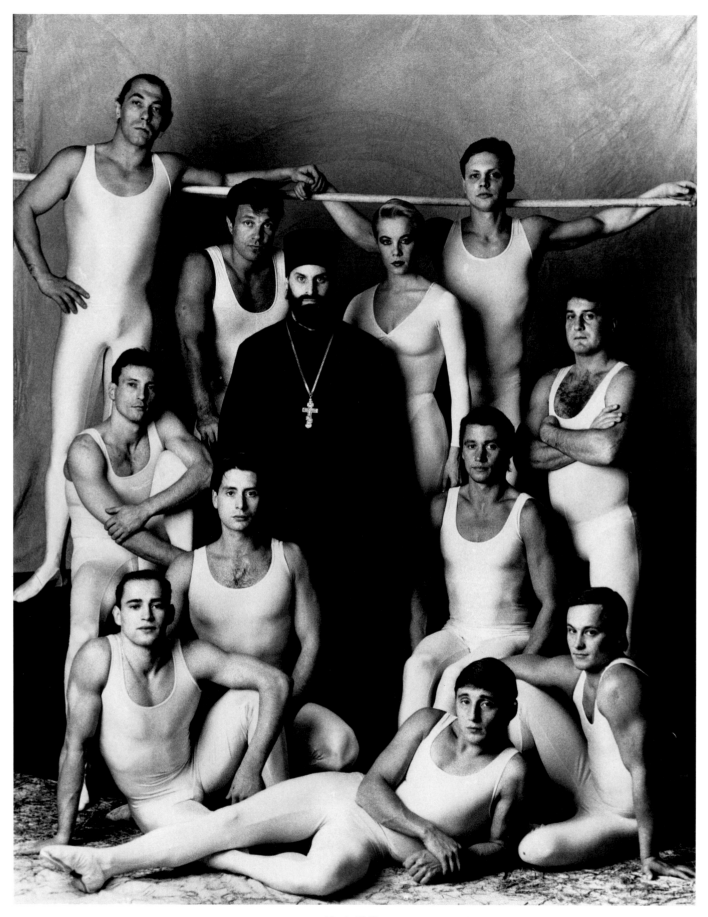

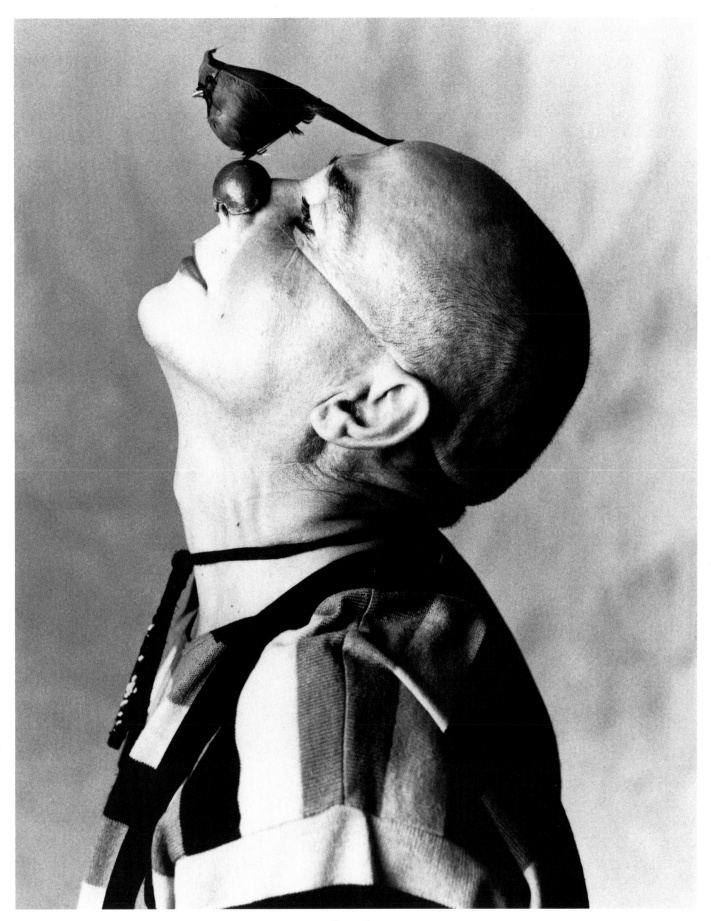

Paul Mobley

Ron Hildebrand

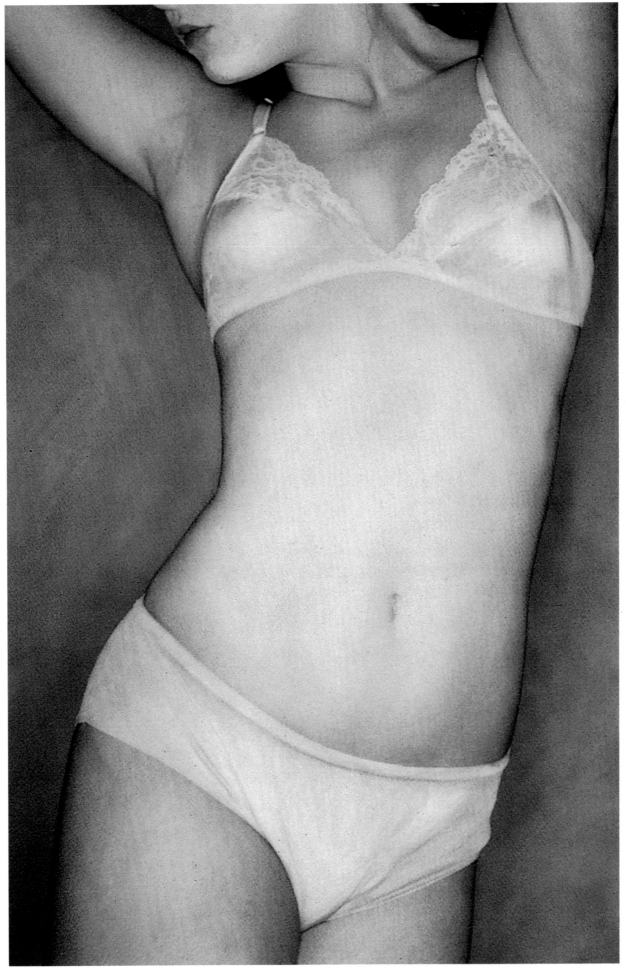

Dan Weaks

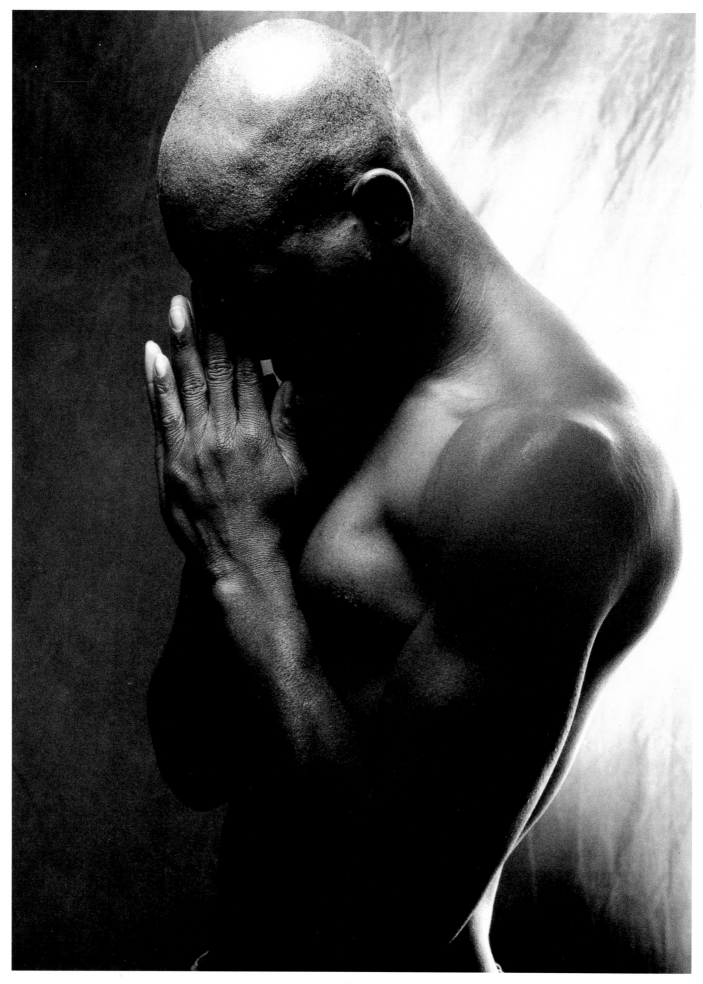

Sue Bennett

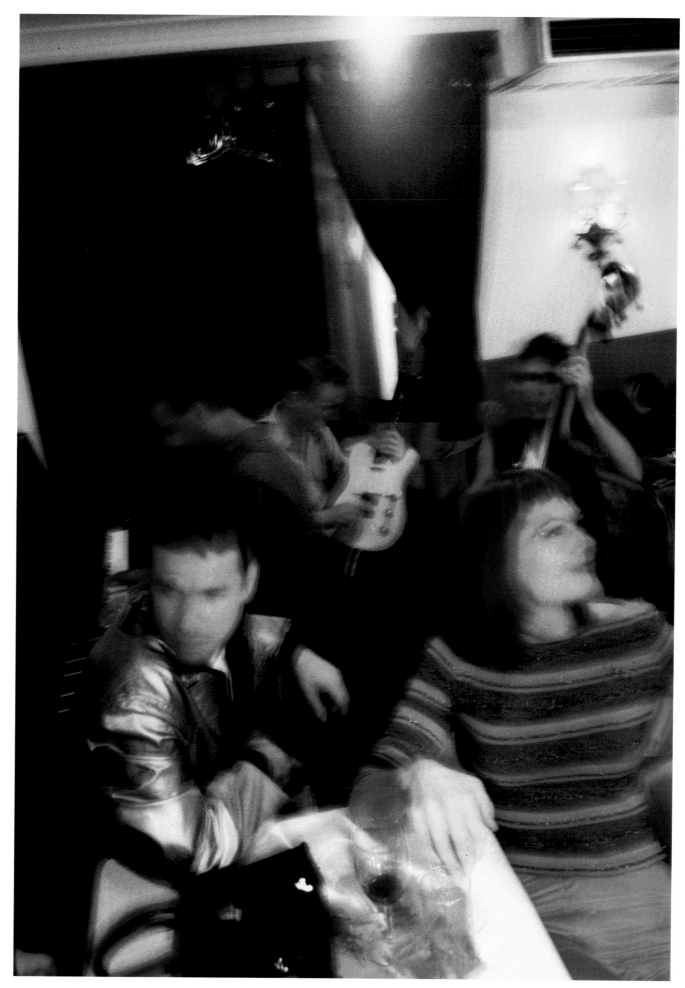

Ludovic Moulin

Donald W. Mason

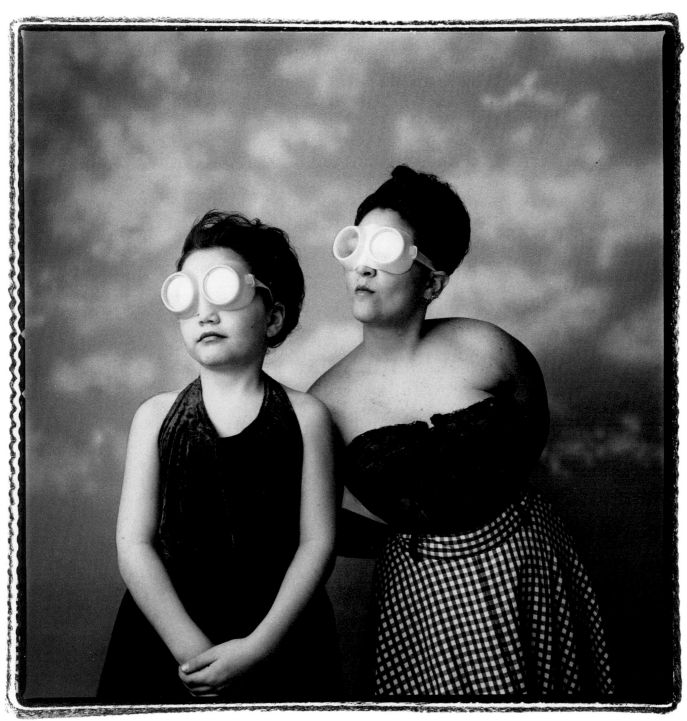

Donald W. Mason

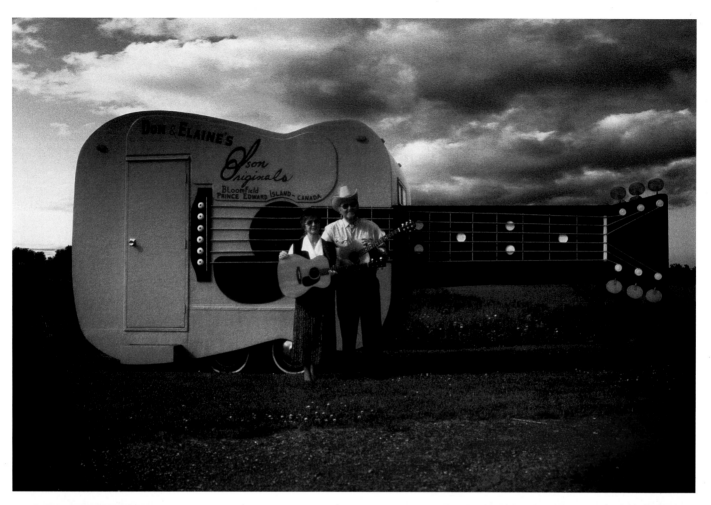

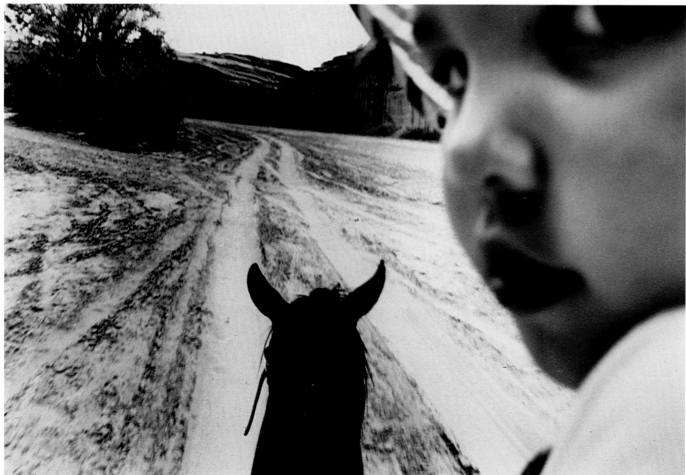

Top: George Simhoni · Bottom: William Mercer McLeod

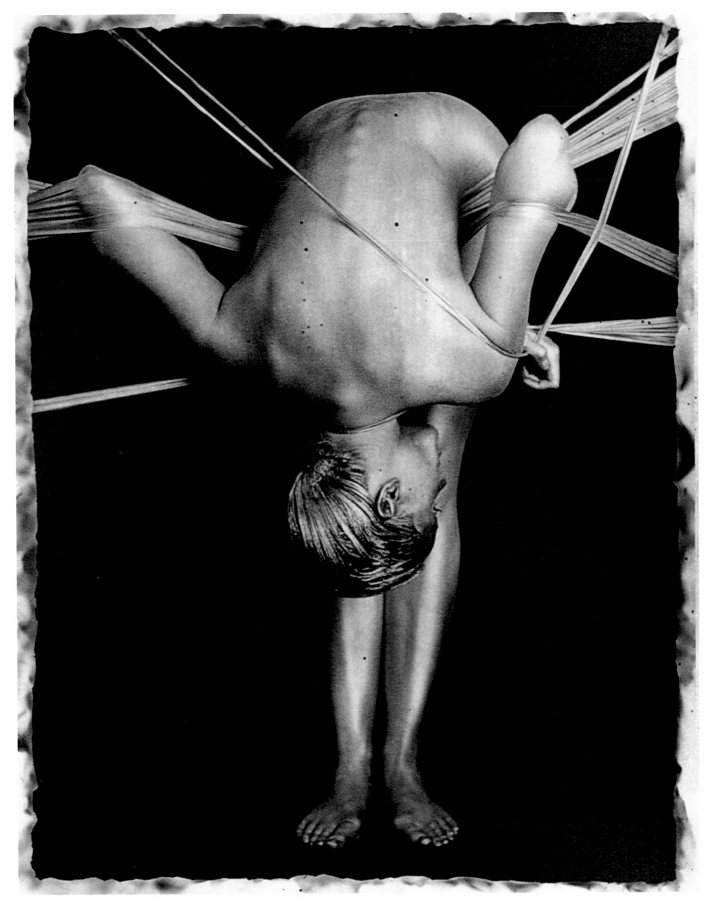

Alvin Booth

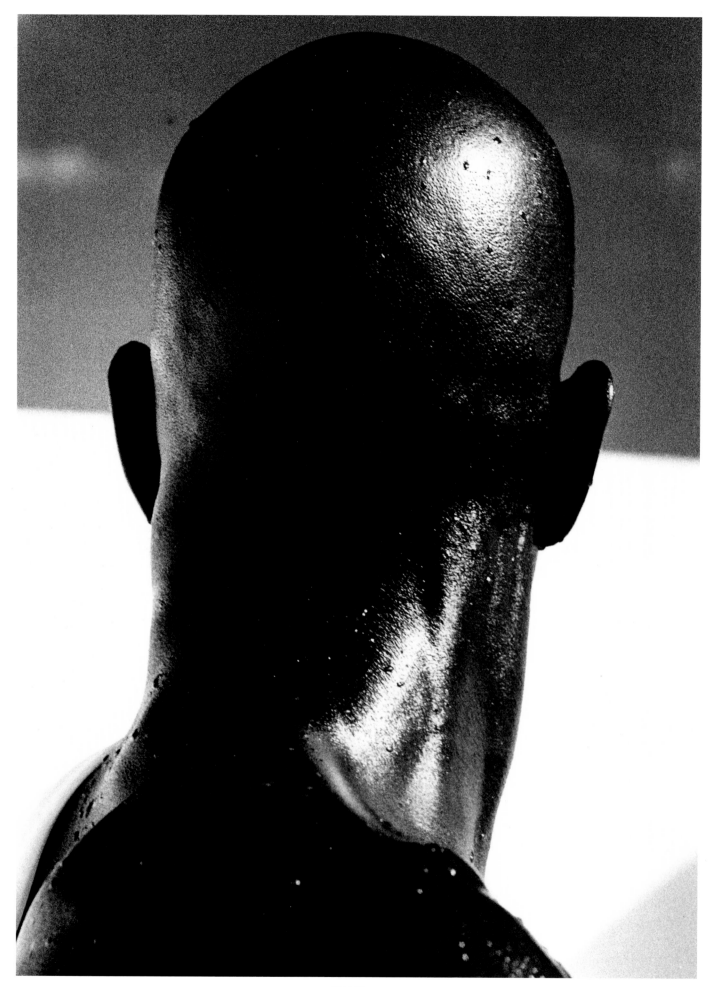

Jeff Licata

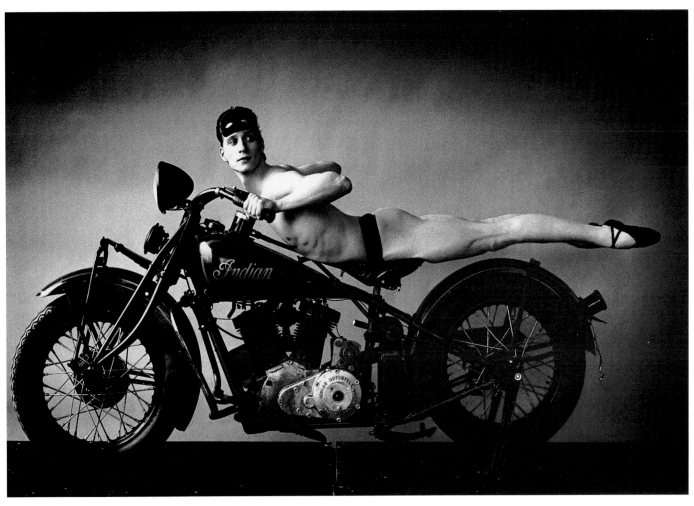

Ruven Afanador

Per-Erik Berglund

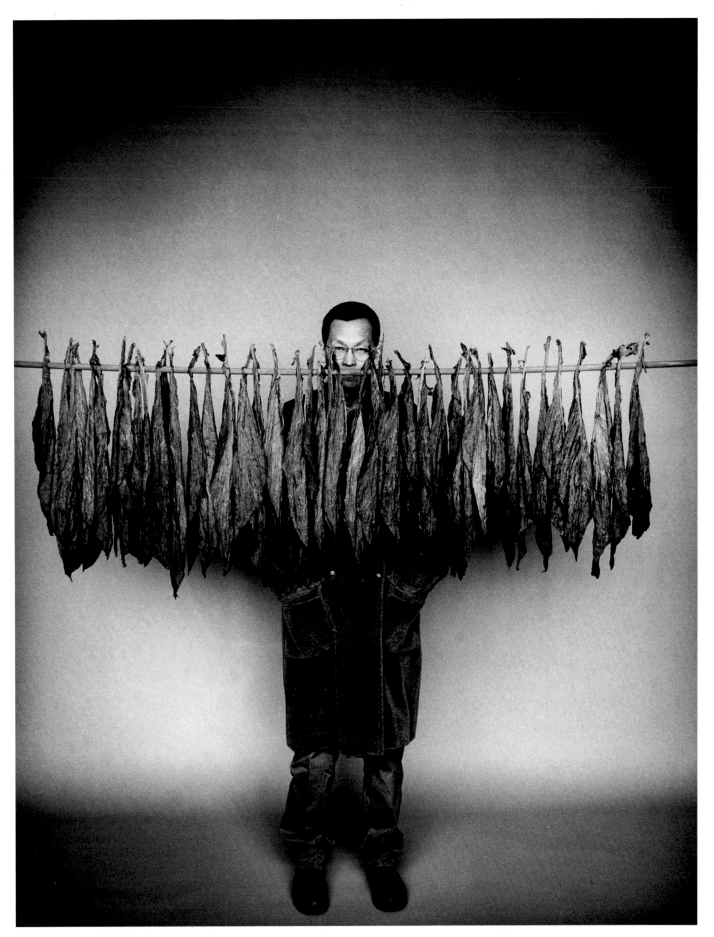

Ruven Afanador

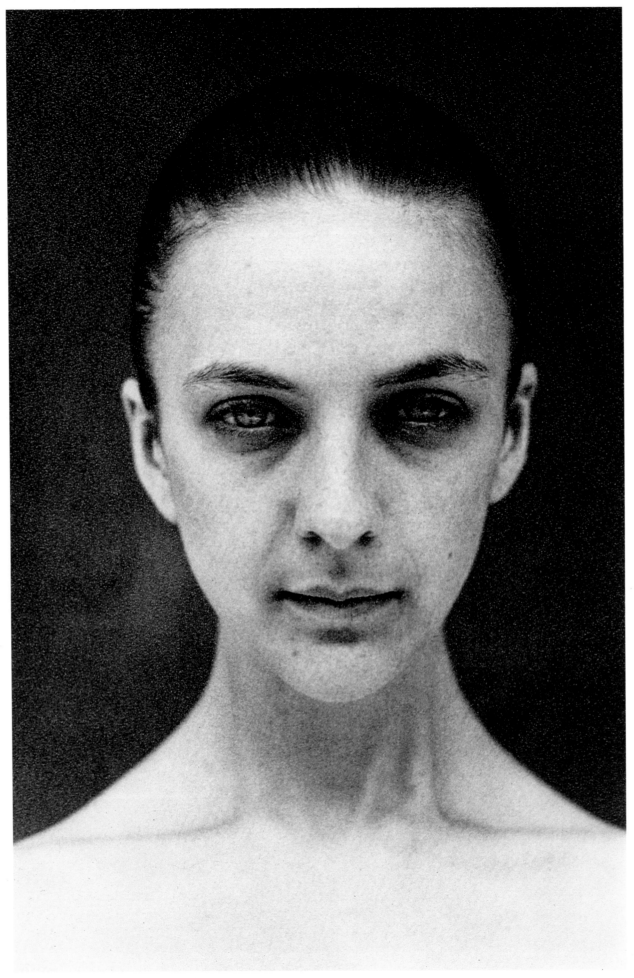

Simon Obarzanek

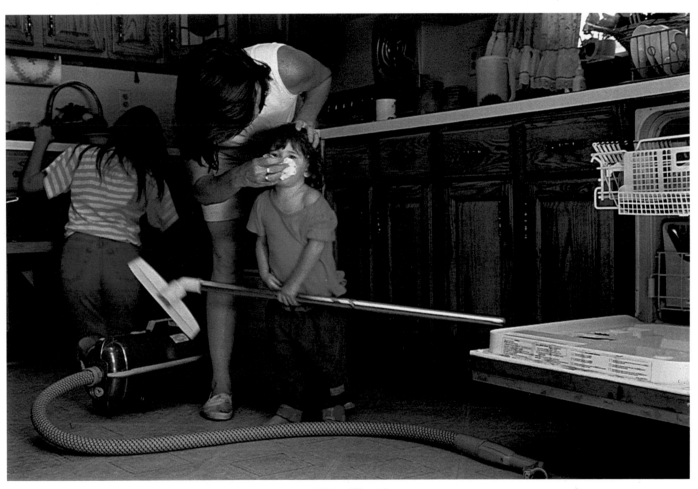

Lizzie Himmel
BEST OF CATEGORY

PRODUCTS

SACHAUFNAHMEN

PRODUITS

Preceding Spread and Above: Barry Robinson

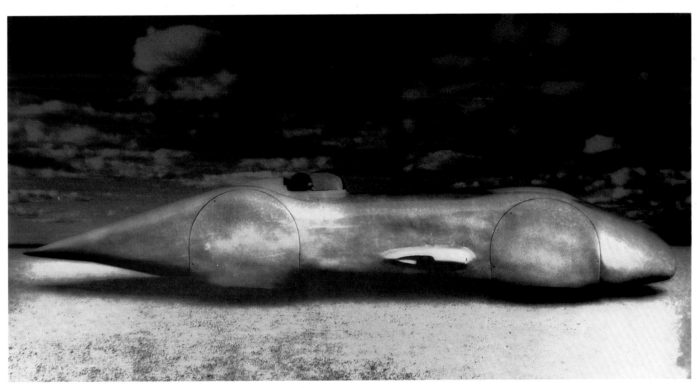

Aernout Overbeeke

P R O D U C T S · S A C H A U F N A H M E N · P R O D U I T S

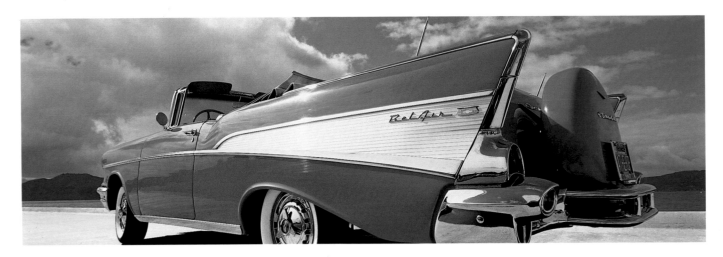

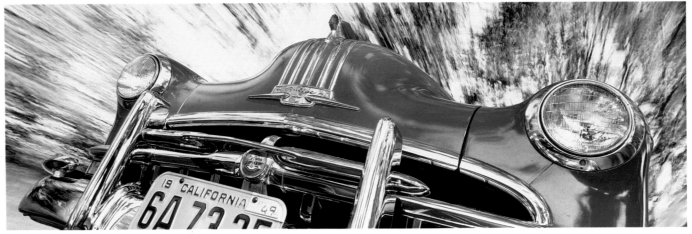

Hunter Freeman

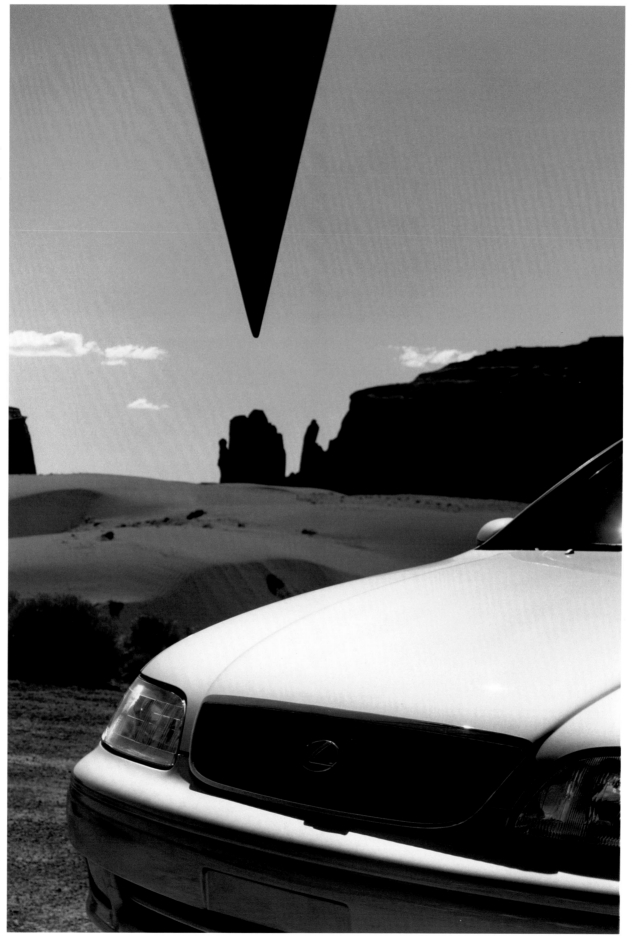

Rick Rusing

Michael Furman

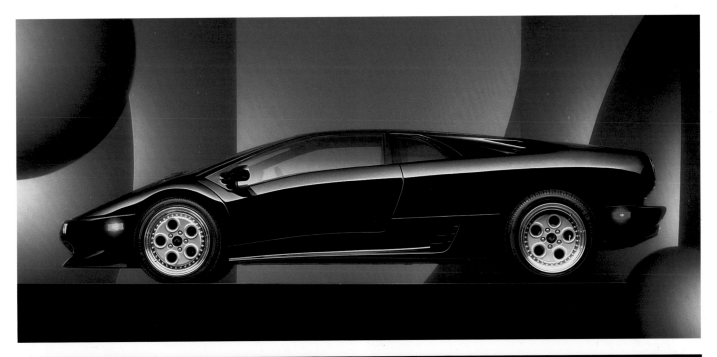

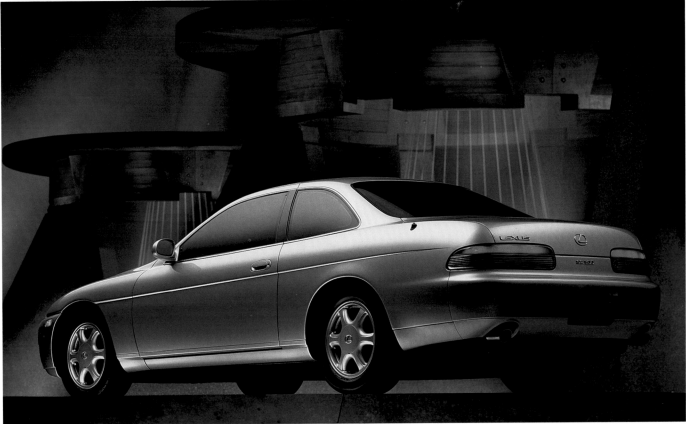

Top: Steve Hathaway · Bottom: Rick Rusing

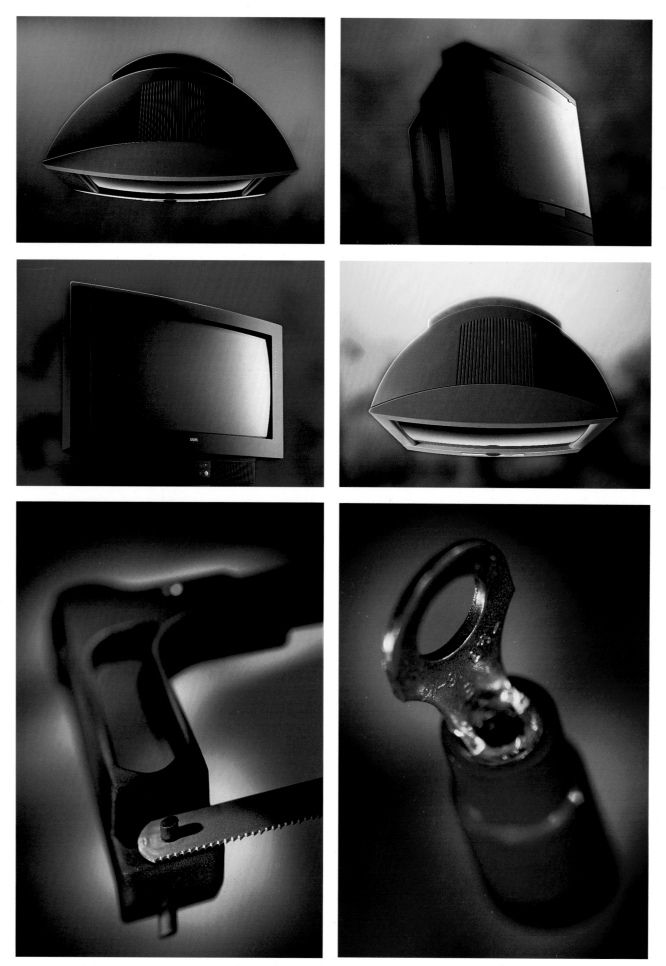

Top Two Rows: Ernesto Martens · Bottom Row: Mark Wiens

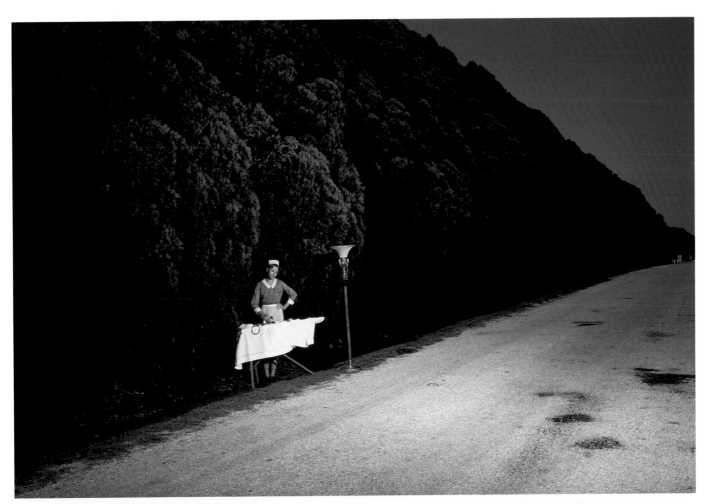

Top: Geof Kern · Bottom: Michael Schnabel

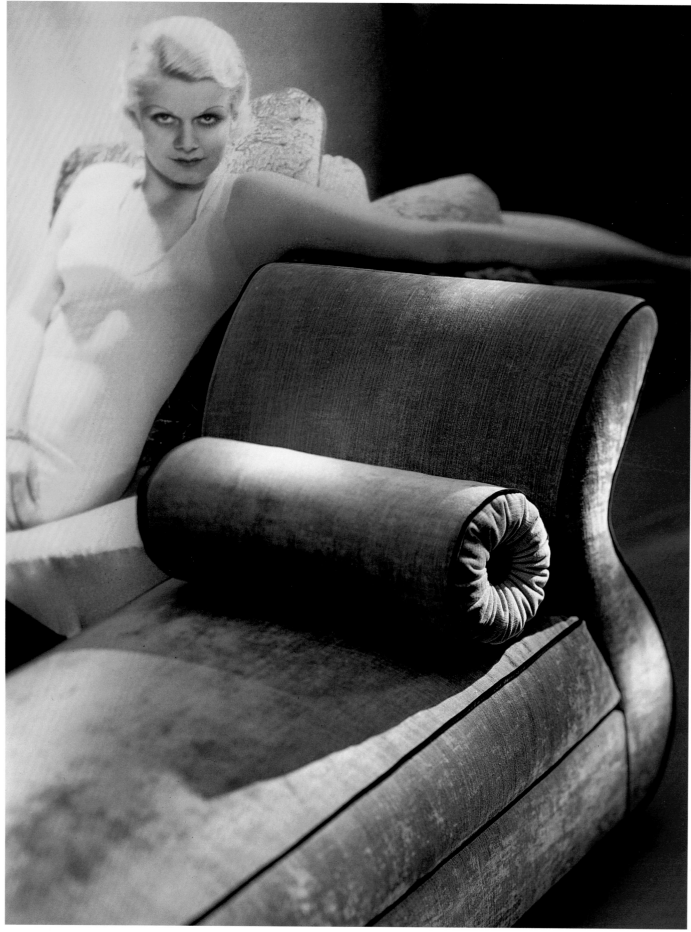

Alan Richardson

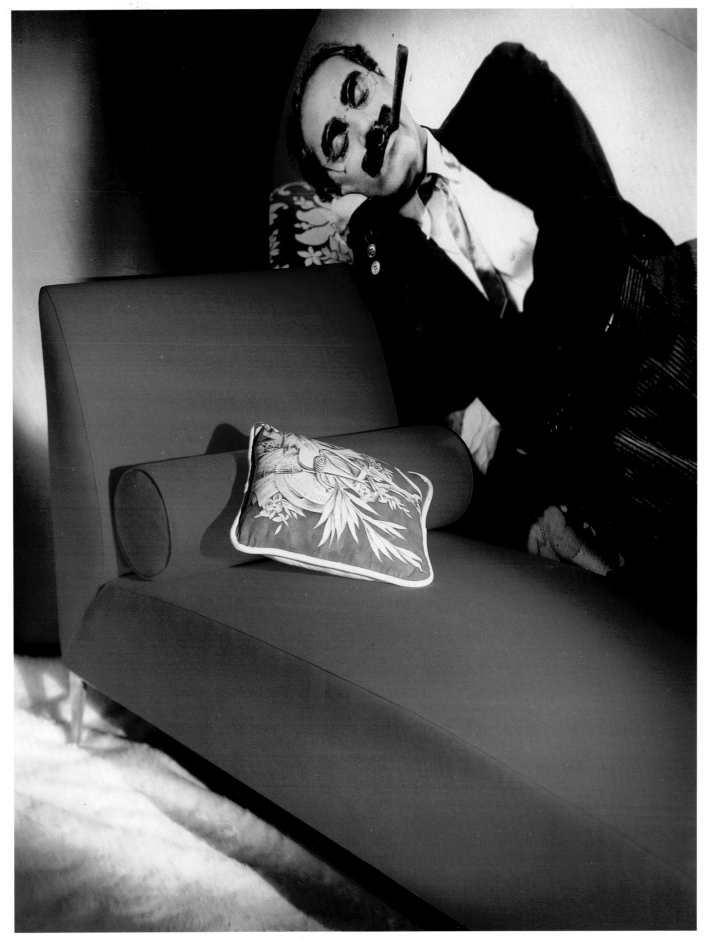

Alan Richardson
BEST OF CATEGORY

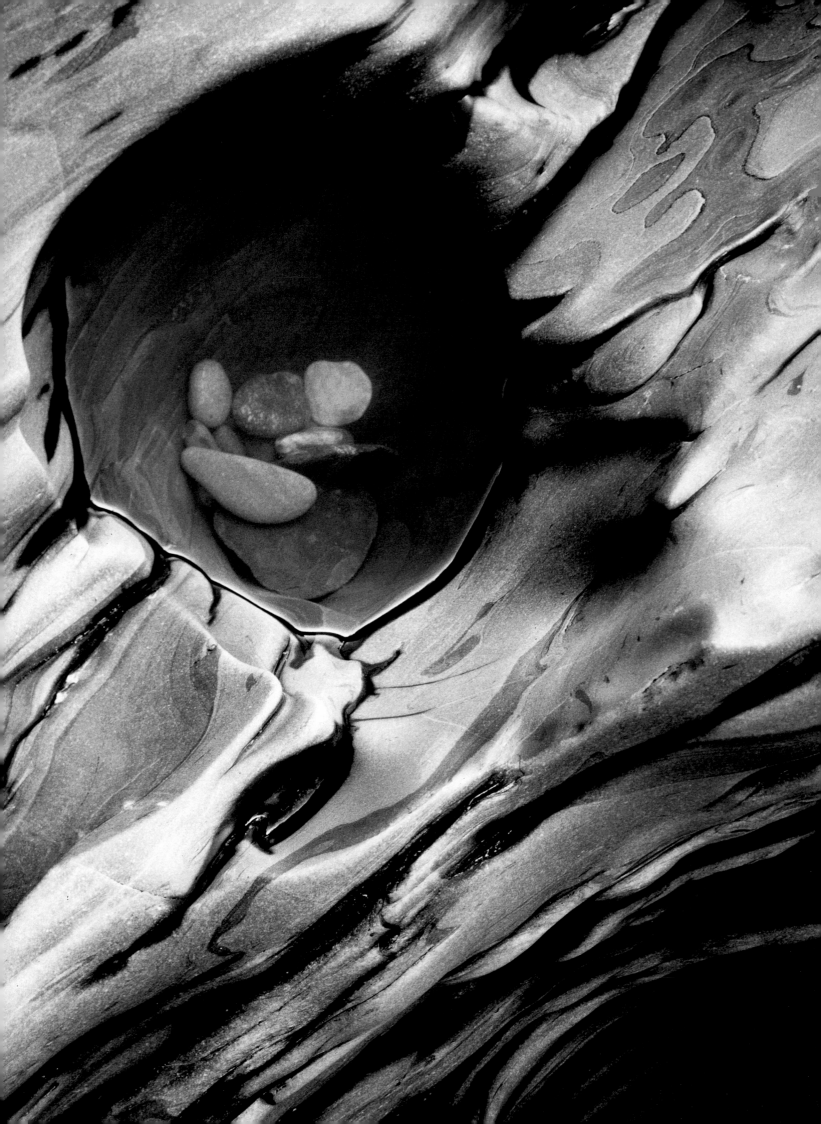

LANDSCAPES

LANDSCHAFTEN

PAYSAGES

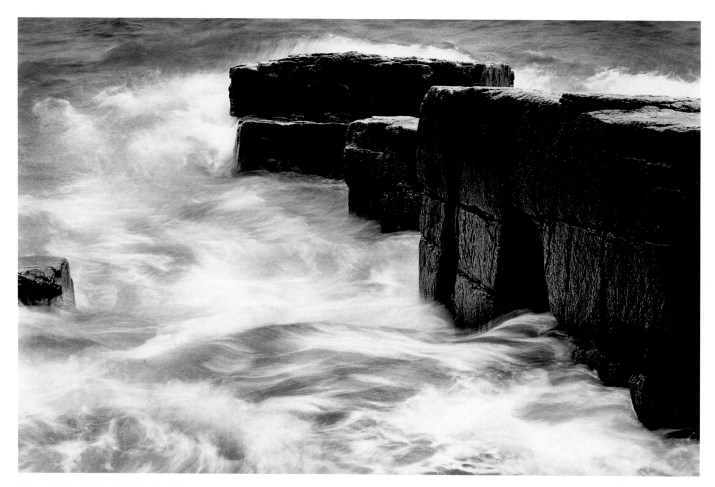

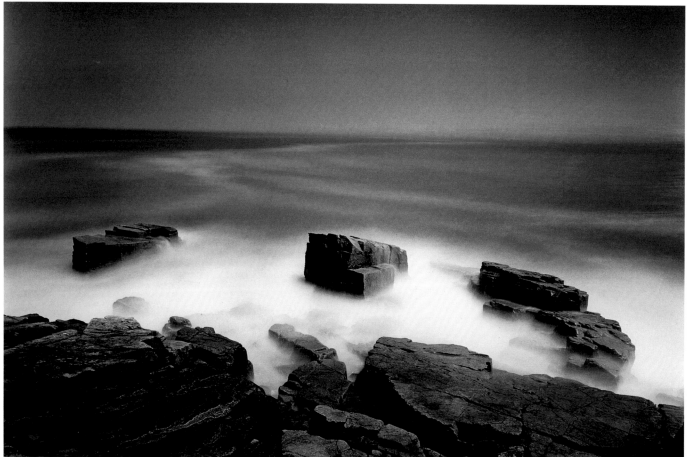

Preceding Spread and Above: Chip Forelli

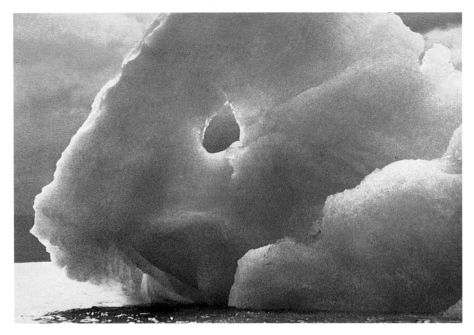

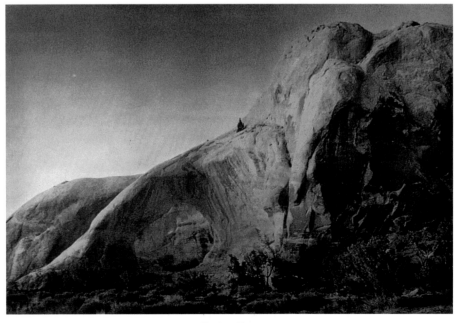

Sheila Metzner

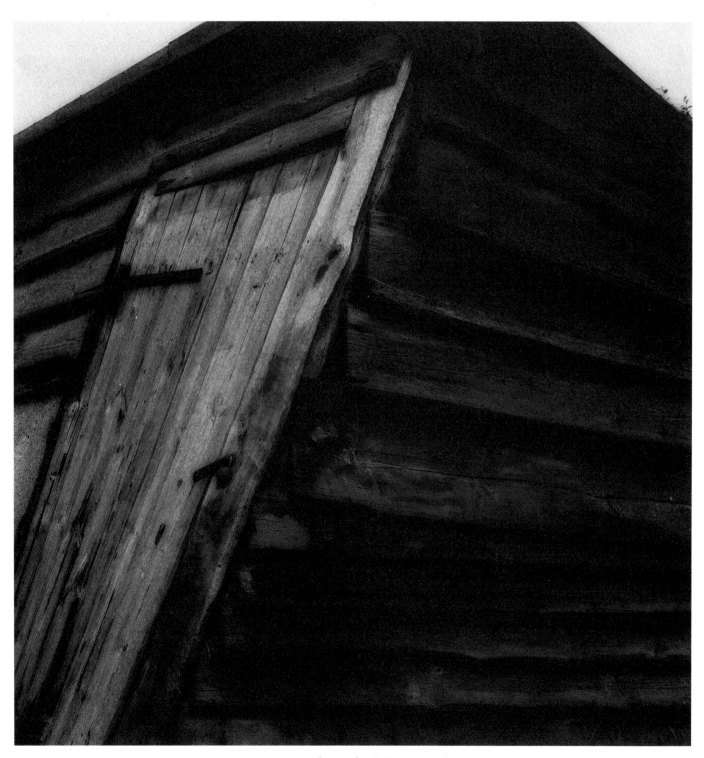

Aernout Overbeeke

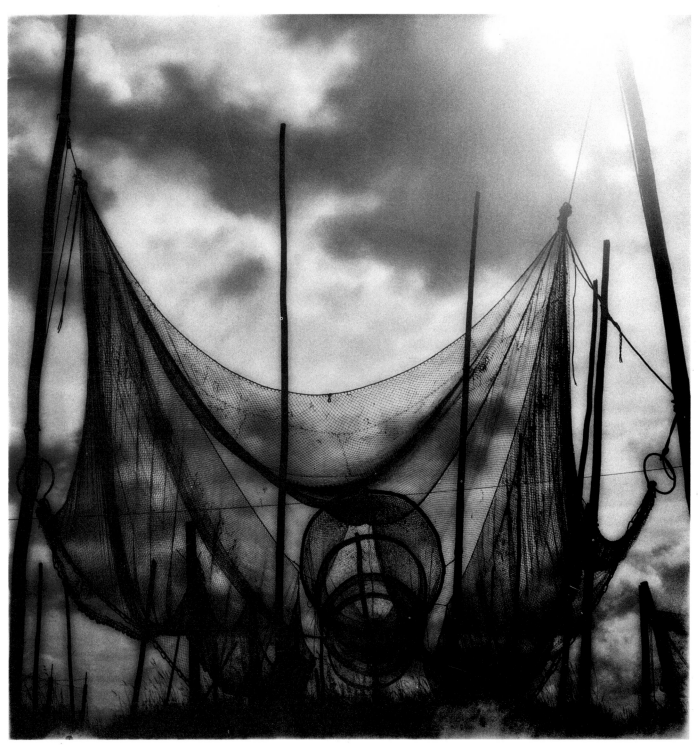

Aernout Overbeeke

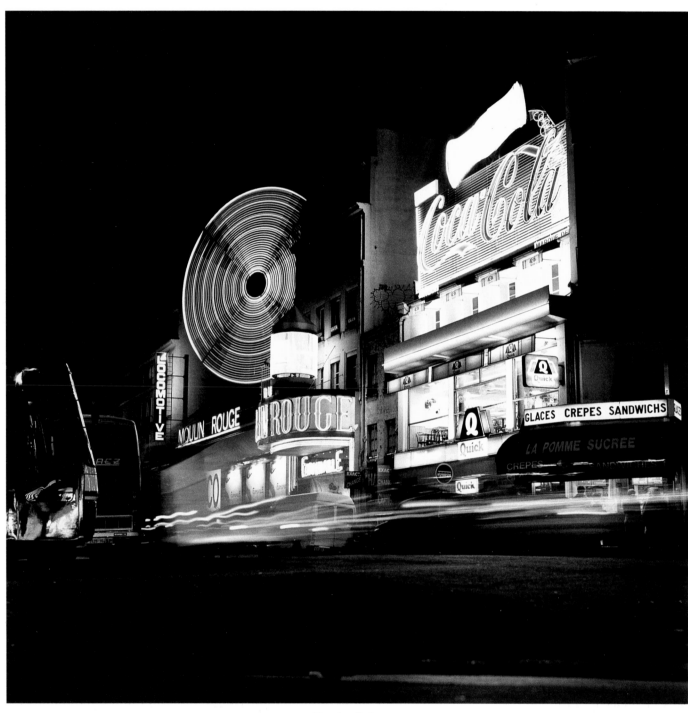

Jonathan Exley

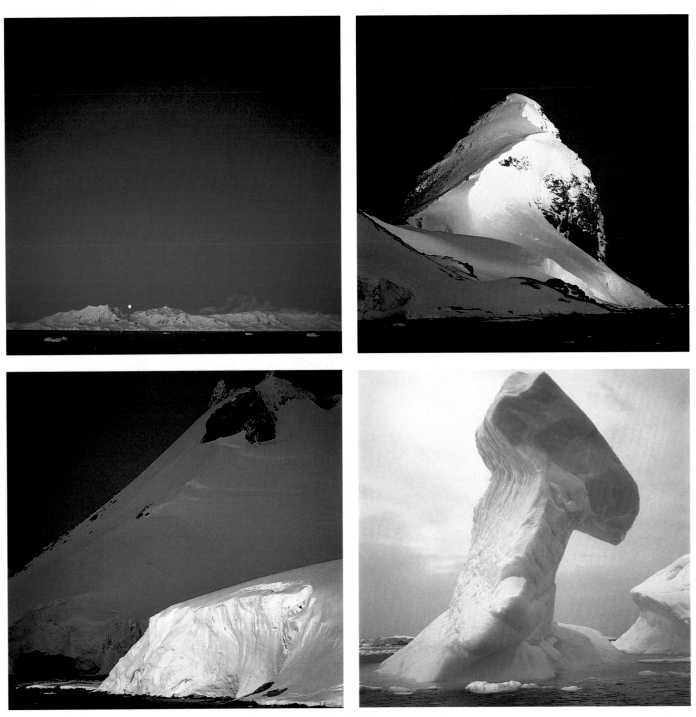

Rob Badger

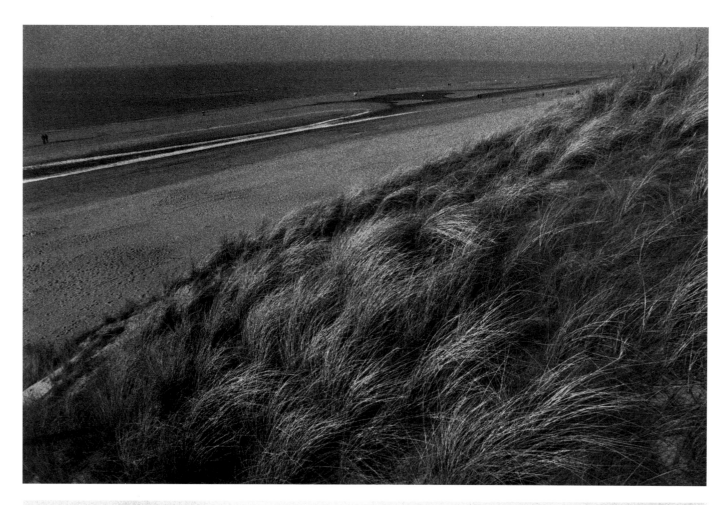

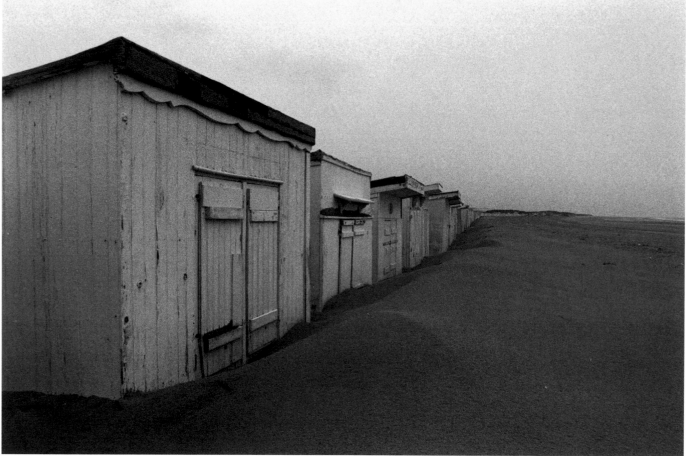

István Lábady

Hans Pieler

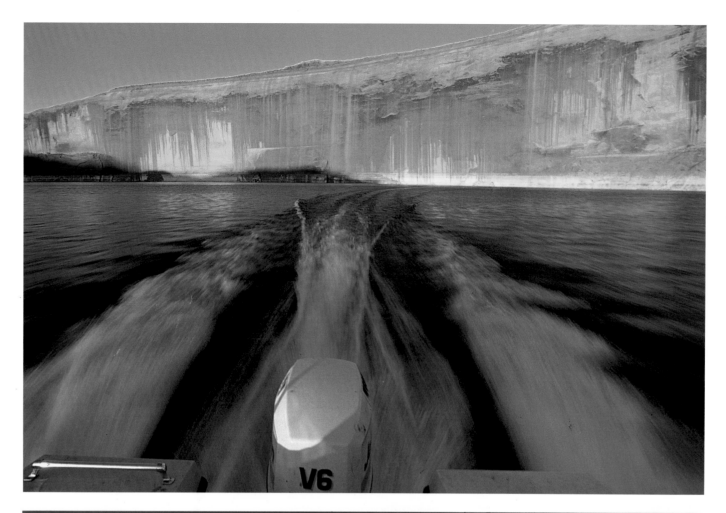

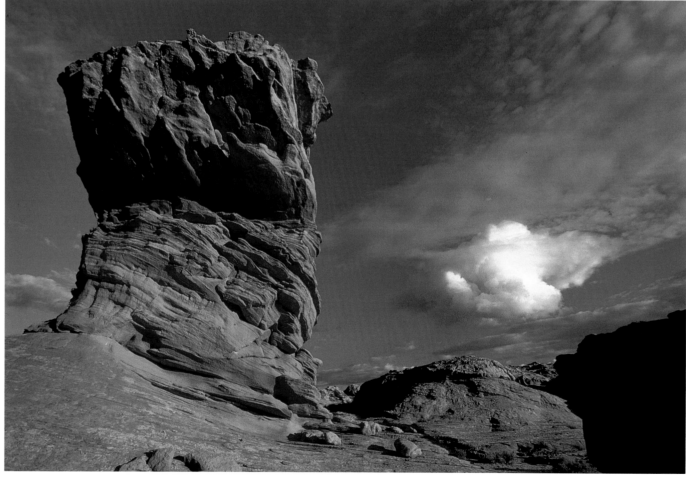

Michael Melford

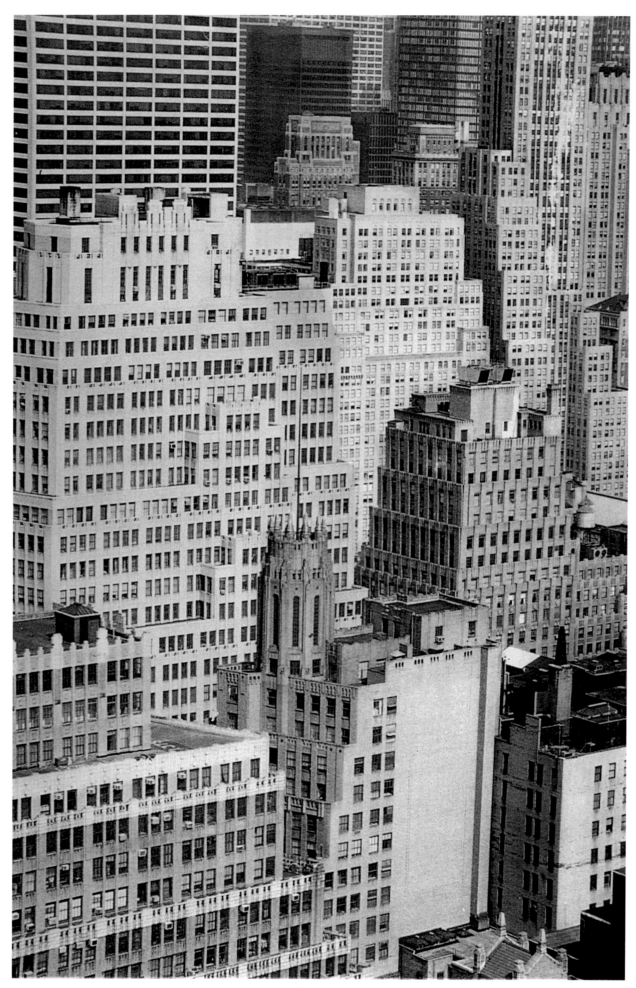

Dan Weaks

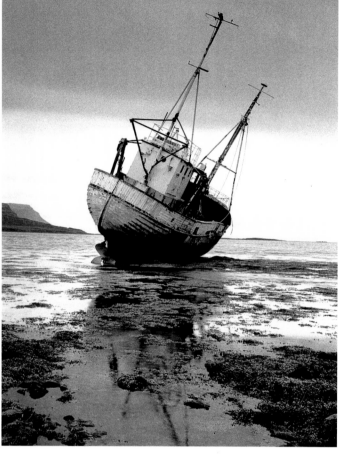
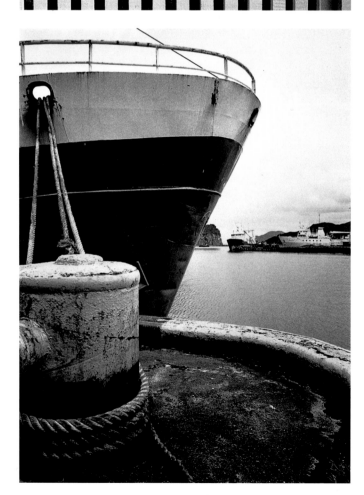
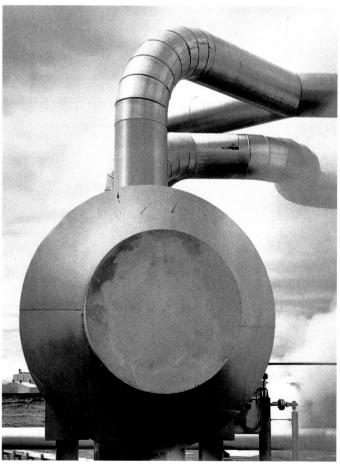

Marco Paoluzzo

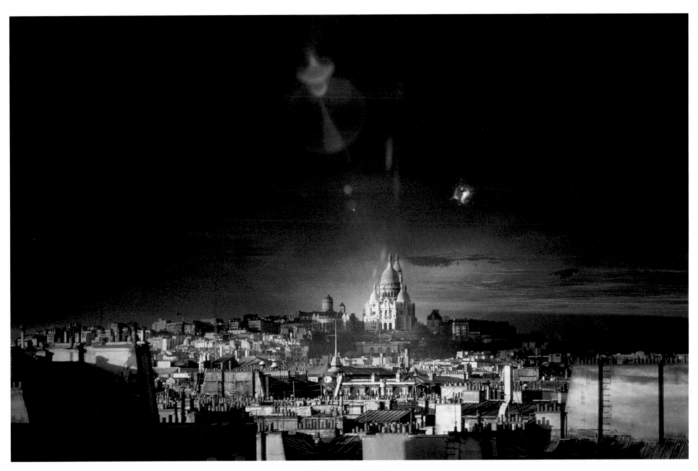

Francisco Hidalgo

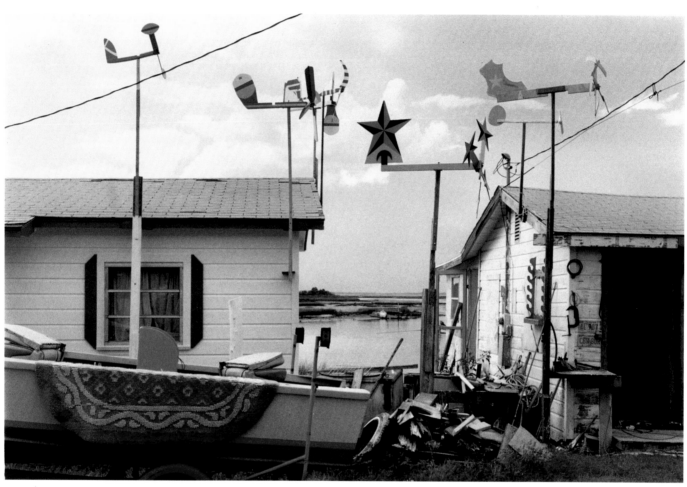

Deborah Brackenbury
BEST OF CATEGORY

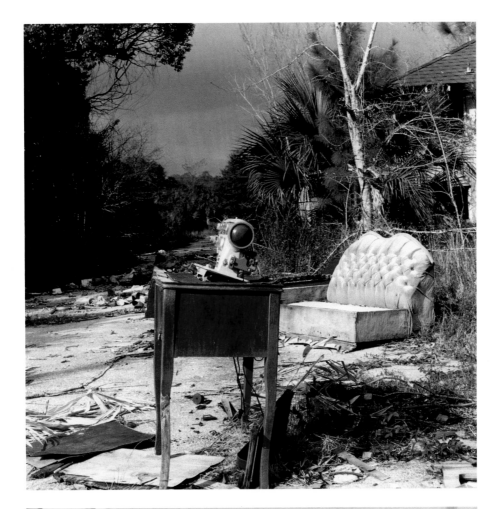

Deborah Brackenbury

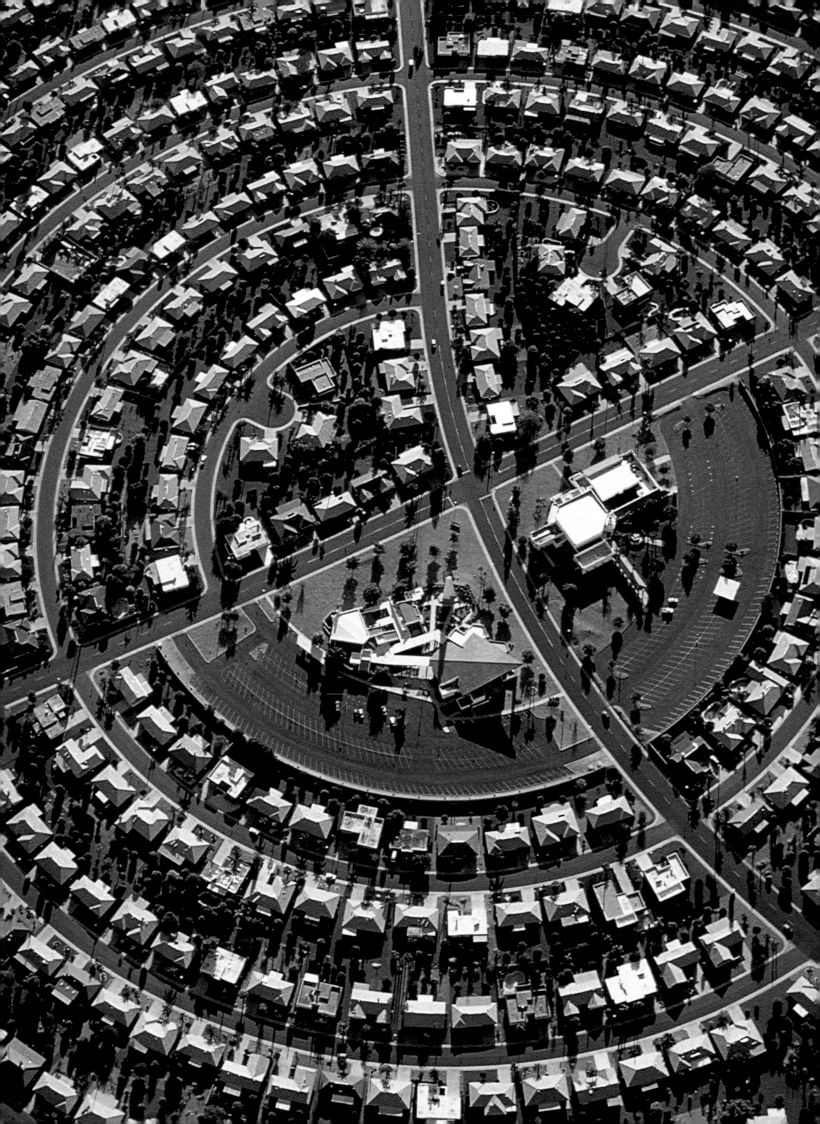

ARCHITECTURE

ARCHITEKTUR

ARCHITECTURE

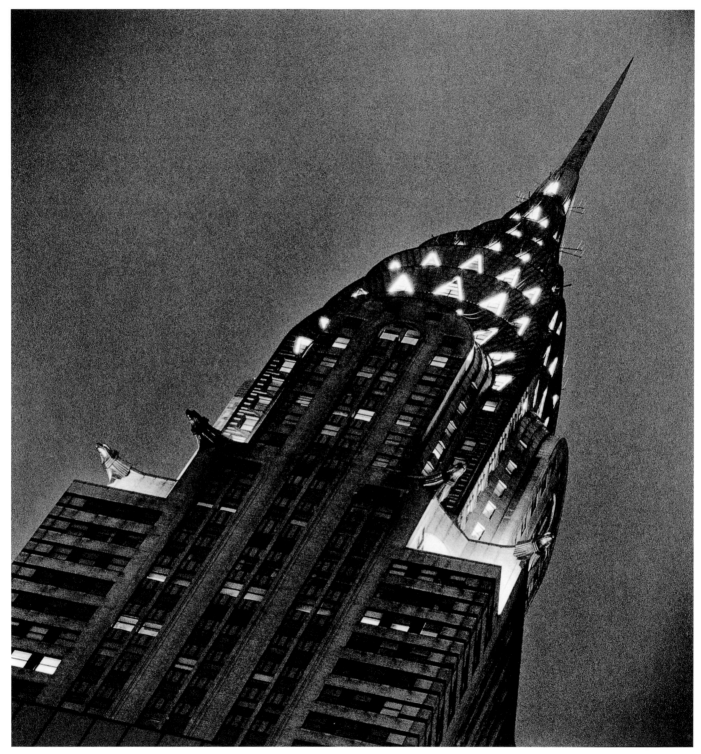

Harry De Zitter

Preceding Spread: Randy Wells

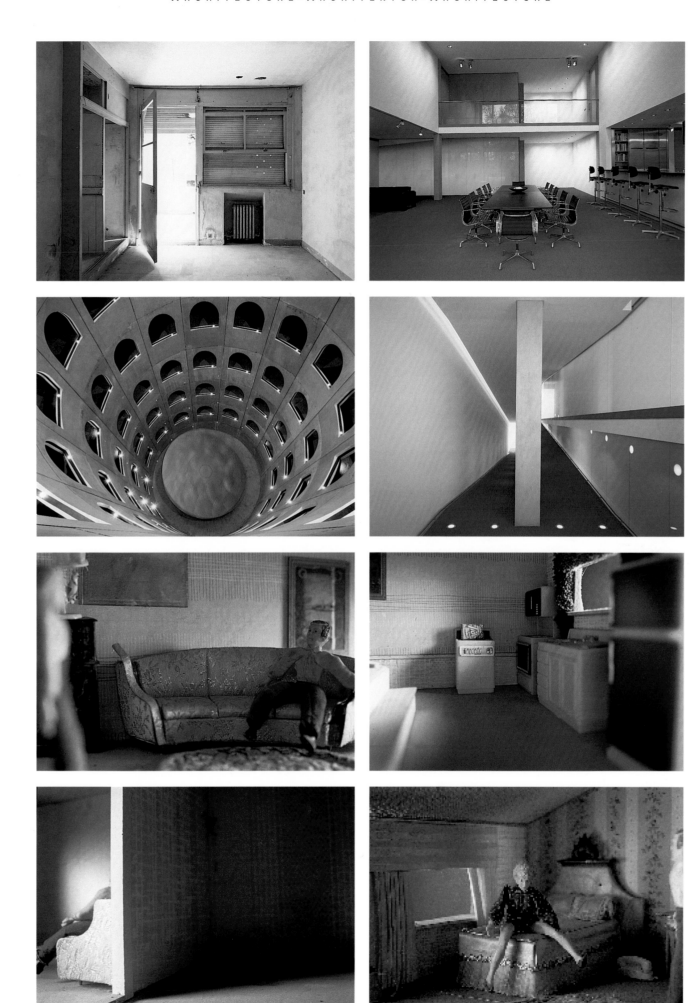

Top Two Rows: Dieter Lestner · Bottom Two Rows: David Everitt

Dan Weaks

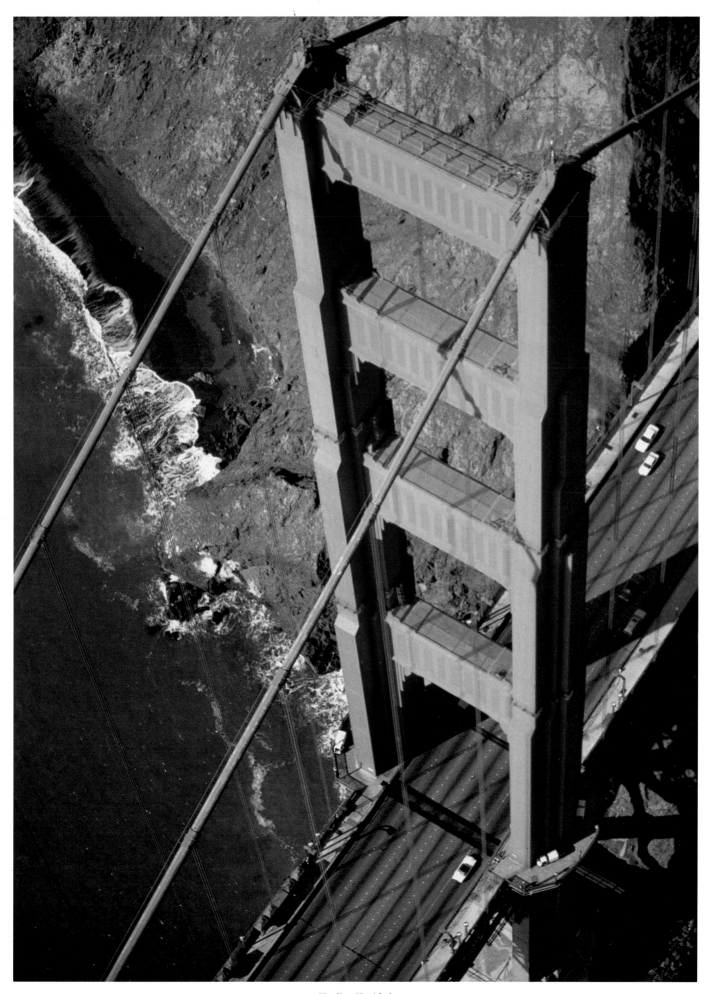

Dudley DeNador
BEST OF CATEGORY

J. Peter Pawlak

Stefan Longin

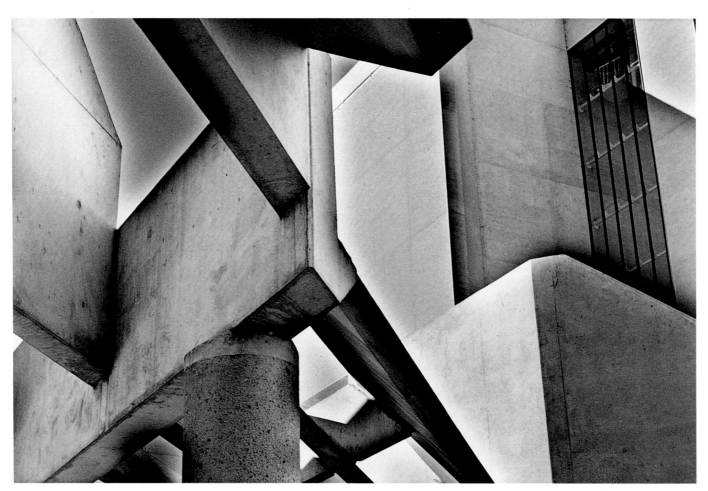

Frances Mocnik

ARCHITECTURE · ARCHITEKTUR · ARCHITECTURE

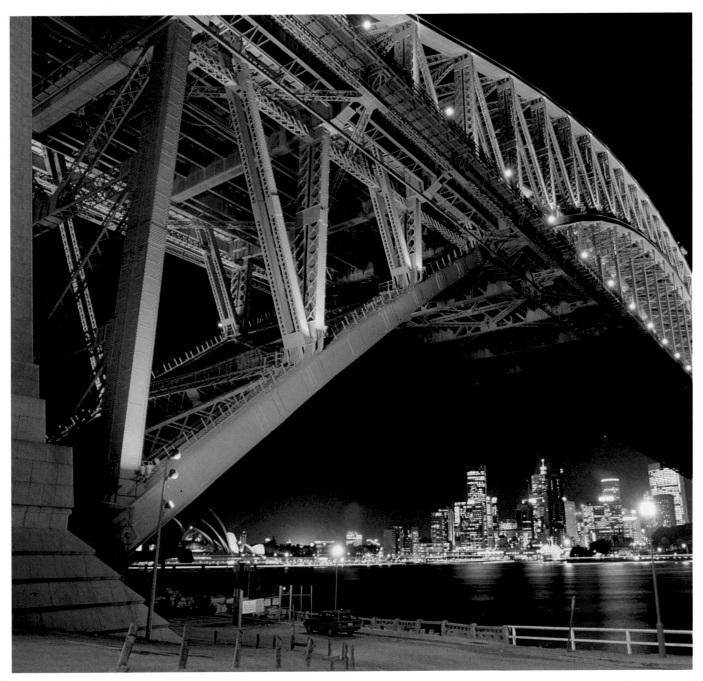

Hale Coughlin

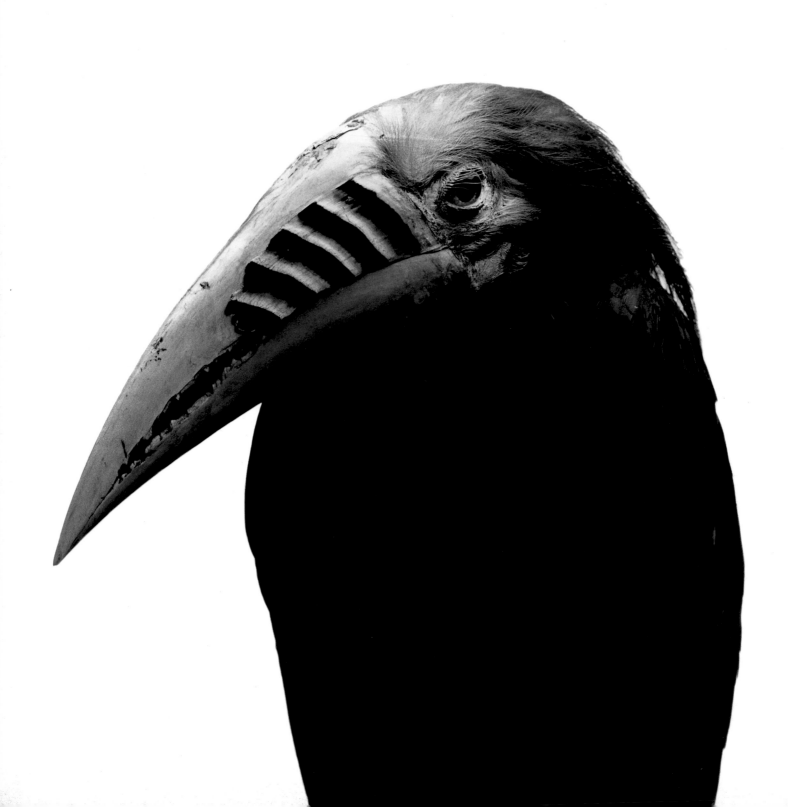

WILDLIFE

TIERE

ANIMAUX

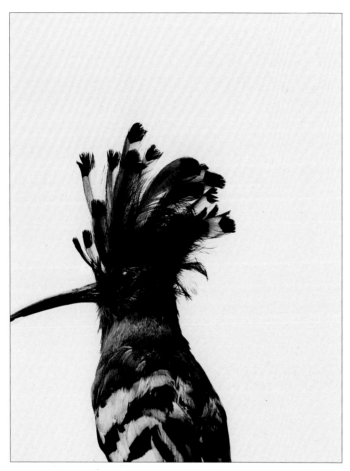

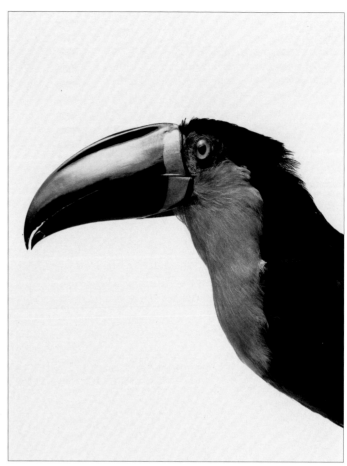

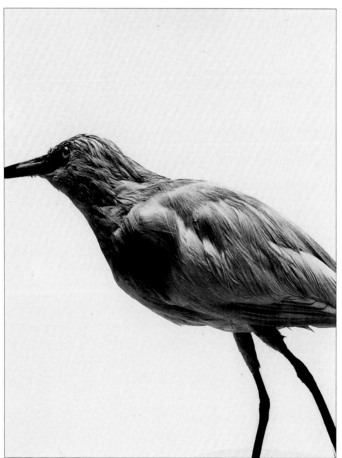

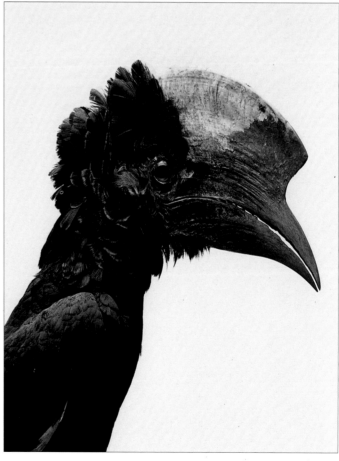

Preceding Spread and Above: Luciano Morini
BEST OF CATEGORY

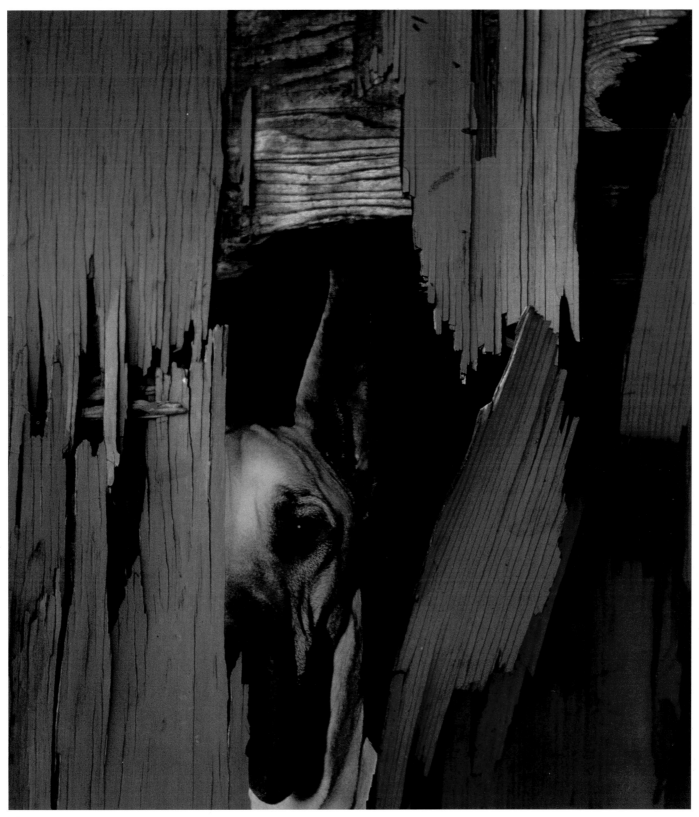

Joseph Brazan

Claudio Allesandri

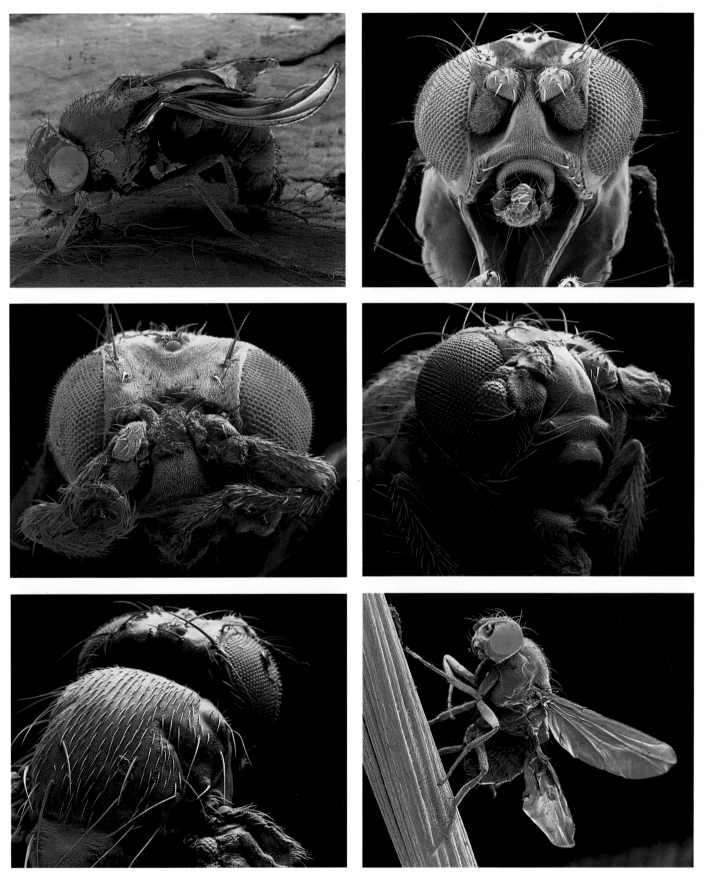

Oliver Meckes

John Huet

Jody Dole

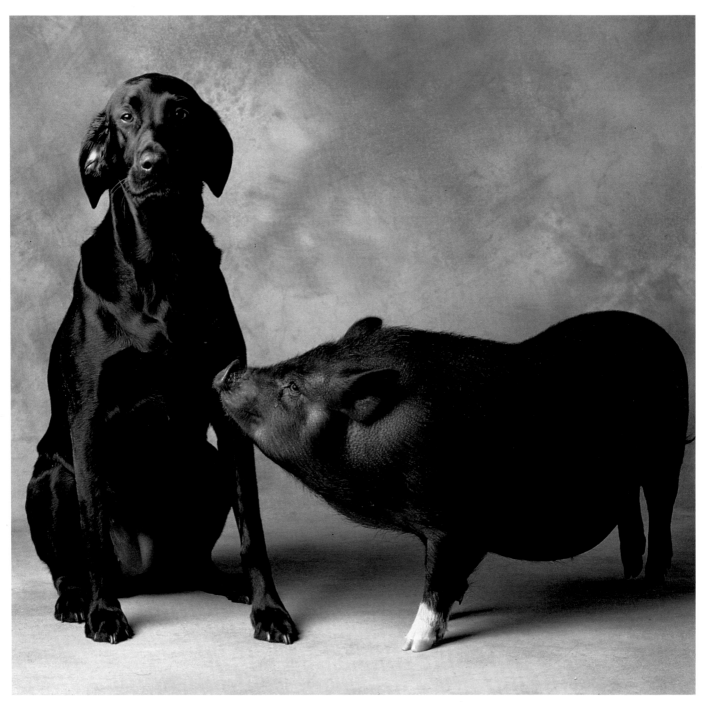

Steve Grubman

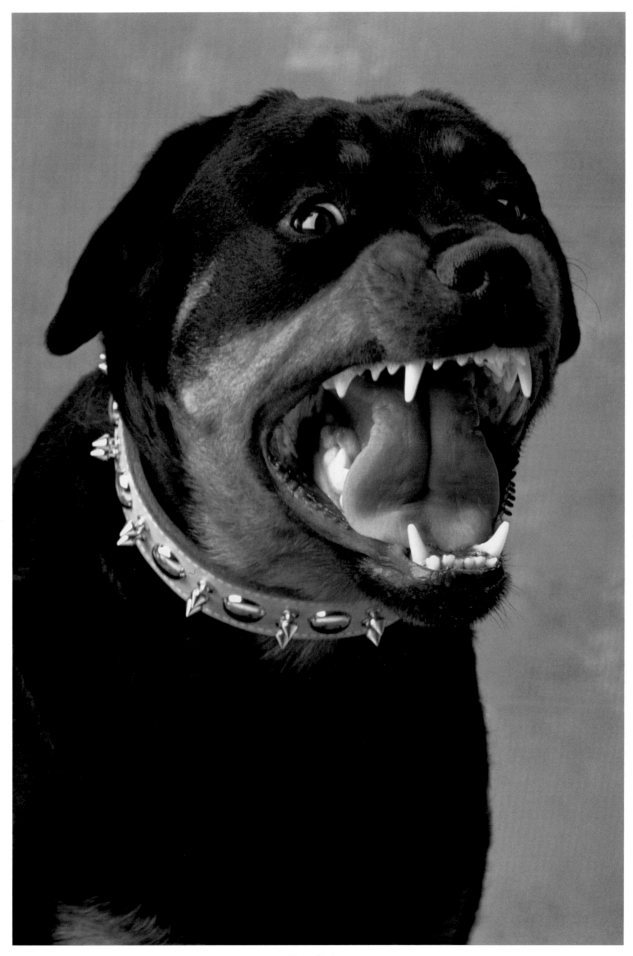

Steve Grubman

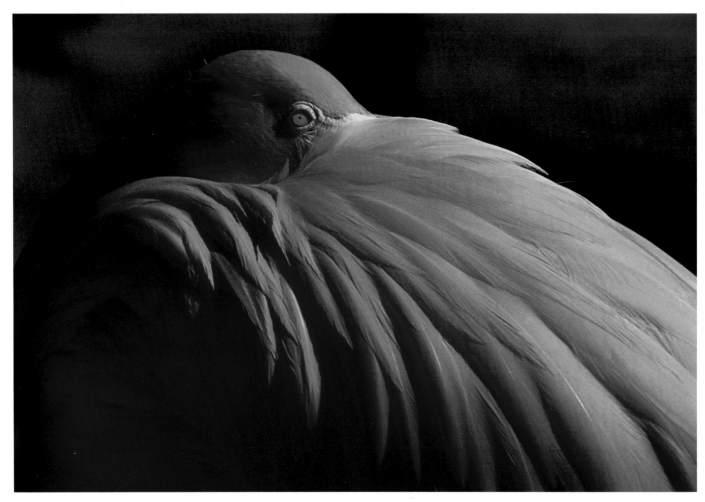

Michael Kammerdiener

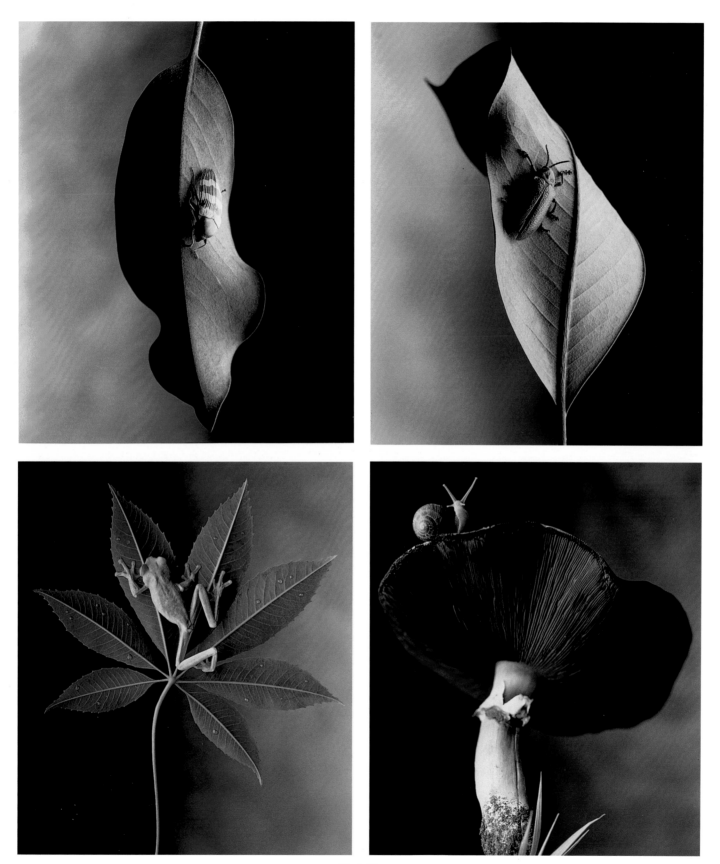

Mark Laita

This Page: Michael Melford · Opposite: Steve Grubman

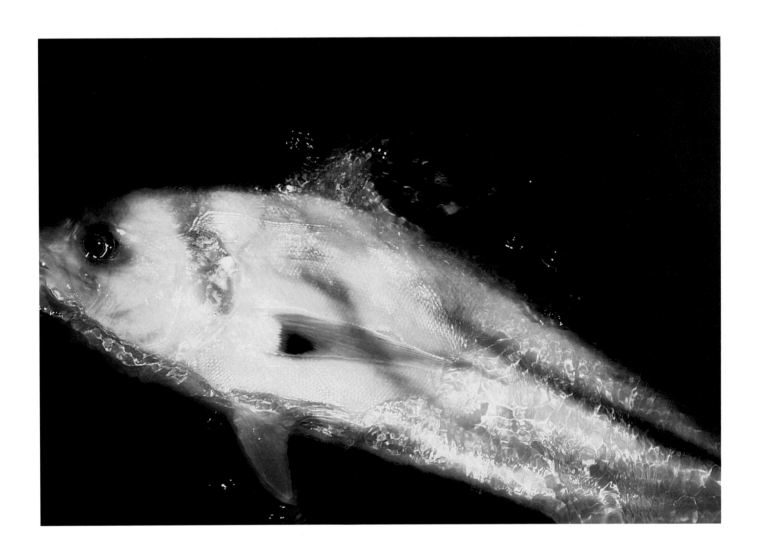

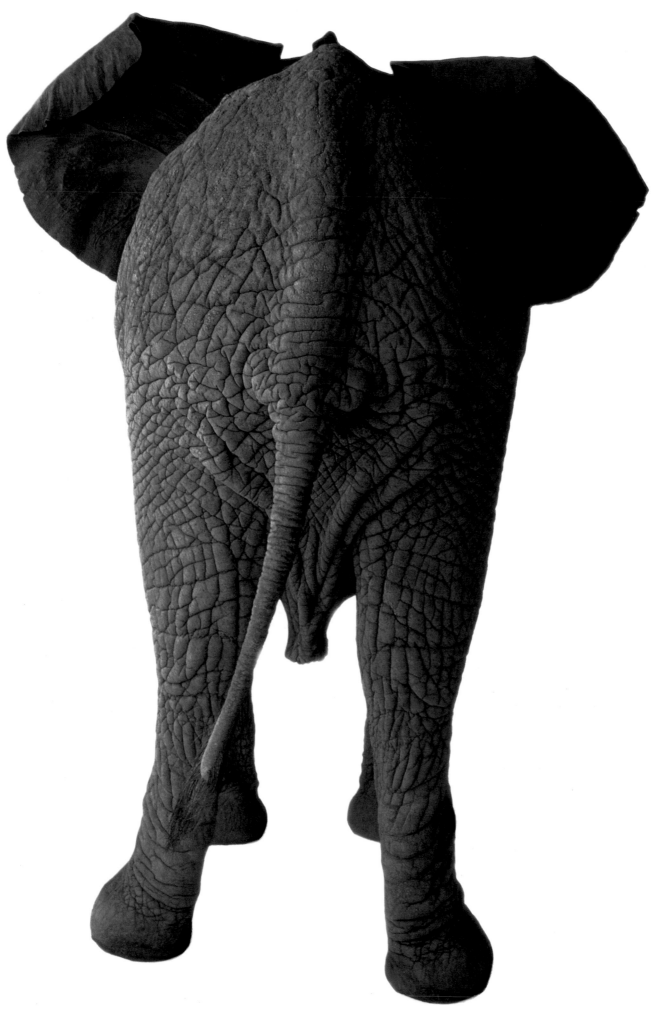

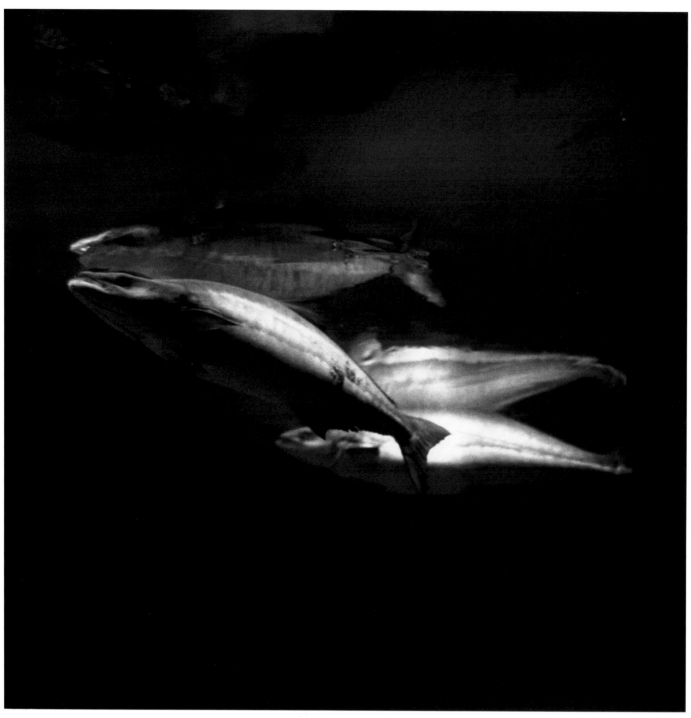

Amos Chan

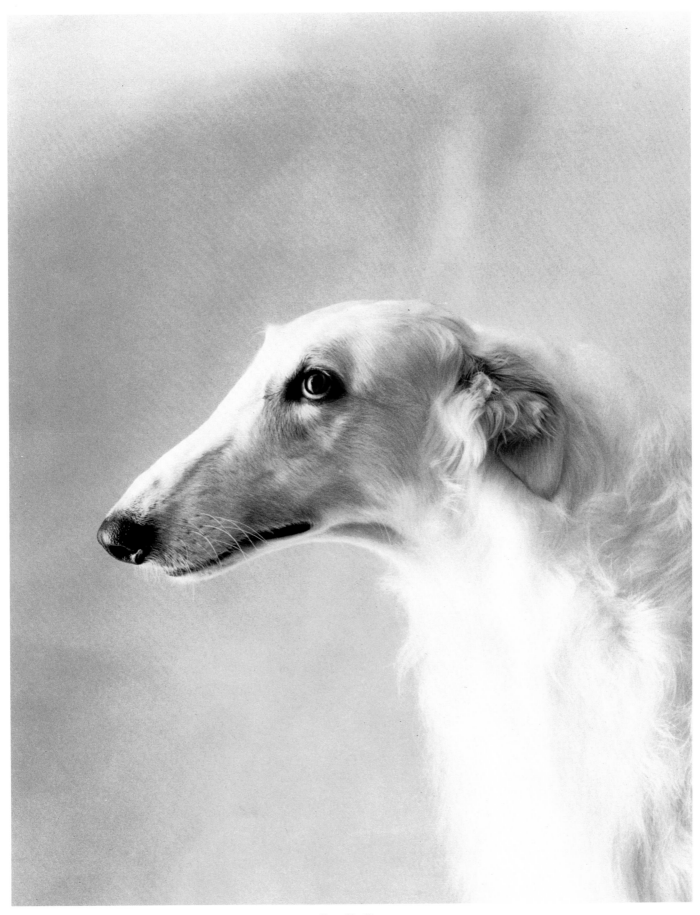

Alen MacWeeney

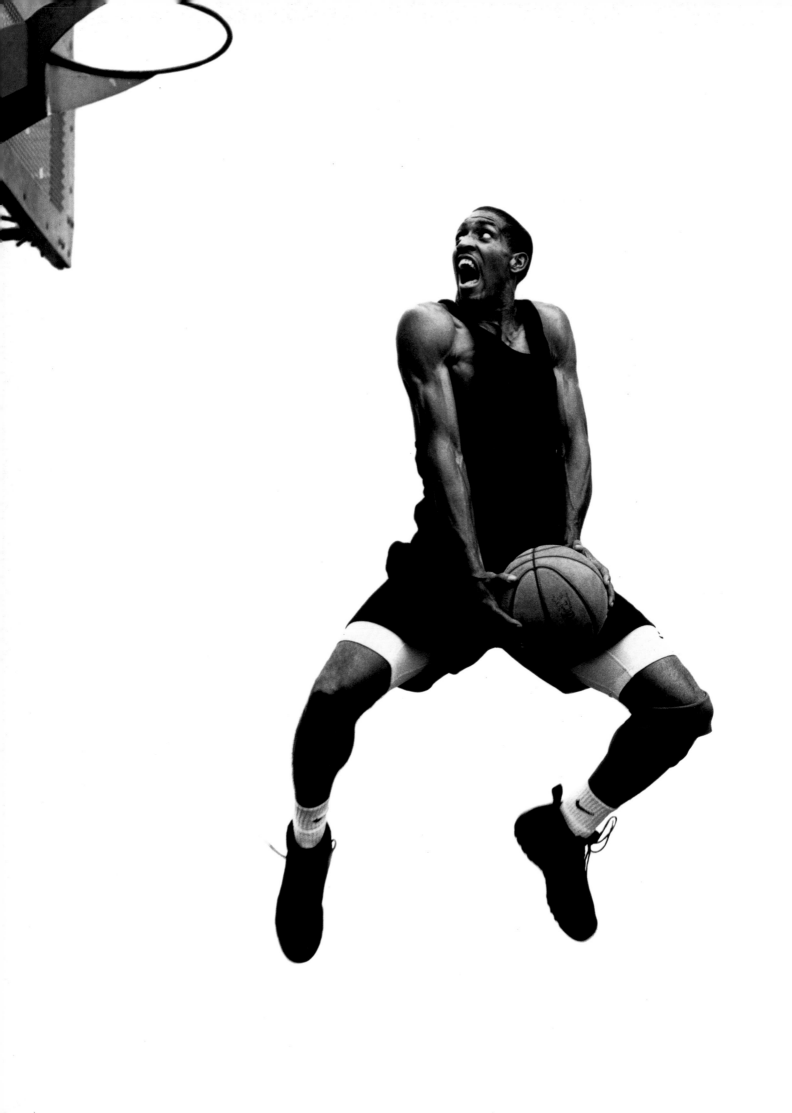

SPORTS

SPORT

SPORT

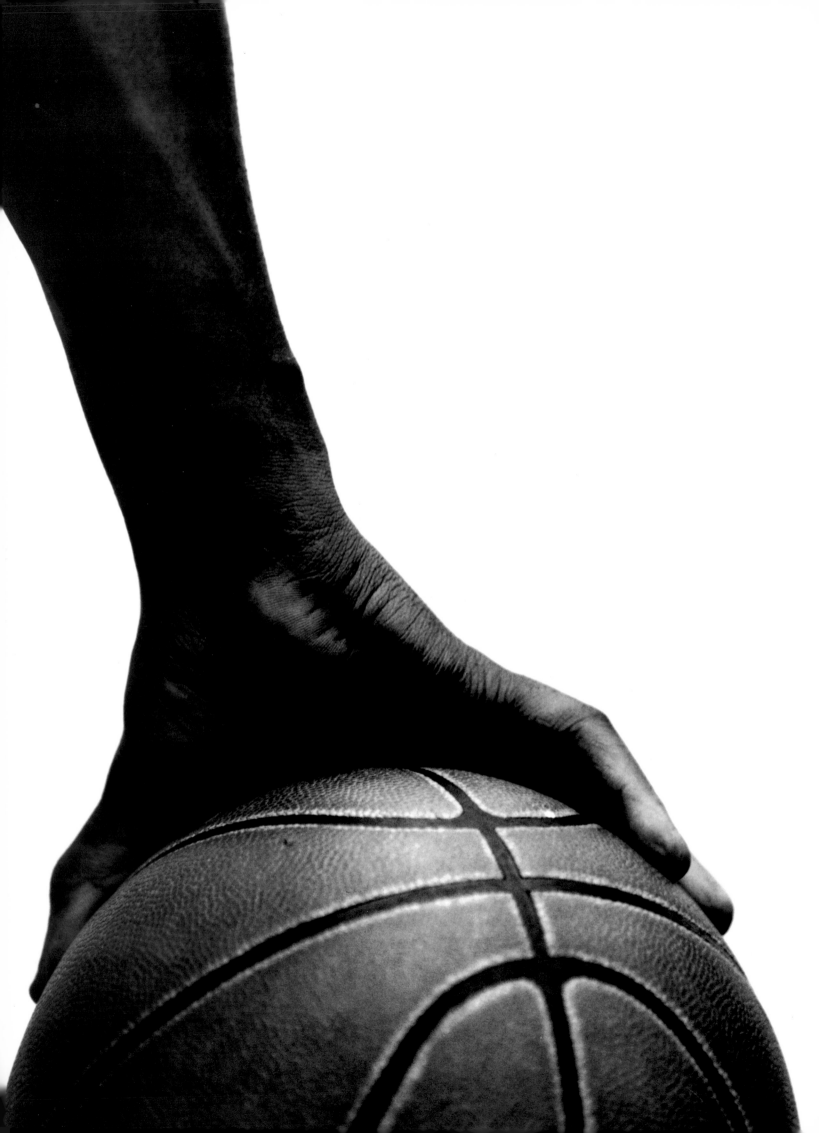

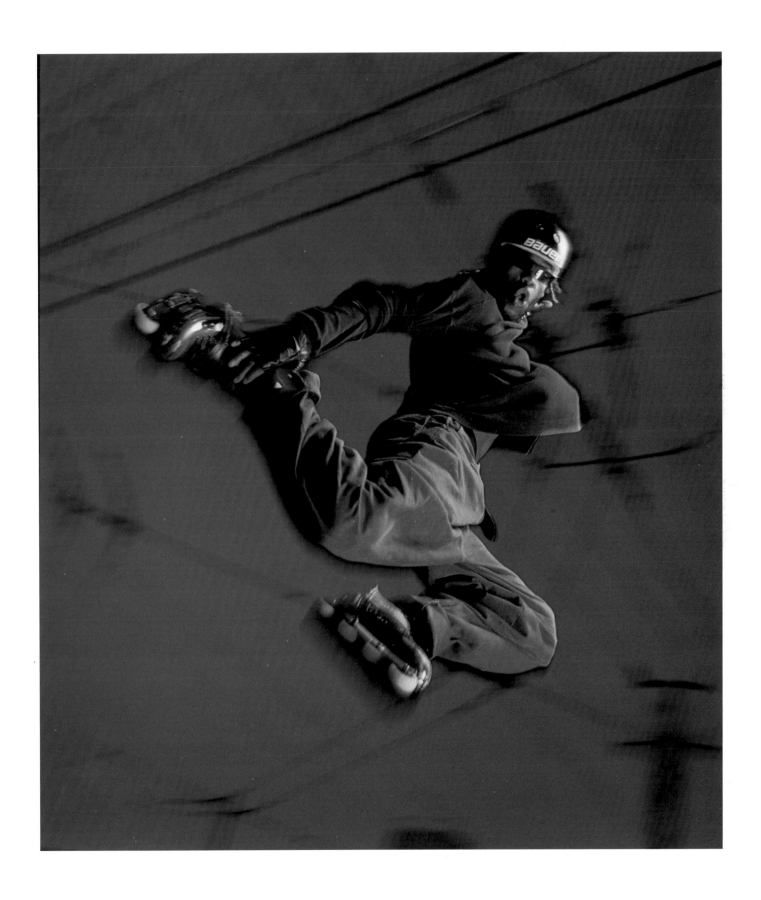

Above: Jim Erickson
Preceding Spread and Opposite: John Huet

Monica Stevenson

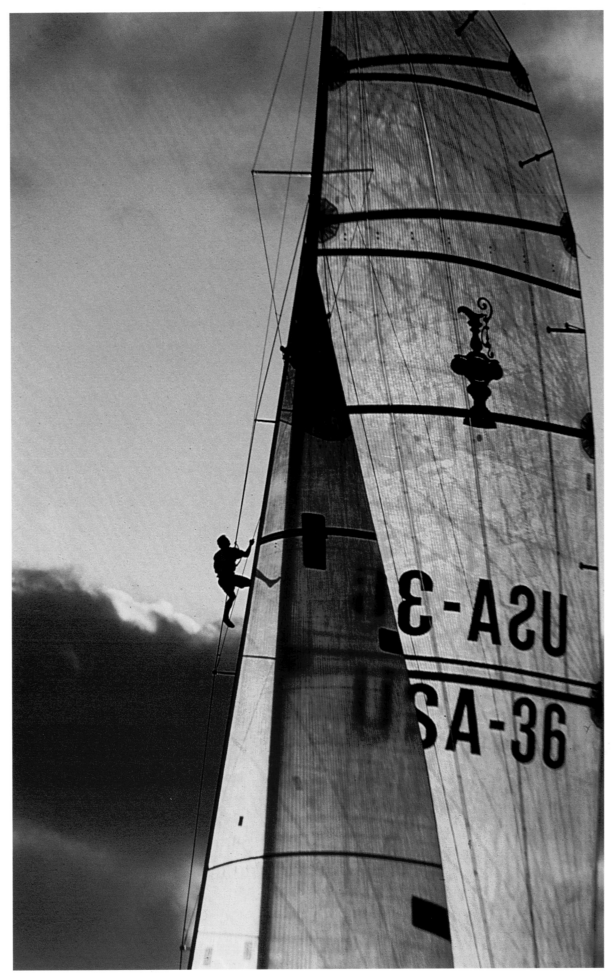

Matthew Atanian

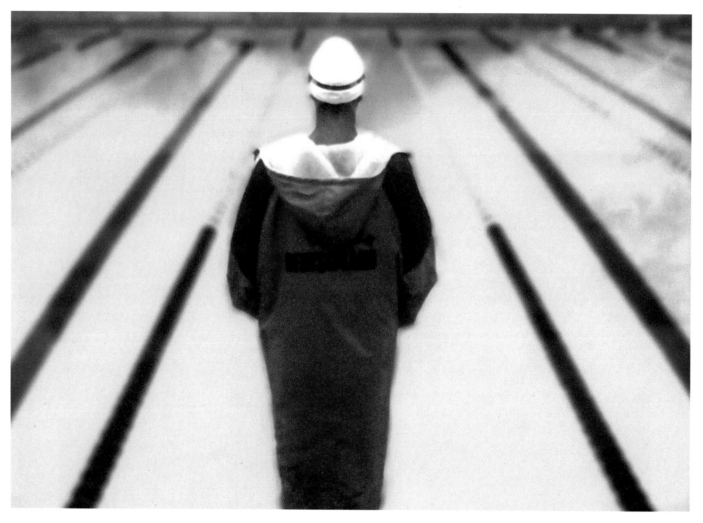

John Huet
BEST OF CATEGORY

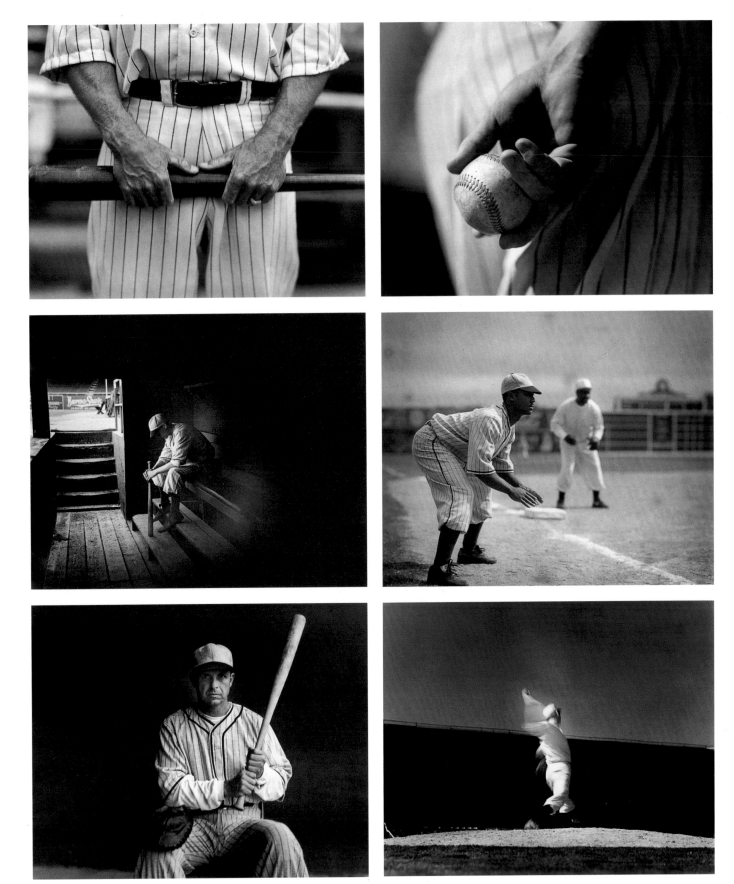

John Huet

PAGE 2 PHOTOGRAPHER: *Kathryn Kleinman* CLIENT: *Chronicle Books* CAMERA: *Nikon F3, Sinar 4X5"* FILM: *Scotch 1000, Fuji 100* ART DIRECTOR: *Kathryn Kleinman* DESIGNER: *Jacqueline Jones Design* COUNTRY: *USA* ■ *Images from the book "Les Immortelles: Everlasting Blooms–the Beauty of Dried Flowers."* ● *Bilder aus dem Buch über getrocknete Blumen mit dem Titel «Les Immortelles: Everlasting Blooms–the Beauty of Dried Flowers».* ▲ *Images extraites du livre «Les Immortelles: Everlasting Blooms–the Beauty of Dried Flowers».*

PAGE 4 PHOTOGRAPHER: *Terry Heffernan* CLIENT: *Spencer Stuart* CAMERA: *Sinar P 8x10* FILM: *Kodak Ektachrome 100* EXPOSURE: *5000 joules/f45* ART DIRECTOR: *Julie Klein* AGENCY: *Burson Marsteller*

PAGES 6-7 PHOTOGRAPHER: *Lizzie Himmel* PUBLISHER: *REDBOOK/Hearst* CAMERA: *Nikon* FILM: *Kodak Tri-X 135* EXPOSURE: *f5.6 ½/60 seconds* COUNTRY: *USA* ■ *Image published in REDBOOK.* ● *In der Zeitschrift REDBOOK veröffentlichte Aufnahme.* ▲ *Image publiée dans REDBOOK.*

PAGE 8 PHOTOGRAPHER: *Deborah Brackenbury* CAMERA: *Mamiya C330* FILM: *Kodak T-Max 400* EXPOSURE: *f11/ ½ second* ■ *This image is from a series entitled "Specimens," and refers to monkeys in outer space. The image was a multiple exposure, bleached, redeveloped and sepia-toned.* ● *Ein Photo aus einer Serie mit dem Titel «Prachtexemplare».* ▲ *Photo extraite d'une série intitulée «Spécimen» .*

PAGES 22, 24 PHOTOGRAPHER: *Man* CAMERA: *Pentax 645* FILM: *Kodak Tri-X* ART DIRECTOR: *Man* STYLIST: *Man* COUNTRY: *USA* ■ *Images from a self-promotional series of models in action. The images reflect movement while retaining strong graphic edges around the subjects. This series was created to portray fashion in a spontaneous manner.* ● *Als Eigenwerbung verwendete Aufnahmen von Mannequins in Aktion. Als Kontrast zur Bewegung in diesen Aufnahmen wurden starke graphische Akzente gesetzt.* ▲ *Extraits d'une série autopromotionnelle illustrant des mannequins au cœur de l'action. L'impression de mouvement rendue sur les photos contraste avec le graphisme marqué entourant les sujets. L'objectif était de présenter la mode de façon spontanée.*

PAGES 25-27 PHOTOGRAPHER: *Annie Leibovitz* REPRESENTATIVE: *Contact Press* CLIENT: *Neiman Marcus for HARPER'S BAZAAR* ART DIRECTOR: *Georgia Christensen* COUNTRY: *USA* ■ *Images of Jennifer Jason Leigh for "The Art of Fashion," published in HARPER'S BAZAAR.* ● *Aufnahmen von Jennifer Jason Leigh für «The Art of Fashion» vorgestellt in HARPER'S BAZAAR.* ▲ *Photos de Jennifer Jason Leigh pour «The Art of Fashion» publiée dans HARPER'S BAZAAR.*

PAGES 28-29 PHOTOGRAPHER: *Sheila Metzner* PUBLISHER: *MIRABELLA* CAMERA: *Canon 35mm* FILM: *Agfa 1000* ART DIRECTOR: *Sam Shahid* AGENCY: *Shahid & Company* COUNTRY: *USA* ■ *Images published in MIRABELLA.* ● *In der Zeitschrift MIRABELLA veröffentlichte Aufnahme.* ▲ *Image publiée dans MIRABELLA.*

PAGES 30-31 PHOTOGRAPHER: *Rodney Smith* CLIENT: *ULTA 3* CAMERA: *Hasselblad* FILM: *Kodak Plus-X, Tri-X* ART DIRECTOR: *April Norman* AGENCY: *Hal Riney & Partners* COUNTRY: *USA* ■ *"Compact" and "Inges." Two images for ULTA 3, a retail chain specializing in beauty products.* ● *«Compact» und «Inges», zwei Aufnahmen für ULTA 3, eine Kosmetik-Ladenkette.* ▲ *«Compact» et «Inges», deux photos pour ULTA 3, chaîne de magasins spécialisée dans les produits cosmétiques.*

PAGE 32 PHOTOGRAPHER: *Helmut Newton* REPRESENTATIVE: *tdr Tutti i diritti riservati* PUBLISHER: *VOGUE/The Condé Nast Publications Inc.* COUNTRY: *USA* ■ *Image from "The Body Suits," a fashion feature in American VOGUE.* ● *«The Body Suits» waren Thema eines Modebeitrags in der amerikanischen VOGUE.* ▲ *«The Body Suits». Série de photos publiée dans l'édition américaine de VOGUE.*

PAGE 33 PHOTOGRAPHER: *Helmut Newton* REPRESENTATIVE: *tdr Tutti i diritti riservati* PUBLISHER: *VOGUE/The Condé Nast Publications Inc.* COUNTRY: *USA* ■ *The sex appeal of high heel shoes is the theme in these photographs for "High and Mighty," a fashion feature in American VOGUE.* ● *«Hoch und mächtig», der Sex-Appeal hochhackiger Schuhe steht im Mittelpunkt dieser Aufnahmen für einen Modebeitrag in der amerikanischen VOGUE.* ▲ *«Hauts et puissants». Le sex appeal des talons hauts, un sujet chaud paru dans les pages mode de l'édition américaine de VOGUE.*

PAGE 34 PHOTOGRAPHER: *Helmut Newton* REPRESENTATIVE: *tdr Tutti i diritti riservati* PUBLISHER: *VOGUE/The Condé Nast Publications Inc.* COUNTRY: *USA* ■ *Image from "The Body Suits," a fashion feature in American VOGUE.* ● *«The Body Suits» waren Thema eines Modebeitrags in der amerikanischen VOGUE.* ▲ *«The Body Suits». Série de photos publiée dans l'édition américaine de VOGUE.*

PAGE 35 PHOTOGRAPHER: *Helmut Newton* REPRESENTATIVE: *tdr Tutti i diritti riservati* PUBLISHER: *VOGUE/The Condé Nast Publications Inc.* COUNTRY: *USA* ■ *The sex appeal of high heel shoes is the theme in these photographs for "High and Mighty," a fashion feature in American VOGUE.* ● *«Hoch und mächtig», der Sex-Appeal hochhackiger Schuhe steht im Mittelpunkt dieser Aufnahmen für einen Modebeitrag in der amerikanischen VOGUE.* ▲ *«Hauts et puissants». Le sex appeal des talons hauts, un sujet chaud paru dans les pages mode de l'édition américaine de VOGUE.*

PAGE 36 PHOTOGRAPHER: *TC Reiner* REPRESENTATIVE: *Hamilton Gray* PUBLISHER: *Landmark Calendars* CAMERA: *Hasselblad 2003 FCW* FILM: *Kodak VPS* COUNTRY: *USA* ■ *Image for a calendar inspired by the artist Alberto Vargas.* ● *Aufnahme für einen von dem Illustrator Alberto Vargas inspirierten Kalender.* ▲ *Image pour un calendrier inspirée de l'artiste Alberto Vargas.*

PAGE 37 PHOTOGRAPHER: *Lizzie Himmel* CLIENT: *SELF/Condé Nast* CAMERA: *Nikon* FILM: *EPR* EXPOSURE: *F8.5/60 seconds* COUNTRY: *USA* ■ *Image published in SELF.* ● *In der Zeitschrift SELF veröffentlichte Aufnahme.* ▲ *Image publiée dans SELF.*

PAGES 38-39 PHOTOGRAPHER: *Geof Kern* REPRESENTATIVE: *Hannah Wallace* CLIENT/PUBLISHER: *Neiman Marcus for HARPER'S BAZAAR* CAMERA: *Mamiya RZ 67* FILM: *Kodak EPZ* ART DIRECTOR: *Georgia Christensen* ART DIRECTOR: *Peggy Bennett* COUNTRY: *USA* ■ *Six images from "The Art of Fashion," Fall Collection 1995, a 29-page advertising portfolio for Neiman Marcus. A sequential narrative tells the story of a girl who falls asleep, dreaming of one day becoming a famous fashion model. She flies from her bedroom window and lands in the morning at an affluent estate. She becomes a famous woman, and in each frame she wears a different outfit. The dream becomes a nightmare, as the fame becomes consuming and dehumanizing. The images were shot in the county of Devon, England. For the images in which the model is flying, she was elevated by a crane and a thin tungsten wire.* ● *Sechs Bilder aus «The Art of Fashion», ein 29 Seiten starker Katalog mit der Herbstkollektion von Neiman Marcus. Erzählt wird die Geschichte eines jungen Mädchens, das davon träumt, ein berühmtes Modell zu werden. Es fliegt aus seinem Schlafzimmerfenster und landet am Morgen auf einem stattlichen Anwesen. Das Mädchen wird eine berühmte Frau und trägt auf jedem Bild andere Kleider. Der Traum wird zum Albtraum, als der Ruhm beginnt sie zu verzehren und unmenschlich zu werden. Die Bilder entstanden in Devon, England. Bei den Aufnahmen, in denen das Modell fliegt, war es mit einem feinen Kunststoffdraht an einem Kran befestigt.* ▲ *Six images extraites de «The Art of Fashion», un catalogue de 29 pages présentant la collection automne 1995 de Neiman Marcus. Séquences narratives sur l'histoire d'une jeune fille endormie qui rêve de devenir un top model. Elle s'envole à travers la fenêtre de sa chambre à coucher et, le lendemain matin, elle atterrit sur une propriété publique. Devenue une femme célèbre, elle peut se permettre de porter des vêtements différents sur chaque nouvelle image. Le rêve se transforme en cauchemar dès lors que la célébrité commence à la ronger, à la consumer, la rendant inhumaine. Images prises dans le Devon, Angleterre. Photos avec mannequin «volant»: cette charmante créature a été élevée dans les airs grâce à une grue et une fine roue de tungstène.*

PAGES 40-41 PHOTOGRAPHER: *Jeanloup Sieff* PUBLISHER: *ELLE/Hachette Magazines Inc.* CAMERAS: *Nikon, Leica* ART DIRECTOR: *Régis Pagniez* COUNTRY: *USA* ■ *Gianfranco Ferré's spring couture collection for Christian Dior, based on the the close-fitting, racy, upholstered shapes of the 1950s.* ● *Gianfranco Ferrés Frühjahrskollektion für Christian Dior, ein offensichtlicher Flirt mit den eng anliegenden, rassig ausstaffierten Formen der fünfziger Jahre.* ▲ *La collection haute couture printemps griffée Gianfranco Ferré pour Chirstian Dior. Audacieux, un corps à corps avec les formes moulantes et racées des années 50.*

PAGE 42 PHOTOGRAPHER: *Piero Gemelli* REPRESENTATIVE: *Aforisma* PUBLISHER: *VOGUE Italia/Edizioni Condé Nast S.p.A.* CAMERA: *Sinar P 8x10"* FILM: *Kodak EPP 100*

EXPOSURE: *F 64 Creative Director: Piero Gemelli* COUNTRY: *Italy* ■ *"Elegance in technicolor."* For this image in Italian VOGUE , the photographer used a very strong direct flash and a contrasting background. ● *«Eleganz in Techni-Color.»* Um der farbenfrohen Schuhkollektion gerecht zu werden, arbeitete der Photograph mit sehr starkem, direktem Blitzlicht und farblich kontrastierendem Hintergrund. ▲ *«Elegance en technicolor».* Pour rendre l'esprit de cette collection de chaussures haute en couleurs, le photographe a utilisé un flash direct très puissant et un fond offrant un grand contraste.

PAGE 43 PHOTOGRAPHER: *Albert Watson* REPRESENTATIVE: *Elizabeth Watson* PUBLISHER: *VOGUE/The Condé Nast Publications Inc.* CAMERA: *Horseman* EXPOSURE: *F16* ■ *Image published in Italian VOGUE.* ● *In der Zeitschrift VOGUE veröffentlichte Aufnahme.* ▲ *Image publiée dans VOGUE.*

PAGE 44 PHOTOGRAPHER: *Nick Knight* REPRESENTATIVE: *Charlotte Wheeler* PUBLISHER: *VOGUE/The Condé Nast Publications Inc.* CAMERA: *Mamiya RZ* ART DIRECTOR: *Charles Churchyard* DESIGNER: *Anna Molinari* COUNTRY: *USA* ■ *"Cut to pieces," photograph for a fashion feature in American VOGUE.* ● *«In Stücke geschnitten», Aufnahme für einen Modebeitrag in der amerikanischen VOGUE.* ▲ *«Découpés en morceaux», photo de mode publiée dans l'édition américaine de VOGUE.*

PAGE 45 PHOTOGRAPHER: *Richard Avedon* CLIENT: *Gianni Versace* CAMERA: *Hasselblad 80mm* FILM: *Kodak Plus-X* EXPOSURE: *F16/ ¹⁄₆₀ second* ART DIRECTOR: *Ruth Ansel* DESIGNER: *Gianni Versace* COUNTRY: *USA/Italy* ■ *"Two Tall Women," featuring Nadja Auermann and Kristen McMenamy taken for Versace Atelier. ©1995 Richard Avedon* ● *Die Mannequins Nadja Auermann und Kristen McMenamy, aufgenommen für Versace Atelier. ©1995 Richard Avedon* ▲ *«Two Tall Women». Nadja Auermann et Kristen McMenamy pour Versace Atelier. ©1995 Richard Avedon*

PAGES 46-47 PHOTOGRAPHER: *Nick Knight* REPRESENTATIVE: *Charlotte Wheeler* PUBLISHER: *VOGUE/The Condé Nast Publications Inc.* CAMERA: *Sinar P2 8x10"* ART DIRECTOR: *Raul Martinez* COUNTRY: *USA* ■ *Images from "The Body is Back," a feature on fashion that defines and flatters the body published in American VOGUE.* ● *«Der Körper ist wieder da», schmeichelnde, figurbetonte Mode, vorgestellt in der amerikanischen VOGUE.* ▲ *«Le Corps est de retour», lignes sculpturales et flatteuses pour une mode à fleur de peau. Photo publiée dans l'édition américaine de VOGUE.*

PAGES 48-49 PHOTOGRAPHER: *Raymond Meier* PUBLISHER: *HARPER'S BAZAAR* ART DIRECTOR: *Johan Svensson* COUNTRY: *USA* ■ *"Eight Black Bags Five Times," and "Three Mules," published in HARPER'S BAZAAR.* ● *«Fünf Mal acht schwarze Säcke» und «Drei Maultiere», Aufnahmen aus HARPER'S BAZAAR.* ▲ *«Cinq fois huit sacs noir» et «Trois mules», photos publiées dans HARPER'S BAZAAR.*

PAGE 50 PHOTOGRAPHER: *Daniel Proctor* REPRESENTATIVE: *Danielle Melanson* CAMERA: *Leica* FILM: *Kodak Tri-X* COUNTRY: *USA* ■ *Images from an uncommissioned self-assignment taken at a ball sponsored by the Art Deco Society of San Francisco and held at the Paramount Theater in Oakland, California. The prints were chemically toned in the darkroom.* ● *Freie Aufnahmen des Photographen, die bei einem von der Art Deco Society, San Francisco, veranstalteten Ball im Paramount Theater in Oakland, Kalifornien, entstanden sind. Die Abzüge wurden in der Dunkelkammer im chemischen Verfahren getont.* ▲ *Photos personnelles du photographe prises lors d'un ball parrainé par la Art Deco Society de San Francisco qui s'est déroulé au Paramount Theater à Oakland, Californie. Epreuves virées dans la chambre noire.*

PAGE 51 PHOTOGRAPHER: *Herb Ritts* REPRESENTATIVE: *Visages* PUBLISHER: *VOGUE* COUNTRY: *USA* ■ *Image of Nadja Auermann published in VOGUE.* ● *Nadja Auermann, für VOGUE Photographiert.* ▲ *Photo de Nadja Auermann publiée dans VOGUE.*

PAGES 52-53 PHOTOGRAPHER: *Gilles Bensimon* REPRESENTATIVE: *Jean Gabriel Kauss* PUBLISHER: *ELLE* ■ *Images of Isabella Rosselini published for a feature in ELLE.* ● *Aufnahmen von Isabella Rosselini vorgestellt in ELLE.* ▲ *Photos de Isabella Rosselini publiées dans ELLE.*

PAGE 54 TOP RIGHT, BOTTOM LEFT PHOTOGRAPHER: *Paolo Roversi* REPRESENTATIVE: *Marion de Beaupré* PUBLISHER: *THE NEW YORK TIMES MAGAZINE* COUNTRY: *USA* ■ *"Decolletage*

worthy of a Gainsborough." These "Portraits of a neckline" appeared in THE NEW YORK TIMES MAGAZINE. ● *«Decolletés, die einem Gainsborough Ehre machen würden.»* Diese Porträts gehören zu einem Modebeitrag im NEW YORK TIMES MAGAZINE. ▲ *«Des décolletés dignes d'un Gainsborough».* Portraits publiés dans la rubrique mode du NEW YORK TIMES MAGAZINE.

PAGE 54 TOP LEFT, BOTTOM RIGHT, PAGE 55 PHOTOGRAPHER: *Paolo Roversi* REPRESENTATIVE: *Marion de Beaupré* PUBLISHER: *British VOGUE/Condé Nast Publications* COUNTRY: *Great Britain* ■ *Images from "Wild and Wonderful," a feature in British VOGUE.* ● *Diese Bilder gehören zu einem Modebeitrag in der britischen VOGUE, mit dem Titel «Wild und wundervoll». Vorgestellt wird klassischer Chic, der schönes, exzentrisches Beiwerk zulässt.* ▲ *Photos de mode publiées dans l'édition anglaise de VOGUE sous le titre «Sauvage et sublime». Les classiques jouent la carte de l'excentricité.*

PAGE 56 PHOTOGRAPHER: *Andrej Glusgold* REPRESENTATIVE: *Carmen Winterberg* PUBLISHER: *Sybille* CAMERA: *Nikon F3* FILM: *Kodak T-Max 400* ART DIRECTOR: *Andrej Glusgold* COUNTRY: *Germany* ■ *Image for an underwear campaign photographed in a Berlin hotel. The image was printed on handmade photo paper.* ● *Diese Dessous-Aufnahmen entstanden in einem berliner Hotel «Askanischer Hof». Die Bilder wurden vom Photographen auf selbsthergestelltem Photopapier abgezogen.* ▲ *Ces photos de lingerie prises dans un hôtel berlinois ont été tirées sur du papier photo mis au point par le photographe.*

PAGE 57, TOP PHOTOGRAPHER: *Frank Herboldt* REPRESENTATIVE: *Horton Stephens* CAMERA: *Sinar 8x10"* FILM: *Kodak EPP* EXPOSURE: *F45/Flash* COUNTRY: *Great Britain* ■ *Artist Fiona Skine painted the background for this "Last Supper," inspired by the photographer's observations in a London restaurant. He saw a surprising number of women in designer clothes staring at each other cruelly, checking who had the most up-to-date outfit and who was slimmest.* ● *Die Künstlerin Fiona Skine malte den Hintergrund für dieses «Abendmahl». Inspiration für den Photographen war eine Beobachtung in einem Londoner Restaurant, in dem überraschend viele Frauen in Designer-Kleidern sassen, die sich kalt musterten, um festzustellen, wer die neusten Kleider trug und am dünnsten war.* ▲ *L'artiste Fiona Skine a peint le fond de ce «dernier repas». Le photographe a trouvé son inspiration dans un restaurant londonien; il s'étonna de voir tant de femmes porter des vêtements couture, se dévisager de pied en cap, l'œil perçant et cruel, pour savoir laquelle d'entre elles avait le modèle dernier cri et la taille la plus fine.*

PAGE 57, BOTTOM PHOTOGRAPHER: *Frank Herboldt* REPRESENTATIVE: *Horton Stephens* CAMERA: *Sinar 8x10"* FILM: *Kodak EPP* EXPOSURE: *F45/Flash* COUNTRY: *Great Britain* ■ *This personal project was inspired by the illustrator Vargas, whose work is considered sexy, but also innocent and fun. Makeup artist Anne Marie Lepretre painted the shorts onto the model and a piece of cloth was attached with tape. The image was retouched on the computer by Alchemy Retouchers.* ● *Diese persönliche Studie wurde von den Arbeiten des Illustrators Vargas inspiriert, die zwar sehr sexy, aber gleichzeitig unschuldig und lustig sind. Die Make-up-Spezialistin Anne Marie Lepretre malte die Shorts auf das Modell, und fügte ein Stück Stoff hinzu, das mit Klebstreifen befestigt wurde. Das Bild wurde im Computer von Alchemy Retouchers fertiggestellt.* ▲ *Cette étude personnelle s'inspire de Vargas, dont les dessins sexy n'excluent pas une touche d'innocence et d'humour. L'artiste-maquilleuse Anne Marie Lepretre a peint les shorts directement sur le modèle, lesquels sont «retenus» par un morceau de tissu fixé avec du ruban adhésif. Les dernières retouches ont été apportées sur ordinateur par Alchemy Retouchers.*

PAGES 58-59 PHOTOGRAPHER: *Nick Knight* REPRESENTATIVE: *Charlotte Wheeler* PUBLISHER: *British VOGUE/The Condé Nast Publications Inc.* CAMERA: *Nikon F2* ART DIRECTOR: *Robin Derrick* DESIGNERS: *Missie Graves, Graham Hughes* COUNTRY: *Great Britain* ■ *"Sweet Dreams,"photographs for a fashion feature in British VOGUE.* *«Süsse Träume», Aufnahmen für einen Modebeitrag in der britischen VOGUE.* *«Doux Rêves», photos de mode publiées dans l'édition anglaise de VOGUE.*

PAGE 60 PHOTOGRAPHER: *Simon Norfolk* CAMERA: *Mamiya 6* COUNTRY: *Great Britain*

PAGE 62 PHOTOGRAPHER: *Pierre Adenis* REPRESENTATIVE: *GAFF Fotoagentur* PUBLISHER: *FOCUS* CAMERA: *Nikon F 801s* FILM: *Fuji RD 100* EXPOSURE: *¹⁄₆₀* COUNTRY: *Germany*

PAGE 63 PHOTOGRAPHER: *Christopher Thomas* REPRESENTATIVE: *Dagmar Staudenmaier* CAMERA: *Nikon F4* FILM: *Ilford Delta 100/400* COUNTRY: *Germany*

PAGE 64 PHOTOGRAPHER: *Juan Ignacio Delgado Santamaria* CAMERA: *Canon F-1* FILM: *Kodak T-Max 3200* EXPOSURE: *F8/ ¹⁄₅₀₀ second* ART DIRECTOR/DESIGNER: *Juan Ignacio Delgado Santamaria* COUNTRY: *Spain*

PAGE 65 PHOTOGRAPHER: *Ron Haviv* REPRESENTATIVE: *Saba Press Photos* PUBLISHER: *TIME* CAMERA: *Canon EOS* FILM: *Fujichrome RDP* ART DIRECTORS: *Hillary Raskin, Robert Stevens* COUNTRY: *USA*

PAGES 66-67 PHOTOGRAPHER: *Simon Norfolk* CAMERA: *Mamiya 6* COUNTRY: *Great Britain*

PAGES 68-69 PHOTOGRAPHER: *Christopher L. Morris* CAMERA: *Hasselblad Classic* FILM: *Kodak T-Max 100* COUNTRY: *USA*

PAGES 70, 72 PHOTOGRAPHER: *David Sacks* CAMERA: *Horseman 4X5"* FILM: *Kodak EPP* EXPOSURE: *F5.6/ ½ second.* ART DIRECTOR: *Heather Church* AGENCY: *Gotham Group* COUNTRY: *USA* ■ *The photographer, who initially had a tremendous fear of insects, was significantly less scared of the creatures after the weeklong production of these photographs. He used a combination of strobe and tungsten lighting on white plexiglass. The film was pushed in processing to increase contrast.* ● *Der Photograph photographierte diese Insekten während einer Woche und verlor dabei seine ursprünglich panische Angst vor den kleinen Bestien. Er verwendete eine Kombination von Strobe- und künstlichem Licht auf weissem Plexiglas. Der Film wurde gepuscht, um den Kontrast zu verstärken.* ▲ *Le photographe qui, à l'origine, avait une peur bleue des insectes était beaucoup moins effrayé par ces petites bestioles après les avoir eues dans le viseur pendant une semaine. Il a combiné éclairage stroboscopique et lumière artificielle sur du plexiglas blanc. Le film a été poussé durant le développement pour renforcer le contraste.*

PAGE 73 PHOTOGRAPHER: *Craig Cutler* REPRESENTATIVE: *Marzena* CAMERA: *Toyo 4X5* FILM: *Fuji* PROP STYLIST: *Anita Calero* COUNTRY: *USA* ■ *Images from a personal study of common objects. The goal was to photograph everyday items in order to reveal otherwise unnoticed texture, shape, and form. The purpose of the black background was to strip away any semblance of an environment so as to concentrate on the objects themselves.* ● *Persönliche Studien alltäglicher Dinge. Das Ziel war, ihre oft übersehenen Oberflächenstrukturen und Formen zu zeigen. Um nicht von den Gegenständen abzulenken, wurde auf jegliches Beiwerk verzichtet. Verstärkt wurde die Wirkung der Objekte durch den schwarzen Hintergrund.* ▲ *Etude personnelle. L'objectif était de photographier des objets de tous les jours pour révéler leur texture et leur forme souvent ignorées. Pour éviter toute ressemblance avec un environnement et mettre l'accent sur les objets uniquement, le photographe a opté pour un fond noir.*

PAGES 74-75 PHOTOGRAPHER: *Colin Faulkner* CLIENT: *Unisource Canada Inc./Domtar Fine Papers* CAMERA: *Mamiya 645* FILM: *Agfa APX 25* ART DIRECTOR: *Glenda Rissman, Peter Scott* AGENCY: *Q30 Design* COUNTRY: *Canada* ■ *For this promotional project for a paper company, the photographer wanted to give the images an illustrative feel. He matched materials to their background and photographed them flat-on in order to create a two-dimensional feeling. When printing, he selectively bleached around the shapes in the images to enhance the effect.* ● *Die für die Promotion eines Papierherstellers bestimmten Aufnahmen sollten wie Illustrationen wirken. Der Photograph stimmte alles auf den Hintergrund ab und photographierte ohne Tiefenschärfe, um die gewünschte zweidimensionale Wirkung zu erzielen. Beim Abziehen der Bilder hellte er einige Konturen noch auf.* ▲ *Pour cette promotion d'un fabricant de papier, le photographe voulait que ses images aient un peu l'aspect d'illustrations. Il a assorti les matériaux au fond et a photographié sans profondeur de champ pour donner cette impression d'un espace bidimensionnel. Au tirage, il a renforcé cet effet en blanchissant certains contours.*

PAGE 76 PHOTOGRAPHER: *Joseph Keller* CAMERA: *Nikon FM2* FILM: *Fuji Velvia* COUNTRY: *USA* ■ *This image is from a personal series for which the goal was to depict humanistic relationships in pairs of objects.* ● *Aufnahme aus einer Reihe persönlicher Studien, deren Thema menschliche Beziehungen sind, ausdrückt anhand von paarweise gezeigten Objekten.* ▲ *Série de photos personnelles. L'objectif était de mettre en scène les relations humaines en les transposant dans des paires d'objets.*

PAGE 77 PHOTOGRAPHER: *Deborah Brackenbury* CAMERA: *Canon F-1* FILM: *Fuji HG 400* COUNTRY: *USA* ■ *"Dignity," from a series entitled "Specimen." This image is of a Great Blue Heron in the process of taxidermy. The feathers are wrapped while drying to hold them in place.* ● *«Würde», ein Photo aus einer Serie mit dem Titel «Prachtexemplare». Gezeigt ist ein Reiher beim Präparator. Die Federn werden beim Trocknen umwickelt, damit sie nicht verrutschen.* ▲ *«Dignité», photo extraite d'une série intitulée «Spécimen» montrant un héron soumis au processus de taxidermie. Ses plumes sont enveloppées pour qu'elles restent immobiles durant le séchage.*

PAGE 78 PHOTOGRAPHER: *Markku Lahdesmaki* REPRESENTATIVE: *Ellen Knable & Associates* CLIENT: *Nintendo* CAMERA: *Sinar* FILM: *Polaroid* ART DIRECTOR: *Camble Templeton* AGENCY: *Bowes Dentsu & Partners* COUNTRY: *USA* ■ *This is the second image from a Nintendo campaign in which the first image was a foot approaching the bug. The campaign sought to visually portray the idea of a 'smashing' new product.* ● *Das zweite Bild aus einer Nintendo-Kampagne – das erste zeigte einen Fuss, der sich dem Käfer näherte. Es geht dabei um ein «umwerfendes» neues Produkt, bzw. um das englische Wort «smashing» (zertreten, zerstören), mit dem auch ein solches Produkt bezeichnet wird.* ▲ *Deuxième visuel d'une campagne Nintendo; le premier montrait un pied s'approchant d'un coléoptère. La campagne cherchait à traduire l'idée d'un nouveau produit «fracassant», en anglais «smashing» (écraser, détruire), également utilisé pour désigner un produit exceptionnel, hors pair.*

PAGE 79 PHOTOGRAPHER: *Kenro Izu* REPRESENTATIVE: *Jean Conlon* CLIENT: *Asprey* CAMERA: *Deardof 14X20"* FILM: *Kodak Plus-X* EXPOSURE: *F64* COUNTRY: *USA* ■ *"Asprey Sunflowers."* ● *Sonnenblumen.* ▲ *«Tournesols Asprey».*

PAGE 80 PHOTOGRAPHER: *Hans Neleman* REPRESENTATIVE: *Bernstein & Andriulli* CAMERA: *Sinar P 8X10"* FILM: *Fuji* COUNTRY: *USA* ■ *Still life of pressed, dried flowers from the 1850s.* ● *Stilleben mit getrockneten und gepressten Blumen von ca. 1850.* ▲ *Nature morte aux fleurs séchées et pressées, datant des années 1850.*

PAGE 81 PHOTOGRAPHER: *Paolo Marchesi* CAMERA: *Horseman 4X5"* FILM: *Kodak T-Max 100* EXPOSURE: *F22/ ¹⁄₁₂₅ second* COUNTRY: *USA* ■ *For this self-promotion, the fish were photographed on white backgrounds using 4X5" black and white film. After processing the film, the photographer exposed 3M color key film, sandwiched with the negatives. This resulted in a series of color key negatives of the original image. Finally, the black and white negative was printed in conjunction with the color keys on RA4 color paper.* ● *Der Photograph nahm die Fische vor weissem Hintergrund mit einem 4x5" Schwarzweissfilm auf. Nachdem der Film entwickelt war, belichtete er einen 3M Color Key Film im Sandwich mit den Negativen der Originalaufnahme. Das ergab eine Reihe von Color Key Negativen des ursprünglichen Photos. Dann wurde das Schwarzweiss-Negativ zusammen mit den Color Keys auf Farbpapier RA4 übertragen.* ▲ *Pour cette image servant à sa promotion personnelle, le photographe a utilisé un fond blanc et un film n&b 4X5". Une fois le film développé, il a exposé du film color key 3M, pris en sandwich avec les négatifs de la photo originale. Le résultat est une série de négatifs color key de l'image originale. Finalement, le négatif n&b a été tiré avec les color keys sur du papier couleur RA4.*

PAGES 82-83 PHOTOGRAPHER: *Kathryn Kleinman* CLIENT: *Chronicle Books* CAMERA: *Nikon F3, Sinar 4X5"* FILM: *Scotch 1000, Fuji 100* ART DIRECTOR: *Kathryn Kleinman* DESIGNER: *Jacqueline Jones Design* COUNTRY: *USA* ■ *Images from the book "Les Immortelles: Everlasting Blooms–the Beauty of Dried Flowers."* ● *Bilder aus dem Buch über getrocknete Blumen mit dem Titel «Les Immortelles:Everlasting Blooms–the Beauty of Dried Flowers».* ▲ *Images extraites du livre «Les Immortelles: Everlasting Blooms–the Beauty of Dried Flowers».*

PAGES 84-85 PHOTOGRAPHER: *Andre Baranowski* CLIENT: *Golden Capricorn Publication* CAMERA: *Mamiya RZ 67* FILM: *Kodak Tri-X Pan* EXPOSURE: *F11/¹⁄₁₂₅ second, F11/ ¹⁄₆₀ second* ART DIRECTOR: *Andre Baranowski* COUNTRY: *USA* ■ *Through composition and lighting, the photographer sought to portray common objects found in any home in different dimensions and as objects of art.* ● *Durch die Komposition und Beleuchtung versuchte der Photograph Alltagsgegenstände in neuen Dimensionen und als Kunstobjekte zu zeigen.* ▲ *Par la composition et l'éclairage, le photographe a cherché à représenter des objets usuels comme des objets d'art, en leur donnant de nouvelles dimensions.*

PAGE 86 PHOTOGRAPHER: *Craig Cutler* REPRESENTATIVE: *Marzena* CAMERA: *Toyo* FILM: *Fuji* PROP STYLIST: *Anita Calero* COUNTRY: *USA* ■ *From a personal study of flowers created for self promotion, and eventually published in SELECT MAGAZINE. The photographer wanted to create images with a monochromatic, transparent quality, similar to that of architectural schematics or blueprints, in order to bring out the intricate shape of the flowers.* ● *Dieses Bild gehört zu einer Reihe freier Studien von Blumen. Dem Photographen ging es um eine monochromatische, transparente Qualität, ähnlich den für Baupläne verwendeten Blaupausen, um die vielfältigen Formen der Blumen zu betonen.* ▲ *Cette image fait partie d'une étude personnelle. Le photographe a voulu créer des images d'une transparence monochromatique similaire à celle des croquis ou des épreuves d'architecture afin de faire ressortir les formes complexes des fleurs.*

PAGE 87 PHOTOGRAPHER: *Imre Gabor Eck* CAMERA: *Linhof-Kardan Color 4x5"* FILM: *Fuji* EXPOSURE: *Flash* COUNTRY: *Hungary* ■ *Photograph from a series of still lifes with trash, using diffusion filters. The trumpet was from a Paris flea market; the frame was found in a second-hand store.* ● *Eines von mehreren Stilleben mit «Abfall». Diese Trompete, mit Weichzeichner aufgenommen, stammt von einem Pariser Flohmarkt, der Bilderrahmen aus einem Trödlerladen.* ▲ *Photo extraite d'une série de natures mortes composées de bric et de broc repêché en divers endroits. La trompette a été dénichée dans un marché aux puces à Paris, le cadre, dans une brocante.*

PAGE 88 PHOTOGRAPHER: *Lynn Sugarman* REPRESENTATIVE: *Brooke Davis* CAMERA: *Toyo View* FILM: *Kodak Plus-X* ART DIRECTOR: *Paula Scher* DESIGNER: *Paula Scher* AGENCY: *Pentagram* COUNTRY: *USA* ■ *"After the deer came" is part of a self-promotional book "After," illustrating what takes place after events happen.* ● *«Nachdem der Hirsch dagewesen war.» Die Aufnahme gehört zu einem Eigenwerbungskatalog mit dem Titel «After», in dem gezeigt wird, was nach einem Ereignis geschieht.* ▲ *«Après le passage du daim» est extrait d'«After», un livre pour la promotion personnelle du photographe axé sur les moments succédant à un événement.*

PAGE 89 PHOTOGRAPHER: *Hans Neleman* REPRESENTATIVE: *Bernstein & Andriulli* COUNTRY: *USA* ■ *"Bug in a Box."* ● *«Käfer in einer Schachtel.»* ▲ *«Coléoptère dans une boîte.»*

PAGE 90 PHOTOGRAPHER: *Paul Sanders* CAMERA: *Toyo 4X5"* FILM: *Kodak EPP* EXPOSURE: *F16/¼ second.* ART DIRECTOR: *Paul Sanders* COUNTRY: *USA* ■ *This image was shot in a single exposure without the use of a computer, although a non-traditonal method was used to create the background.* ● *Diese Aufnahme entstand mit einer einzigen Belichtung – ohne Computer –, wenn auch für den Hintergrund keine herkömmliche Methode verwendet wurde.* ▲ *Pas de recours à l'ordinateur et une seule exposition pour réaliser cette image, bien qu'une méthode non conventionnelle ait été utilisée pour le fond.*

PAGE 92 PHOTOGRAPHER: *Terry Heffernan* CLIENT: *Deloitte & Touche LLP* CAMERA: *Sinar P 8X10"* FILM: *Kodak Ektachrome 100* EXPOSURE: *F45/5000 joules* ART DIRECTOR: *Glen DiCicco* AGENCY: *Keiler & Company* COUNTRY: *USA* ■ *"Bulb." These images were commissioned for an anthology commemorating the one hundred year anniversary of an accounting firm.* ● *«Knolle». Diese Bilder entstanden für eine Anthologie zur Erinnerung an das 100jährige Bestehen einer Steuerberatungsfirma.* ▲ *«Bulbe». Ces images résultent d'une commande pour une anthologie commémorant le 100e anniversaire d'une société fiduciaire.*

PAGE 93 PHOTOGRAPHER: *Stephan Abry* PUBLISHER/CLIENT: *VIEW ON COLOUR/United Publishers S.A.* CAMERA: *Sinar P* FILM: *Fuji Velvia 4x5"* ART DIRECTOR: *Lidewij Edelkoort* AGENCY: *Studio Edelkoort* COUNTRY: *France* ■ *Taro Root, Lotus Root, Cameroonian Gourd, Turia Gourd. These images are from a feature in VIEW ON COLOUR magazine entitled "Vegetable Planet," focusing on the vegetables' textures, structures, shapes and colors.* ● *Taro-Wurzel, Lotus-Wurzel, 2 Flaschenkürbis-Arten. Diese Bilder gehören zu einem Beitrag in der Zeitschrift VIEW ON COLOUR, bei dem es um Oberflächen, Struktur, Formen und Farben geht.* ▲ *Racine de taro, racine de lotus, gourdes (espèces de courge). Photos publiées dans le magazine VIEW ON COLOUR sous le titre «La planète Légumes»; l'accent a été mis sur les surfaces, la structure, les formes et les couleurs.*

PAGE 94 PHOTOGRAPHER: *Eivind Lindberget* PUBLISHER: *Murdoch Books* CAMERA: *Canon*

EOS 5 FILM: *Fuji Provia 1600* ART DIRECTOR/STYLIST: *Eivind Lindberget* DESIGNER: *Juliet Cohen* COUNTRY: *Australia* ■ *The ambience for these images was created by using available light, filters, and fast film pushed two stops.* ● *Wärme, Reflexion und reife Früchte, Metaphern für den Herbst. Der Photograph erreichte die gewünschte Stimmung durch Nutzung des natürlichen Lichts, Filter und eines um zwei Blenden gestossenen Films.* ▲ *Tons chauds, introspection et fruits mûrs, une métaphore automnale. Le photographe a réussi à rendre cette atmosphère en travaillant à la lumière du jour et en utilisant des filtres et un film de haute sensibilité qui a été poussé de deux diaphragmes.*

PAGE 95 PHOTOGRAPHER: *Alan Blakely* REPRESENTATIVE: *Colelyn S. Blakely* CAMERA: *Sinar* FILM: *Fuji Provia 100* EXPOSURE: *F45/¹/₃₀ second* ART DIRECTOR: *Alan Blakely* COUNTRY: *USA* ■ *This image was created for an on-going direct mail campaign. The illusion of bright and clear morning light was created through carefully placed shadows and reflections.* ● *Diese Aufnahme war für eine Direct-Mail-Kampagne bestimmt. Die Illusion des hellen, klaren Morgenlichts wurde durch sorgfältig arrangierte Schatten und Reflexionen erreicht.* ▲ *Cette image a été conçue pour une campagne sous forme de publipostage. L'illusion d'une lumière matinale vive et claire fut créée grâce aux ombres et aux reflets soigneusement dirigés.*

PAGE 96 PHOTOGRAPHER: *Patrick Tregenza* CAMERA: *Sinar 4X5"* FILM: *Kodak LPP* COUNTRY: *USA* ■ *In still life food photography, household items such as clothespins, toothpicks, conduits, etc., are often used but always hidden. This series was meant to portray these items with the food in a sculptured way.* ● *Bei Stilleben werden Dinge wie Wäscheklammern, Zahnstocher, Leitungsrohre etc. oft verwendet und dabei immer versteckt. Bei dieser Serie ging es darum, sie zusammen mit den Nahrungsmitteln als skulpturale Einheit zu zeigen.* ▲ *Certains objets domestiques, tels les pinces à linge, les cure-dents ou les conduits, etc., sont souvent utilisés dans les natures mortes, mais ils sont toujours cachés. Cette série vise à les mettre en scène de façon sculpturale avec les aliments.*

PAGE 97 PHOTOGRAPHER: *Deborah Brackenbury* CAMERA: *Mamiya C330* FILM: *Kodak T-Max 400* COUNTRY: *USA* ■ *"Regal," from a series entitled "Specimen." This image was taken at a taxidermy shop in the fish drying room/kitchen.* ● *«Königlich», Aufnahme aus einer Reihe mit dem Titel «Specimen» (Arten). Das Bild wurde beim Präparator im Fischtrockungsraum bzw. in der Küche aufgenommen.* ▲ *«Royal», d'une série intitulée «Spécimen». Cette photo a été prise dans un magasin de taxidermie, plus précisément dans la cuisine qui fait office de séchoir à poissons.*

PAGE 98 PHOTOGRAPHER: *Steve Tregeagle* CAMERA: *Sinar P 4X5"* FILM: *Kodak Ektachrome 100 Plus* COUNTRY: *USA* ■ *The subjects of these self-promotional photographs were leftover props from another assignment. A fiber-optic light painting technique was used to bring out the texture and to enhance color saturation.* ● *Die Objekte dieser freien Aufnahmen des Photographen sind übriggebliebene Ausstattungstücke eines Auftrags. Er arbeitete mit Lightpainting-Technik, um die Strukturen zu betonen und volle Farbtöne zu erreichen.* ▲ *Pour sa promotion personnelle, le photographe a choisi pour sujet des accessoires qui traînaient là après une prise de vue. Une lumière à fibres optiques, dite «lightbrush», a permis de rehausser la texture et de forcer sur la saturation des couleurs.*

PAGE 99 PHOTOGRAPHER: *Achim Falkenthal* CAMERA: *Toyo View GX* FILM: *Kodak EPP* ART DIRECTOR: *Achim Falkenthal* COUNTRY: *Germany* ■ *This study was used for self-promotion.* ● *Diese Studie wurde als Eigenwerbung verwendet.* ▲ *Etude utilisée comme publicité autopromotionnelle.*

PAGES 100-101 PHOTOGRAPHER: *Pamela Strauss* CAMERA: *Nikon 2020* FILM: *Kodak Infrared* EXPOSURE: *F22/6 seconds.* COUNTRY: *USA* ■ *These images were part of a series on flowers, vegetables, and fruit. The images of bananas and tropical fruit were shot with infrared film, printed on fiber-based paper, toned, and hand painted.* ● *Diese Bilder gehören zu einer Reihe über Blumen, Gemüse und Früchte. Die Aufnahmen der Bananen und tropischen Früchte wurden mit Infrarot-Film gemacht, auf Photopapier übertragen, getont und von Hand koloriert.* ▲ *Ces images proviennent d'une série sur les fleurs, les légumes et les fruits. Les photos de bananes et de fruits tropicaux ont été prises avec un film infrarouge, tirées sur un papier à base de fibres, virées et peintes à la main.*

PAGE 102 PHOTOGRAPHER: *Ruven Afanador* REPRESENTATIVE: *Jed Root* PUBLISHER: *ENTERTAINMENT WEEKLY* DIRECTOR OF PHOTOGRAPHY: *Mary Dunn* PICTURE EDITOR: *Doris Brautigan* CAMERA: *Pentax* COUNTRY: *USA* This portrait is of Val Kilmer as Batman in "Batman Forever." He is posing with Batcuffs, a prop from the movie. ● *Ein Porträt von Val Kilmer als Batman in «Batman Forever». Er posiert mit «Fledermausmanschetten», Requisiten aus dem Film* ▲ *Il s'agit d'un portrait de Val Kilmer en Batman dans «Batman Forever». Il pose avec les «batmenottes» qui ont servi dans le film.*

PAGE 104 PHOTOGRAPHER: *John Madere* REPRESENTATIVE: *PROOF* PUBLISHER: *SELF* ART DIRECTOR: *John Madere* COUNTRY: *USA* ■ *For this image from a series on kids' summer camps, the photographer wanted to separate the subject from the ongoing action and maintain the feeling of a formal portrait.* ● *Bei dieser Aufnahme, die zu einer Reihe über Kinder in Sommerlagern gehört, ging es dem Photographen um den Charakter eines formellen Porträts.* ▲ *Image extraite d'une série consacrée aux colonies de vacances. Le photographe a voulu séparer le sujet du feu de l'action pour donner l'impression d'un portrait formel.*

PAGE 105 PHOTOGRAPHER: *Raymond Allbritton* CLIENT: *ICOS* CAMERA: *35mm* FILM: *Polapan* ART DIRECTOR: *John Van Dyke* COUNTRY: *USA* ■ *This image is an outtake from the photographer's assignment to illustrate research on asthma for a medical research/drug company. He chose to show a healthy woman with a strong profile, and shot the subject on 35 mm Polapan with a self-made lens and a very direct light.* ● *Dieses Bild entstand am Rande von Aufnahmen für die Asthma-Forschung eines pharmazeutischen Unternehmens. Für diese Aufnahme wählte der Photograph eine gesunde Frau mit prägnantem Profil, und er arbeitete mit einem 35mm-Polapan-Film, einem selbsthergestellten Objektiv und sehr direktem Licht.* ▲ *Cette image provient d'un travail réalisé pour illustrer les recherches sur l'asthme, à la demande d'une entreprise de l'industrie pharmaceutique. Le photographe a choisi une femme en bonne santé et au profil marqué. Il a utilisé du Polapan 35 mm, un objectif fait maison et un éclairage très direct.*

PAGES 106-107 PHOTOGRAPHER: *Colin Faulkner* CAMERA: *4X5" view camera* FILM: *Polaroid* ART DIRECTOR: *Todd Richards* AGENCY: *Tudhope Associates Inc.* COUNTRY: *Canada* ■ *The images represent key words in printing. These previously unpublished photographs are graphic representations of "fine line" and "fine point." A beak of copper with ear hooks made of brass was used for "fine point." A pulley hat was used for "fine line."* ● *Diese Bilder sollten Schlüsselbegriffe des Druckereigewerbes interpretieren. Die bisher unveröffentlichten Aufnahmen sind graphische Interpretationen der Begriffe «Strichbild» und «feiner Punktraster».* ▲ *L'objectif était de représenter des mots clés de l'imprimerie. Ces photos, inédites, sont les représentations graphiques du «trait fin» et du «point de trame».*

PAGE 108 PHOTOGRAPHER: *Matt Mahurin* PUBLISHER: *ROLLING STONE* ART DIRECTOR: *Fred Woodward* PHOTO EDITOR: *Jodi Peckman* COUNTRY: *USA* ■ *Image of Henry Rollins published in ROLLING STONE.* ● *Portrait von Henry Rollins für die Zeitschrift ROLLING STONE.* ▲ *Image d'Henry Rollins publiée dans ROLLING STONE.*

PAGE 109 PHOTOGRAPHER: *Kiyoko Horvath* REPRESENTATIVE: *Valeri Picardi* CAMERA: *Canon EOS* FILM: *Kodak EPP* COUNTRY: *USA* ■ *Images from a book project titled "Harlem Colors." Attracted to the colorful culture and unique history of Harlem, the photographer wanted to convey the rhythm and vibrancy of the colors she found in the fashion, culture, houses, and streets of Harlem.* ● *Aufnahmen für ein Buchprojekt mit dem Titel «Harlem Colors». Angezogen von der Kultur und einzigartigen Geschichte Harlems, wollte die Photographin die rhythmischen, vibrierenden Farben der Mode, Kultur, Häuser und Strassen von Harlem wiedergeben.* ▲ *Images réalisées dans le cadre d'un projet de livre, «Harlem Colors». Attirée par la culture colorée et l'histoire fascinante d'Harlem, la photographe a voulu communiquer le rythme et la vibration des couleurs qu'elle a ressentis à travers la mode, la culture, les maisons et les rues de Harlem.*

PAGE 110 PHOTOGRAPHER: *Dieter Blum* PUBLISHER: *DER SPIEGEL* CAMERA: *Leica R7* EXPOSURE: *⅓₀* ART DIRECTOR: *Dietmar Suchalla* COUNTRY: *Germany* ■ *This portrait of dancer Ismael Ivo was taken while he was studying the role of Francis Bacon. The image was taken in the photographer's studio so that he could control the lighting.*

This series was on music, dance, and artists, and this particular photograph was also shown in the exhibition "XTC-Ecstasy–Dance Photography by Dieter Blum." ● *Dieses Porträt des Tänzers Ismael Ivo, der zu dieser Zeit die Rolle von «Francis Bacon» einstudierte, entstand im Studio des Photographen, der so das Licht nach seinen Wünschen gestalten konnte. Die Aufnahme gehört zu seinem Zyklus Musik/Tanz/Künstler und wurde auch in der Ausstellung «XTC-Ecstasy, Tanzfotografie von Dieter Blum», gezeigt.* ▲ *Ce portrait du danseur Ismael Ivo, absorbé à l'époque par l'étude du rôle de «Francis Bacon», a été réalisé dans le studio du photographe qui a ainsi pu obtenir l'éclairage souhaité. Présenté lors de l'exposition XTC-Ecstasy, il fait partie de la série de Dieter Blum consacrée à la musique, à la danse et aux artistes.*

PAGE 111 PHOTOGRAPHER: *Liz Hampton* REPRESENTATIVE: *Graphistock* CAMERA: *Pentax* FILM: *Polaroid Polapan* EXPOSURE: *F5.6/½second*. COUNTRY: *USA* ■ *"Erin, 1995," from a series of portraits of women entitled [WO]MANDALA.* ● *«Erin, 1995» gehört zu einer Porträtreihe von Frauen mit dem Titel [WO]MANDALA.* ▲ *«Erin, 1995» s'inscrit dans une série de portraits de femmes intitulée [WO]MANDALA.*

PAGE 112, TOP LEFT PHOTOGRAPHER: *Stephanie Pfriender* REPRESENTATIVE: *Judy Casey* PUBLISHER: *ENTERTAINMENT WEEKLY* PICTURE EDITOR: *Doris Brautigan* CAMERA: *Mamiya 645 Pro* FILM: *Procolor 100 Negative* EXPOSURE: *F5.6/¹/₁₂₅ second* COUNTRY: *USA* ■ *Photograph of Samuel L. Jackson on the Staten Island Ferry.* ● *Samuel L. Jackson, photographiert auf der Staten-Island-Fähre.* ▲ *Photographie de Samuel L. Jackson sur le ferry de Staten Island.*

PAGE 112, TOP RIGHT PHOTOGRAPHER: *Stephanie Pfriender* REPRESENTATIVE: *Judy Casey* PUBLISHER: *ENTERTAINMENT WEEKLY* PICTURE EDITOR: *Doris Brautigan* CAMERA: *Mamiya 645 Pro* FILM: *Procolor 100 Negative* EXPOSURE: *F11/ ¹/₆₀ second* COUNTRY: *USA* ■ *Photograph of actress Sandra Bullock, shot while the movie "While You Were Sleeping" was in release.* ● *Diese Aufnahme der Schauspielerin Sandra Bullock entstand, als der der Film «While You Were Sleeping» gerade in die Kinos kam.* ▲ *Photographie de l'actrice Sandra Bullock, prise à la sortie du film «While You Were Sleeping».*

PAGE 112, BOTTOM LEFT PHOTOGRAPHER: *Mary Ellen Mark* PUBLISHER: *ENTERTAINMENT WEEKLY* PICTURE EDITOR: *Doris Brautigan* ASSISTANT PICTURE EDITOR: *Mark Jacobson* COUNTRY: *USA* ■ *Image of Jean Claude Van Damme published in ENTERTAINMENT WEEKLY.* ● *Jean Claude Van Damme, porträtiert für ENTERTAINMENT WEEKLY* ▲ *Image de Jean Claude Van Damme publiée dans ENTERTAINMENT WEEKLY.*

PAGE 112, BOTTOM RIGHT PHOTOGRAPHER: *Michael Norton* REPRESENTATIVE: *Tom Ring* CAMERA: *Nikon 8008* FILM: *Polacolor* EXPOSURE: *F2.8/¹/₆₀ second* ART DIRECTOR: *Michael Norton* COUNTRY: *USA* ■ *"Baby in Pink Blanket." This photograph was produced as a self-assignment for Polaroid. The photographer used a Zeiss Softar 1 diffusion filter.* ● *«Baby in rosafarbener Decke.» Diese Aufnahme entstand im Eigenauftrag für Polaroid. Der Photograph arbeitete mit einem Zeiss Softar-1-Weichzeichner.* ▲ *«Bébé dans une couverture rose». Le photographe a choisi ce sujet de prise de vue pour Polaroid. Il a utilisé un filtre de diffusion Softar 1 de Zeiss.*

PAGE 113 PHOTOGRAPHER: *David Strick* PUBLISHER: *PEOPLE* CAMERA: *Hasselblad* FILM: *Fuji RDP* COUNTRY: *USA* ■ *Björk was exhausted from four hours of music video rehearsal and tap dancing, but she pulled herself together long enough to strike this "don't try this at home" pose in a hallway of the Chateau Marmont hotel.* ● *Björk war erschöpft nach vierstündigen Stepptanzproben für einen Musik-Video-Clip, aber sie nahm sich lange genug zusammen, um im Korridor des Château-Marmont-Hotels diese Haltung der Art «Versuch's ja nicht zu Hause» anzunehmen.* ▲ *Björk était épuisée après avoir dansé des claquettes et répété pendant quatre heures pour un vidéoclip. Elle a toutefois fait l'effort de tenir cette pose, du genre «ne fais pas ça à la maison», dans le hall de l'hôtel Château Marmont.*

PAGE 114 PHOTOGRAPHER: *Mark Seliger* REPRESENTATIVE: *Robbie Feldman, PROOF* PUBLISHER: *ROLLING STONE* ART DIRECTOR: *Fred Woodward* PHOTO EDITOR: *Jodi Peckman* DESIGNER: *Fred Woodward* COUNTRY: *USA* ■ *Image of Courtney Love published in ROLLING STONE.* ● *Aufnahme von Courtney Love für ROLLING STONE.* ▲ *Photo de Courtney Love publiée dans ROLLING STONE.*

PAGE 115 PHOTOGRAPHER: *Mark Seliger* REPRESENTATIVE: *Robbie Feldman, PROOF*

PUBLISHER: *ROLLING STONE* ART DIRECTOR: *Fred Woodward* PHOTO EDITOR: *Jodi Peckman* COUNTRY: *USA* ■ *Image of Brad Pitt published in ROLLING STONE.* ● *Brad Pitt, photographiert für ROLLING STONE.* ▲ *Photo de Brad Pitt publiée dans ROLLING STONE.*

PAGE 116, TOP LEFT PHOTOGRAPHER: *Stephanie Pfriender* REPRESENTATIVE: *Judy Casey* PUBLISHER: *ENTERTAINMENT WEEKLY* PICTURE EDITOR: *Doris Brautigan* CAMERA: *Nikon F-3* FILM: *Kodak Tri-X* EXPOSURE: *F11/ 1/60 second* COUNTRY: *USA* ■ *Image of Mickey Rourke published in ENTERTAINMENT WEEKLY.* ● *Ein in ENTERTAINMENT WEEKLY veröffentlichtes Porträt von Mickey Rourke.* ▲ *Photo de Mickey Rourke publiée dans ENTERTAINMENT WEEKLY.*

PAGE 116, TOP RIGHT PHOTOGRAPHER: *Brigitte LaCombe* REPRESENTATIVE: *Janet Johnson* PUBLISHER: *US MAGAZINE* PHOTO EDITOR: *Jennifer Crandall* ART DIRECTOR: *Richard Baker* COUNTRY: *USA* ■ *Photo of Michelle Pfeiffer published in US MAGAZINE.* ● *Michelle Pfeiffer, aufgenommen für US MAGAZINE.* ▲ *Photo de Michelle Pfeiffer publiée dans US MAGAZINE.*

PAGE 116, BOTTOM LEFT PHOTOGRAPHER: *Mary Ellen Mark* REPRESENTATIVE: *Art+Commerce* PUBLISHER: *US MAGAZINE* PHOTO EDITOR: *Jennifer Crandall* ART DIRECTOR: *Richard Baker* COUNTRY: *USA* ■ *Photo of Meryl Streep published in US MAGAZINE.* ● *In US MAGAZINE erschienenes Porträt von Meryl Streep.* ▲ *Photo de Meryl Streep publiée dans US MAGAZINE.*

PAGE 116, BOTTOM RIGHT PHOTOGRAPHER: *David Bailey* REPRESENTATIVE: *Robbie Montgomery, Creative Talent* PUBLISHER: *US MAGAZINE* PHOTO EDITOR: *Jennifer Crandall* ART DIRECTOR: *Richard Baker* COUNTRY: *USA* ■ *Photo of Aidan Quinn published in US MAGAZINE.* ● *Porträt von Aidan Quinn für US MAGAZINE.* ▲ *Photo d'Aidan Quinn publiée dans US MAGAZINE.*

PAGE 117 PHOTOGRAPHER: *Herb Ritts* REPRESENTATIVE: *Visages* PUBLISHER: *ROLLING STONE/Wenner Media* ART DIRECTOR: *Fred Woodward* PHOTO EDITOR: *Jodi Peckman* COUNTRY: *USA* ■ *Image of Jim Carrey published in ROLLING STONE.* ● *Jim Carrey, für ROLLING STONE photographiert.* ▲ *Photo de Jim Carrey publiée dans ROLLING STONE.*

PAGES 118-121 PHOTOGRAPHER: *John Huet* REPRESENTATIVE: *Marilyn Cadenbach* CLIENT: *West Cigarettes* CAMERA: *Pentax 6X7* FILM: *Kodak Tri-X* ART DIRECTOR: *Ilona Kluck* AGENCY: *Scholtz & Friends* COUNTRY: *Germany* ■ *Shots from "Smoking enjoyment," a campaign for West Cigarettes. The campaign runs in Germany in magazines and on billboards.* ● *Diese Aufnahmen gehören zu einer Zeitschriften- und Plakatkampagne für West-Zigaretten in Deutschland.* ▲ *Photos de la campagne multimédia «Smoking enjoyment» pour les cigarettes West, destinée au marché allemand.*

PAGE 122 PHOTOGRAPHER: *James R. Minchin III* REPRESENTATIVE: *Renee Hersey* CLIENT: *Nicholas Payton* CAMERA: *Polaroid Land Camera* FILM: *Polaroid 665* ART DIRECTOR: *David Lau* DESIGNER: *David Lau* RECORD COMPANY: *Polygram/Verve* COUNTRY: *USA* ■ *This photograph was shot in New Orleans for a published CD package. During shooting, two prostitutes were watching on a corner, swinging a cat around by its tail.* ● *Dieses Photo wurde in New Orleans für eine CD-Hülle gemacht. Während der Aufnahmen standen zwei Prostituierte an der Strassenecke und wirbelten eine Katze am Schwanz herum.* ▲ *Cette photo, destinée à une jaquette de CD, a été faite à la Nouvelle-Orléans. Lors de la prise de vue, deux prostituées étaient postées au coin de la rue, balançant un chat par la queue.*

PAGE 123 PHOTOGRAPHER: *James Salzano* REPRESENTATIVE: *Frank Meo* CAMERA: *Hasselblad* FILM: *Kodak LPZ* EXPOSURE: *F8/1/8 second* ART DIRECTOR: *James Salzano* DESIGNER: *James Salzano* COUNTRY: *USA* ■ *Self-promotional photo shot in the ladies' lounge of New York City's Roseland Theater. The event was "The Most Awesome Collection of Female Muscle," and this group is gathered around the "queen" of the show.* ● *Diese Aufnahme, die als Eigenwerbung verwendet wurde, entstand in der Damen-Toilette des New York City Roseland-Theaters. Gezeigt wurde «Die beeindruckendste Ansammlung weiblicher Muskeln», und die Gruppe umringte die «Königin» der Show.* ▲ *Cette image, utilisée à des fins de promotion personnelle, a été prise dans les toilettes des dames du théâtre Roseland de New York. A l'affiche: «La plus redoutable collection de muscles féminins»; un groupe de gens se presse autour de la «reine» du spectacle.*

PAGE 124 PHOTOGRAPHER: *Amy Arbus* CAMERA: *Nikon FM2* FILM: *Kodak Tri-X* COUNTRY: *USA* ■ *"Neck," "Sneeze," "Ear," "Angry Girl."* ©1994 Amy Arbus. ● *«Hals», «Niesen», «Ohr», «Wütendes Mädchen».* ©1994 Amy Arbus. ▲ *«Cou», «Eternuement», «Oreille», «Jeune fille en colère».* ©1994 Amy Arbus.

PAGE 125 PHOTOGRAPHER: *James Salzano* REPRESENTATIVE: *Frank Meo* CLIENT: *Astra Merck* CAMERA: *Hasselblad* FILM: *Kodak LPZ* EXPOSURE: *F5.6/ 1/15 second* ART DIRECTOR: *Amil Gargano* AGENCY: *Amil Gargano and Partners* COUNTRY: *USA* ■ *This assignment was to get a portrait of a Russian couple living in Brighton Beach, Brooklyn. After meeting several couples, the photographer decided on a man and woman who were married, but not to each other. At first they were uneasy about posing as a married couple, but after careful explanation, they agreed to act the part.* ● *Verlangt war ein Porträt eines russischen Paares, das in Brighton Beach, Brooklyn, lebt. Nachdem der Photograph mehrere Paare besucht hatte, entschied er sich für ein Paar, das verheiratet war, aber nicht miteinander. Anfänglich fühlten die beiden sich in ihrer Rolle als Ehepaar unwohl, aber dank behutsamer Erklärungen waren sie schliesslich einverstanden.* ▲ *Le client avait demandé au photographe de réaliser le portrait d'un couple de Russes vivant à Brighton Beach, Brooklyn. Après en avoir rencontré plusieurs, le photographe a choisi un homme et une femme, mariés certes, mais pas l'un à l'autre. Au début, ils étaient mal à l'aise dans leur rôle de couple, mais après leur avoir gentiment expliqué la situation, ils ont toutefois accepté de jouer le jeu.*

PAGES 126-127 PHOTOGRAPHER: *Paul Mobley* REPRESENTATIVE: *Janet Zaleski* CAMERA: *Pentax 6X7* LIGHTING: *Pro-Foto* FILM: *Kodak T-Max 100* ART DIRECTOR: *Paul Mobley* ART DIRECTOR: *Tom Wood* AGENCY: *Wood Design* COUNTRY: *USA* ■ *Images from a personal project on the Russian circus. As many as three to four family members travel and perform together in the circus. None of the performers spoke English, which made the shooting difficult. These images are of the "Flying Cranes," considered one of the best high-wire trapeze acts in the world, and of one of the premiere clowns.* ● *Der russische Zirkus ist das Thema eines Projektes des Photographen. Bei diesem Zirkus gehören bis zu vier Mitglieder einer Familie zu den Artisten. Keiner von ihnen spricht englisch, was das Photographieren schwierig machte. Diese Bilder zeigen die «fliegenden Kraniche», die als einer der besten Hochtrapez-Akte der Welt gelten, sowie einen der besten Clowns.* ▲ *Images extraites d'un projet personnel sur le cirque russe. Trois ou quatre membres de la même famille voyagent et se produisent ensemble. Aucun de ces artistes de cirque ne parlait anglais, ce qui compliqua les choses. Ces photos montrent les «grues volantes», l'un des plus beaux numéros de corde raide et de trapèze au monde, ainsi que l'un des meilleurs clowns.*

PAGE 128 PHOTOGRAPHER: *Ron Hildebrand* CAMERA: *Bronica ETRS* FILM: *120 Verichrome Pan* COUNTRY: *USA* ■ *This uncommissioned image was from the last session with this model, whom the photographer spotted while she was working behind the counter of a local CD store. He used basic lighting, but then softened and diffused the image by using black netting over the camera lens and then over the enlarger lens during the print exposure.* ● *Diese freie Aufnahme entstand bei der letzten Sitzung mit dem Modell. Der Photograph hatte sie bei ihrer Arbeit in einem CD-Laden entdeckt. Er arbeitete mit einfacher Belichtung, benutzte aber ein schwarzes Netz auf dem Objektiv und später auch auf dem Vergrösserungsobjektiv, um ein weiches, unscharfes Bild zu erlangen.* ▲ *Cette photo, qui ne fit pas l'objet d'une commande, fut réalisée lors de la dernière prise de vue avec ce modèle. Le photographe l'avait remarquée alors qu'elle était vendeuse dans un magasin de CD du quartier. L'éclairage est très simple, mais l'image a été adoucie et rendue diffuse en plaçant un filet noir sur l'objectif; un même filet a été fixé sur l'objectif de l'agrandisseur.*

PAGE 129 PHOTOGRAPHER: *Dan Weaks* COUNTRY: *USA* ■ *This unpublished photograph was a test image for an underwear campaign.* ● *Diese unveröffentliche Photographie war eine Testaufnahme für eine Wäsche-Kampagne.* ▲ *Cette photo inédite était en fait un test réalisé pour une campagne de sous-vêtements.*

PAGE 130 PHOTOGRAPHER: *Sue Bennett* CAMERA: *Nikon* FILM: *Ilford XP2* EXPOSURE: *F8/ 1/60 second* COUNTRY: *USA* ■ *From an unpublished series called "The Nature of Excellence–Being Black in America."* ● *Aufnahme aus einer unveröffentlichten Serie über die schwarze Bevölkerung Amerikas.* ▲ *Image provenant d'une série inédite intitulée «La nature de l'excellence – Etre noir en Amérique.»*

PAGE 131 PHOTOGRAPHER: *Ludovic Moulin* PUBLISHER: *Seen Publishing* ART DIRECTOR: *Zachary Soreff* COUNTRY: *USA* ■ *Image published in "Seen," a nightlife and dining guide to New York City. This image was designed to evoke the casual lounge atmosphere of Manhattan club life.* ● *Aufnahem aus "Seen," einem Führer über Restaurants, Bars, Clubs etc. in New York. Bei dieser Aufnahme ging es um die Darstellung der legeren Atmosphäre des Clublebens in Manhattan.* ▲ *Image publiée dans "Seen," un guide new-yorkais sur les restaurants, bars, clubs, etc. Image devant évoquer l'atmosphère désinvolte qui règne dans les clubs de Manhattan.*

PAGES 132-133 PHOTOGRAPHER: *Donald W. Mason* CAMERA: *Hasselblad* FILM: *Kodak T-Max* ART DIRECTOR: *Donald W. Mason* AGENCY: *Mason Photography* COUNTRY: *USA* ■ *"Sister Connie Wise" and "Suzy & Niece." While walking his dog, the photographer noticed the unusual variety of characters around his neighborhood, and started to invite them to come to his studio. He then came up with the concept, "Two Blocks," a portrait series.* ● *«Schwester Connie Wise» und «Suzy & Niece». Beim Laufen mit seinem Hund entdeckte der Photograph die ungewöhnliche Vielfalt der Charaktere in seiner Nachbarschaft, und er lud sie in sein Atelier ein. Das Resultat ist eine Porträt-Reihe, die er «Zwei Blocks» nennt.* ▲ *«Sœur Connie Wise» et «Suzy & Nièce». En promenant son chien, le photographe remarqua l'incroyable variété des habitants de son quartier et les invita dans son studio. De là est né le concept « Deux pâtés de maisons», une série de portraits.*

PAGE 134, TOP PHOTOGRAPHER: *George Simboni* REPRESENTATIVE: *Robin Dictenberg* CLIENT: *Prince Edward Island Tourism* CAMERA: *Mamiya 645* FILM: *Kodak EPL* ART DIRECTOR: *Peter Holmes* AGENCY: *Holmes Donin Alloul* COUNTRY: *USA* ■ *While on location for Prince Edward Island Tourism, the photographer came across this trailer behind a restaurant. This image was used for one of the ads in the campaign.* ● *Bei Aufnahmen für ein Touristikunternehmen entdeckte der Photograph diesen Wohnwagen hinter einem Restaurant. Das Photo wurde in einer der Anzeigen der Kampagne verwendet.* ▲ *Alors qu'il était en prise de vue pour Prince Edward Island Tourism, le photographe est tombé sur cette caravane située derrière un restaurant. Cette photo fut choisie pour l'une des annonces de la campagne.*

PAGE 134, BOTTOM PHOTOGRAPHER: *William Mercer McLeod* CAMERA: *Minolta CLE* FILM: *Kodak Tri-X* COUNTRY: *USA* ■ *From a series, "Travels with Ava Ray." This photograph is of Ava Ray on horseback in Canyon de Chelly.* ● *Aus einer Serie mit dem Titel «Reisen mit Ava Ray». Die Aufnahme zeigt Ava Ray beim Reiten im Canyon de Chelley.* ▲ *D'une série intitulée «Voyages avec Ava Ray». Il s'agit d'une photo d'Ava Ray à cheval dans le canyon de Chelly.*

PAGE 135 PHOTOGRAPHER: *Alvin Booth* REPRESENTATIVE: *Hamiltons Gallery* CAMERA: *Mamiya RB 67* ■ *This hand-toned image was part of an installation of twenty framed photographs arranged in a square formation.* ● *Diese handkolorierte Aufnahme war Teil einer Installation von zwanzig gerahmten Photographien, die im Karree angeordnet waren.* ▲ *Cette image, colorée à la main, faisait partie d'une installation de vingt photos encadrées, disposées en carré.*

PAGE 136 PHOTOGRAPHER: *Jeff Licata* REPRESENTATIVE: *Allan Hardy* ART DIRECTOR: *Jeff Licata* CAMERA: *Hasselblad ELX* FILM: *Kodak Tri-X 400* EXPOSURE: *F11/¹⁄₂₅₀ second.* COUNTRY: *USA* ■ *From a series on the beauty and form of the black male. The location with the stark white walls was chosen to emphasize the body and its form.* ● *Die Aufnahme gehört zu einer Serie über die Schönheit und den Körper des schwarzen Mannes. Die weissen Wände dienten als wirkungsvoller Kontrast.* ▲ *Image d'une série sur la beauté et la plastique du corps de l'homme noir. Le cadre choisi pour la prise de vue avec ses murs blancs met en valeur le corps et sa plastique.*

PAGE 137 PHOTOGRAPHER: *Ruven Afanador* REPRESENTATIVE: *Jed Root* PUBLISHER: *VANITY FAIR* COUNTRY: *USA* ■ *Image of Ethan Stiefel published in VANITY FAIR.* ● *Ethan Stiefel, für VANITY FAIR photographiert.* ▲ *Photo de Ethan Stiefel publiée dans VANITY FAIR.*

PAGE 138 PHOTOGRAPHER: *Per-Erik Berglund* REPRESENTATIVE: *Milena Najdanovic, Art Production Team* CAMERA: *Sinar P2 8x10"* FILM: *Polaroid 809* COUNTRY: *Sweden* ■ *One of a series of six nudes. This particular photograph is not a dye transfer.* ● *Beispiel einer Aktaufnahme von insgesamt sechs, die der Phantasie des Betrachters viel Raum lassen. Es handelt sich bei dieser speziellen Aufnahme nicht um einen*

Transfer. ▲ *Extrait d'une série de six nus qui laisse une grande place à l'imagination de l'observateur. Dans ce cas précis, il ne s'agit pas d'un transfert.*

PAGE 139 PHOTOGRAPHER: *Ruven Afanador* REPRESENTATIVE: *Jed Root* PUBLISHER: *SAN FRANCISCO FOCUS/KQED* ART DIRECTOR: *David Armario* COUNTRY: *USA* ■ *Image of Wayne Wang, who had just directed the film "Smoke." Wang was captured in a series of tobacco-related shots: with tobacco leaves, smoking a cigar, etc.* ● *Wayne Wang, der Regisseur des Films «Smoke». Der Photograph porträtierte ihn in Anspielung auf den Film mit Tabakblättern, mit Zigarre etc.* ▲ *Image de Wayne Wang qui venait de réaliser le film «Smoke». Wang a été photographié avec divers éléments en relation avec le tabac: avec des feuilles de tabac, en train de fumer un cigare, etc.*

PAGE 140 PHOTOGRAPHER: *Simon Obarzanek* REPRESENTATIVE: *Phillipe Achard* CAMERA: *Nikon FM2* FILM: *Agfa Pan 100* EXPOSURE: *f4/¹⁄₁₂₅ second* ■ *Image of the photographer's full-time assistant.* ● *Porträt der Assistentin der Photographin.* ▲ *Images de l'assistant à plein temps du photographe.*

PAGE 141 PHOTOGRAPHER: *Lizzie Himmel* CLIENT: *Ogilvy and Mather* CAMERA: *Nikon* FILM: *NHG* EXPOSURE: *F5.6¹⁄₂/60 seconds* ART DIRECTOR: *Allen Sprulls* COUNTRY: *USA*

PAGES 142, 144 PHOTOGRAPHER: *Barry Robinson* CLIENT: *Bell Bicycle Helmets* CAMERA: *Fuji 680* FILM: *Kodak EPN* EXPOSURE: *F5.6/¹⁄₁₂₅ second* ART DIRECTOR: *Keith Anderson* ART DIRECTOR: *Frank Kofsuske* DESIGNER: *Keith Anderson* AGENCY: *Goodby, Silverstein Design Group* COUNTRY: *USA* ■ *Selective focus was used to emphasize the helmets in these photos, and to let the people go soft. A hard, directional light source was used and the highlight reflection was hidden in the vents of the helmets.* ● *Bei dieser Aufnahme wurde die Schärfentiefe so gelegt, dass die Helme betont wurden, während die Menschen unscharf abgebildet wurden. Der Photograph verwendete hartes, punktuelles Licht, wobei die Reflexionen des Lichtes von den Öffnungen der Helme geschluckt werden.* ▲ *La mise au point met en valeur les casques tout en atténuant les personnages. Une lumière forte, directionnelle a été utilisée bien que les reflets de la lumière aient été «avalés» par les ouvertures des casques.*

PAGE 145 PHOTOGRAPHER: *Aernout Overbeeke* REPRESENTATIVE: *Freddy Brazil* REPRESENTATIVE: *Christa Klubert* CLIENT: *Mercedes Benz* CAMERA: *Hasselblad* FILM: *Kodak Tri-X* ART DIRECTOR: *Diederik Hellenius* AGENCY: *TBWA Campaign Company* COUNTRY: *Netherlands* ■ *This old photograph of a Mercedes Benz was merged with a new background in the darkroom with traditional methods. The image is from a campaign for Mercedes Benz in the Netherlands.* ● *Diese alte Aufnahme eines Mercedes Benz wurde in der Dunkelkammer nach traditionellen Methoden in den neuen Hintergrund integriert. Sie stammt aus einer Werbekampagne für Mercedes Benz in den Niederlanden.* ▲ *Utilisée pour une campagne publicitaire aux Pays-Bas, cette vieille photographie d'une Mercedes Benz a été intégrée dans un nouveau fond avec les méthodes traditionelles de la chambre noire.*

PAGE 146 PHOTOGRAPHER: *Hunter Freeman* REPRESENTATIVE: *Heather Elder* CAMERA: *Sinar 4X5"* FILM: *Kodak Ektachrome* ART DIRECTOR: *Hunter Freeman* DESIGNER: *Hunter Freeman* AGENCY: *Hunter Freeman Photography* COUNTRY: *USA* ■ *A panoramic camera was used to capture these images of classic cars.* ● *Für diese Bilder klassischer Autos wurde eine Panorama-Kamera verwendet.* ▲ *Ces images de vieilles voitures ont été fixées sur la pellicule d'un appareil panoramique.*

PAGE 147 PHOTOGRAPHER: *Rick Rusing* REPRESENTATIVE: *Jean Gardner* CLIENT: *Lexus* CAMERA: *Horseman 4X5"* FILM: *Kodak Plus-X* EXPOSURE: *F22/¹⁄₁₂₅ second* ART DIRECTOR: *Gabrielle Mayeur* AGENCY: *Team One Advertising* COUNTRY: *USA* ■ *One of a series of photographs produced for the 1996 Lexus GS300 product brochure. The image juxtaposes man-made design elements with the natural desert and rock of Monument Valley, Utah. The photograph was exposed on black and white negative film and then printed using a color enlarger and paper to create the monochromatic color tone.* ● *Die Aufnahme gehört zu einer Broschüre über den Lexus GS300 von 1996. Hier werden vom Menschen gestaltete Dinge der Wüste und den Felsen des Monument Valley in Utah gegenübergestellt. Die mit einem Schwarzweissfilm gemachte Aufnahme wurde im Farbvergrösserungsgerät auf Farbpapier übertragen, um den monochromen Farbton zu erzielen.* ▲ *Photo réalisée pour la brochure de*

produits Lexus GS300 1996. Des éléments de design manufacturés sont juxtaposés au désert et aux rochers de Monument Valley, Utah. L'image a été faite avec un film négatif n&b, puis tirée sur un papier couleur avec un agrandisseur couleur pour lui donner cette teinte monochrome.

PAGE 148 Photographer: *Michael Furman* Representative: *Peter Grims* Client: *HOECHST Celanese* Camera: *Sinar 4x5"* Film: *Kodak Lumiere* Art Director: *Kevin Thompson* Digital Imaging: *Ergo Digital Imaging* Agency: *McMillen Giacalone Thompson Design* Country: *USA* ■ The cars used for this 1996 calendar project were selected by the photographer and prior to shooting the layouts for the assemblies were finalized in a "walk-around" of each car with the art director. The final film was sent for four-color scanning, and then forwarded to digital artists who assembled the images. ● *Der Photograph suchte selbst die Autos aus, die für einen Kalender des Jahres 1996 aufgenommen werden sollten. Der Aufbau der Aufnahmen wurde mit dem Art Director bei einer sorgfältigen Inspizierung eines jeden Autos abgestimmt. Der fertige Film wurde vierfarbig eingescannt und dann digitalen Künstlern übergeben, die die Zusammenstellung der Bilder übernahmen.* ▲ *Le photographe a selectionné lui-même les voitures utilisées pour ce projet de calendrier 96 Avant la prise de vue, toutes les voitures ont fait l'objet d'une inspection méticuleuse avec le directeur artistique pour finaliser les layouts des assemblages. Le film définitif a été scanné en 4 couleurs, puis transmis à des spécialistes du traitement numérique qui ont composé les images.*

PAGE 149, TOP Photographer: *Steve Hathaway* Photographer: *Jeff Strauss* Camera: *Sinar 4x5"* Film: *Kodak EPP* Exposure: *Multiple–hard and soft focus* Art Director: *Steve Hathaway* Art Director: *Jeff Strauss* Country: *USA* ■ By using thin gray panels, a geometric environment was constructed for the Lamborghini Diablo. Each panel was carefully cut to add the needed design shapes. Color and soft focus were added to the background and foreground panels as secondary exposure to separate the automobile from the environment. All color and soft focus was controlled at the lens to help speed the process. ● *Mit Hilfe von dünnen, grauen Platten wurde für den Lamborghini Diablo ein geometrisches Umfeld geschaffen. Jede Platte wurde sorgfältig zugeschnitten, um sich auf die gewünschte Weise dem Design anzupassen. Farbe und die Unschärfe der Platten im Hinter- und Vordergrund dienten dazu, das Auto von der Umgebung zu trennen. Farbe und Unschärfe wurden nur mit Hilfe des Objektivs erzielt, um den Prozess zu beschleunigen.* ▲ *De fins panneaux gris ont été utilisés afin de créer un environnement géométrique pour la Lamborghini Diablo. Chaque panneau a été découpé soigneusement pour créer le design souhaité. De la couleur et une focale douce ont été ajoutées sur les panneaux du fond et du premier plan comme deuxième exposition pour que la voiture se détache de son environnement. La couleur et la mise au point étaient entièrement contrôlées au niveau de l'objectif pour accélérer le processus.*

PAGE 149, BOTTOM Photographer: *Rick Rusing* Representative: *Jean Gardner* Client: *Lexus* Camera: *Sinar 8X10"* Film: *Fuji 64-T* Exposure: *F22/12 seconds.* Art Director: *Scott Bremner* Agency: *Team One Advertising* Country: *USA* ■ This photograph is one in a series produced for the 1996 Lexus SC300 brochure. The photographer wanted to present the automobile in a futuristic, otherwordly, architectural environment. The image was captured in studio on 8X10" color film with a single exposure. ● *Diese Aufnahme stammt aus einer Broschüre für den Lexus SC300 von 1996. Der Photograph wollte das Auto in einer futuristischen, ausserirdischen, architektonischen Umgebung zeigen. Die Aufnahme wurde im Studio mit 8x10" Farbfilm und einer einzigen Belichtung gemacht.* ▲ *Cette photo est extraite de la brochure de produits 1996 Lexus SC300. Le photographe a voulu présenter la voiture dans un cadre architectural futuriste et irréel. La prise de vue a eu lieu en studio avec un film couleur 8X10" et en une seule exposition.*

PAGE 150, TOP ROW Photographer: *Ernesto Martens* Client: *Loewe Opta GmbH* Camera: *Sinar P2* Film: *Kodak* Art Director: *Rainer Hellmann* Agency: *Leonhardt + Kern GmbH* Country: *Germany* ■ The theme for this advertising campaign was the classic shape of Loewe television sets. ● *Die überzeugenden, zeitlosen Formen der Loewe-Fernsehgeräte waren Gegenstand einer Publikumskampagne.* ▲ *Les formes classiques et intemporelles des téléviseurs Loewe étaient au centre d'une campagne publicitaire.*

PAGE 150, BOTTOM ROW Photographer: *Mark Wiens* Representative: *Linda Pool* Client:

Thomas & Betts Camera: *Sinar 4X5"* Film: *Kodak 64 Tungsten* Art Director: *Pat Powell* Creative Director: *Trace Hallowell* Agency: *Thompson & Company* Country: *USA* ■ These images were used in a series of trade advertisements for an electrical supply company. To portray products outside of their usual contexts, wide angle lenses were used in conjunction with view camera movements to create close-ups. Camera movements were employed to help minimize depth of field, maintaining sharp focus on only limited areas. Small spotlights emphasize surface texture and details in the subject. The backgrounds were painted canvas illuminated with colored light to help increase color saturation. ● *Die Aufnahmen wurden in Fachanzeigen einer Elektrofimra verwendet. Um die Produkte nicht im üblichen Umfeld zu zeigen, arbeitete der Photograph mit Weitwinkel-Objektiven und speziellen Kameraeinstellungen, um Nahaufnahmen zu erzielen. Die begrenzte Schärfentiefe bewirkte, dass nur bestimmte Bereiche scharf abgebildet wurden. Kleine Spots akzentuieren die Oberflächenbeschaffenheit und Details der Objekte. Als Hintergrund dienten bemalte Leinwände, die mit farbigem Licht angestrahlt wurden, um die Farbintensität zu erhöhen.* ▲ *Ces images ont illustré les annonces commerciales d'une entreprise de matériel électrique. Afin de présenter les produits hors de leur contexte habituel, le photographe a choisi des objectifs grand angle, combinés à des mouvements de l'appareil, pour réaliser ses gros plans. Les mouvements de l'appareil ont permis de réduire la profondeur de champ en maintenant la mise au point seulement sur des zones déterminées. De petits spots ont permis d'accentuer la texture de l'objet et les détails. Pour le fond, le photographe a utilisé de la toile peinte, éclairée par des lumières teintées qui saturent les couleurs.*

PAGE 151, TOP Photographer: *Geof Kern* Representative: *Hannah Wallace* Client: *S.D. Warren* Art Director: *Cheryl Heller* Agency: *Siegel & Gale* Camera: *Cambo Wide Field Camera 4x5"* Country: *USA* ■ This is one photograph from a series of three for a paper promotion, illustrating historic points regarding the history of sheets in printing (for example, sheet-fed press). ● *Eine von drei Aufnahmen für eine Papier-Promotion. Diese Reihe zeigte wichtige Abschnitte der Geschichte des Papiers im Druckgewerbe (z.B. die Hochdruck-Bogen-Rotationspresse).* ▲ *Une des trois images réalisées dans le cadre de la promotion d'un papier. Cette série présente des étapes importantes de l'histoire du papier dans l'imprimerie (par exemple, la rotative typographique à feuilles).*

PAGE 151, BOTTOM Photographer: *Michael Schnabel* Camera: *Widelux* Film: *Fuji RVP* Exposure: *F 5.6/ ½ second* Art Director: *Helene Öberg* Country: *Germany* ■ The subjects for this series of broad-format photographs were American landscapes and products. ● *Amerikanische Landschaften und Produkte waren das Thema einer Breitformatserie des Photographen.* ▲ *Extrait d'une série de large format consacrée à des paysages et à des produits américains.*

PAGES 152-153 Photographer: *Alan Richardson* Representative: *PROOF* Publisher: *DEPARTURES Magazine* Art Director: *Bernard Schaff* Camera: *4X5"* Film: *Kodak EPR* Exposure: *Multiple exposures at F8 with mixed light sources.* Country: *USA* ■ For these images, the art director presented the photographer with the idea of vintage photos of people on settees and daybeds. This was executed by using projected images and double exposures. ● *Die Idee war, bei dieser Serie alte Photos von Leuten auf Canapés und Sofas zu verwenden. Der Photograph arbeitete dabei mit projizierten Bildern und Doppelbelichtungen.* ▲ *Pour réaliser cette série, le directeur artistique a suggéré au photographe d'utiliser des tirages de collection représentant des gens sur des canapés ou des sofas. Le photographe a travaillé avec des images projetées et une double exposition.*

PAGE 154 Photographer: *Chip Forelli* Camera: *Linhof Technika* Film: *Kodak Tri-X 4X5"* Exposure: *F45/8 seconds.* Country: *USA* ■ "Pebbles and Pool." Considerable magnification for this image required a long exposure and tripod. ● *«Steine und Pfütze». Die Aufnahme verlangte wegen der beträchtlichen Vergrösserung eine lange Belichtungszeit und ein Stativ.* ▲ *«Pierres et flaque». Le grossissement extrême de cette image a exigé un long temps de pose et un trépied.*

PAGE 156, TOP Photographer: *Chip Forelli* Camera: *Linhof Technika 4x5"* Film: *Kodak Tri-X* Exposure: *F32/½/1 second.* Country: *USA* ■ "Turbulence and Rocks." Polaroid tests at 1/2 second, one second, and two seconds showed that a one second exposure gave the desired amount of movement in the water. Very high contrast was con-

trolled by special development and printing techniques. ● «Stürmisches Wasser und Felsen.» Polaroid-Belichtungstests mit einer halben Sekunde, einer Sekunde und zwei Sekunden ergaben, dass eine Sekunde Belichtungzeit geeignet war, die gewünschte Bewegung im Wasser zu erreichen. Der starke Kontrast wurde durch spezielle Entwicklungs- und Übertragungsmethoden erzielt. ▲ «Turbulence et rochers». Les tests polaroïd d'une demi-seconde, d'une seconde et de deux secondes ont montré qu'un temps de pose d'une seconde était idéal pour rendre le mouvement souhaité de l'eau. La force du contraste a été obtenue à l'aide de techniques spéciales de développement et de tirage.

PAGE 156, BOTTOM PHOTOGRAPHER: *Chip Forelli* CAMERA: *Linhof Technika 4x5"* FILM: *Kodak T-Max 100 4X5* EXPOSURE: *F32/90 seconds* COUNTRY: *USA* ■ *"Three Rocks and an Island."* A 90 second exposure revealed meandering patterns on the surface of the ocean not visible to the naked eye. ● «Drei Felsen und eine Insel.» Bei einer Belichtungszeit von neunzig Sekunden werden Muster auf der Oberfläche des Meeres sichtbar, die mit blossem Auge nicht erkennbar sind. ▲ «Trois rochers et une île». Un temps de pose de 90 secondes a permis de révéler des formes sinueuses à la surface de l'océan, invisibles à l'œil nu.

PAGE 157, TOP PHOTOGRAPHER: *Sheila Metzner* PUBLISHER: *AMERICAN WAY Magazine* CAMERA: *Canon* FILM: *Agfa 1000* ART DIRECTOR: *Alison Marshall* DESIGNER: *Alison Marshall* COUNTRY: *USA* ■ *"Liquid Solid."* Image of an iceberg published in *AMERICAN WAY magazine.* ● «Feste Flüssigkeit» Aufnahme eines Eisbergs für die Zeitschrift *AMERICAN WAY* ▲ «Liquide Solide». Image d'un iceberg publiée dans le magazine *AMERICAN WAY.*

PAGE 157, CENTER PHOTOGRAPHER: *Sheila Metzner* CAMERA: *Canon* FILM: *Agfa 1000* ART DIRECTOR: *Sheila Metzner* ■ *Egyptian pyramids, from the photographer's personal fine art work.* ● *Pyramiden in Ägypten, eine künstlerische Arbeit der Photographin.* ▲ *Pyramides d'Egypte, travail artistique et personnel de la photographe.*

PAGE 157, BOTTOM PHOTOGRAPHER: *Sheila Metzner* PUBLISHER: *AMERICAN WAY Magazine* CAMERA: *Canon* FILM: *Agfa 1000* ART DIRECTOR: *Marilyn Calley* DESIGNER: *Marilyn Calley* COUNTRY: *USA* ■ *"Arches of the Southwest."* Image of Red Rock Canyon published in *AMERICAN WAY magazine.* ● *Beispiel aus einer Reihe von Aufnahmen, die im Red Rock Canyon entstanden sind. Sie wurde in der Zeitschrift AMERICAN WAY veröffentlicht.* ▲ «Arches du Sud-Est». Image du Red Rock Canyon publiée dans le magazine *AMERICAN WAY.*

PAGES 158-159 PHOTOGRAPHER: *Aernout Overbeeke* REPRESENTATIVES: *Freddy Brazil, Christa Klubert* CAMERA: *Hasselblad* FILM: *Ilford XP2* EXPOSURES: *¹/₁₂₅, ¹/₆₀* COUNTRY: *Netherlands* ■ *There are still places in the world where time appears to stand still. These photographs were taken on the island Usedom (former East Germany) in the Baltic Sea.* ● *Es gibt noch Orte, wo die Zeit stillzustehen scheint. Diese Bilder entstanden auf der ehemals ostdeutschen Ostseeinsel Usedom.* ▲ *Il y a encore des endroits au monde où le temps semble s'être arrêté. Photos prises sur l'île Usedom, ex-Allemagne de l'Est.*

PAGE 160 PHOTOGRAPHER: *Jonathan Exley* REPRESENTATIVE: *Gamma Liaison* CAMERA: *Hasselblad 80 mm* FILM: *Ilford Pan* EXPOSURE: *F5.6/6 seconds.* ART DIRECTOR: *Jonathan Exley* COUNTRY: *USA* ■ *Though the photographer had never been to Paris before shooting this image, he knew the look and feel he wanted to capture on film; but he also realized that rarely did his end results equal his expectations. When on assignment, he traditionally traveled with eight to 20 cases of equipment, but for this trip, he limited himself to one camera, one 80mm lens, one A12 back, and ten rolls of black and white film. Happily, the result is what he envisioned prior to beginning.* ● *Obwohl der Photograph zuvor nie in Paris gewesen war, wusste er genau, welche Stimmung er einfangen wollte. Aus Erfahrung wusste er aber auch, dass die Ergebnisse oft nicht den Erwartungen entsprechen. Im Gesatz zu Auftragsarbeiten, für die er normalerweise acht bis zwanzig Koffer Ausrüstung mitschleppt, beschränkte er sich auf eine Kamera, ein 80mm-Objektiv, eine A12-Kassette und zehn Schwarzweissfilme. Das Resultat entsprach dieses Mal genau seinen Vorstellungen.* ▲ *Bien que le photographe n'ait jamais mis les pieds à Paris avant de prendre cette photo, il savait exactement ce qu'il voulait photographier, mais aussi que les résultats obtenus étaient rarement à la hauteur de ses attentes. Lorsqu'il faisait des photos pour un client, il emportait*

en principe huit à vingt valises de matériel. Mais pour ce voyage, il ne s'était muni que d'un boîtier, d'un objectif 80 mm, d'un dos A12 et de 10 films n&b. Heureusement, le résultat a satisfait ses attentes.

PAGE 161 PHOTOGRAPHER: *Rob Badger* CAMERA: *Hasselblad* FILM: *Fuji Velvia, Kodak EPZ, Fuji RHP* COUNTRY: *USA* ■ *Images of Antarctica taken within eight hours of each other from a moving boat.* ● *Aufnahmen aus der Antarktis, die von einem fahrenden Boot aus in Abständen von acht Stunden gemacht wurden.* ▲ *Images de l'Antarctique, prises dans un intervalle de huit heures; le photographe se trouvait à bord d'un bateau.*

PAGE 162 PHOTOGRAPHER: *István Lábady* CAMERA: *Nikon F4* FILMS: *Kodak T-Max 400, Ilford HP5 Plus* ART DIRECTOR/DESIGNER: *István Lábady* COUNTRY: *Hungary* ■ *Images of a beach in the Netherlands and huts on a beach near Calais, France.* ● *Ein Strand in Holland und Strandhütten am Meer bei Calais, Frankreich.* ▲ *Plage en Hollande et cabanons en bord de mer près de Calais.*

PAGE 163 PHOTOGRAPHER: *Hans Pieler* CLIENT: *ELVIA-Versicherungsgesellschaft* CAMERA: *Hasselblad* FILM: *Agfa Ultra* ART DIRECTOR: *Erik Voser* AGENCY: *Aebi, Strebel AG* COUNTRY: *Switzerland* ■ *From a series of shots for a car insurance company. The assignment was not to emphasize the beauty of the car and the excitement of driving, but rather to emphasize the funny, frightening, annoying, or ridiculous.* ● *Beispiel aus einer Reihe von Aufnahmen für eine Autoversicherungsgesellschaft. Gewünscht waren Situationen mit Autos, die nicht mit der Schönheit des Autos oder dem Fahrvergnügen zusammenhängen, sondern eher witzig, furchterregend, ärgerlich oder lächerlich sind.* ▲ *Extrait d'une série de photos pour une compagnie d'assurances automobile. L'objectif n'était pas de montrer une belle cylindrée ou le plaisir de conduire, mais des voitures dans des situations tantôt humoristiques ou effrayantes, tantôt ennuyeuses ou ridicules.*

PAGE 164 PHOTOGRAPHER: *Michael Melford* REPRESENTATIVE: *Travel Holiday* PUBLISHER: *READER'S DIGEST* CAMERA: *Nikon F-4* FILM: *Fuji Velvia* ART DIRECTOR: *Lou DiLorenzo* ONLINE PHOTO EDITOR: *Stephanie Syrop* DIRECTOR OF PHOTOGRAPHY: *Bill Black* PHOTO COORDINATOR: *Sandy Perez* COUNTRY: *USA* ■ *Images for a travel piece on Lake Powell, Arizona. The sandstone reflected its best colors at sunrise and sunset.* ● *Bilder für einen Reisebericht über Lake Powell in Arizona. Bei Sonnenaufgang und bei Sonnenuntergang kamen die Farben des Sandsteins am besten zur Geltung.* ▲ *Images réalisées pour un récit de voyage à Lake Powell, Arizona. Le grès blanc et rose resplendit au lever et au coucher du soleil.*

PAGE 165 PHOTOGRAPHER: *Dan Weaks* COUNTRY: *USA* ■ *Image from a series on international cities.* ● *Aufnahme aus einer Reihe über kosmopolitische Städte.* ▲ *Image appartenant à une série sur des métropoles.*

PAGE 166 PHOTOGRAPHER: *Marco Paoluzzo* PUBLISHER: *Flashback Publications* CAMERA: *Hasselblad SWC and 60mm* DESIGNER: *Peter Scholl* COUNTRY: *Switzerland* ■ *Images from a book on Iceland: (A) Geothermal plant in Reykjahlid (B) A rainy day near Brjanslaekur (C) The harbor of Heimaey (Westman Islands), still one of the busiest fishing harbors of Iceland (D) Typical house on the island of Flatey.* ● *Aufnahmen aus einem Island-Bildband: (A) Geothermisches Werk von Reykjalid (B) Ein Regentag in der Nähe von Brjanslaekur (C) der Hafen von Heimaey, Westmännerinseln, einer der wichtigsten Fischereihäfen Islands (D) Typisches Haus auf der Insel Flatey.* ▲ *Images extraites d'un livre consacré à l'Islande: (A) usine géothermique de Reykjablid (B) jour de pluie à Brjanslaekur (C) Le port de Heimaey (îles Vestmann) est l'un des ports de pêche les plus actifs d'Islande (D) Maison typique de l'île de Flatey.*

PAGE 167 PHOTOGRAPHER: *Francisco Hidalgo* REPRESENTATIVE: *The Image Bank* PUBLISHER: *NIKON NEWS* CAMERA: *Nikon F3* FILM: *Kodak 64* EXPOSURE: *F5.6/ ¹/₂₅₀ second* DESIGNER: *Francisco Hidalgo* AGENCY: *AGEP Marseille* COUNTRY: *France* ■ *A view over the roofs of Paris–in the center are the white domes of Sacré-Cœur. The photographer took this image from the second floor of the Centre Pompidou in the late afternoon to capture the warm colors. From a book entitled "Paris."* ● *Ein Blick über die Dächer von Paris, in der Mitte die weissen Kuppeln von Sacré-Cœur. Als bester Standort für den Photographen erwies sich der zweite Stock des Centre Pompidou*

und als beste Zeit der späte Nachmittag wegen der warmen Farben. Die Aufnahme gehört zu einem Bildband mit dem Titel «Paris». ▲ Vue sur les toits de Paris avec, au centre, les coupoles du Sacré-Cœur. Le photographe a pris cette image depuis le deuxième étage du Centre Pompidou, en fin d'après-midi, afin de rendre ces tons chauds. Photos extraites d'un livre consacré à la ville Lumière.

PAGES 168-169 PHOTOGRAPHER: *Deborah Brackenbury* CAMERA: *Mamiya C330 and Canon F1* FILM: *Fujicolor 400* COUNTRY: *USA* ■ *"Whirligigs," "Sectional," and "Twain." From a documentary study around the small southern town of Archer, Florida, where the photographer lived for seven years. She focused on how human beings and nature interfere with each other so as to form a hybrid environment in which neither is wholly comfortable. The images are meant to jar and unsettle.* ● *Die Aufnahmen gehören zu einer Serie über die Kleinstadt Archer in Florida, wo die Photographin sieben Jahre lang lebte. Sie konzentrierte sich auf das Verhältnis zwischen Mensch und Natur und die daraus entstandene hybride Umwelt, die weder dem Menschen noch der Natur ganz entspricht. Mit diesen Bildern will sie die Menschen schockieren und aufrütteln.* ▲ *Photos extraites d'une étude documentaire sur une petite ville de Floride, Archer, où la photographe a vécu sept ans. Elle s'est concentrée sur les interférences entre les êtres humains et la nature, qui résultent en un environnement hybride, finalement très insatisfaisant pour les deux. Ces images visent à perturber.*

PAGE 170 PHOTOGRAPHER: *Randy Wells* CAMERA: *Leica* FILM: *Fujichrome* EXPOSURE: *F5.6/¹⁄₅₀₀ second* COUNTRY: *USA* ■ *Sun City, Arizona. "Aerials of US Towns" was a self-assigned project to portray US cities from the air. The photographer wanted to portray a cross-section of geographical settings and applied architectural patterns as part of a book of photographs on America.* ● *Sun City, Arizona. Luftaufnahmen von Städten in den USA. Bei diesem Projekt, das Teil eines Buches mit Bildern aus Amerika werden soll, wollte der Photograph verschiedene geographische Gegebenheiten und architektonische Muster zeigen.* ▲ *Sun City, Arizona. «Photos aériennes de villes américaines», tel était le nom d'un projet personnel visant à présenter des villes américaines vues du ciel, dans le cadre d'un livre sur l'Amérique. Le photographe a voulu montrer un échantillon des différents sites géographiques et modèles architecturaux.*

PAGE 172 PHOTOGRAPHER: *Harry De Zitter* CLIENT: *Mercedes Benz* CAMERA: *Bronica SQ1* FILM: *Ilford HP 5* EXPOSURE: *F11/1 second.* ART DIRECTOR: *Deborah Girard* AGENCY: *The Designory* COUNTRY: *USA* ■ *This photograph is part of a series for the S-class Mercedes Benz. The photographer wanted to capture the energy and feel of New York City.* ● *Diese Aufnahme gehört zu einer Serie über die S-Klasse von Mercedes Benz. Energie und Atmosphäre der Stadt New York waren das Thema des Photographen.* ▲ *Cette photographie est extraite d'une série sur la Mercedes Benz Classe S. Le photographe a voulu rendre l'énergie et l'atmosphère de New York.*

PAGE 173 PHOTOGRAPHER: *Dieter Leistner* PUBLISHER/CLIENT: *HÄUSER/Gruner + Jahr* FILM: *Fuji RDP II* COUNTRY: *Germany* ■ *Image of an empty house in France, from an article in HÄUSER.* ● *Ein leerstehendes Haus in Frankreich, photographiert für einen Wohnartikel in der Zeitschrift HÄUSER.* ▲ *Maison abandonnée en France. Cette photo illustrait un article sur l'habitat publié dans le magazine HÄUSER.*

PAGE 173 PHOTOGRAPHER: *Dieter Leistner* CLIENT: *ERCO* CAMERA: *Silvestri* FILM: *Kodak EP4* COUNTRY: *Germany* ■ *Private house in Lüdenscheidt, Germany, built by London architect Norman Forster. The images appeared in various architectural magazines.* ● *Ein Wohnhaus in Lüdenscheidt, entworfen von dem Londoner Architekten Norman Forster. Die Bilder erschienen in verschiedenen Architekturfachzeitschriften.* ▲ *Demeure privée à Lüdenscheidt, conçue par l'architecte londonien Norman Forster. Les photos ont paru dans diverses revues spécialisées.*

PAGE 173 PHOTOGRAPHER: *Dieter Leistner* PUBLISHER: *ARCHITEKTUR & WOHNEN* CAMERA: *Silvestri* FILM: *Fuji RHP* COUNTRY: *Germany* ■ *This garage built by architect Daniel Buren in Lyon, France, was the subject of a feature in the magazine ARCHITEKTUR & WOHNEN.* ● *Das von Daniel Buren entworfene Parkhaus in Lyon war Gegenstand einer Reportage in der Zeitschrift ARCHITEKTUR UND WOHNEN.* ▲ *Conçu par l'architecte Daniel Buren, ce parking a fait l'objet d'un reportage publié dans le magazine ARCHITEKTUR UND WOHNEN.*

PAGE 173 PHOTOGRAPHER: *David Everitt* CAMERA: *Nikon F-3* FILM: *Fuji RFP* EXPOSURE: *F5.6/¹⁄₆₀ second* DESIGNER: *Thomas Thurneaur* COUNTRY: *USA* ■ *Images from the series "Thomas' Dollhouse."* ● *Bilder aus einer Reihe mit dem Titel «Thomas' Puppenhaus».* ▲ *Images de la série «La maison de poupée de Thomas».*

PAGE 174 PHOTOGRAPHER: *Dan Weaks* COUNTRY: *USA* ■ *"Calcutta Market," "East Bound Holland Tunnel," "World's Largest Steam Locomotive," "New Jersey Condos," and "Election Day, Quito, Ecuador." These previously unpublished pictures are excerpted from a series on street elevations of towns and cities around the world. They were taken from 1982 through to the present.* ● *«Markt in Kalkutta»; «Holland-Tunnel nach Osten»; «Die grösste Dampflok der Welt»; «Eigentumswohnungen in New Jersey» und «Wahltag in Quito, Ecuador». Diese bisher unveröffentlichten Aufnahmen gehören zu einer Reihe über Strassenzüge in Städten in aller Welt. Die Bilder sind zwischen 1982 und heute entstanden.* ▲ *«Marché à Calcutta», «East Bound Holland Tunnel», «La plus grande locomotive à vapeur du monde», «Copropriétés dans le New Jersey», «Jour d'élections à Quito, Equateur». Ces images inédites proviennent d'une série de scènes de rues, réalisées dans différentes villes de la planète. Elles ont été prises entre 1982 et aujourd'hui.*

PAGE 175 PHOTOGRAPHER: *Dudley DeNador* CLIENT: *PKF Consulting* CAMERA: *Nikon 8008* FILM: *Kodak Pro 400* EXPOSURE: *F8/¹⁄₁₀₀₀ second* ART DIRECTOR: *Dudley DeNador* DESIGNER: *Dudley DeNador* COUNTRY: *USA* ■ *This aerial photo was taken while returning to Sausalito Airport in a Bell Jet Ranger helicopter with the door removed. The pilot suggested flying over the north tower of the Golden Gate Bridge. As the pilot banked and spiraled over the tower, the photographer held his breath and shot a series of photos. This shot was subsequently used for the cover of "Trends in the Hotel Industry International Edition 1995."* ● *Diese Luftaufnahme wurde durch die offene Tür eines Hubschraubers auf dem Weg zum Sausalito-Flughafen gemacht. Als der Pilot den nördlichen Turm der Golden Gate Bridge umkreiste und in Querlage ging, hielt der Photograph den Atem an und machte eine Reihe von Bildern. Diese Aufnahme wurde später für den Umschlag der internationalen Ausgabe 1995 von «Trends in der Hotelbranche» verwendet.* ▲ *Cette photo aérienne a été réalisée à bord d'un hélicoptère Bell Jet Ranger, sans porte, se dirigeant sur l'aéroport de Sausalito. Le pilote a proposé un survol de la tour nord du Golden Gate Bridge. Quand l'avion s'est incliné sur l'aile, puis est monté en flèche, le photographe a retenu son souffle et fait cette série d'images. Celle-ci fut ensuite utilisée pour la couverture de l'édition internationale 1995 des «Tendances de l'industrie hôtelière».*

PAGE 176 PHOTOGRAPHER: *J. Peter Pawlak* CAMERA: *Minolta Maxxum 7000* FILM: *Kodak* COUNTRY: *USA* ■ *These photos are of the monastery "La Tourette" designed by Le Corbusier and located in southern France. The photographer is a practicing architect and studies buildings through drawings and photographs. He spent two weeks drawing and measuring the structure and later used a camera to study the landscape as part of the building's exterior.* ● *Aufnahmen des Klosters «La Tourette» in Südfrankreich, das von Le Corbusier entworfen wurde. Der Photograph ist selbst Architekt und studiert Gebäude anhand von Plänen und Photographien. Er verbrachte zwei Wochen damit, die Struktur auszumessen und zu zeichnen; später benutzte er die Kamera, um die Landschaft als Teil des Äusseren des Gebäudes zu erfassen.* ▲ *Photos du monastère La Tourette, situé dans le Sud de la France et conçu par Le Corbusier. Le photographe exerce le métier d'architecte et étudie les bâtiments à partir de dessins et de photographies; il a passé deux semaines à dessiner et à mesurer la structure, puis il est passé à la photo pour étudier le paysage, considéré comme partie intégrante de l'extérieur du bâtiment.*

PAGE 177 PHOTOGRAPHER: *Stefan Longin* CAMERA: *Hasselblad* FILM: *Kodak TRI-X* ART DIRECTOR: *Stefan Longin* COUNTRY: *Germany* ■ *"View."* ● *«Ausblick» ist das Thema dieser Aufnahme.* ▲ *«Vue», tel est le thème de cette photographie.*

PAGE 178 PHOTOGRAPHER: *Frances Mocnik* CAMERAS: *Nikon 801, Toyo 4x5"* FILM: *Ilford FP4, Kodak Technical Pan* EXPOSURE: *Various* COUNTRY: *Australia* ■ *The High Court, Canberra, Australia. The strength and direction of line, together with manipulated contrast, combine to create the photographer's architectural perception of law.* ● *Das Obergericht in Canberra, Australien. Die kraftvolle Komposition, die Stärke und die klaren Linien, kombiniert mit den manipulierten Kontrasten, sind die architektonische Interpretation dessen, was der Photograph sich unter der Rechtssprechung*

vorstellt. ▲ *La Cour suprême de Canberra, Australie. Pour le photographe, la loi est à l'image de cette composition architectonique qui allie force, puissance, lignes rigoureuses, combinées à des contrastes manipulés.*

PAGE 179 PHOTOGRAPHER: *Hale Coughlin* CAMERA: *ETRS* FILM: *Kodak Ektachrome 100 Plus* EXPOSURE: *F11/8 seconds.* COUNTRY: *USA* ■ *This uncommissioned image was taken because the photographer wanted to portray how massive and spectacular the structure was.* ● *Bei dieser Aufnahme ging es dem Photographen um die massive, spektakuläre Konstruktion.* ▲ *Par cette photo personnelle, le photographe a voulu illustrer l'aspect massif et spectaculaire de la construction.*

PAGES 180, 182 PHOTOGRAPHER: *Luciano Morini* PUBLISHER: *Maurizio Bonas* CAMERA: *Hasselblad* FILM: *Kodak Plus-X* EXPOSURE: *Flash* ART DIRECTORS: *Jean Yves Malbos, Paolo Bonsignore* AGENCY: *Malbos Bonsignore* COUNTRY: *Italy* ■ *Stuffed birds brought to life for a fashion catalog. On opposite pages they were matched with their human male counterparts.* ● *Ausgestopfte Vögel, zum Leben erweckt für einen Modekatalog, in dem sie mit ihren menschlichen Gegenstücken männlichen Geschlechts präsentiert werden.* ▲ *Oiseaux empaillés, ramenés à la vie pour une série de photos publiée dans un catalogue de mode où ils ont été présentés avec leurs pendants humains de sexe masculin.*

PAGE 183 PHOTOGRAPHER: *Joseph Brazan* REPRESENTATIVE: *Impact Public Relations* CLIENT: *Landscape Industry Promotion Fund* CAMERA: *Dog–Minolta XD-11; Fence-Minolta 700si* FILM: *Dog-Kodak Tri-X; Fence-Ektachrome 200* EXPOSURE: *Dog-F16/ $^1/_{250}$ second; Fence-F11/ $^1/_{125}$ second* ART DIRECTOR: *Joseph Brazan* COUNTRY: *USA* ■ *"Watch Dog" is a composite computerized image. The horizontal photo of the fence was flipped vertically so the picture of the photographer's Great Dane, taken ten years earlier, would fill the hole. By manipulating the images on an office copier, the photographer was able to get the size and perspective he wanted, and turned over the elements for digital imaging for a final computerized composite print. The dog was colorized, but the fence color was preserved from the original transparency.* ● *«Wachhund.» Die horizontale Aufnahme eines Zauns wurde vertikal verwendet, damit der Kopf des Hundes, der bereits vor zehn Jahren aufgenommen wurde, in das Loch gesetzt werden konnte. Der Photograph manipulierte die Bilder auf einem einfachen Photokopiergerät und gab die Elemente dann zur digitalen Verarbeitung weiter. Die Dänische Dogge des Photographen wurde koloriert, aber die Farbe des Zauns wurde originalgetreu übernommen.* ▲ *«Chien de garde». L'image horizontale de la clôture a été utilisée verticalement pour que la tête du chien, photographiée dix ans auparavant, remplisse le trou. Le photographe a manipulé les images sur une simple photocopieuse, puis elles ont été retravaillées sur ordinateur. Le dog danois du photographe a été coloré, tandis que la couleur de la clôture a conservé sa couleur originale.*

PAGE 184 PHOTOGRAPHER: *Claudio Alessandri* REPRESENTATIVE: *Stefano Tartini* CAMERA: *Polaroid 50x60* FILM: *Polaroid* CAMERA OPERATOR: *Jan Hnizdo* ART DIRECTOR: *Claudio Alessandri* COUNTRY: *Austria* ■ *The tail of a chameleon, an uncommissioned study.* ● *Der Schwanz eines Chamäleons—eine freie Studie des Photographen.* ▲ *La queue d'un caméléon - étude libre du photographe.*

PAGE 185 PHOTOGRAPHER: *Oliver Meckes* DIGITAL IMAGING: *Nicole Ottawa* PUBLISHER/ CLIENT: *GEO/Gruner + Jahr* COUNTRY: *Germany* ■ *Side and front view of a fruit fly, 2mm big. Its larvae have huge chromosomes which makes it a favorite object for gene manipulation. The remaining four images show mutants (gene-manipulated flies) with legs as antennas, eyes at the antennas, eyes on the wings, and with four wings. For the screen electrode micro shots, the flies were killed, dehydrated, and gilded. In a second step, the digital black-and-white images were colored on a Macintosh computer to create the insects' natural colors.* ● *Seiten- und Vorderansicht einer ca. 2 mm grossen Fruchtfliege (Drosophilia melanogaster). Wegen der Riesenchromosomen der Larven ist die Fliege ein beliebtes Objekt der Genforschung. Die übrigen vier Bilder zeigen Mutanten: mit Beinen als Fühler, Augen an den Fühlern, Augen an den Flügeln und mit vier Flügeln. Für die Aufnahmen mit einem Elektronenmikroskop (R.E.M.) wurden die Insekten getötet, entwässert und vergoldet. Die digitalen Schwarzbilder des R.E.M. wurden in einem zweiten Schritt am Mac farbig nachgearbeitet, so dass das Insekt seine natürliche Farbe zurückerhielt.* ▲ *Vues latérale et frontale d'une mouche du vinaigre*

mesurant env. 2mm (drosophilia melanogaster). La taille énorme des chromosomes de ses larves en fait un objet d'études privilégié en matière de manipulation génétique. Les quatre autres images présentent des mutantes avec des pattes comme antennes, des yeux aux antennes, des yeux sur les ailes et quatre ailes. Pour pouvoir être pris au microscope électronique R.E.M., les insectes ont d'abord été tués, puis déshydratés et dorés. Ensuite, les photos numériques noir et blanc en résultant ont été colorées sur un Mac pour rendre aux insectes leurs couleurs naturelles.

PAGE 186 PHOTOGRAPHER: *John Huet* REPRESENTATIVE: *Robin Dictenberg* CLIENT: *Omolene* CAMERA: *Pentax 6X7* FILM: *Kodak Tri-X* ART DIRECTOR: *Eric Tilford* AGENCY: *Simmons, Durham & Assoc.* COUNTRY: *USA* ■ *The photographer wanted to capture the power of horses in these images.* ● *Bei dieser Aufnahme ging es dem Photographen um die Kraft der Pferde.* ▲ *Le photographe a voulu faire transparaître la puissance des chevaux.*

PAGE 187 PHOTOGRAPHER: *Jody Dole* REPRESENTATIVE: *Kathy Bruml* CLIENT: *Simpson Paper* CAMERA: *Nikon N90S, Hasselblad, Phase 1* FILM: *Fuji Velvia, Digital Back* DESIGNERS: *Dave Mason, John Van Dyke* COUNTRY: *USA* ■ *Images created for Simpson Paper.* ● *Aufnahmen für den Papierhersteller Simpson Paper.* ▲ *Images pour le fabricant de papier Simpson Paper.*

PAGES 188-189 PHOTOGRAPHER: *Steve Grubman* REPRESENTATIVE: *Carolyn Somlo* CLIENT: *Steve Grubman Photography* CAMERA: *Hasselblad* FILM: *EPN* ART DIRECTOR: *Steve Liska* DESIGNER: *Kim Fry* DESIGNER: *Amy Stanec* AGENCY: *Liska and Associates* COUNTRY: *USA* ■ *These images were created for a promotional book showcasing the photographer's specialty, animal photography. The book was oversized to contribute to the whimsical nature of the imagery and to help differentiate it from other promotions.* ● *Aufnahmen für einen Eigenwerbungskatalog des Photographen, der sich auf Tierphotographie spezialisiert hat. Er wählte ein Überformat, um sich von ähnlichen Katalogen der Konkurrenz zu unterscheiden, aber auch um dem merkwürdigen Charakter der Bilder gerecht zu werden.* ▲ *Images réalisées pour un catalogue autopromotionnel du photographe, spécialisé dans la photographie animalière. Il a opté pour un grand format afin de se distinguer de la concurrence et de mieux rendre le caractère étrange de ses photographies.*

PAGE 190 PHOTOGRAPHER: *Michael Kammerdiener* REPRESENTATIVE: *Naturescapes* CAMERA: *Nikon FM-2, SB-24 fill flash* FILM: *Fuji Velvia* EXPOSURE: *F5.6/ $^1/_{250}$ second* COUNTRY: *USA* ■ *Image created as part of a self-promotional series of wildlife portraits. Emphasis was placed on the tropical hues of the Greater Flamingo at the Honolulu Zoo.* ● *Die Aufnahme gehört zu einer Serie von Tierporträts. Hier ging es um die tropischen Färbungen einer Flamingoart im Zoo von Honolulu.* ▲ *Image extraite d'une série de portraits d'animaux. L'accent a été mis sur les colorations tropicales d'une espèce de flamands du zoo de Honolulu.*

PAGE 191 PHOTOGRAPHER: *Mark Laita* CAMERA: *Fatif 8X10", Schneider 355mm* FILM: *Kodak T-Max 100* ART DIRECTOR: *Mark Laita* AGENCY: *Mark Laita Photography* COUNTRY: *USA* ■ *The photographer felt the rich earth tones and subtle lighting of these images reflected the beauty found in nature. All images were created in the studio.* ● *Diese Aufnahmen entstanden im Studio. Das Thema des Photographen war die Art von Schönheit, die man in der Natur findet, interpretiert mit vollen, erdigen Farben und subtiler Beleuchtung.* ▲ *La beauté de la nature exprimée à travers les tons chauds de la terre et grâce à un éclairage subtil. Toutes les photographies ont été prises en studio.*

PAGE 192 PHOTOGRAPHER: *Michael Melford* REPRESENTATIVE: *Travel Holiday* PUBLISHER: *READER'S DIGEST* CAMERA: *Nikon F/4* FILM: *Fuji Velvia* ART DIRECTOR: *Lou DiLorenzo* DIRECTOR OF PHOTOGRAPHY: *Bill Black* ONLINE PHOTO EDITOR: *Stephanie Syrop* PHOTO COORDINATOR: *Sandy Perez* COUNTRY: *USA* ■ *The photographer's assignment was to illustrate a travel piece on Cabo San Lucas, Mexico, a popular fishing area. Although many fish are killed for sport there, "catch and release" is gaining in popularity.* ● *Bei diesem Auftrag ging es um einen Reisebericht über Cabo San Lucas, Mexiko, ein beliebtes Ausflugsziel von Sportfischern. Obwohl noch viele Fische zum Spass getötet werden, setzt sich die Methode von Fangen und Freilassen immer mehr durch.* ▲ *Pour cette commande, il s'agissait de fournir des images pour un article consacré à Cabo San Lucas, Mexique, un endroit privilégié des pêcheurs. Même si*

beaucoup de poisssons sont encore tués par plaisir, la méthode «attraper et relâcher» fait de plus en plus d'adeptes.

PAGE 193 PHOTOGRAPHER: *Steve Grubman* REPRESENTATIVE: *Carolyn Somlo* CLIENT: *Steve Grubman Photography* ART DIRECTOR: *Steve Liska* DESIGNER: *Kim Fry* AGENCY: *Liska and Associates* COUNTRY: *USA* ■ *This image was created to showcase the photographer's specialty, animal photography.* ● *Mit dieser Aufnahme demonstriert der Photograph sein Können in seinem Spezialgebiet, der Tierphotographie.* ▲ *Image destinée à montrer la spécialisation du photographe, à savoir la photographie animalière.*

PAGE 194 PHOTOGRAPHER: *Amos Chan* FILM: *Kodak Tri-X* COUNTRY: *USA* ■ *Photograph used for self-promotion.* ● *Als Eigenwerbung verwendete Aufnahme.* ▲ *Photographie autopromotionnelle.*

PAGE 195 PHOTOGRAPHER: *Alen MacWeeney* PUBLISHER: *DEPARTURES/Palm Press* CAMERA: *Leica* FILM: *PKL 200* EXPOSURE: *F11/¹/₄₅ second* ART DIRECTOR: *Bernard Schaaf* COUNTRY: *USA* ■ *Image of a Borzoi, originally made for DEPARTURES magazine, and then used for a self-promotional postcard. The photographer used strobe lighting and the background was painted to reflect the dog's personality.* ● *Aufnahme eines russischen Windhundes für die Zeitschrift DEPARTURES. Der Photograph arbeitete mit Strobe-Licht und bemaltem Hintergrund, um die Persönlichkeit des Hundes zum Ausdruck zu bringen.* ▲ *Image d'un lévrier russe pour le magazine DEPARTURES. Le photographe a travaillé avec un éclairage stroboscopique, et le fond a été peint pour faire ressortir la personnalité du chien.*

PAGES 196, 198 PHOTOGRAPHER: *John Huet* CLIENT: *Nike* CAMERA: *Pentax 6X7* FILM: *Kodak Tri-X* ART DIRECTOR: *John C. Jay* DESIGNER: *Pao* AGENCY: *Wieden & Kennedy* COUNTRY: *USA* ■ *Images from "Trash Talk," one component of a New York City multimedia campaign which celebrated New York's love for basketball. The campaign ran only in New York.* ● *«Geschwätz» war eine Komponente einer Multimedia-Kampagne, in der es um die Vorliebe der New Yorker für Basketball ging. Die Kampagne lief ausschliesslich in New York.* ▲ *«Bavardage» fait partie d'une campagne multimédia sur la passion des New-Yorkais pour le basket. Cette campagne se limitait à la ville de New York.*

PAGE 199 PHOTOGRAPHER: *Jim Erickson* REPRESENTATIVE: *David Custack* CLIENT: *Bauer* ART DIRECTOR: *Greg Boker* DIGITAL IMAGING: *Wes Hardison* AGENCY: *Leonard Monahan* COUNTRY: *USA* ■ *Photograph from an assignment for Bauer inline skates.* ● *Die Aufnahme entstand im Auftrag für Inline-Skates der Firma Bauer.* ▲ *Commande pour les inline skates de la société Bauer.*

PAGE 200 PHOTOGRAPHER: *Monica Stevenson* CAMERA: *Holga* FILM: *Kodak Tri-X* ART DIRECTOR: *Monica Stevenson* COUNTRY: *USA* ■ *Picture from a personal series on hors-es and horse-related activities. This is a scene from the Far Hills Steeplechase in New Jersey. A Holga camera was used to create an antiquated look.* ● *Die Aufnahme gehört zu einer Studie der Photographin über Pferde und mit Pferden verbundene Tätigkeiten. Diese Szene wurde in den Far Hills Steeplechase in New Jersey aufgenommen. Die Holga-Kamera sorgte für den antiquierten Touch.* ▲ *Image extraite d'une étude sur les chevaux et les activités équestres. Cette scène a été prise dans les Far Hills Steeplechase, New Jersey. L'utilisation d'un Holga a permis de conférer cette touche ancienne.*

PAGE 201 PHOTOGRAPHER: *Matthew Atanian* REPRESENTATIVE: *Pamela Black* CLIENT: *North Sails Catalog* CAMERA: *Canon EOS-IN* FILM: *Fuji Provia* ART DIRECTOR: *Mark Smith* COUNTRY: *USA* ■ *The photographer climbed up to the top of a 110-foot mast to shoot down on the subject in this photo. At the same time, he prepared a second camera and framed the shot for his assistant to shoot after he was up the mast. He was able to take advantage of the sunset from two angles at one time.* ● *Für diese Aufnahme stieg der Photograph auf einen ca. 35m hohen Mast. Er hatte eine zweite Kamera vorbereitet, seinen Assistenten an einem bestimmten Ort postiert und sich mit ihm verständigt, so dass sie die Szene gleichzeitig aus zwei Blickwinkeln einfangen konnten.* ▲ *Pour prendre cette image, le photographe a tout d'abord dû monter sur un mât d'environ 35 m. Il avait préparé un deuxième appareil pour son assistant posté à un endroit précis afin que tous deux prennent au même moment cette scène sous des angles différents.*

PAGE 202 PHOTOGRAPHER: *John Huet* REPRESENTATIVE: *Marilyn Cadenbach* CLIENT: *Gatorbar* CAMERA: *Pentax 6X7* FILM: *Polaroid 665* EXPOSURE: *F4/ ¹/₆₀ second* ART DIRECTOR: *Steve Wowinder* AGENCY: *Bayer Bess Vanderwalker* ■ *This unpublished image was scanned into a computer from a black-and-white polaroid and then color was added.* ● *Diese ursprünglich schwarzweisse Polaroid-Aufnahme wurde mit Hilfe des Computers koloriert.* ▲ *Ce polaroïd noir et blanc a été coloré sur ordinateur.*

PAGE 203 PHOTOGRAPHER: *John Huet* REPRESENTATIVE: *Marilyn Cadenbach* CLIENT: *Friends of Rickwood Field* CAMERA: *Graphflex* FILM: *Polaroid Type 55* ART DIRECTOR: *Gregg McGough* AGENCY: *Slaughter-Hanson Advertising* CAMERA: *Linhof* FILM: *Polaroid Type 55* COUNTRY: *USA* ■ *These images are from a series for a fundraising campaign for Rickwood Field, the oldest baseball park in America. The park is located in Birmingham, Alabama, where teams still play baseball in vintage uniforms.* ● *Die Aufnahmen wurden in einer Benefizkampagne zugunsten von Rickwood Field, dem ältesten Baseball-Gelände in Amerika, verwendet. Es befindet sich in Birmingham, Alabama, und die Mannschaften spielen hier noch im alten Dress.* ▲ *Images utilisées pour une campagne destinée à la collecte de fonds pour le Rickwood Field, le plus vieux terrain de baseball en Amérique qui se trouve à Birmingham, Alabama. Les équipes qui y jouent portent encore les équipements d'époque.*

. .

PHOTOGRAPHERS

. .

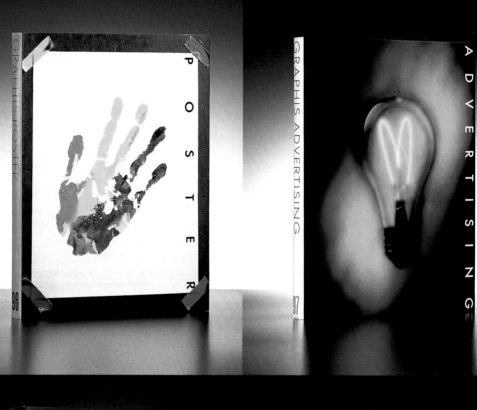

GRAPHIS BOOKS

BOOKS	ALL REGIONS
☐ BLACK & WHITE BLUES (HARDCOVER)	US$ 69.95
☐ BLACK & WHITE BLUES (PAPERBACK)	US$ 45.95
☐ GRAPHIS ADVERTISING 97	US$ 69.95
☐ GRAPHIS ALTERNATIVE PHOTOGRAPHY 95	US$ 69.95
☐ GRAPHIS ANNUAL REPORTS 5	US$ 69.95
☐ GRAPHIS BOOK DESIGN	US$ 75.95
☐ GRAPHIS BROCHURES 2	US$ 75.00
☐ GRAPHIS CORPORATE IDENTITY 2	US$ 75.95
☐ GRAPHIS DESIGN 97	US$ 69.95
☐ GRAPHIS EPHEMERA	US$ 75.95
☐ GRAPHIS FINE ART PHOTOGRAPHY	US$ 85.00
☐ GRAPHIS INFORMATION ARCHITECTS	US$ 49.95
☐ GRAPHIS MUSIC CDS	US$ 75.95
☐ GRAPHIS NUDES (PAPERBACK)	US$ 39.95
☐ GRAPHIS PACKAGING 7	US$ 75.00
☐ GRAPHIS PHOTO 96	US$ 69.95
☐ GRAPHIS POSTER 96	US$ 69.95
☐ GRAPHIS PRODUCTS BY DESIGN	US$ 69.95
☐ GRAPHIS SHOPPING BAGS	US$ 69.95
☐ GRAPHIS TYPOGRAPHY 1	US$ 69.95
☐ GRAPHIS TYPE SPECIMENS	US$ 49.95
☐ **GRAPHIS PAPER SPECIFIER SYSTEM (GPS)**	US$ 495.00
** ADD $30 SHIPPING/HANDLING FOR GPS	
☐ HUMAN CONDITION	US$ 49.95
☐ SHORELINE	US$ 85.95
☐ WATERDANCE (PAPERBACK)	US$ 24.95
☐ WORLD TRADE MARKS 1OO YRS.(2 VOL. SET)	US$ 250.00

NOTE! NY RESIDENTS ADD 8.25% SALES TAX

☐ CHECK ENCLOSED (PAYABLE TO GRAPHIS)
(US$ ONLY, DRAWN ON A BANK IN THE USA)

USE CREDIT CARDS (DEBITED IN US DOLLARS)

☐ AMERICAN EXPRESS ☐ MASTERCARD ☐ VISA

CARD NO. _____ EXP. DATE _____

CARDHOLDER NAME _____

SIGNATURE _____

(PLEASE PRINT)

NAME _____

TITLE _____

COMPANY _____

ADDRESS _____

CITY _____

STATE/PROVINCE _____ ZIP CODE _____

COUNTRY _____

SEND ORDER FORM AND MAKE CHECK PAYABLE TO:
GRAPHIS INC.,
141 LEXINGTON AVENUE, NEW YORK, NY 10016-8193, USA

GRAPHIS MAGAZINE

MAGAZINE	USA	CANADA	SOUTHAMERICA/ ASIA/PACIFIC
☐ ONE YEAR (6 ISSUES)	US$ 89.00	US$ 99.00	US$ 125.00
☐ TWO YEARS (12 ISSUES)	US$ 159.00	US$ 179.00	US$ 235.00
☐ AIRMAIL SURCHARGE (6 ISSUES)	US$ 59.00	US$ 59.00	US$ 59.00

☐ ONE YEAR (6 ISSUES) US$ 59.00
FOR STUDENTS WITH COPY OF VALID STUDENT ID AND
PAYMENT WITH ORDER

☐ CHECK ENCLOSED ☐ PLEASE BILL ME

USE CREDIT CARDS (DEBITED IN US DOLLARS)

☐ AMERICAN EXPRESS

☐ MASTERCARD

☐ VISA

CARD NO. _____ EXP. DATE _____

CARDHOLDER NAME _____

SIGNATURE _____

(PLEASE PRINT)

NAME _____

TITLE _____

COMPANY _____

ADDRESS _____

CITY _____

STATE/PROVINCE _____ ZIP CODE _____

COUNTRY _____

SERVICE BEGINS WITH ISSUE THAT IS CURRENT WHEN
ORDER IS PROCESSED.

SEND ORDER FORM AND MAKE CHECK PAYABLE TO:
GRAPHIS INC.,
141 LEXINGTON AVENUE, NEW YORK, NY 10016-8193, USA

(C9B0A)

CALL FOR ENTRIES

The Human Condition:
PHOTOJOURNALISM 97
ENTRY DEADLINE: AUGUST 31 1997

GRAPHIS PHOTO 98
ENTRY DEADLINE: AUGUST 31 1997

GRAPHIS DESIGN 98
ENTRY DEADLINE: DECEMBER 30 1996

Graphis Design 98 (Entry Deadline: December 30, 1996)

■ Annual reports, books, brochures, calendars, corporate identity/signage, currency, diagrams, editorial, ephemera, games, illustration, letterhead, logos, menus, music, new media, packaging, paper companies, posters, products, promotion, shopping bags, stamps, t-shirts. Eligibility: All work produced between December 1995 and December 1996. ●Jahresberichte, Bücher, Broschüren, Kalender, Corporate Identity/Beschilderungen, Geldnoten, Münzen, Diagramme, redaktionelles Design, Ephemera (kurzlebige Graphik), Spiele, Illustrationen, Briefschaften, Logos, Menus, CD Design, neue Medien, Packungen, Promotionen für Papierhersteller, Plakate, Produktdesign, Promotionsmaterial, Tragtaschen, Briefmarken, T-Shirts. In Frage kommen: Arbeiten, die zwischen Dezember 1995 und Dezember 1996 entstanden sind. ▲Rapports annuels, livres, brochures, calendriers, identité institutionnelle, billets de banque, monnaies, diagrammes, design rédactionnel, graphisme éphémère, jeux, illustrations, lettres, logos, menus, musique, nouveau médias, promotions des fabricants de papier, affiches, design de produits, matériel promotionnel, sacs, timbres, T-Shirts. Seront admis: les travaux réalisés entre décembre 1995 et décembre 1996.

The Human Condition: Photojournalism 97 (Entry Deadline: August 31, 1997)

■ Eligibility: All photojournalists may submit work produced between June 1, 1996 and August 31, 1997. ● In Frage kommen: Photojournalistische Arbeiten, die zwischen Juni 1996 und August 1997 entstanden sind. ▲ Seront admis: tous les travaux des photojournalistes réalisés entre juin 1996 et août 1996.

Graphis Photo 98 (Entry Deadline: August 31, 1997)

■ Fashion, journalism, still life, food, people, products, landscapes, architecture, wildlife, sports. Photographs taken for consumer or trade magazines, newspapers, books and corporate publications. Personal studies, experimental or student work on any subject. Eligibility: All work produced between September 1996 and August 1997. ● Mode, Journalismus, Stilleben, Lebensmittel, Menschen, Sachaufnahmen, Landschaften, Architektur, Tiere, Sport. Photos für Zeitschriften, Zeitungen, Bücher und Firmenpublikationen. Persönliche Studien, Experimentelle Aufnahmen oder Studentenarbeiten. In Frage kommen: Arbeiten, die zwischen September 1995 und August 1996 entstanden sind. ▲ Mode, journalisme, nature morte, cuisine, personnes, produits, paysages, architecture, animaux, sport. Reportages pour magazines et journaux, livres et publications d'entreprise. Études personnelles, créations expérimentales ou projets d'étudiants. Seront admis: tous les travaux réalisés entre septembre 1996 et août 1997.

■ **What to send:** Reproduction-quality duplicate transparencies (4"x5" or 35mm), printed piece, or both. Transparencies are required for large, bulky or valuable pieces. ALL 35MM SLIDES MUST BE CARDBOARD-MOUNTED. NO GLASS SLIDE MOUNTS! *Please mark the transparencies with your name.* If you send printed pieces, they should be unmounted. WE REGRET THAT ENTRIES CANNOT BE RETURNED. ● **Was einsenden:** Wenn immer möglich, schicken Sie uns bitte reproduktionsfähige Duplikatdias. *Bitte Dias mit Ihrem Namen versehen.* Bitte schicken Sie auf keinen Fall Originaldias. KLEINBILDDIAS BITTE IM KARTONRAHMEN, KEIN GLAS! Falls Sie uns das gedruckte Beispiel schicken, bitten wir Sie, dieses gut geschützt aber nicht aufgezogen zu senden. WIR BEDAUERN, DASS EINSENDUNGEN NICHT ZURÜCKGESCHICKT WERDEN KÖNNEN. ▲**Que nous envoyer:** Nous vous recommandons de nous faire parvenir de préférence des duplicata de diapositives 4x5" ou 35mm. N'oubliez pas d'inscrire votre nom dessus). NE PAS ENVOYER DE DIAPOSITIVES SOUS VERRE! Si vous désirez envoyer des travaux imprimés, protégez-les, mais ne les montez pas sur carton. NOUS VOUS SIGNALONS QUE LES ENVOIS QUE VOUS NOUS AUREZ FAIT PARVENIR NE POURRONT VOUS ÊTRE RETOURNÉS.

■ **How to package your entry:** Please tape (do not glue) the completed entry form (or a copy) to the back of each piece. Also enclose an extra photocopy of the entry form. Please do not send anything by air freight. Write "No Commercial Value" on the package, and label it "Art for Contest." ● Wie und wohin senden: Bitte befestigen Sie das ausgefüllte Einsendeetikett (oder eine Kopie davon) mit Klebstreifen auf jeder Arbeit und legen Sie noch ein Doppel davon lose bei. Bitte auf keinen Fall per Luftfracht senden. Deklarieren Sie «Ohne jeden Handelswert» und «Arbeitsproben für Wettbewerb». ▲ Comment préparer votre envoi: Veuillez scotcher (ne pas coller) au dos de chaque spécimen les étiquettes dûment remplies. Nous vous prions également de faire un double de chaque étiquette, que vous joindrez à votre envoi, mais sans le coller ou le fixer. Ne nous expédiez rien en fret aérien. Indiquez «Sans aucune valeur commerciale» et «Echantillons pour concours».

■ **Entry fees:** Single Entries: North America US$25; Germany DM 25,00; all other countries SFr 25.00. Campaign or series of three or more pieces entered in a single contest category: North America US$65, Germany DM 65,00; all other countries SFr 65.00. Students entry fees (please send copy of student identification): US$15 for each single entry, US$35 for each campaign or series of three or more pieces entered in a single contest category. ● **Einsendegebühren:** Für jede einzelne Arbeit: DM 25,00/SFr 25.00. Für jede Kampagne oder Serie von drei oder mehr Stück: DM 65,00/SFr 65.00. Einsendegebühren für Studenten (Ausweiskopie mitschicken): Für jede einzelne Arbeit: DM 15,00/SFr 15.00. Für jede Kampagne oder Serie von drei oder mehr Stück: DM 35,00/SFr 35.00. ▲ **Droits d'admission:** Envoi d'un seul travail: US$ 25/SFr. 25.00. Campagne ou série de trois travaux ou plus pour un seul concours: US$ 65/SFr. 65.00. Droits d'admission pour étudiants (veuillez envoyer une photocopie de la carte d'étudiant): $15/SFr. 15.00 pour un seul travail, $35/SFr. 35 pour chaque série de trois travaux ou plus.

■ **Where to send:** Make check payable to GRAPHIS, INC. and mail with entries. ● Wohin senden: Bitte senden Sie uns Ihre Arbeiten zusammen mit einem Scheck, ausgestellt in $US ▲Où envoyer: Veuillez envoyer vos travaux à Graphis, Inc. et joindre un chèque tiré sur une banque américain.

ENTRY FORMS

The Human Condition:
PHOTOJOURNALISM 97
ENTRY DEADLINE: AUGUST 31 1997

GRAPHIS PHOTO 98
ENTRY DEADLINE: AUGUST 31 1997

GRAPHIS DESIGN 98
ENTRY DEADLINE: DECEMBER 30 1996

I WISH TO ENTER THE ATTACHED IN THE FOLLOWING GRAPHIS COMPETITION:

☐ **THE HUMAN CONDITION: PHOTOJOURNALISM 97** (AUGUST 31, 1997)

☐ **GRAPHIS PHOTO 98** (AUGUST 31, 1997)
CATEGORY CODES

- ☐ PH1 FASHION
- ☐ PH2 JOURNALISM
- ☐ PH3 STILL LIFE
- ☐ PH4 FOOD
- ☐ PH5 PEOPLE
- ☐ PH6 PRODUCTS
- ☐ PH7 LANDSCAPES
- ☐ PH8 ARCHITECTURE
- ☐ PH9 WILDLIFE
- ☐ PH10 SPORTS

☐ **GRAPHIS DESIGN 98** (DECEMBER 30, 1996)
CATEGORY CODES

- ☐ DE1 ANNUAL REPORTS
- ☐ DE2 BOOKS
- ☐ DE3 BROCHURES
- ☐ DE4 CALENDARS
- ☐ DE5 CORPORATE IDENTITY/SIGNAGE
- ☐ DE6 CURRENCY
- ☐ DE7 DIAGRAMS
- ☐ DE8 EDITORIAL
- ☐ DE9 EPHEMERA
- ☐ DE10 GAMES
- ☐ DE11 ILLUSTRATION
- ☐ DE12 LETTERHEAD
- ☐ DE13 LOGOS
- ☐ DE14 MENUS
- ☐ DE15 MUSIC (CD DESIGN)
- ☐ DE16 NEW MEDIA
- ☐ DE17 PACKAGING
- ☐ DE18 PAPER COMPANIES
- ☐ DE19 POSTERS
- ☐ DE20 PRODUCTS
- ☐ DE21 PROMOTION
- ☐ DE22 SHOPPING BAGS
- ☐ DE23 STAMPS
- ☐ DE24 T-SHIRTS

SENDER _____ PRODUCT NAME _____

TELEPHONE _____ FAX _____

ART DIRECTOR _____ DESIGNER _____

DESIGN FIRM _____

STREET _____

CITY/STATE _____ ZIP/COUNTRY _____

TELEPHONE _____ E-MAIL ADDRESS _____

ILLUSTRATOR _____ MEDIUM _____

CITY/STATE _____ ZIP/COUNTRY _____

TELEPHONE _____ FAX _____

PHOTOGRAPHER & AGENCY _____ PRODUCT PHOTOGRAPHER _____

CITY/STATE _____ ZIP/COUNTRY _____

TELEPHONE _____ FAX _____

AUTHOR/ COPYWRITER _____ EDITOR _____

CITY/STATE _____ ZIP/COUNTRY _____

TELEPHONE _____ FAX _____

PRINTER/MANUFACTURER _____

PAPER _____ TYPEFACE _____

CLIENT/PUBLISHER _____

CITY/STATE _____ COUNTRY _____

ENTRANTS TO GRAPHIS PHOTO 97 & GRAPHIS PHOTOJOURNALISM 96: PROVIDE BRIEF CAPTION FOR EACH IMAGE AND SERIES OF IMAGES ALONG WITH INFORMATION ON CAMERA, FILM, SHUTTER SPEED AND APERTURE AS APPLICABLE. ENTRANTS TO GRAPHIS DESIGN 97: PROVIDE A BRIEF DESCRIPTION OF THE DESIGN PROBLEM & THE DESIGN SOLUTION.

SIGNATURE _____ DATE _____

COMPLETE FORM, TAPE IT TO ENTRY, ENCLOSE A PHOTOCOPY AND PAYMENT. SEND TO CLOSEST ADDRESS:
☐ PAYMENT ENCLOSED ☐ PAYMENT BY CREDIT CARD # _____ EXP. DATE _____
GRAPHIS BOOK CONTEST, C/O AMERICAN BOOK CENTER, BROOKLYN NAVY YARD, BLDG. #3, BROOKLYN, NY 11205 USA
GRAPHIS BOOK CONTEST, C/O CRONAT, PARC 3, F-68870 BARTENHEIM FRANCE

Paolo Marchesi

CAMP ROLLING HILLS

4

FREEFALL

MISSI

WIENER

Stacy Davidowitz

Amulet Books • New York

For Erica Finkel,
my fairy bookmother and bestie.

Cataloging-in-Publication Data has been applied for and may be obtained from the Library of Congress.

ISBN: 978-1-4197-2873-0

Text copyright © 2018 Stacy Davidowitz
Illustrations by Melissa Manwill
Book design by Pamela Notarantonio

Inspired by the original musical *Camp Rolling Hills*
Copyright © 2013 Adam Spiegel, David Spiegel, and Stacy Davidowitz
Music and lyrics by Adam Spiegel
Book and lyrics by David Spiegel & Stacy Davidowitz

Published in 2018 by Amulet Books, an imprint of ABRAMS. All rights reserved. No portion of this book may be reproduced, stored in a retrieval system, or transmitted in any form or by any means, mechanical, electronic, photocopying, recording, or otherwise, without written permission from the publisher.

Amulet Books and Amulet Paperbacks are registered trademarks of Harry N. Abrams, Inc.

Printed and bound in U.S.A.
10 9 8 7 6 5 4 3 2 1

Amulet Books are available at special discounts when purchased in quantity for premiums and promotions as well as fundraising or educational use. Special editions can also be created to specification. For details, contact specialsales@ abramsbooks.com or the address below.

ABRAMS The Art of Books
195 Broadway, New York, NY 10007
abramsbooks.com

THE CAMP ROLLING HILLS SERIES

Showing the Ropes

"The summer of the Meyer brothers is here at last," Wiener whispered to himself, fidgeting on the porch steps of Bunker Hill Cabin. He was afraid to blink—he didn't want to miss the moment his nine-year-old brother, Max, burst outside for his big brother–led tour!

Wiener had been looking forward to Max's first day of camp for five whole summers, ever since he started coming to the Hills. And now, Wiener was in the perfect position to show him around: He was officially a teenager. His biceps were baby boulders. And, most impressive of all, he had a sauce girlfriend! Wiener put his hands on his hips, all superhero, and took a deep breath of mountain air, but—even better—his lungs filled up with his own man-smell: Swagger cologne.

"Hi, Ernie!" Max raced out of the cabin, a huge smile smacked on his face.

"Waz up, Max! How's the unpacking going?"

"Good! I tried to color constellate—"

"Coordinate."

"—but I couldn't remember what colors go where."

"ROY G. BIV, man."

Max cocked his head.

Kids these days, Wiener thought. *So young. So much to learn.* "It's an acronym. Red. Orange. Yellow. Green. Blue. Indigo. Violet."

"Then where do camp shirts go, and also, what's indigo?"

"It's purplish blue, bro. Indigo is a type of plant used to dye jeans. So blue jeans should really be called indigo jeans." Wiener did not know why he knew stuff like this. Probably because at home he watched reruns of *Project Runway* for dating research, since women were complicated creatures. "And camp shirts can go in a separate pile," he added. "Easy access for inter-camp games if you play on sports teams, like me."

"Cool, yeah, that would be awesome."

"Sauce," Wiener corrected him. "That's what we say here: Awesome-*sauce*."

"Awesome-sauce."

Wiener and Max high-fived, and Wiener couldn't help but beam. "So," he said, "ready for the tour of a lifetime?"

"Where's the golf cart?" Max asked. "You said you'd drive me around in a golf cart."

Wiener vaguely remembered promising Max a golf cart tour like visiting families get for official Camp Rolling Hills tours, but only TJ and the Captain drove them, so he didn't really know what he'd been thinking. "Hmm," he said, like their golf cart had suddenly disappeared, and that sort of thing sometimes happened at camp. "You know what? I'll take you on a walking tour. With so many steep inclines, it's important for newbies to build up stamina early. Follow me!"

2

Wiener led the way down Bunker Hill and up San Juan Hill, pointing out cabins and fields and courts. He was trying not to breathe heavily, especially since Max was climbing with ease—his mouth stayed closed and he wasn't breathing like a monster through his nose. Wiener guessed that made sense. While his most rigorous cardio was walking the half mile to CVS for more leave-in conditioner, Max played junior lacrosse all spring. Wiener partly wished his asthmatic bunkmate, Steinberg, was on their tour, too, just to make him look better.

At the top of San Juan Hill, Wiener took a casual four-Mississippi pause to catch his breath, then he said, "So, I bet you'll be insta-cool like me when I started in Bunker Hill."

"Thanks," Max said. "It would be fun to have stories like yours."

Wiener smiled. "Like mine? What makes you say that?" He knew what made Max say that—the dozens of letters Wiener wrote him over the years. But Wiener was eager to hear which of his legendary stories Max was thinking of. It could have been Wiener's story about how he started the Dandi-Tape Trend, a makeshift boutonniere made out of a dandelion and Scotch tape. It could have been Wiener's story about how he got his nickname. (Wiener's real name was Ernest Meyer, which became Ernie, which became Bert from *Sesame Street*, which became Oscar the Grouch from *Sesame Street*, which became Oscar Mayer, who is the Hot Dog Guy, which paved the way for the nickname that had stuck: Wiener!) Or, really, it could have been any one of the amazing anecdotes he'd written to his brother back in the day.

3

"You know, like the ghost story," Max said.

Wiener racked his brain while they walked, trying to remember that one. He and the guys had told a lot of ghost stories last summer when they'd visited Camp Polio, the abandoned camp across the lake, but in Bunker Hill?

Max elaborated: "You told a scary ghost story and then one kid peed his pants!"

"Oh, yeaaah," Wiener said, remembering that one a bit differently from how he must have written it. He preferred the Max version. "Totally epic."

Now at the top of Tennis Hill, Wiener could see the lacrosse field up ahead, where his cabinmates—Totle, Play Dough, and Dover—were hanging out. Totle, the most athletic of the bunch and already tall, must have grown at least three inches taller over the winter, making him look like a ripped exclamation mark. He was playing catch with himself—throwing, sprinting, trapping, scooping, repeat. Play Dough, the hilarious leader of the pack, had maintained his robust figure, probably because he was always eating calories and then burning half of them with laughter. Even now, he was perched over the equipment crate, inhaling a hero sandwich. Dover, the cabin's resident Eagle Scout, was trying to steal the hero with a lacrosse stick. Also, he was sporting a Jew 'fro that had gotten so much 'fro-ier, Wiener made a mental note to let him sample his best mousses.

"Want to say hi to my friends?" Wiener asked, even though of course Max's answer would be yes. Wiener's friends were cool. In fact, they were the coolest.

"Let's do it!" Max said, right on cue.

As they got closer, Play Dough spotted them and called out, "LI'L WIENER!" He shoved his hero in his cargo-shorts pocket, ran up to them, threw Max over his shoulder, and began to spin. Slowly. "Dude, you're heavier than your brother! Actually . . ." He dropped Max to his feet and pushed him and Wiener back to back. Then he balanced a lacrosse stick across the top of their heads.

Uh-oh. Play Dough was doing the same thing Wiener's gym teacher had done a few years ago when he and his brother were in elementary school together. Except now, the height gap had gotten even smaller. Wiener took a deep breath and let his spine grow like he was a marionette.

"No way," Play Dough said.

"Holy cannoli," Dover said.

"Such great heights," Totle said.

Play Dough threw his hands up and shouted, "LI'L WIENER is BIG WIENER and BIG WIENER is LI'L WIENER!"

No! There was no chance Max was taller than him.

"The field isn't flat!" Wiener blurted. Everyone knew there were no flat parts of camp, only hills. Plus, Max was wearing basketball sneakers and Wiener was wearing flip-flops. Wiener wished Steinberg were here to help him prove his point with science.

The guys just looked at him funny.

"I'm Big Wiener since I'm older," he tried instead.

"Wait, I've got an even more perfect name!" Play Dough said. He threw his sandwich in the air and Dover caught it with a lacrosse stick. "Max Wiener! Get it? Wiener to the Max!"

5

Max giggled a yes. Wiener groaned a no.

"Does that make our Wiener 'Minimum Wiener'?" Totle asked.

Play Dough exploded with laughter. "Okay, okay, never mind!" He pointed at Max. "Li'l Wiener." He pointed at Wiener. "Big Wiener."

Phew.

Dover tried to knight Max with a lacrosse stick, since there were no brooms or plungers around, but Play Dough grabbed the stick out of Dover's hand to take back his hero. He took another bite. "Dude, it's great you finally made it to Rolling Hills," he told Max, the crumbs falling into the shirt folds on his belly. "How's Bunker Hill Cabin?"

"It's awesome-sauce! I got the bottom bunk by the front door, same as when Ernie was there. I even checked—same mattress! It says 'Wiener 4 life' on it."

"Does it still smell like pee?" Play Dough asked.

"I dunno," Max said. "Why would it?"

Uh-oh.

"You don't know this story about your brother?" Play Dough asked. "Oh man, it's a classic."

Wiener gave Play Dough desperate *Stop it* eyes, but Play Dough was too busy flinging tomato slices into the grass to notice.

"What happened was this!" Play Dough began. "One night, I was telling my cabinmates the story of Cropsy, a lake monster who kidnaps the youngest camper he can find—which would have been Wiener cause he's a year younger than us—and feeds

6

him to his monster mother. The next morning, the lower half of your brother's bed was soaked."

Dover and Totle clutched their stomachs, laughing and saying, "Good times! Good times!"

Max's face fell. "I didn't know," he said to Wiener without actually looking him in the eyes.

"The mattress has had five years to disinfect," Wiener assured him, trying to sound chill. "You put your foam egg crate over it anyway."

"True," Max said like a question. "The story's just different from how you wrote it."

"Probably you're thinking of a different story."

"No, I'm not."

"Yeah. Well." Wiener didn't know what else to say. He'd lied to his li'l bro. Had he lied to him about other stuff? "So, what are you guys doing here anyway?" he asked his cabinmates, eager to change the subject.

"Lacrosse tryouts are tomorrow," Totle said, rapping his knuckles on the equipment crate. "I came to check out the new sticks."

"You have to try out?" Max asked.

"Yeah, of course," Totle said.

"Not you, Ernie," Max said to Wiener. "Right? The coaches just save you a spot?"

Wiener's heart started to rise in his chest. But before he could think of a reply, Play Dough scoffed. "Where'd you hear that? Big Wiener doesn't have to try out because he's the water boy."

As Max's eyes glazed over with disappointment, Wiener

bit his tongue. He was afraid he'd accidentally spin another lie or stupidly defend a job any Bunker Hiller could do. "Hydration is key," he finally muttered, figuring it was safest to stick to facts.

"Here's hydration," Play Dough said, emptying his water bottle onto Wiener's head. In a suspended moment of wet, splashy shock, Wiener felt like he was about to scream. But then Max dumped Dover's water onto Play Dough—and Totle dumped his water onto himself, Max, and Dover—and Wiener's frustration blew over. They all ended up soaked and giggling.

Play Dough gave Wiener a whiff. "Honestly, dude, now you smell much better." He looked at Max. "Li'l Wiener, does your brother reek of cologne at home?"

Reek? Wiener thought. *You mean smell like a manly forest?*

Max shrugged. "Sometimes. Once he wore cologne to school and—"

"The ladies loved it, challaaaah," Wiener said, not wanting his brother to share the real story: He was sent home from school for giving his fragrance-allergic classmate inflamed nostrils. But that was one girl, one time!

"What is it this summer?" Dover asked.

Wiener grinned, unleashing his famous swagger as a clue: Right step. *Bounce.* Left step. *Bounce.* Always lead with the hips.

Dover followed him. Totle scratched his imaginary mustache. Play Dough bulged his eyes like, *You weird species of camper, what are you doing?*

Wiener stopped swaggering. "It's Swagger by Old Spice."

"You smell like a bunk bed," Play Dough said.

8

"You should just rub against a bunk bed," Dover said. "You're welcome for the life hack."

Wiener sighed. Even though he was thirteen and the rest of his cabinmates were fourteen, sometimes he felt like he was twenty and they were ten. "Guys, it's a nuanced smell of pine and bark."

"So, a tree!" Dover said, like he'd solved the world's most difficult puzzle.

"Why would you want to smell like a tree?" Play Dough asked. "It's not like girls go around macking it with tree trunks."

"Well, there are tree huggers," Totle said.

"I once saw Sophie hug a tree for a whole period!" Dover exclaimed.

"See?" Wiener said to the guys, but mostly to Max. "Case in point."

Just then a bunch of girls passed by. For a split second, Wiener thought he spotted Missi's wild red curls, but at a closer glance, it was a Faith Hiller in an Annie wig singing "Tomorrow."

Wiener was excited to see Missi. They'd Snapchatted a lot over the winter, and the bunny ears and vomit-rainbow filters she'd used had made him laugh. On Wiener's toughest days, Missi would instinctively send him a flute instructional video or a face swap with one of her seven cats, and everything would suddenly get brighter.

"Anyway," Wiener said, going back to the cologne debate. "Don't knock it till you've tried it. My cloud of spray-on macho is how I stole my girl's heart."

Max started to nod. Play Dough held Max's chin in place,

then faced Wiener. "Dude-a-cris, you got with Missi by chance." He turned back to Max. "It was Spin the Flashlight, which is Spin the Bottle but with a flashlight. Wiener spun and the light beamed on Missi, so they ate each other's faces while we all barfed in our mouths."

"C'mon, she totally digs my fragrance," Wiener said. "Ask her tonight."

Wiener instantly regretted saying that. Even though he and Missi had been in touch through distorted faces, they hadn't actually talked about being romantic. They'd only ever kissed once during Spin the Flashlight last summer, and even though Wiener didn't want to admit it, he wasn't confident that qualified as dating.

Two taps over the PA pushed Wiener's worries aside. *First announcement of the summer!* He swung his arm around Max's shoulder and the five of them looked up at the sky, where TJ's voice seemed to be blasting from.

TJ: Good morning, Rrrrrolling Hills! First day of summer, and Mr. Sun could not be any shinier! The birds are chirping. The hills are rolling. The trees are treeing.

Captain: However, this summer is *special*.

TJ [*like an echo*]: SPECIAL, special, special.

Captain: It's Camp Rolling Hills' . . .

TJ / Captain: FIFTIETH ANNIVERSARY!

TJ: Some fun trivia in the form of a rap.

Captain: It's not a—it's normal talking.

Wiener and the guys laughed as TJ beatboxed and the Captain read the trivia dryly with no rhythm at all.

Captain: The first bit of trivia is—

TJ: *Boots 'n' cats 'n' boots 'n' cats.*

Captain: Camp Rolling Hills was founded by Cindy and Mark Rollinghillowitz—TJ, this isn't right.

TJ: *Here we roll, here we roll now—POW!*

Captain: Correction: Cindy and Mark Finkel-Frankel.

TJ: *Give it up for hyphenated names.*

Captain: That first summer of Rolling Hills, there were only fifty-four campers. They enjoyed sports like soccer and basketball, and facilities like the Nature Shack, where there were two resident goats named Knish and Rhonda. Special activities included a camp-wide carnival and Square Dancing.

TJ: *Dance, dance, dance in a square!*

Captain: In celebration of fifty summers of Camp Rolling Hills, we will be documenting a throwback of such activities. This means we will reopen the Nature Shack, put together a carnival, and bring back Fufu and Stu, our Square Dancing experts, for a hoedown.

TJ: Fufu and Stu are nearly ninety now—say whaaaaaa! And Captain, what do you mean by *documenting*? Sounds invasive.

Captain: What? No. What I mean is that there will be a film crew shooting a new Camp Rolling Hills recruitment video!

11

TJ: Paparazzi, toot-toot! Who wants to be a celebrity? ME.

Captain: So, get ready for the summer of a lifetime as—

TJ: Hold up, we forgot to tell them about the surprise trips! Wait, what do the surprise trips have to do with the anniversary anyway?

Captain: Oh, um. Well, we need the campers to clear the grounds so the film crew can get their aerial shot.

TJ: Shot dibs on the helicopter ride!

Captain: No, that's a liability.

TJ: *You're* a liability, sweetie.

Captain: Um. So! Get ready for the summer of a lifetime as we celebrate our home away from home's . . .

TJ / Captain: FIFTIETH ANNIVERSARY!!!

There was so much hype echoing around the hills, Wiener half expected the clouds to rain confetti. After the guys exchanged a bunch of high fives and chest bumps, they walked Max back to Bunker Hill Cabin. When they reached the front porch, Wiener said, "Peace out, brother," and offered Max a fist bump. Max gave a weak fist bump back, then walked inside without a word. He thought his big brother was a loser, Wiener could tell. "I'll see you later, crocodile," Wiener called after him, praying Max would turn around and offer a thumbs-up, but the cabin door slammed shut behind him.

Deflated, Wiener headed to Wawel Hill Cabin with the guys for more unpacking and to meet their counselor. They'd heard their counselor was a newbie, but they hadn't met him yet. He'd been on duffel duty all morning, and upper campers, especially

upper-upper campers like the Wawels, had the freedom to hang out on their own. Walking over, Wiener couldn't help but wonder if some of the embarrassing stuff that had gone down on the lacrosse field just now could have been avoided with supervision.

As Wiener entered Wawel Hill Cabin, he bumped right into Play Dough, who'd stopped in his tracks. Then Dover and Totle bumped into Wiener, and they all spread out in a line to see what the big holdup was.

"Hi, I'm Arman," the counselor said from his top bunk. He waved, and then the holdup was obvious.

"Dude, where's your arm?" Play Dough asked. Totle elbowed him, probably for being so insensitive. The counselor had a normal shoulder and half an upper arm. It ended in a stump, no fingers.

But the counselor didn't seem bothered. "It's right there," Arman said, shrugging to the bottom bunk where Steinberg and Smelly were shamelessly playing with what looked like a robot arm made of shiny, black metal. The wrist extended into a giant hand with long mobile fingers. It could have belonged to The Terminator.

Dover and Totle rushed over to check it out.

Play Dough stayed planted. "But, I mean, what happened to your *real* arm?"

Totle was too far away to elbow him again, but Steinberg delivered his laser beam stare.

"Cheetahs ate it," Arman replied. "In Armenia, where I'm from, there're a lot of wildcats."

13

"I thought cheetahs ate cheese doodles."

"Nah," Arman said casually. "Just arms."

Wiener thought that sounded like a lie and wished Play Dough would call him out on it like how he'd called Wiener out in front of Max. But Play Dough knew nothing about Armenia. He knew nothing about cheetahs. He knew nothing about Arman and his missing arm. This counselor could spin all sorts of stories and the Wawel Hillers would never know what was true and what was totally made up. It wasn't fair.

"Hey, if you want, you can rub the nub," Arman told Wiener and Play Dough.

They were still standing by the door, the whole length of the cabin between them and their counselor. But then Play Dough walked over and climbed up to Arman's top bunk and rubbed his nub. "Coooooool. It feels like an elbow but less bony."

Wiener didn't want to be rude by staying put, so he climbed up Arman's bunk to rub the nub, too. It was cool! But the nub quickly reminded him of Max's unexcited fist bump, and Wiener began turning over stupid strategies to make things right: *Throw Max a pretend birthday party.* No—it's another lie. *Take Max on a raid!* No—it's illegal. *Get on your knees and beg forgiveness.* No—that's pathetic.

From up top, Wiener sighed and looked around the cabin. He noticed something strange. There were two bunk beds and *one, two, three, four* beds. Wawel Hill Cabin only needed to sleep seven—six campers, one counselor. So what was up with the eighth bed?

Suddenly there was a knock at the door.

"Oh, guys, he's here," Arman said.

"Who's here?" Wiener asked.

"The new camper. Are you ready?"

The robot arm dropped with a *clank* to the cabin floor. The room erupted in cheers.

"SO READY, YEAH!" Wiener shouted. His voice cracked on "YEAH" but he was so pumped, he didn't care. This was just what he needed! Wiener could take the newbie under his wing. And hey, with any luck, Number Eight could be shorter than him. Younger than him. Dweebier than him. Anything was possible. Wiener might still stand a chance of proving to Max just how cool-sauce he was after all!

The whole cabin was drumrolling now, until Arman whooshed his non-Terminator arm and nub through the air like a conductor. Everyone stopped.

The cabin door creaked open and in walked Number Eight.

He wore high-top denim Nike sneakers, jean shorts, an argyle belt, a short-sleeved button-down, and denim Ray-Ban sunglasses. His hair was thick up top and faded to a zero buzz at the nape of his neck.

"Qué está pasando, mis hermanos de otra madre?" he asked in a secret language.

Wiener's jaw dropped. He couldn't speak. He could hardly breathe. The newest addition to Wawel Hill Cabin was, undeniably, devastatingly, the Coolest Kid Alive.

LET'S CELEBRATE...

CAMP ROLLING HILLS'
50TH ANNIVERSARY

with a throwback of events and activities!

NATURE SHACK

CARNIVAL

SURPRISE TRIPS WITH ANNIVERSARY-INSPIRED SCAVENGER HUNT

FUFU AND STU'S SQUARE-DANCING HOEDOWN

AND A NEW RECRUITMENT VIDEO TO BOOT!

Third Wheeling

"We are the Notting Hills, the mighty, mighty Notting Hills!"
Missi sang her cabin cheer as she skipped along, a laundry bag
slung over her back. The Captain had helped her fill the bag
with camp towels, toilet paper, hand soap, sticky tack, and,
at Missi's request, a copy of the Camp Rolling Hills' Fiftieth
Anniversary flyer.

Missi had agreed to grab the supplies from the Head
Counselor's Office while the rest of her cabinmates pulled their
luggage inside from the porch. It was a risk leaving just as her
cabinmates were about to claim their beds—usually her two
best friends, Jenny and Jamie, shared a bunk bed, leaving
Missi out. But over the winter, Jamie had mentioned that this
summer, the two of them would share a bunk bed, or if that
made Jenny feel left out, the three of them would push three
single beds together to make a Miss Jen-Jam bed! So, for the
first summer ever, Missi wasn't worried about who she'd share
a bunk bed with. Thanks to last summer's Color War drama,
their three-way friendship was now tighter than ever.

As Missi started up Notting Hill, she felt her lungs suck in
the sweet upstate New York air. It smelled like her farm, except

better, without all the manure. Her legs were moving faster and faster, the laundry bag slapping her back like an encouraging teammate: *Go, go, go!*

Missi wondered which bunk bed Jamie had picked for them. The one by the front door? The one closest to the bathroom? When they'd talked about it six months ago in the comments section of one of Jamie's Instagram selfies, Missi had asked which bunk bed they should try to claim, but then Jamie had just Liked her comment. Missi guessed it didn't really matter as long as they were together. They would definitely still be together, right? Jamie remembered the plan?

Before Missi could give it another thought, she was launching up the four . . . five . . . six porch steps of the cabin. Her ears perked up to a Justin Bieber song leaking from inside. Missi bet her cabinmates were jumping on the bare mattresses, lip-syncing with tampons: *"Is it too late now to say sorry?"* She also bet they were craving her dance moves.

She dropped the laundry bag and burst through the cabin door, shaking her hips and whipping her red hair through the air. After a single whip, she stopped. No one was dancing. Everyone was unpacking.

Missi scanned the cabin for Jamie and spotted her stretching a hot-pink fitted sheet over a top bunk's mattress. She lunged toward its bottom bunk but stopped short when she saw Jenny on the bed with all her stuff, drying her polished nails in front of a clip-on fan. *No, no, no, no.*

In a panic, she glanced around the rest of the cabin. Melman was on a top bunk, Velcroing her shin guards to the bunk bed

ladder. Slimey was in the bunk below her, fastening tape to a sketch of her and her boyfriend, Smelly. Sophie had snagged the bunk under their new counselor, Cookie, and the two of them were poring over a giant textbook.

There was one unclaimed single bed by the bathroom.

The beds had been selected. Jamie and Jenny had chosen each other over her like always. Only Justin Bieber was apologizing to her, and it was too late now to say sorry.

Dejected, Missi shuffled to the porch and grabbed her lonely duffel coated with cat hair. Then, back inside the cabin, she began to unpack. She shelved her clothes, made her bed with her retro Hello Kitty sheets, and began decorating her space. She tacked the Camp Rolling Hills' Fiftieth Anniversary flyer to the wall and put two star stickers on either side of NATURE SHACK. In case that didn't scream *I <3 ANIMALS!* loud enough, she bordered the flyer with portraits of her seven cats—Happy, Sleepy, Grumpy, Dopey, Bashful, Doc, and Snow White. And then, hoping it might help soften the blow of rejection, for the first time ever, she put up a picture of her and her mom.

Missi leaned onto her jean pillow and stared at the photo, slipping into the memory of last Christmas. Totally stuffed from sweet-potato pie, she'd heard the "cock-a-doodle-doo" bell and trudged to the door, expecting to welcome friends, neighbors, Santa even. Anyone but Rebecca Joy Snyder. But there she was, standing on the snowy stoop in a forest-green sweater and a jeweled infinity scarf. She had twinkling brown eyes and a butterfly of freshly sun-kissed freckles across her face. A long, red braid hung like a horse's tail down her back. She gave Missi

a bow and said, "Darling, I am your *birth* mother." As if Missi had any other kind.

Missi had felt a lot of stuff that day: hyper like a goat, angry like a crow, confused like a chicken, and timid like a field mouse. And when her mom retrieved a selfie stick from her luggage, Missi also felt poorly dressed. She'd raced to her room to throw on a skirt, slick back her frizz, and apply strawberry ChapStick. Then the two of them had posed in front of the ornamented Christmas tree. Rebecca Joy had wrapped her arm around Missi's shoulders. Missi hadn't been sure what to do with her hands, so she'd clasped them together like a caroler. Missi was captured in the photo as a bony, awkward miniversion of her effortlessly beautiful mom. Her mom would never get bent out of shape over a bunk bed.

From across the room, Missi heard the J-squad giggling. Jenny was painting Jamie's toes, and Jamie was too ticklish to stay still. She kept spazzing, the nail polish streaking her skin. Missi wanted to smile at them, but she didn't have it in her. They were so in their own little bubble, she doubted they'd notice her anyway.

Needing a distraction, she reached into her cubby and pulled out the chunky beaded necklace and silk top Rebecca Joy had brought her all the way from India. She'd given it to Missi the day after Christmas, and at the time, it hadn't meant much. It wasn't until the winter snow began to melt, and Missi had spent more and more time with her mom, that the gift began to mean everything. Things had become amazing between them. They talked about all the things they would do together

one day, and how they were weird in exactly the same ways. How, to them, life seemed to glitter with magic. Trash could look like art, and honking cars could sound like music. "You're a snowflake, you know that?" her mom had told her one spring afternoon, and Missi had shrugged modestly, even though for the first time in her life, she believed she was as special as her mom said she was.

Missi slipped on the necklace and top. Instantly she felt more confident, like she was more than just the J-squad's third wheel. Ready to hang, she left her bed and climbed up to Jamie's top bunk, where the J-squad was sitting cross-legged, surrounded by art supplies. Jamie was tearing out a centerfold of a shirtless teen idol, and Jenny was cutting out a blown-up photo of Play Dough's face. "Whatcha girls making?" Missi asked curiously.

"It's a surprise," Jenny said.

"She's putting Play Dough's face on Shawn Mendes's body!" Jamie said.

"JAMIE!" Jenny screamed.

"Whoops," Jamie replied.

Missi wasn't sure who Shawn Mendes was, but based on last summer's wall art, she assumed he was a Disney star. Missi's grandparents hoarded a lot of TVs—they had eleven in their farmhouse—but none of them was hooked up to cable. Without access to most shows, she didn't know basic pop culture, and that was kind of embarrassing, even at camp.

Missi would never forget how awkward she'd felt the first day of camp last year, when everyone was decorating their

areas with teen celebrities she'd never heard of. In a panic, she'd torn a centerfold of a cute guy named Austin from Jamie's *J-14* magazine, tacked him to her wall, and pretended to be his most devoted fan. She wasn't proud of this. She hadn't liked hiding her Buttercup Whiskers III poster under her bed to collect dust. She hadn't liked having a guy she'd never seen on TV watch her sleep at night. She hadn't liked lying to her best friends just to fit in.

Missi had decided that this summer would be different. She was done pretending. If her mom could be herself without apology, then so could she.

Still, that was easier said than done. The J-squad had already left her out of the sleeping arrangements. What would they leave her out of next if they found out she was more hyped about her pet goats than teen heartthrobs? So, Missi took a breath and let out one last, hopefully harmless lie: "Yeah, I love him on that Disney show."

"Who?" Jenny asked.

"Um . . ." Missi tried to remember the name of the idol Jenny had just mentioned.

"Shawn Mendes isn't on Disney," Jamie said. "He's a singer."

"I know," Missi lied. "But he's probably sung for Disney."

And then, just as the J-squad shared one of their looks Missi thought they were going to stop making after last summer, Sophie shouted from across the room, "HE HAS! It's called 'Believe' and it's in the Disney movie *Descendants*."

"How do you know that?" Jenny asked, totally baffled.

"We sang it in chorus. It's a very inspiring song."

This made Missi feel even more out of the loop. For a fleeting

second, she considered climbing back down the ladder and taking a nap in her single, lonely bed, but then she pictured her mom telling her, "Don't let your lack of pop-culture knowledge get in the way of a first-day hang. Us Snyder girls are braver than that." She climbed the rest of the way up the ladder and sat on the edge of Jamie's bed.

Jenny taped Play Dough's face on top of this guy Shawn's face, and then she and Jamie clapped in rapid succession. "Yay, Play Shawn! JINX. Yay, Dough Mendes! DOUBLE JINX. Yay—"

"Body-face mashups! TRIPLE JINX," Missi cried. It was followed by crickets.

"I love you girls," Jenny said, "but it's honestly so claustrophobic up here." Since they were on Jamie's bed, and Jenny couldn't possibly be asking Jamie to leave her own space, Missi said, "No worries," and began to climb back down. When they were little, even up to their Anita Hill summer, the three of them could easily fit on a camp bed. But she guessed now, at age fourteen, it was a tight squeeze.

"But don't *leave*-leave," Jamie said to Missi. "Take my bungee chair."

"Okay," Missi said, surprised by how good that invitation made her feel. She plopped into Jamie's trendy chair made of bungee cords (everyone except for her had brought one to camp) and craned her neck up. "So, how were each of your eighth-grade graduations?" she asked. Missi had seen Instagrams of Jenny and Jamie wearing lacy white dresses with funky belts.

"So good!" Jamie and Jenny said in unison. Then they looked at each other and began gabbing about girls from their schools.

Missi couldn't hear so well from six feet below, especially with Jenny's fan droning in her ear. She went to flick it off just as Jenny said something to her about a dress.

"Yeah, my graduation dress was white, too," Missi said, hoping she'd answered Jenny's question. She'd been inspired by the J-squad's look, but also white was an obvious choice since most other colors clashed with her red hair.

"That's not what I asked," Jenny said. "I asked: Are you, like, in a religious cult?"

"Oh! What? No," Missi said. She didn't have to look down to know that Jenny was referring to her outfit. She didn't get how it could be religious or cult-y—the top had elephants on it—but sometimes Jenny just liked to be dramatic. "The beads and top are from my mom," she told them, then froze, anxiously awaiting their reactions.

She imagined Jamie's face would cloud with confusion. Jenny would shriek with excitement: "IT'S LITERALLY BEEN A DECADE." Then Jenny would invite Missi to climb back onto Jamie's bed, totally cool with the claustrophobia if it meant hearing all about her mom's four summers at Camp Rolling Hills in the '90s, and her hitchhikes across Australia, and her meditation guru boyfriend in India, and the near-death experience that had brought her back home.

As expected, Jamie's mouth dropped. Missi clutched her beads, ready to spill the whole long story. But then Jamie said, "Ow, I think I got that Airhead stuck in my braces," and Jenny peered into Jamie's mouth to confirm.

That's it?! Missi figured the J-squad hadn't heard what she'd

said. Or maybe they'd heard, but since they saw their moms every day, the weight of the news hadn't sunk in. Or maybe now wasn't the time for *The Missi Show*, as her grandparents called it. Maybe something so personal was too much for them to handle on the first day of camp.

Missi decided she'd let Jenny deal with Jamie's Airhead crisis, and she'd catch up with the rest of her friends. "Good luck! I'll be back," she called to them, then walked over to Slimey and Melman, who were playing catch with a soccer ball on Slimey's bottom bunk.

"Am not!" Melman said, giggling.

"Oh, come on!" Slimey said. "Just admit it!"

"Just admit what?" Missi asked.

Slimey laughed into her tie-dye pillow. Melman hugged the soccer ball to her chest, sighed away her giggles, and said, "Nothing, nothing."

Then they stopped talking.

Missi stood over them, digging her fingernail into their bunk bed ladder. She felt bad for being nosy. She hadn't meant to intrude, just join in on the fun.

"So, what's up?" Melman finally asked.

"Well . . ." Missi wished she didn't need a reason for coming over. Melman would never ask Slimey, "What's up?" if she approached her. They'd just jump into a conversation about something random, like the fishing elective.

"What's up with the fishing here?" Missi blurted dumbly.

"What? Oh. Well, the rods are really old," Slimey replied, too nice to call Missi out for spoiling their fun. "Sometimes I wear

surgical gloves from the infirmary so I don't get rusty fish smell on my hands."

"Caption: Artist fishes for human body parts," Melman said. Slimey swung her pillow at Melman's head. They laughed some more.

Missi tried to laugh at the inside joke, too, even though she didn't really understand it. When their giggles settled, Missi tugged at her silk top. She hoped Slimey, being the artsy one in the cabin, would compliment it. And then they could talk about how an artist's home is the open road where the soul is fed with endless inspiration. At least, that's how her mom had explained it.

But Slimey didn't say anything about the top. She just smiled at Melman, who smiled back with her lips pressed together. Missi got the hint: Slimey and Melman wanted to catch up alone together. And of course they did! Unlike the J-squad who lived only twenty minutes apart on Long Island, Slimey and Melman were separated by a whole ocean and a wonky time difference.

"Are you okay?" Slimey asked.

Missi looked at Melman to catch her response, but Melman was looking at Missi. "Oh, me?" Missi asked Slimey. "Yeah, why?"

"You seem like something's on your mind."

Missi realized that this was the perfect chance to open up about her mom, but then she spotted Slimey's locket—the one her late dad had given her—dangling from the underside of Melman's top bunk, and she thought better of it. It would

be insensitive. Missi's mom had reappeared, whereas Slimey's dad was gone forever. "My mind's good," Missi replied, a little delayed. "I was just thinking ahead to what's going to be an amazing summer."

"Fiftieth Anniversary, say *hey* now!" Melman said, flicking her wrist and making her fingers snap. "If you're hoping for a surprise trip to Moo-Moo's raise your hand."

Slimey pressed her arms to her sides. Melman tickled Slimey's armpits until both of her hands spazzed up. "Mel, that's not—! The Norman Rockwell Museum is where I want to go, and I'm not backing down!"

"I'm just—dude!—can't a girl dream of ice cream?" Melman said in between spurts of laughter.

Missi wasn't sure she had anything funny or worthwhile to add, so she left them with, "I gotta pee," and then pit-stopped at Sophie's bunk. She sat down next to Sophie, who she could now see was reading a giant volume of Shakespeare's collected works. "Which play are you reading, Soph?" Missi asked.

"Thou asketh a good question. Do you bite your thumb at me, woman?"

Missi looked down at her hands, which were nowhere near her mouth.

"Sophie Edgersteckin, my girrrl!" Their counselor Cookie called lovingly from the bunk above. Suddenly, Cookie's head was upside down over the edge of the bunk bed, her purple-and-black braided weave cascading two feet from her scalp. She must have been the only person at camp with more braids than Sophie, who wore seven at all times. "Can I just adopt you?" she asked.

Missi didn't understand what was going on or why their counselor was charmed by Sophie's Shakespearean insults.

"I was hoping for a battle of wits," Sophie said to Missi, "but I see you are unarmed."

"Sophie, can we just have a normal conver—"

"To quote *Hamlet*, Act Three, Scene Three, Line Eighty-seven: 'No!'"

"How was your winter? Sometimes, when I had to feed the chickens in the snow, I'd think about you by the pool in Florida and just, like, look up flights to Fort Lauderdale for fun."

"Brevity is the soul of wit."

Missi groaned. Then she got up and went to the bathroom, where she sat on the toilet, thinking about how even Sophie was paired off this summer. It had never been so clear that, in their cabin, Missi was no one's number-one friend.

"MISSI!" she heard Jenny call. "FIIIIIRE!"

Missi scrambled out of the bathroom and met the J-squad, who were beaming with excitement on Jenny's bottom bunk. There was no fire. Jenny should probably not do that.

"Ready?" Jenny asked mischievously. She and Jamie separated, exposing the finished Frankenstein of Play Dough and Shawn Mendes, now sticky-tacked to the wall. "Do you LOVE it?" Jenny purred.

Missi laughed. "I mean, sure."

"Good. We're making you one."

Jamie nodded enthusiastically.

Missi cocked her chin. "I mean, he's *your* boyfriend, so—"

28

"No, with Wiener and Bieber!" the J-squad cried in unison. "JINX!"

"Oh, that's—" *Strange*. She'd rather put up a photo of her and Wiener in their normal bodies, because that's just who they were.

"Don't you like Wiener?" Jamie asked.

"Yeah, of course I do," Missi said. She didn't mind his corny moves or his tree-bark scent. He made her smile. A lot, actually. "I just hope he still likes me."

"What do you mean?" Jamie asked Missi, dumbfounded.

"I dunno, it's just, we haven't really seen each other since last August. We've only been in touch through text and Snapchat, sort of, and it's hard to know if a guy feels romantic about you through a screen."

While the J-squad nodded with understanding, Missi thought about her and Wiener's most recent exchange. Right before his middle-school prom, he'd texted her "Gel or no gel?" with side-by-side pictures: one with his hair flipped up like a ramp and the other with a fluffy side part. She'd texted him back, "You look great both ways," and attached side-by-side pictures of her cats: Happy with a gelled Mohawk and Grumpy with a messy tease. Wiener had responded with a GIF of a cat filing his nails. Missi had laughed so loud she'd woken her grandpa from his nap.

"Whatever," Jamie finally said, taking Missi's hand and pulling her onto the bed. "You'll see him face-to-face tonight, and he'll realize he's literally the luckiest to have you as a girlfriend."

"Agreed," Jenny said. "You're both weird-sauce in the best way."

For the first time all day, Missi felt like herself. Her honest, true, weird self. "You know what? Sure, I'd love a Wiener-Bieber thingamajig."

The J-squad high-fived over Missi's head and shrieked, "WIENER-BIEBER!" As the three of them gathered materials for the creepiest art project to date, Missi was reminded that her camp friends knew her better than she'd thought. At times, they knew her inside and out.

Chico Nuevo

Wiener and his cabinmates watched the new kid with awe as he bounced a ping-pong ball on a paddle with the ease of a table-tennis pro. "See if you can translate this," he was saying. "De donde vengo, los churros se sumergen en chocolate."

Dover dropped his paddle to the floor. "I've got it! You said"— he cleared his throat—"'Where I'm from, the churros are dipped in chocolate.'"

Wiener laughed. "Well, I think he said: 'Waaaz up, I drink chocolate soy milk.'"

Play Dough smacked the back of Wiener's head. "Dover wasn't making up a translation, brain clog. He speaks Spanish."

"He does?" Wiener asked.

"Yeah, dude, you didn't know?" Dover said, pointing to his enormous curly 'fro with both hands. "My ma's Puerto Rican. I'm a Puerto Rican Jew."

"Oh," Wiener replied, his cheeks suddenly hot.

Dover man-hugged the newbie, who was somehow STILL BOUNCING his ping-pong ball. "That's why I nicknamed Paolo Alejandro here 'Chico Nuevo,'" Dover explained. "It means 'New Kid.'"

"Correcto," Chico Nuevo said. "But you can call me Chico for short. What language do you study, my Wiener?"

"French." He'd chosen it because he'd thought it was romantic. Wiener had imagined using it on a picnic date by the Seine river with French toast and French fries and French pick-up lines like, "Est-ce que tu as une carte? Je me suis perdu dans tes yeux." Translation: *Do you have a map? I'm lost in your eyes.* But now he was certain that on a picnic date with tapas by the Spanish Riviera, the Spanish language would be twice as romantic as French. Language choice = epic fail.

"Hey, you know what, Chico?" Play Dough said. "We owe you a welcome."

"A welcome?" Chico stopped bouncing the ping-pong ball to unbutton the top of his shirt, and three glorious chest hairs popped out. The dude was a god. "No, thank you," he said politely. "I already feel very welcome."

But it was too late. Wiener and the rest of the Wawel Hillers were racing into a *V* formation. "*A one, a two, a one, two, three,*" Steinberg crooned. The guys began to sing. In harmony. Wiener took the high part like a fierce falsetto warrior.

"We welcome you to Rolling Hills.
We roll, you roll with us.
If loyal to your cabinmates,
We're glad to add a plus!"

In what felt like slow motion, Chico removed his Ray-Bans.

32

"It's wonderful you sing," he said. "Though the harmony could use some work."

Wiener sighed with relief. He was thinking the same thing! The guys hadn't sung the welcome song since they'd inducted Smelly into San Juan Hill cabin two summers ago, and their act was rusty. Wiener should have showed off more of his range. "I can go higher," he told Chico. He took it up half an octave: "*Camp Rolling Hills*—wait, that's flat." He tried again, a little higher: "*Camp Rolling Hills, our home*—" He cracked, and then laughed it off. "One second you're a boy, the next you're a man."

"I will show you," Chico said. He put his hand below his ribcage and sang along to the Ricky Martin song playing over the speakers in the Canteen: "*Upside inside out, She's livin' la vida loca.*" He held the final "loca" and his voice soared into a rich vibrato.

The guys exploded with applause.

"Wow, you should be a famous singer!" Totle said.

"I almost was," Chico replied, casually popping his collar. "I won *The Voice Jr.* in Spain, but my parents thought the record deal would interfere with my studies."

Wiener's eyes bulged so hard, he thought they might fall out of his face.

"So, tell me," Chico said, waving the guys closer, "what is the best thing about this Rolling Hills camp?"

Play Dough farted as loud as a trumpet and the guys scrambled to all corners of the Canteen, laughing hysterically. Except for Wiener. At this point, he was immune to Play Dough's farts.

"Hey," Chico said to Wiener with his nose scrunched in disgust. "Let's get fresh air on the porch."

Wiener's heart began to thump. He had no idea why the semi-famous, Euro-sleek kid had chosen him of all people, the loser of the cabin, for a private hang, but he wasn't about to question his motives. He followed the newbie out, wishing Max could see him in this moment. He thought about taking their chill sesh to the basketball court where the Bunker Hillers were playing icebreakers, but then Chico stopped and leaned on the rail overlooking the lake. The setting sun was cowering behind some major clouds, but he slipped his Ray-Bans back on anyway. Like a movie star.

"That humor belongs in the—how do you say—*potty,*" Chico said.

"That's how you say it. And I agree," Wiener said. "In case you can't tell, I'm a man of class." He raised his arms just a little to let his Axe deodorant waft in Chico's direction.

"A class act."

"Exactly!" Wiener said, stunned he'd found someone at camp who also understood hygiene and sophistication. "Anyway, I don't know what a churro is—"

"A donut like a stick."

"Oh, cool. But I *do* know a lot about camp, if you're wanting to hear more."

"That I do." Chico stretched his calf on the railing like he was warming up for a track meet. "The ladies here—are they nice?"

"The ladies?" Wiener wiggled his eyebrow. "It's funny you should ask. I'm a ladies' man myself."

"Yes, you smell like a lady."

"What? No. I smell like—" Wiener sighed. He didn't want to go into it again. "Let's focus on the girls. I can school you on everything from their styles to their schedule, which I've already gotten my hands on and memorized. Mondays, first period: Lacrosse. Tues—"

"Sure, maybe their styles," Chico cut in. He brought his Ray-Bans to the top of his head and his hair nestled them just right.

"Got it," Wiener said. "There's Slimey, who's cute, but she's with Smelly."

"There's love between a Slimey and our Smelly person?"

"Yeah, classic camp couple. And then there's Jenny, who's standard popular, but she's with Play Dough—the biggest, coolest one in the cabin."

"Gran Chico has a popular girlfriend? Good for him."

"Totally. And then there's Jamie, who wears pink on the daily. And Sophie, who's post-vamp, post-bot weird-sauce."

"What kind of sauce?"

"Weird, I said. Weird-sauce. And then there's Melman, who's crazy-hot and a European transplant like you, except she's originally from New Jerz. We had a thing. It was wild. And lastly, there's Missi." Wiener put his hand over his heart and squeezed it in little bursts like a literal heartthrob. "She's really cute and sweet and funny, too. And actually she's my—"

Suddenly Wiener heard the girls singing the classic camp

song "John Jacob Jingleheimer Schmidt." He swung around toward the dirt road, where the Notting Hillers were skipping arm in arm toward the Canteen. Mid-verse, Missi flicked her hand up by way of hello, and Wiener's heart fluttered. She looked even prettier than she had last summer. Her hair was pulled back into a loose braid and she wore an exotic shirt with a matching beaded necklace. She looked like Lindsay Lohan in *The Parent Trap* meets Princess Fiona from *Shrek* (when she's not an ogre, doy).

Wiener waved back, but the window for hellos had clearly passed. The girls were busy whispering into each other's ears. Then they began giggling. Wiener hoped they weren't giggling at him. As the girls skipped closer, Wiener could see that they weren't. They were giggling at Chico, who was smiling and waving. At Missi. Wiener watched as Jenny manipulated Missi's arms like a puppet, moving her hand to her mouth and then away as if Missi were blowing a kiss at him.

"The girl with hair the color of fire," Chico said. "I hope she's not Stinky, or Sticky, or Saucy."

"Dude," Wiener said. Either he'd done a poor job schooling his new cabinmate or Chico was a terrible listener. "She's not."

"Then what is her name, this fire-haired beauty?"

"Well, um, that's Missi."

"You're right," Chico said. "She is nice."

Wiener thought about adding, "Except she's *my* girlfriend." But the thing was, maybe she wasn't, technically. Wiener wasn't actually sure. And besides, Chico was handsome and cool. Way

more handsome and cool than Wiener. So, if Chico liked Missi, then Wiener had no shot.

As Missi and the J-squad bounded up the porch steps, Wiener stayed quiet, praying Missi would set their romantic relationship straight before Chico could make a move. And then Chico might go for Jamie or Sophie or even Melman.

"Hey, Wiener!" Missi said, going in for a hug. Wiener went to give one of his great hugs back (long, strong, and emotional), but he was thrown off by Chico clearing his throat, all *Introduce me!*, and ended up spazzing his forearms out and not touching her, while Missi patted his back.

"What the *heaven*?" Jenny said. "Hug her, you Wiener-Bieber!"

The J-squad laughed like Cinderella's stepsisters, and Missi pulled away. Her face was as pink as Jamie's shirt. Then, like a total Prince Charming, Chico put his left hand behind his back and his right hand out for Missi's hand. She put her hand in his, and he brought it to his lips for a gentle kiss.

Jenny fake-fainted into Jamie's arms, but Jamie was too little and unprepared to catch her, so they both fell, "omigod"-ing. "Now that's how you greet a woman," Jenny said, fanning herself from the porch floor.

"A woman as cute and sweet and funny as Missi?" Chico said. "Of course."

"YOU KNOW HER NAME?" Jenny screamed.

Chico winked at Wiener. Wiener frantically looked at Missi. Missi was beaming at Chico.

"JENNY, I GOT YOU FAT-FREE LICORICE," Play Dough called from inside.

"Ugh, doesn't he know that all licorice is fat-free?" Jenny muttered to Jamie. "AWWW-SAUCE, THAT'S SO SWEET!" she called back to him. Jenny pulled Jamie up and whisked her inside, leaving the love triangle to triangulate. Basically, Missi and Chico were staring into each other's eyes, and Wiener was just watching.

Beep, beep, beep, beep randomly went Wiener's watch alarm. Mortified, he pressed it silent.

"So, Wiener," Missi began, almost definitely about to end their undefined relationship. "I was wondering if you ever ended up playing—"

"The field behind your back?"

"What?"

"What?"

Missi shook her head. "I was going to ask if you ended up playing one of the leads in your temple play. I know you were excited to audition."

"Oh." He saw where this was going. First the small talk, next the big blow. "I was Big Jule in *Guys and Dolls*. It's a guy part and the 'big' isn't ironic. I'm not the shortest in my grade. Jon is."

"Good for you! I, uh—So, how was your eighth-grade prom?" Missi pushed on.

"My prom, huh?" He'd slow danced with Kelsey Adler, but that was only because they were family friends and his parents had told him it would be the kind thing to do. It wasn't romantic.

Still, maybe mentioning it would get Missi's attention, and she'd stop looking at Chico like that . . .

"Did you have fun?" she pressed.

"I did," Wiener replied. "Kelsey's dress was a stunning Brandy Melville."

Missi cocked her chin. "I don't know who or what that is." Then she made MOON EYES AT CHICO.

Wiener wanted Missi to make moon eyes at him, angry eyes, any eyes. "The hot girl I danced with and the brand of her dress."

"Oh, that's great," she said quickly, then smiled at Chico. "So, um, who's this?"

Clearly Wiener and Missi were not an item. She couldn't care less about him. And if she didn't care, then why should he? He'd had enough embarrassment for one day. "Oh, right," he said, trying to play it as cool as possible. "Missi, this is Chico. He thinks you're cute, like he told you. And yeah. He wanted to meet you." Then he excused himself with the tip of an invisible hat, like a moron.

"Hey, wait!" Missi called after him. But Wiener knew he had nothing to wait for. Chico liked Missi. Missi liked Chico. The only real choice Wiener had now was to give the blooming lovers their space, before he embarrassed himself further. He hung his head and went inside to play air hockey by himself, thinking about how, on top of everything, he'd have to admit to Max that Play Dough was right—he had no girlfriend. He had nothing-sauce at all.

At the booth to his left, Play Dough and Jenny sat opposite

Jamie and Dover. "What's he even doing here?" he overheard Play Dough ask. "Shouldn't he be pursuing that record deal or shooting a blue-jeans commercial?"

"Being a celebrity is hard," Jenny said. "I bet he wanted one summer to be a normal kid in America."

Wiener wondered if that was true. The kid was a walking Levi's ad. It would be so sick to star in one of their commercials. He bet they let their models keep the jeans.

Wiener felt his butt get flogged. It was Jenny, whipping her zip-up sweatshirt at him. "Wiener, come here."

With the spotlight on him, Wiener smacked the puck toward the goal, but it bounced back and he scored on himself. "Boom," he said, as if he'd done it on purpose. Then he walked over to the booth. Jenny squeezed closer to Play Dough and patted the tiny space next to her. Wiener was sure only one butt cheek would fit, but somehow both butt cheeks fit comfortably. He must be smaller than he thought.

"So, what do *you* think about Chico?" she asked him.

Before Wiener could mention his impeccable hygiene, Play Dough cut in. "Wiener's in love with the dude. He was practically drooling on the air hockey table, dreaming of him." Dover, Jamie, and Jenny laughed. Then Jenny tousled Wiener's perfectly gelled hair, which was his biggest pet peeve after dirty fingernails.

"Oh, please," Wiener snorted. "You're just jealous, PD. Chico is super-cool, and the two of us are going to take this summer by storm."

"Right after he steals your girlfriend," Play Dough scoffed.

"So *now* Missi's my girlfriend?" Wiener fired back. He glanced over his shoulder to the window. Chico was tucking a loose strand of hair behind Missi's ear, which he couldn't help but admit was a baller move.

"Wait, *isn't* she your girlfriend?" Jenny asked.

"Nope," Wiener replied. "The flashlight wants who the flashlight wants, and I, Jenny, am no flashlight."

"Huh?" Jenny said.

"We kissed for a stupid game and that's it." Wiener exhaled.

"Well, Missi thinks you're boyfriend and girlfriend," Jamie said.

Wiener's heart began to thud like mad. Regret, pain, and excitement—he was feeling all of it. "Oh. Well, I—" Wiener cut himself off. Missi might have thought she was his girlfriend, but that was *before* she'd met Chico. They had each other now and all Wiener could do was watch and learn the European ways to a woman's heart.

Just then, the double doors of the Canteen swung open and in walked the Captain and TJ. "Hello, Wawel and Notting Hillers!" the Captain said. "Pardon the interruption, but we've got a carnival to plan!"

The campers clapped and "woo"-ed at a medium-crazy volume.

"We've got three days and three days only to revive all the original booths from the nineteen sixties," the Captain continued. "Tonight we're making our rounds so that each cabin can choose the booth that they will design, build, and run . . . from this hat."

TJ revealed a giant sunhat that he was "hiding" behind his back.

"Arman and Cookie?" the Captain called. "We need one representative from each cabin."

"We'll do it," Chico jumped in, entering the Canteen holding Missi's hand in the air.

"Already off to a good start, young man," the Captain said to Chico. "Your father will be proud to hear you're taking initiative."

Chico rolled his eyes. "Proud—yeah right."

The Captain gave him one of her "watch it" looks, which sent his gaze to the Canteen floor. Then he bowed with an outstretched hand toward the sunhat. "Ladies first." Missi closed her eyes, felt around inside the hat, and pulled out a piece of paper. She read aloud: "The Love Shack."

The girls flipped out. Well, the J-squad shrieked, then broke into song: "*Love shack, baby, love shack*," while Sophie and Slimey hugged. Melman twirled her finger in the air and let out a sarcastic "Whoop whoop."

Now it was Chico's turn. The guys collectively held their breath as he fished around for a piece of paper. Wiener hoped for henna tattoos—he thought they were cool since his friend Meera wore them at her Basmati Bat Mitzvah. That, or sand art! He'd even be happy with a good old ring toss.

Chico lifted a slip of paper from the sunhat and read: "Dunk Tank."

Dunk Tank? Wiener wondered. *What got dunked and how?*

Play Dough and Dover high-fived. Either they knew exactly

how the game worked and it was awesome, or they were follow-
ing camp's unspoken rule of unconditional excitement.

"You'll teach me what a Dunk Tank is, my Wiener?" Chico
asked, rejoining the guys.

"You know it," Wiener replied, making a mental note to ask
Dover about it later. "Wanna play?" Chico asked, picking up an
air hockey mallet.

"Sure!"

As they played, Wiener soaked up Chico's cool vibes. Missi
or no Missi, this was all about the long game.

June 30

Dear Mom,

Something really cool happened today—
we got a new kid! Now, in my third summer,
I'm officially a veteran. My whole cabin is
calling him "Chico," kind of like how they
all call me "Smelly."

NOTE: This does not mean your "friend"
Terrence gets to call me "Smelly." Hi,
Terrence. I know you're reading this. Be
good to my mom and Clark Kent, please. You
can call me "Bobby." "Robert" if you beat
me at chess next time I'm home.

Love,

Bobby

P.S. It's the 50th anniversary of Camp Rolling
Hills this summer, so there's a mystery trip.
I really hope we go to Cooperstown, where
there's the Baseball Hall of Fame.

July 2

Hola Mom and Dad,

You know how when I show tough love to Cassie you say, "Benjamin Dover! You cause any more trouble, we're pulling you from camp and sending you to Puerto Rico, where you'll study Spanish under Abuela Maria all summer long!"

Well, it turns out Camp Rolling Hills is where the Spanish is at. My new cabinmate is from Barcelona and by the time I come home, I guarantee I'll be as fluent as Dad. (Yes, Dad, this is a challenge.)

Cassie, if you're reading this:

Eres la hermana más estúpida del mundo.

Translation: You are the most amazing sister in the world.

Adios,

Ben

A MASH of Feelings

"Omigod, the wind is insane," Jamie said, pointing at Missi's thrashing ponytail. The Notting Hillers were chilling on the new wraparound porch of the Arts & Crafts shack, and its nearness to Harold Hill produced a wind-tunnel effect. It felt awesome on a hot day like today, but it made creating their Love Shack very tricky. The plastic cups of pink paint kept blowing over. There was as much glitter on their clothes as on their banner. And the scrap paper had to be weighted by three flip-flops at all times.

"Do you think your babies will have red hair?" Jenny asked Missi out of nowhere.

"It depends. Why?" Missi replied, thinking of her red-haired mom and red-haired grandma. Her grandpa was blond-turned-gray, but apparently his mom had been a redhead, too. As far as her father and his parents, she'd never met them and didn't know what they looked like.

"There's only one way to know," Sophie said, snatching a cut-out heart from under a flip-flop. She quickly sketched four squares inside a larger square.

"What is that?" Missi asked, a little nervous. Knowing

Sophie, she was about to compose a Shakespeare-style survey and then poll everyone over the PA, like, "To be *ginger*, or not to be *ginger*: that is the question!" Missi wasn't sure she wanted to bring more attention to her hair anyway—her middle-school nickname was Raggedy Ann, and that red-yarn-for-hair doll haunted her dreams.

"Yeah, Sophie, why are there big *R*s and little *r*s?" Slimey asked.

"Is that a relationship quiz for redheads?" Jenny asked.

"It's a Punnett square!" Jamie said. "A diagram to find the probability that Missi's babies will have genetic traits like red hair and green eyes."

Missi dropped her paintbrush. Slimey stopped gluing feathers. Jenny froze while sanding wood. Melman quit drilling. Sophie looked in Jamie's line of vision, probably to see if Steinberg, the science whiz of the group, had fed her the answer. He hadn't.

"Aw! You are so smart-sauce," Jenny said, squeezing Jamie's cheeks.

"Thank you," Jamie said through fish lips. "DNA is fun times."

"Are we breeding Missi with Chico or Wiener?" Sophie asked, labeling the top of her Punnett square with two little *r*s.

"Wiener," Slimey and Melman said.

"Chico," Jenny and Jamie overlapped.

Then they all looked at Missi. Her heart started beating fast like a rabbit's. She should have seen this coming. "Well, let's see . . ." she started. Last night's Canteen was bizarre. She'd run up to Wiener, thinking they'd share this big hug and catch up

over Twix bars, but then he'd thrown her all this shade. Didn't he like her? Had she done something wrong? "It's complicated," she finally replied.

Jenny put her pointer finger up—she'd address Missi's non-answer in a minute. "Why did you pick Wiener over Chico?" she challenged Melman and Slimey. "That makes zero sense."

"Aw, because it's Wiener," Slimey said. "It's sweet how hard he tries to be cool. Like when he starts his pushup count at one hundred. It's endearing. Right, Mel?"

"Uh, sure."

Jenny raised an eyebrow at Melman. "You just like that when Wiener's wrapped up in Missi, he leaves you alone."

Melman tapped her nose—ding, ding, ding!

Great. On top of everything, she didn't need a reminder that she would always be Wiener's number-two crush.

"But, hey," Melman said to Missi, "if you go for Chico, I can handle Wiener's moves." She demonstrated the yawn-over-shoulder move, full-body yawning and then casually dropping her arm around Missi's shoulders. "Seriously, I'll just tickle his pits." She revved the drill.

"Ewww!" Jamie cried.

"At least his pits don't stink," Melman replied. "The guy reapplies deodorant after every activity period. The bugle sounds and he's all swipe left, swipe right."

Missi smiled. "That's true. See, that's why it's hard. Wiener's not like other guys."

Jenny gave her a skeptical look. "Yeah, no other Wawel Hiller would suffer separation anxiety over a travel stick

of deodorant. What a turn-on." She handed a paintbrush to Jamie, who dropped it in a cup of pink paint. The Love Shack was never going to get done. "Okay, so, take us through your emotional journey."

"Huh?" Missi said.

"Like, what were you feeling when you saw Wiener last night?"

"Oh." Jenny was now in relationship-therapist mode, and Missi had no choice but to play patient. "So. It was weird when we hugged."

"Yes, he acted like he was allergic to you. Go on."

"And when I asked him about his prom, he talked about dancing with another girl."

"So he was trying to spark some jealousy?"

"Well, I dunno. He said she was wearing a Brandy Melville dress."

"Then yes," Jenny said, eyeing Missi's T-shirt, which was from Goodwill. "Now tell me how you feel about Chico." She bumped her eyebrows. "Other than the fact that he's fresh, hot, well-dressed meat."

"You literally just described a hamburger," Melman said, rubbing her stomach.

Jenny ignored her. "Look, Chico's obsessed with you, Miss, and Wiener's a weenie. What is there to debate?"

"I don't know," Missi said. Jenny was right. The one person who thought she was special had just dissed her. Plus, a foreign fling with Chico could be fun. He was just as handsome as all the centerfolds in *J-14* magazine. He had the easy confidence of

an ox. He didn't play hard to get. His accent made every word adorable. It would be like one of her mom's adventures! Who needed a serious boyfriend anyway?!

"Missi?" Jenny nudged.

"You know what? Sure. I choose Chico."

"HOORAY! MISS CHICO!" Jenny shouted, just as Chico's face appeared between two railings of the porch. Wiener was standing on his tippy toes beside him, which brought him up to Chico's shoulder.

"Hello, ladies," Chico said with a dazzling smile. "How is the making of the Love Shack?"

Not even Slimey had the maturity to answer him. Instead, the girls burst into giggles. Missi joined them, even though she was absolutely mortified.

"We were definitely not talking about you," Jamie said to Chico and Wiener.

"Omigod, Jamie!" Jenny playfully shoved Jamie, who tipped over the pink paint. Then Jamie, laughing hysterically, tried to scoop the paint back inside. It wasn't working so well. Everyone was kind of just watching the J-squad. Well, not everyone. Missi could feel Chico's eyes on her. Not knowing what to do, except not lock eyes with Chico in front of Wiener and all of her cabinmates, she tucked some escaped strands of hair back into her ponytail.

Finally, Jenny turned her attention back to the guys. "So, um, what are you doing here anyway?"

"We've been hard at work on our Dunk Tank," Wiener said. "It's gonna be sweet."

"Not as sweet as the Love Shack," Chico said.

"No, like sweet-sauce," Wiener said.

"Right," Chico said, winking at Missi. "Everything here is a sauce."

Wiener winked at no one in particular. Maybe it was a tic. Missi wasn't sure.

"Alright, my Wiener friend," Chico said, throwing on his sunglasses, "let's get a move on. We need our supplies." He held up a list of items and read it aloud. "A spatula, two hockey pucks, and a buttload of floss." It screamed Steinberg.

The guys walked along the wraparound porch and up into the Arts & Crafts shack. When they were out of sight, Missi sighed with relief through the gap in her two front teeth—it whistled. She was glad Chico was too far to hear it.

"I just realized it doesn't matter!" Sophie cried suddenly, throwing her cut-out heart in the air.

"Love? Yeah, it does," Jenny said.

"Not that," Sophie said. "Wiener and Chico might not look alike, but they both have brown hair, and I doubt their parents have red hair."

"Dominant genes!" Jamie squealed. "Red hair is a recessive trait, so if Missi gets with a guy who has no redheads in his family, only brownheads, then their baby's hair will have to be brown!" She rubbed her brown hair against Sophie's brown braids. It was the most bonding Missi had ever seen Jamie and Sophie do in five full summers.

"Ugh, there's a reason this is camp, not school," Jenny said with a sunken face. Then she gasped and her eyes lit up. "MASH time!"

Jamie squealed again and hugged Jenny around the neck. Within seconds, they were pummeling Missi with questions to determine her future.

"Say four potential hubbies."

"Say their potential jobs."

"Where would you and your hubby have your first kiss?"

"How many children would you have?"

"What pets would you adopt?"

Jenny finished scribbling Missi's answers, and then took a deep, dramatic breath. "Are you ready to find out your destiny?"

Missi smiled. Even though she didn't really believe in games like MASH determining anything, she let all her doubts go. Right now, this was far easier and more fun than figuring it all out for herself. "Ready Freddy," she said.

Jenny flipped the paper over and began to draw spirals. Missi closed her eyes and counted for five . . . ten . . . fifteen . . . eighteen Mississippi. "STOP!" Missi cried. She opened her eyes. Jenny counted the spirals—fourteen! Then she began to cross off parts of Missi's future, every fourteenth option, until there was only one of every category left.

Oh, boy, Missi thought, holding the MASH game in her trembling hands. *My fate is officially sealed.*

M. A. S. H.

(Mansion, Apartment, Shack, House)

Boys / Future Hubby
1. Shawn Mendes
2. Wiener
3. ~~Justin Bieber~~
4. (Chico Nuevo)

Hubby's Future Job
1. ~~eans model~~
2. cologne chemist
3. (fashion designer)
4. singer–songwriter

Place of 1st (or 2nd) Kiss
1. (Love Shack)
2. Softball 1 bleachers
3. ~~heeere~~ A&C porch
4. Missi's farm in NJ

of Kids
1. (17)
2. 1 billion
3. 3
4. only goats

Future Job
1. cat masseuse
2. veggie burger maker
3. ~~Camp RH counselor~~
4. (vet (animals not war))

Pets
1. skunk munk
2. (unicorn)
3. baby sloth
4. Li'l Wiener (soo cute)

14 swirls!!!!
Go Missi ☺

CAMP ROCKS!

Dear Li'l Wiener,

You might be wondering why you're getting a letter from me when I could just pop by your cabin. Well, I figured you could add this to your collection. Let the memories live on forever. Plain and simple: The carnival is going to rock. I'm bonding a lot with the Spanish newbie, Chico. You've probably seen him around camp, looking fly. The two of us—we put the Slam Dunk in Dunk Tank. Get hyped to see your big bro in action.
Just so I know you got this, and we're cool, give me a holler. We're cool, right?
Catch you soon, carnie goon.

Your bro (Dunk Tank pro),
Big Wiener

A Carnie Catastrophe

"Shout it with me." Play Dough prompted the Wawel Hillers. *"D-U-N-K, DUNK THE PUNK! D-U-N-K, DUNK THE PUNK!"*

Wiener stood twenty feet from the Dunk Tank, softball in hand, honored that Steinberg had gifted him the privilege of testing his cabin's creation. He guessed it made sense, since he was the one who'd gone "shopping" around camp, trading travel-size toiletries for scraps of wood and metal so that Steinberg could work his magic. There were some supplies Wiener couldn't find, but Chico had found genius substitutes. Like a go-cart wheel for a bike wheel and a bungee chair for a bike seat. *That guy, is there anything he can't do?!* Wiener thought, glancing at Chico. It was no wonder the Wawels had started borrowing his clothes and gel and international stamps—everything about Chico was Cool with a capital *C*.

"C'mon, Smellsky," Play Dough called. "If you don't heckle Wiener, he's got no motivation to dunk you."

"Hey, I've got motivation," Wiener said, popping his left bicep and giving it a gentle kiss. "The glory."

"Dude-a-cris. Heckle him. Now."

Smelly took a shaky breath. Putting their panic-prone

cabinmate in the tank was not the most sensitive choice. "Yo mamma's so Social she's got a . . . she's got a Hall," he stumbled. "Get it? Social Hall."

"BOOOOOOOOOOOOOOO!" Play Dough said. He tossed a handful of gummy bears at Smelly, smacking him on the forehead. "Pretend these are tomatoes."

All of a sudden, Wiener heard mic feedback. He turned around to face the fourth hole of the Golf Course, where TJ and the Captain were standing on a platform stage. Behind them were blue and white balloons and a banner that read: Carnival Fun.

TJ: ATTENTION, ALL YOU CARNIE ANIMALS! Please have your booths ready to rock and roll in five minutes.

Captain: And remember to follow your carnival schedule. At least two campers have got to man or woman your booth at all times.

TJ: Be a good *sport* and hold down the *fort*.

Captain: Please see TJ for prizes to distribute to the winners of your activity. You can also distribute tickets to trade in for cotton candy, popcorn, or ice cream!

TJ: And be sure to smile wide with Rolling Hills pride— the film crew is in da hoouuuuuse!

Captain: They'll be capturing the carnival for our new recruitment video.

TJ: We'll be tricking families into believing we do this every summer.

Captain: Well, not tricking—

TJ: AND THE COUNTDOWN STARTS . . .

"NOW!" Wiener shouted alongside every Hiller at camp. When he and his cabinmates had arrived thirty minutes ago, they'd been the first campers there. Now there were hundreds of campers hustling to set up their booths in the shape of the number fifty. To his left was Skee-Ball. To his right was Sand Art. In front of him was a Bouncy House. Mini Bowling? Mom-Gift Making? Leg-Muscle Building? This was going to be epic!

Wiener spotted Max half a golf hole away, collecting rings for his cabin's Ring Toss. His heart started doing nervous flips. He hadn't talked to Max since the first day of camp. It could have been a scheduling thing, or a Wawel Hill Cabin to Bunker Hill Cabin distance thing, but he feared it was mainly a *My big bro is a loser* thing.

That's why today was so important. During his shift, he'd call Max over to the Dunk Tank and hand him a softball. Max would try again and again to hit the target. Finally, when Max complained that it was too hard, Wiener would demonstrate, hitting the target on his first try. "Wow—you're so good at this game," Max would say. "Well, I created it," Wiener would respond modestly. Then he'd put Max on his shoulders, and they'd race toward the bull's-eye, slapping it together. Chico would fall into the tank. *Splash! Hoorah!* Wiener and Max would high-five. "Can I man the DT instead of the RT?" Max would ask. Wiener would put his hand out for a shake. "You got it, brother."

"Wiener, HELLO!" Play Dough said, snapping him from his daydream. "Stop drooling over your mamma in the Social Hall."

"Oh. Ha." Wiener dabbed his lip for drool, just in case. *Dry as cotton.* "So, Smelly, what was that you were saying about my mamma?" he cracked, running a hand through his freshly gelled hair. He wound his arm faster and faster, gaining speed, and a split second before he meant to let the softball rip, he lost control. The ball slipped from his goopy fingers and went flying, flying, flying, *SMACK* into Chico's eye.

Chico flung his hands over his face and then went totally still.

A wave of shock washed over the guys. Guilt filled Wiener from his belly button to his throat. He couldn't think of anything but a jumbled apology. And he couldn't voice it because his vocal chords were all locked up.

"YAAAAWOOOOOOOOOOOW," Chico howled.

Arman rushed out from behind the Dunk Tank and sat Chico on the grass. Claudia Cooking suddenly appeared with a bag of frozen tater tots. "I'm okay," Chico said, pushing the tots aside. A bluish-black streak was already forming below his eye.

"It's gonna swell," Arman said. "I'll grab actual ice."

The guys huddled around Chico, fanning him, blowing cool(er) air on him, and distracting him with fart jokes. "*F-E-E-L, feel better,*" Wiener chanted over them, since he was the only one who knew about Chico's disdain for potty humor.

"BOOOOOOOOOO!" Play Dough yelled over Wiener, throwing handfuls of grass in Wiener's mouth to make him stop, until finally, he did.

Luckily Arman arrived seconds later with a plastic bag of

ice cubes. He broke through the huddle and put the ice right onto Chico's face. "I think you should go to the infirmary," he told him. "Chill out for a bit."

"Dude-a-cris, go," Play Dough said.

"It's that bad?" Chico asked.

"Your face? No," Play Dough said. "I was just hoping you'd grab Nurse Nanette's birthday cake from the infirmary freezer. I've been eyeing it since last August and she's on to me."

"I don't need an injury to steal some cake," Chico said. "I can get it for you later."

"I heard that," Arman said. "So, guys, we still need someone to test the Dunk Tank. Poor Smelly here has been waiting patiently for ten minutes."

Wiener looked at Smelly clinging to the bungee chair for dear life and instantly sympathized. Secretly he feared free-falls—they made him feel like his skin was draped in melting plastic. Under no circumstance would he be getting in the tank.

Play Dough tossed Chico the softball. "Ice after. It's all you."

Chico nodded a thanks. "Let's get this carnival started." He wound his arm and pitched the softball toward the target. It curved slightly and then *POW*—it slammed right into the bull's-eye. Except Smelly was still seated, dry as a land turtle.

"Uh, guys . . ." Steinberg started, his head moving in little nervous twitches. "Why didn't that work?" He ran behind the Dunk Tank to examine it. "THE WHEEL!"

"What's wrong with it?" Dover asked.

"The release mechanism is jammed."

"English, please," Play Dough said.

Steinberg ducked out from behind the tank. "Someone used a go-cart wheel instead of a bike wheel."

The guilt in Wiener's chest grew into a mountain. He could throw Chico under the bus—the go-cart wheel *was* his idea—but the dude had suffered enough for one day. Plus, what did a newbie know? Wiener should have used his veteran veto power to get Steinberg exactly what he'd wanted. "My fault," Wiener said, kneeling at Steinberg's feet for forgiveness.

Chico looked at him bizarrely. "Actually, it was my—"

"NO," Wiener cut in, drawing manly inspiration from Chico, who had taken his eye slam like a man. "Me. I failed you," Wiener told Steinberg.

"Uhhhh, okay," Steinberg said, seemingly not mad, just weirded out. "You can rise I guess." He turned to Arman. "You know the magnets that hold doors shut for security? They run on twelve volts. We need one of those for an electric release."

"Buddy, it's gonna be impossible to get ahold of something like that now."

"You say *impossible*, I say *try me*," Steinberg said. "You did defeat a cheetah, right?"

"A whole family of them."

"So let's fix this Dunk Tank."

"HUDDLE UP!" Play Dough called. The guys, minus Smelly, formed a huddle and put their hands in the middle.

"PUPPY FACES!" Play Dough ordered. They fired puppy faces at Arman for one . . . two . . . three seconds.

Arman surrendered. "I guess let's see what we can do."

"SAUCE!" the Wawels shouted, their sandwiched hands blasting into the air.

Arman took charge. "Totle, you'll interface with campers. Dover, in the tank."

"Sure thing!" Dover said. "How about if a camper hits the target, then Totle, you'll shout in an Aussie accent—"

"BULL'S-EYE, MATE!"

"—and then I'll jump into the laundry bin of my own free will."

"Great plan," Arman said. "Steinberg, help Smelly out of the tank, and then the two of you can go searching for your magnet."

"Cool," Steinberg said.

"I have nothing to do," Play Dough complained.

"You can distribute prizes," Arman said. "Someone needs to grab them."

"ON IT!" Wiener shouted. He grabbed Chico's wrist and raised it in the air, desperate to get him alone for a man-to-man apology, and also, to be the one to show him the awesomeness of the carnival.

"Fine, but keep the ice on, Chico," Arman called. "Wiener, I'm relying on you."

"You got it!" Wiener called back, already leading Chico toward the platform stage.

As they passed amazingly crafted booths like the Water-Balloon Toss, and Pinball, and Squirt-Gun the Clown Mouth, Wiener couldn't help but smile. "Pretty cool, huh?" he asked Chico.

"Sure. It's cute for a kiddie carnival," Chico replied.

Wiener shook his head, baffled. "A *kiddie* carnival?"

"Oh, my Wiener, you should see the one in Barcelona. There are parades, and floats, and dancers, and costumes, and live music, and tortilla-making competitions!"

"Wow," Wiener said. "That sounds amazing."

"It is. Our Carnaval is the biggest, best fiesta. You should come to Spain to check it out."

Wiener nodded, feeling conflicted. Of course a camp carnival wouldn't hold up to Barcelona's world-famous Carnaval. But camp activities weren't supposed to be held to real-world standards. They were incredible for different reasons. Today was a celebration of camp history. And friendship. And teamwork. And booth pride. That wasn't nothing. That was EVERYTHING. But, on the other hand, *Yes, please, to a European adventure eating tortillas and shaking hips with a Barcelonan pop star.*

Once the guys got in line for the prizes, Chico removed the ice from his face and winced like a movie star fresh from a fight scene.

"Hey, I'm really sorry for hitting you," Wiener said. "If it helps, I've got concealer back at the cabin."

"Maybe," Chico said. Then he pointed his chin at a barrel of bobbing apples. "My father's going to be pissed. He already thinks I'm a spoiled fruit."

"A bad apple?"

"Yeah. He sent me here to stay out of trouble."

Trouble? Wiener wondered. Chico seemed so mature. His dad should call him "sweet as pie" like his mom did when she tucked him in at night, not a "bad apple."

The *whee-yoo, whee-yoo* of a siren cut their conversation short. Wiener looked toward the noise and spotted Jenny and Jamie inside the Love Shack, only half a golf hole away, playing tug-of-war with a loudspeaker.

"IF YOU'RE LOOKING FOR LOVE, please report to the Love Shack. We repeat—IF YOU'RE LOOKING FOR LOVE, CHICO, please report to the Love Shack. The love of your life awaits—*Jenny, no!*—We don't bite—*Ow, you actually just bit my arm*—Are you a dog person or a cat person?—*Cat people especially welcome*—Meow Mix ha-ha-ha!"

Missi sat hunched beside the J-squad, shaking her head in small, mortified bursts.

Chico passed Wiener a baggie of prizes. "Those two girls are scary."

Wiener laughed. "Yeah, the J-squad can be pretty intense, but—"

"Pardon. I'm going to go say hello to Missi. Ask her if she'd like some ice cream."

"Oh, okay." Wiener could hardly believe Chico had the guts to just walk over all on his own. And OFFER HER ICE CREAM? The dude should write a book. "Have fun. Meet me back at the DT in twenty for our rotation?"

"Yes, my Wiener. That works."

"Oh, and how do you feel about going in the tank? I'd rather show my little brother how the game works."

"I'm very sweaty, so that sounds—how do you say—*sauce*?"

"That's how you say it!" Wiener smiled and put his hand out for a fist bump. Chico bumped him back.

He watched Chico approach the Love Shack and Missi. Sophie held a fishing rod above them. Instead of bait hanging from the line, there was a makeshift mistletoe—a paper heart with grass and red beads taped to it. Jenny whispered something into Chico's ear, and he slid a Ring Pop onto Missi's finger. Then, as if he'd *actually* proposed and she'd *actually* said yes, the film crew swept in.

Wiener wanted to be happy for them, but he couldn't help but feel pathetic. That could have been him out there with Missi. He would have loved to catch her smile as he slipped on a Ring Pop. He would have loved to soak up the media attention. He would have loved to prove to Max that he and Missi were a Kodak, Love Shack, for-real couple.

He looked down at his feet. His legs moved him away. He delivered the prizes to Arman and then went back out, determined to have fun. He earned a dreidel from a Mini Basketball game, a slap bracelet from a Ping-Pong Toss, and a slice of zucchini bread from Claudia Cooking in exchange for the dreidel. And then, once he was feeling healthy and hyped, his watch alarm beeped. *Dunk Tank time, yo!*

Wiener rushed back to find Max on Play Dough's back and spinning. "This is the best ride of the carnival," he cried happily. "Wheeeeee!" No one was in the Dunk Tank. Chico was nowhere in sight.

"Hey, guys. Here for my shift!" Wiener said. "Max, wanna check out our booth?"

"Whoa!" Max continued, going round and round. "My stomach feels like a washing machine!"

Wiener stood there, waiting for Play Dough to quit it. But he kept spinning. "Did you get my letter about it, Max?" Wiener pressed. More spinning, more "whee"-ing, no answer. "Max?"

"I think so," Max replied.

Play Dough came to a halt. Max slid off his back and they both wobbled a few steps in random directions.

"I didn't get your holler back, so I wasn't sure if you were mad—"

"Holler back, y'all!" Play Dough squealed in a girly voice. He and Max burst into giggles. Wiener laughed with them, but it came out forced.

"Okay, I'm ready to play, PD," Max said, scooping up a softball and tossing it between his two hands.

"Nice!" Wiener said. "We can start just as soon as Chico gets here. He's my shift buddy, and he promised he'd go in the tank."

"Dude, just get in the tank," Play Dough said. "Don't be such a chicken."

"I'm not. Just give Chico a minute," Wiener said.

Play Dough set his watch alarm for a minute. "Fifty-nine, fifty-eight . . ."

Wiener craned his neck to look for Chico. He could feel his pit sweat breaking through its shield of Axe deodorant.

". . . forty-three—I'm bored—eighteen, one."

"Wait—"

"Looks like you're the punk getting dunked."

"Ha! Punk!" Wiener said, laughing it off to Max. The whole point of bringing Max by was to show him how cool Wiener was, not to showcase him as a loser dunkee. Also, Wiener was

wearing his favorite khaki shorts that would surely discolor in lake water. And also also, just imagining the freefall dunk, his skin was already starting to feel like unbreathable plastic. "Did Steinberg fix it at least?" he whispered into Play Dough's ear.

"Hey, it's okay to piss yourself," Play Dough fake-comforted him. "But when Li'l Wiener dunks you, do you really want to fall into a bin of your own urine?"

"Ewwwww," Max said, breaking into giggles.

"I didn't say that," Wiener said.

"Your brother, little dude," Play Dough said. "Never a dry moment."

"Never a wet moment, ha," Wiener said, quickly realizing that made no sense at all. There was nothing left to do but comply. He climbed up the ladder. *It's not that high*, he assured himself. *If you can ride roller coasters, then you can free-fall into the dunk tank.* He reached the bungee chair and gazed twenty feet down. The people looked like ants.

"Dude, you're shaking," Play Dough said. "You're only six feet up."

Right, Wiener thought, trying to get a grip.

Play Dough led Max to the throwing spot, designated by a stick in the dirt. It had been pushed back way more than twenty feet, probably for a cocky upper camper. No way could Max hit the target from there! Wiener thought about telling PD to move the stick up, but, embarrassingly, he was more concerned about falling than he was about his brother feeling like a champ.

Max began to wind his arm. His tongue was pressed up

over his top lip, which was something he did when he was concentrating extra-hard. Wiener took a big brave breath and closed his eyes.

"NO! WAIT. IT'S NOT READY!" he heard Steinberg wheeze-shout.

Wiener's eyes shot open in terror. Whatever the problem, it was too late. Max had released the softball. Suddenly everything felt like it was in slow motion. The softball smacked the target. Wiener was flung from the bungee chair. He was flailing his arms but trying not to, because the laundry bin wasn't big enough for a star jump. Except his arms weren't the problem. It was the release mechanism. It came crashing down with him.

Wiener felt an electric current zap at his toes, up his spine, and through the top of his head. His body convulsed underwater, and the next thing he knew, he was horizontal. The laundry bin had toppled over and he was tumbling, tumbling, tumbling for what felt like an unusually violent shower hour.

Eventually the bin hit something sturdy, a tree maybe, and Wiener somersaulted onto the grass. Then he barfed zucchini bread onto two pairs of familiar shoes: Chico's high-top denim Nikes and Missi's purple Crocs.

July 7

Dear Mom,

How are you? This summer started with a carnival bang! Our booth was the Love Shack. We were supposed to do a Valentine's thing where campers would write cute messages to each other, and then we'd read them over the loudspeaker!

But Jenny being Jenny, she took over and decided we should get guys to propose to us with Ring Pops. Bobby was called over to propose to me, but don't worry, he just got down on one knee and said: "Slimey, will you eat cotton candy with me and then go in the Bouncy House?" I said, "Yes!" and then we hugged, ha-ha!

Love,
Stephanie

P.S. I know you said Charles is just a friend, but you'll let me know if he's thinking of proposing for real?

Dear Moses 'n' Sam,

Do me a favor and say this prayer at Friday's Shabbat dinner.

Baruch atah Adonai, protect all things electric from H2O and all things human from electrocution. Amen.

Please keep Wiener in your thoughts.

From,
Robert Steinberg

ACCIDENT REPORT FORM

Camp Name: I think u know

Date/Time of Incident: Carnival Day, noon-ish

Name of Person Involved: Wiener Age: 13 Sex: LOLZ

☒ Camper ☐ Staff ☐ Visitor

Name of witnesses:
1. Me (Play Dough)
2. Li'L Wiener, Missi, Chico Nuevo
3. everyone at camp

Type of Incident:
☒ Behavioral ☒ Accident ☐ Epidemic/Illness ☒ Other
(describe)

Describe what happened:

I didn't mean to bully Wiener into the
Dunk Tank. It's just that I was kind of
pissed at him for taking Chico to fetch the
prizes when all three of us could have gone
together. Wiener's changed. He sucks up to
Chico and acts like he knows him better
than everyone else. I don't even get why
they like each other. Wiener gave him a
black eye and then barfed on his sneakers.
And Chico stood him up at the Dunk Tank
to eat ice cream with Wiener's ex-girlfriend.
Am I missing something?

1. Wiener in Dunk Tank.

2. Getting electrocuted in water.

3. Rolling in Laundry bin.

4. Throwing up on shoes.

Was injured person participating in the activity?
☒ Yes ☐ No If so, what activity? Dunk Tank

Any equipment involved in accident? ☒ Yes ☐ No
If so, what kind? Dunk Tank equipment

What could the injured person have done to prevent injury?
Wiener could have not hogged the newbie, and
instead shared him with the Wawel Brotherhood.

Submitted by Play Dough Position Sitting
Date Jenny Nolan, and we're going on 11 months
Phone number 1-800-PLAYDOH Ext: GetsExtraCanteen
ForFillingThisOutLikeABoss

An Electronic Slide Down Memory Lane

What a perfect night, Missi thought, cocooned inside her sleeping bag on the crowded basketball court. Being a super-upper camper meant she and her cabinmates had to set up pretty far back from the big white screen so that all the little kids could see, but it was actually the ideal distance. Propped up on her elbows, she'd have a full view of tonight's camp-wide evening activity: the Fiftieth Anniversary Slideshow.

"Scootch, Caterpillar," Jenny said to Missi, standing with a pink bungee chair on her back like a backpack. "I can't see the screen."

Sure, Missi could have said, "Silly, you're the one with the chair, and you want *me* to move to where it's hard to see?!" But she didn't bat an eye. Jenny's random excuses to sit beside Jamie were standard routine, and after so many summers of them, Missi had learned it was best to just obey. She scooted over to make room for Jenny, and as luck would have it, her view was even better. *Booyah!*

Just as Missi went to re-cocoon herself, "Electric Boogie" played in the distance. She sat up with curiosity—most kids

did—and watched the Wawel Hillers emerge from behind the screen, boogie woogie–ing as part of the famous line dance.

"GET IT?" Play Dough shouted to the crowd, lunging into a slide.

The crowd clapped and "woo"-ed with unusually low enthusiasm.

"I don't think they get it," Steinberg said, a portable speaker on his shoulder like a boom box in an '80s movie.

Missi "woo"-ed louder to show support, and *maybe* to get Chico's attention, but she was also confused about why they were dancing the Electric Slide at this particular moment.

"I think I get it," the Captain said into the mic, "but why don't you explain to those who might not be grasping the genius of your wordplay."

"Oh, it's all about the wordplay," TJ said with uncertainty, obviously just as clueless as everyone else.

"You're about to watch an *electronic slideshow*," Steinberg said. "And here we are, doing the Electric Slide."

There was a collective, drawn-out "Ohhhhhhh" in the audience. Missi thought the wordplay was a stretch, but she didn't mind. Every Friday night, her grandparents took her line dancing at Oldwick Senior Citizen Community Center, where she participated in popular dances like Hoedown Throwdown and Catwalk Shuffle. It was the best. So, naturally, Missi jumped to her feet. *Step touch, step touch, arm wind, slap the court, people!* Even Jamie was standing and wiggling her little hips. "Jamie, come with me to the front!" Missi called.

"Okay, yeah!" Jamie said, offering her hand.

But Jenny got to Jamie's hand first. And then instead of Jenny leading Jamie to the front of the court, she pulled Jamie onto her lap. *"Bungee butt dance! Bungee butt dance!"* Jenny sang, as they bounced to the beat on the bungee chair.

Missi kept dancing like a champ, thinking of the Oldwick Hoedown motto: "Go BIG or GO TO BED, seniors!" She shimmied like crazy over the back of Jenny's chair and sang, *"Boogie woogie woogie!"*

"Omigod, personal bubble," Jenny mumbled. She didn't ask Jamie to get up off her lap—in fact, her arm was around Jamie's waist like a seatbelt—so it was clear that, once again, Jenny didn't want Missi to share in their J-squad moment.

Missi shrunk her sashay to small backward shuffles until she was on her sleeping bag, alone. She switched her focus to the gnats and fist-size moths buzzing around the night lamps and wondered if she was nothing but a winged pest.

Keep step-touching, Missi told herself. *Be your own individual. It's what Rebecca Joy would do.* She looked out at the Wawels, who were still dancing, and suddenly she noticed something unusual—and familiar—about their styles. Dover's collar was popped. Totle was wearing jean shorts. Smelly wore sunglasses on the top of his head. Steinberg wore an argyle belt. Play Dough's hair was spiked up with gel. Chico, like normal, was sporting all of it: a popped collar, jean shorts, sunglasses, an argyle belt, and gel. And Wiener . . . *Wait, where was Wiener?*

The guys formed a semicircle and waved up a Bunker Hiller to join them. It was Max Meyer! He jumped in front of the Wawels, dancing better than anyone Missi had ever met at

Oldwick. In fact, he was performing a breakdance solo that was so sharp and original, he could be hired tomorrow as a professional bar mitzvah dancer.

"SLIDE, LI'L WIENER, SLIDE!" the Wawel Hillers cheered. "HE'S ELECTRIC!"

Suddenly Play Dough stepped center stage to throw Max onto his shoulders, and the mystery was solved. A pale Wiener had been standing behind Play Dough, snail-paced Electric Sliding with a bag of frozen tater tots to his head. *Poor guy.* Missi guessed he was still healing from today's Dunk Tank accident.

Steinberg started singing new lyrics to "Moves Like Jagger": *"HE'S GOT THE MOVES LIKE SWAGGER! HE'S GOT THE MOVES LIKE SWAGGER!"* Quickly, the entire camp caught on and joined in: *"HE'S GOT THE MOO-OO-OO-OO-OOVES LIKE SWAGGER!"*

Except Wiener. He was definitely not singing.

Missi wanted to call out to him, "It's okay! Just sit out and enjoy your brother's amazing moves! No one's gonna judge!" But then the song ended, and the Wawel Hillers boogie-woogied to their sleeping bags. Suddenly, she felt a tap on her shoulder. It was Sophie. "On a scale from repugnantly dull to stunningly electric, how would you rate Dover?"

"As a dancer?"

"As a lover."

"Um." Clearly Sophie had decided on her crush of the summer. "Stunningly electric?"

"Yes. I knew it. Thank you, Missi. Though you be but little, you are fierce."

Flattered and a little surprised to have her opinion matter—on boys, of all subjects—Missi smiled a wholehearted *Thanks and you're welcome.* Then, just as she sat down, she spotted Chico wandering onto the girls' side of the court. He had his hand on his forehead like a visor and his eyes were running through the rows of upper campers. He was looking for someone. *Me?* Missi thought. *No way.* But, just in case, she'd have to show her eye-catching red hair. She pulled down her sweatshirt hood and yanked out her scrunchie. Her hair spilled out of a bun. Well, not spilled. More like fluffed. She'd forgotten to use Frizz Ease tonight.

Still, it worked. Chico spotted her. He dropped his hand visor, and his face lit up like a Christmas tree. Translation: *You're not a winged pest. You're special, even when your head looks like a cotton ball dipped in fruit punch.*

He headed to her side and said, "Hi, Missi."

She liked how adorably he said her name: *Mee-see.*

"May I sit?" he asked gently.

Clearly Chico wasn't aware that for activities like this one, the girls always sat on the right and the boys always sat on the left. It's just how it worked. But Missi didn't want to get weighed down by rules. She wanted to think about Chico's perfectly crooked smile and all the bonding stuff they'd gone through today: a proposal, a film crew, and vomit-y shoes.

"Missi?" he repeated.

"Oh, yeah, sure," Missi said, flustered. "Of course, I mean!" She turned around to get Cookie's permission, but her counselor was busy braiding together Sophie's seven braids. *That's a*

yes, I guess! Missi jumped up and began to reposition her sleeping bag horizontally to make room for Chico, but with the court being so packed, she had to fold it in half. Now the bag took up the perfect amount of space for two butts.

As Chico sat beside her, his jeans against her leggings, Missi's heart began to pound. He definitely had space to sit a little farther from her.

"Where is your Pop Ring?" he asked.

"Huh? Oh! Ring Pop!" she said, laughing. "Jamie ate it off my finger."

Jamie glanced over at the mention of her name, and then, seeing Chico, moved Jenny's face to stare at them, too.

"Um, this is the girls' side," Jenny blurted.

"Yes, you are girls," Chico said.

"Yes, we *know* we're girls," Jenny said.

"Yes, that is good," Chico said.

Jenny huffed and began to wave Play Dough over—probably not to start trouble, but because if Missi had a boy sitting with her, then she should, too. But Play Dough was sitting on Dover's lap while Dover laugh-howled in pain, and neither of them seemed to notice Jenny's flailing arms.

Chico paid Jenny no mind. He just looked at Missi while conversation starters frantically blew around in her head like balls in a Powerball machine. "I loved your cabin's dance," she said at random. "I love dancing. I dance a lot with my grandparents and my cats."

"With your cats?" Chico asked.

"She's joking," Jenny said, jumping into rescue mode. "Right, Missi, you were joking?"

"No," Missi said. She wasn't joking, and even though what she'd just said required more explanation, that's what conversation *starters* were for. "Do you have a cat?" she asked Chico, crossing her toes that he'd say yes and they'd have infinite kitty stories to bond over.

"I'm allergic," Chico said.

Missi uncrossed her toes, disappointed. "Oh, that stinks." Then she swept her eyes over the sleeping bag for furballs and spotted two of them at her toe-socked feet. She pretended to stretch and brushed them away. "But you like dancing?" Missi asked.

"In teen clubs," Chico said. "I'm a trained Flamenco dancer. I've also studied Sevillana, which is a lively dance of Seville, and like Flamenco, but has four parts."

"I used to think Flamenco was called 'Flamingo,'" Missi said, giggling. "You know, the pink bird?"

"So you dance Flamenco, too?"

"Oh. No."

"Missi could *totally* dance Flamingo," Jenny cut in. "I dance Hip-hop, Lyrical, and Jazz, so I know a dancer when I see one. One summer, she did the talent show dance with Jamie and me, and as she body-rolled, I was thinking, like, *Omigod she's a natural.*" She smiled at Missi, then pointed at Chico's face. "Also, I'm just going to say it: Your black eye is hot."

Chico dabbed his bumpy bluish-black eye. "Uh, okay," he said.

"So!" Missi burst out, by way of subject change. "Do you play an instrument?"

"For a while I played the oboe, but then I got bored, so I learned the upright bass, but that thing is big and not easy to travel with, so now I—how do you say—*compose electronic*."

"Wait, *what* do you compose?"

"Electronic. At home, I have my own keyboard, synth, and software."

"Cool! I play the flute."

"Oh, man. That's too bad."

"Wait, what is?"

"If you have to practice hours each night, then you should be able to choose your sound, not play whatever your family chooses for you. What did you *want* to play?"

The flute. "Oh, um." She looked at Jenny.

"The harp," Jenny said.

"You should look into the electric harp. That is an instrument worth playing."

"ALL RIGHT, ROLLING HILLS," TJ shouted. Then he brought his voice down to a spooky whisper. "The show is about to sliiiiiiiide!"

The Captain took the mic and spoke totally normally. "Usually we bring you here to watch the end-of-summer slideshow, a tear-jerking chronicle of the past eight weeks. But since we welcomed the film crew today, we wanted to give you a taste of their work, shown alongside similar camp pictures from the last five decades. In another few weeks, just before Visiting Day, we will show you the . . ."

"NEW CAMPER RECRUITMENT VIDEO!" the Captain and TJ shouted together.

Suddenly the night lamps went out. The song "Forever Young" erupted from giant speakers, and Now and Then pictures of campers flew across the screen. Missi joined in on the "ooh"-s and "aww"-s, relieved to get a break. After all, she knew as much about electric harps as she did about Shawn Mendes.

"IT'S US!" the J-squad squealed at the top of their lungs. "GO NOTTING HILLERS—WHAT-WHAT!"

The picture vanished only two seconds later, but when Missi closed her eyes, she could see it clear as day: A split screen of two groups of upper camp girls. The one on the right was a high-quality shot of her cabinmates in front of the Love Shack booth. Missi was on the end, hovering over Jamie, whose arms were tightly wrapped around Jenny's waist. Missi wasn't surrounded by her friends. She was invading their space.

The picture on the left looked like it had a Slumber Instagram filter on. The girls' styles were noticeably old school— off-the-shoulder T-shirts, butterfly barrettes, and blue eye shadow. Smack in the middle was what looked like her graceful, popular twin. It was Rebecca Joy Snyder.

Missi opened her eyes to watch the slideshow, but she got lost in all the recent memories she'd shared with her mom: doing hot yoga, and baking Irish soda bread, and painting the farm at sunrise. Missi loved every second they'd spent together. She hadn't cared that her grades had slipped or that her bandmates had stopped inviting her to pizza after rehearsal because she'd cancelled on them so many times. In fact, Missi had only

agreed to return to camp because Rebecca Joy had assured her that it would bring her matru-prema (aka *motherly love*) to see her daughter in her element.

Suddenly, Missi missed her mom so much it hurt. All she wanted was to talk about her. "Hey, Jamie?" she whispered. "Did you see the old picture next to the one of us?"

"Not really. I was looking at myself." Jamie squinted into the darkness at Missi's unsmiling face. "Wait, are you okay?"

"Yeah, it's just that in the old picture, the other redhead— she's my—"

"Omigod, cheer up, Missi!" Jenny cut in, leaning over and kissing the top of Missi's frizz. "Slideshow time is happy time! Chico, tickle her."

"I don't, uh, tickle," he replied.

Just then the screen went black. Then, in turquoise, one letter appeared at a time as if being typed by a literal ghost-writer: MYSTERY TRIPS LEAVE TOMORROW AT SUNRISE. There was a suspended breath of anticipation in the crowd as the cursor on the screen blinked in thought. The typing continued: BUT TO WHERE? The crowd started muttering in excited confusion, and then scrambled words like OPRTWNCESOO and ISX GSLAF and SEHEYRHKAPR spiraled smaller and smaller into the middle of the screen like a tornado.

"SLOW DOWN! SLOW DOWN!" the campers cried. But the clues spiraled faster and faster until the screen went white. The night lamps turned back on.

Missi swallowed her homesickness and watched Jenny turn

to Jamie: "Bus Buddy?" they asked each other. "Jinx! Double jinx!"

Determined, Missi turned to her left. "Hey, Sl—" but Slimey was tickling Melman.

"Ugh, fine," Melman said. "I'll sit with you as long as you don't draw me while I'm sleeping."

Missi turned around. "Hey, Soph—" But Sophie was already playing thumb war with Cookie for the window seat.

Missi sighed and then stood, rolling up her spine, vertebra by vertebra, like her mom had taught her. *It's just a silly bus ride*, she told herself. If her mom could travel solo around the world, then surely she could handle an empty seat beside her for an hour or two.

When Missi lifted her head, her eyes met Chico's. He looked more gorgeous than ever. He took his hood down from his head, and his hair didn't even fluff like hers had. It was waved and spiked to perfection.

"Need help?" he asked.

"With what?"

"The body bag."

"You mean the sleeping bag?" she asked, her lips unexpectedly curling into a smile. Sometimes morbid stuff made her laugh. "Sure, that's nice of you."

As Chico held up the other end of the sleeping bag and rolled it toward her, Missi tried to think of something impressive to say. Something that would really wow him. But what was she supposed to talk about? Farm life with seven cats and

a nonelectric flute? Nope. *What would Rebecca Joy share with a foreign fling?* she asked herself. Her mom had so many wild stories: Sailing the Mediterranean. Singing backup for a German rock opera. Painting an abandoned ship from INSIDE THE OCEAN.

But then Chico reached her, making a Chico-Sleeping Bag-Missi sandwich. "We can sit together on the bus, yes?" he asked sweetly.

And then, too wowed to wow him back, she replied with a simple nod.

July 7

Dear Mrs. Garfink,

How r u? How is your Zumba class this summer? ~~Play Dough~~ (Sorry, it's a habit calling your son that.) BRIAN said you're also teaching Spin—so fun!

Anyway, as promised, here is HIS list of the stuff he ate today. My comments below.

Breakfast
Bran cereal with milk
(um—he had Cinnamon Toast Crunch with chocolate milk)

Lunch
Tuna sandwich with salad
(his salad was just croutons, ranch dressing, and one pickle)

Dinner
Sloppy Joes and some more tuna
(FYI—he mixed the tuna in the Sloppy Joes and ate three buns)

Note: He forgot to mention the popcorn, cotton candy, Ring Pop, and six Hershey's Kisses he ate at the carnival. I'll get him back on track, so long as tomorrow's "surprise trip" doesn't revolve around more food, ha ha, LOL.

Teach me Zumba after camp? I'll bring my mom.

XOXO,
Jenny

July 7

Dear Shake-It-Up Shakespeare Sisterhood,

I am delighted to be inquiring about the First Annual
Original Sonnet Competition. You're probably thinking:
"This girl is off her rocker. We don't have an Original
Sonnet Competition!"

Well, you should have one. And for the idea: You're
welcome.

Here's a personal statement: Today I developed feelings
for my camp friend, Dover. We had a carnival, and he
visited my cabin's Love Shack Booth. Even though I've
known him for forever, I felt like I was seeing him for
the first time. He was wet and chasing a rolling laundry
bin with my (literally) shocked friend inside, and I saw this
gorgeous desperation in his eyes. As my head spun like a
cotton-candy machine, I sat down with a feather pen and
normal paper, and a sonnet practically wrote itself.

(I have not included the sonnet here out of respect for
your "no unsolicited submissions" policy.)

If you would like to proceed with my contest idea, please
write me back at camp or email my counselor, Cookie, at
CookieRivera4eva@gmail.com with the subject header:
Sophie's Spectacular Sonnet Idea.

In black ink my love may still shine bright,

Sophie Edgersteckin, age 14.27

July 7

Dear Nurse Nanette,

I have a confession to make. It's 2am and I just ate your cake.

I did not steal it from the infirmary freezer, but I egged on my cabinmate to do it as a joke. I did not expect him to FOLLOW through. He's new to camp and also international so probably doesn't understand our rules or my charming sense of humor. Totle gave him the lowdown on STARFISH, his values system, so it won't happen again.

I will make it up to you. After I get back from the surprise trip, I will bake you a fresh cake with the help of Claudia Cooking.

In the meantime, Merry Lice Checks!

With deep regret and terrible gas,
Play Dough

Mystery Ride

"ALL ABOARD," Arman bellowed from the door of the mini yellow bus.

"Wait up!" Wiener cried. He was sprinting from Wawel Hill Cabin, where he'd returned to grab his Sea-Band, a motion-sickness sweat bracelet that looked like it belonged on the wrist of a tennis pro. At least that's how his mom had pitched it to him the first time she'd made him wear it. With the carnival disaster still fresh in everyone's mind, he figured he was better safe than sick.

Wiener was about to pummel up the bus steps when Cookie stopped him. "Spin," she said, waving a silver spray can. "You need protection from the nasty rays you'll be encountering."

Nasty rays, huh? So this Fiftieth Anniversary trip is science-themed! Wiener shut his eyes and mouth and spun as Cookie doused him in sticky solution. "Nice gag," he said with a wink. "Are we headed to a science museum? Is it zombie laser tag? Wait, don't tell me: a screening of an old sci-fi flick!"

Steinberg peered out the bus door at Wiener like he was clinging to his last brain cell. "Dude. She sprayed you with sunscreen."

"Psh, I know," Wiener said, the coconut-lotion smell kicking in twenty seconds too late. He climbed up the steps. "Maybe you didn't hear, but I also guessed that we're going tubing down the Delaware River."

"No, you didn't," Play Dough said, two rows deep.

"I was thinking it." *Just find Chico and take a seat*, Wiener told himself as he swaggered down the aisle. *Stop opening your big, lying mouth.* He spotted Chico's head bobbing over the green leathery seat in the very back, except the spot beside him wasn't empty. Missi's red braid was peeking out into the aisle. *It's cool, totally cool.* He swaggered backward, his eyes darting from row to row for another spot to sit.

Suddenly he felt something hard poke him under his shoulder blade. "Hey, buddy," he heard Arman say behind him. Wiener whipped around to meet his counselor's robot finger. "You're in the three-seater with Chico and Missi."

"Niiice," Wiener said, not budging and hoping that Arman would be the one to explain to the Couple of the Summer that they'd have to make room for the very person who, just yesterday, puked zucchini bread onto their shoes. But Arman was suddenly busy sorting through a bag of individual cereal containers to distribute for breakfast.

Wiener shame-swaggered back down the aisle to their row. *First step: small talk.* "Waaaz up?" he asked them.

"Nothing really," Missi said, yawning into a smile. "It's early, but we're excited."

So they were officially a "we" now. Wiener pretended to blink tired-style but really gave Missi a once-over. She was dressed

differently than usual in feather earrings and a teal flowing dress. Why the costume? *Oh! She knows where we're headed!* "So, we're going to the thee-ay-ter?" he prodded in a mild British accent.

"Huh?" Missi asked, tugging her dress so that it draped over her knees.

He was making her uncomfortable. He should make her less uncomfortable.

"Wiener, my man!" Arman called from the front. "You've gotta take a seat."

"On it!" *Step two: break the news.* He looked pleadingly at Chico and then at Missi, hoping they'd make room without him having to ask outright, but they still seemed to be grappling with his spontaneous British accent. "There's nowhere else to sit," he finally admitted, pathetic as ever.

"Oh!" Missi said, scooting over. "I mean, I just didn't—that's totally fine."

"My butt's small," Wiener let slip. Then he sat down, debating whether he should try to take up more space to show his butt's bigness or if he should cramp himself onto the edge to be polite. He went with the latter.

As the bus took off down the dirt road, and through the camp gates, and along the windy farm roads, Wiener munched on dry Cheerios. Out the window, the orange sun rays danced on a herd of cows, their heads dipping down to the hay. For a second, Wiener imagined the cows eating the hay with milk, which was funny, because cows, like, *made* milk, and then he thought about that one time he'd visited Missi's farm, and

he'd milked her cow named Franc. Play Dough had milked Franc, too, but he'd stunk at it—the milk had squirted all over his face!

"What's so funny?" Missi asked.

"Huh?" *Your cow.* "Oh, *nada*," Wiener said, winking at Chico, who'd taught him that word. It meant "nothing."

"Is it my outfit?" Missi pressed.

"Psh, your outfit's hot," Wiener said. And then, horrified for hitting on Missi in front of Chico while they were on their bus date that he was crashing, he scrambled to say what he should have just said from the beginning. "I was thinking about Franc."

Missi cocked her chin. "Um."

"Still in *udder* bliss?" Wiener asked, reprising the hilarious joke he'd made the day he'd milked her.

Then, even though Missi had laughed hysterically the first time she'd heard it, now she didn't even smile. Instead, she put her hand up to where her red frizzies met her almost-as-red forehead. What was wrong? WAS FRANC DEAD? Not a chance. Missi had Instagrammed some milk in a tall glass right before camp. Unless that was grocery-store milk. *Yikes.*

"Who's Franc?" Chico asked Missi. "Your boyfriend?"

Wiener laughed. Like, thigh-slapping laughed. "No, man! She's her cow."

Chico shook his head. "A *cow*?"

"Yeah, you know, a cow." Wiener looked out the window and pointed, but by now they'd passed the cows and there were sheep.

"Those are sheep," Chico said.

"Uh, yup. Missi's got 'em all. Little Bo Peep in the house. Er, barn."

Chico looked at Missi like she had two heads—a cow's and a sheep's. "You don't seem like a farm girl. Do you live on a farm?"

"No," Missi said, giggling kind of weird. "I mean, sometimes I visit my grandparents on *their* farm, but."

"Dude, she's being totally modest." Wiener gave her a double point. "Best. Farm. Girl."

"Nuh-uh," Missi said. "Seriously."

"Seriously, her farm is a *real* farm," Wiener bragged to Chico. "Missi eats cereal with milk straight from her cow's udder."

Chico scrunched his face in disgust.

"Don't knock it till you've tried it," Wiener said, raising an invisible glass of milk at Missi for a cheers. She ignored it. He cheers-ed himself.

"The farm that Wiener's talking about—it's definitely not home," Missi told Chico. "I live with my mom, and we, like, travel the world together." She pinched her dress at the thighs. "We got this frock in Rishikesh, which is a yoga center in India!"

Wiener hadn't realized Missi had a mom. He guessed that was a dumb assumption—everyone has a mom. But since he'd only ever met her grandparents, he'd never thought much about it. Wiener was happy for Missi. The farm was cool and all, but it was jam-packed with crappy stuff, and the one time he was there, he couldn't help but reorganize the basement closet.

"What about you?" Missi asked Chico. "What's it like with your family in Barcelona?"

"I don't live with my family," Chico replied. "This past year my dad sent me to an international boarding school in Sweden."

"Wow," Missi said. "Not only are you from Europe, but you're a world traveler like me! That must be why you're so independent."

"Maybe."

"Wait," Wiener said. "So if you're away all school year, and then you're at camp for the summer, when do you see your family?"

"I don't," Chico said, swallowing so hard that his Adam's apple slid up and down like a rocket. "Just the way they like it."

"Dude—I'm sure that's not true. They probably miss you twenty-four/seven! Parents, man, they live for their kids."

"Sometimes, my Wiener, I think you live on another planet."

"Ha!" Wiener said. "Me? Another planet?" He looked at Missi for confirmation that he was, in fact, an earthling, but she was busy picking at her cuticles. He looked back at Chico, who was now gazing out the window with his hood up. *Another planet it is.*

Wiener leaned his head back against the sticky seat and closed his eyes. He wished he had Justin Timberlake to listen to, because JT was his favorite artist and the Father of Swagger, but there were no electronics allowed. He was stuck trying to chill to the sing-along of last summer's SING songs, which was now being led by Jenny. Although a talented lyricist, she had the tonality of a humpback whale.

Luckily, Wiener wasn't alone in thinking that. As soon as he opened his eyes to *maybe* say something, Dover called out, "Jenny, Arman has something really cool to show you," and she

said, "Like, *me*, specifically?" and Dover said, "Uh, yup, it's always about you," and then she stopped her wailing to admire Arman's Terminator Arm.

"What happened?" Jenny asked Arman. "Eek. It's okay if you don't want to talk about it."

Arman popped an Advil. "It's not a prob—"

"My neighbor's foot got chopped off because of diabetes, and, like, if you ask her about it, she just spouts Bible passages. Oh, God—is that offensive? I AM SO SORRY."

"Hey, relax," Arman said. "I get asked all the time, and I'm happy to share."

"Phew! Omigod, I felt so bad, like, a second ago, because of course if you find comfort in higher powers—"

Arman made his fingers into a mouth and closed them. Jenny followed suit. "I was hiking alone in Armenia and my arm got crushed by a boulder," he told Jenny and Jamie, who were squeezing each other's hands with nervous anticipation. "After several days, I decided if I was going to survive, I'd have to amputate it with my pocket knife."

"WHAT IN THE WHAT?" Jenny said.

"WHAT IS WHAT IS WHAT?" Jamie said.

Play Dough's eyes slowly appeared over his seat, glimmering with bewilderment. "And *then* a family of cheetahs attacked you?"

"Yes, sir. I fed them my arm."

"That's crazy, man. You're a straight-up superhero."

"Desperate times call for desperate measures."

"Amen," Totle said, jotting it down.

Wiener rolled his eyes. Hard. Also, he might have groaned. The first part of Arman's story was stolen from a wilderness movie his dad forbade him to watch, and the second part made no sense. A whole family of cheetahs surely wouldn't be content with one arm. He watched *Planet Earth*. They ate impalas down to the bone. How did Arman's lies make him a superhero and Wiener's lies make him a baby with his pants on fire? It wasn't fair.

Jenny returned to terrorizing the bus's airwaves with her singing, and Arman walked two rows back to Wiener. "Psst," he said, "you don't dig my stories?"

Suddenly Wiener felt bad for making such a fuss. "The stories are all right," he said. "Just a stretch."

Arman stroked his sideburns. "Yeah, I've got to connect the dots better. Thanks, man, for the constructive feedback."

Wiener nodded, confused. "Uh, anytime?"

"HELLO, LADIES AND GENTS," Cookie announced from the front. "Are you ready for your CATCH OF THE DAY?"

Having waited patiently for hours for a reveal of any kind, the bus went instantly bananas. "Cod, please," Totle said. "Never mind, salmon."

"We're going fishing?" Dover asked.

"No, guys, a *catch*!" Smelly said. "I knew it! We're headed to Cooperstown for the Baseball Hall of Fame!"

Just then Arman rose ominously with a T-shirt cannon.

"OMIGOD, we're seeing A CONCERT!" Jenny screamed. "My sixth Taylor Swift concert had T-shirt cannons!"

"I went to a bat mitzvah that had one!" Jamie cried. "Are we going to a bat mitzvah?!"

"Wrong, wrong, wrong, and wrong." Arman fired the cannon. *Boom! Boom! Boom!* Bandanas, not T-shirts, began flying everywhere. Campers were diving into the aisles and jumping up from their seats to grab them while spewing guesses about their destination: "Western-themed bowling!" "A horse ranch!" "Are we ROBBING A BANK?"

But then Jerry the bus driver flashed angry eyes through the rearview mirror and shouted, "THIS IS NOT A PUNK BAND TOUR VAN!"

"My bad, Jerry," Arman said. "YO! Settle down!" They did. A little. "Everyone have a bandana?" The bus cheered yes. "Great. Now blindfold yourself."

"Um, that's got to be illegal," Jenny said, tying a pink one into her hair.

"But I'm scared of the dark," Jamie whimpered, holding a purple one to her face.

"C'mon, put 'em on," Arman said. "It's just so that you don't know where we're destined to be until we've reached our destination. No street-sign spoilers." Wiener obeyed, and since Cookie and Arman seemed to be pacing up and down the aisle inspecting for cheaters, everyone else probably obeyed, too.

Arman continued: "Cookie will now be distributing paper bags to every row—your teammates for the next three hours. Inside the bags are a disposable camera, a Scavenger Hunt, and ten dollars per camper for lunch. Photograph wisely. TJ and the

Captain will review the developed photos and determine the winner!"

"What's the prize?" Dover asked.

"A Louie bagel?" Arman said. As a newbie counselor, he didn't know about the most coveted prize the camp could offer: a toasted plain bagel with cream cheese and bacon from Duskin's Greasy Spoon, a mile from the camp's gate. But everyone else did. There were lots of screams and lots of joyous wiggling. Melman shouted a prayer: "Let there be light. Let there be Louie." While Wiener couldn't see Chico, he imagined that he must be confused, too. All this excitement over a bagel? But yes. This was camp. To a camper, a Louie bagel was better than a tray of hot wings.

The bags were distributed. The campers were blindly buzzing with excitement. Arman and Cookie began singing "Pure Imagination" from some movie Wiener couldn't place. And then the bus stopped.

Wiener didn't need to remove the bandana to know where they were. Breathing in through his nose and out through his mouth, he could taste it: Hershey's chocolate.

50TH ANNIVERSARY
Hersheypark Scavenger Hunt

Created by the Notting-Wawel Duo: Cookie + Arman

Remember, you are using a disposable camera, not a smartphone. You are limited to 24 pictures, which is plenty for the 19 items below. Highest amount of points a team can earn: 50. (If there is a tie, the winner will be determined based on artistic merit at the discretion of TJ and the Captain. So be creative!)

Snap a pic of the following . . .

- ☐ The highest point in the park (5 points)
- ☐ Hershey's Kiss earmuffs (2 points)
- ☐ A kid on a leash (2 points)
- ☐ Park mascot (2 points)
- ☐ Park mascot on a shift break (2 points)
- ☐ French fries with mayo, arranged like the number 50 (2 points)
- ☐ The first roller coaster at Hersheypark (3 points)
- ☐ A Free Parking sign (1 point)
- ☐ Milton S. Hershey's signature (2 points)
- ☐ An unexpected edible dipped in chocolate (1 point)
- ☐ A love letter to Hershey from Camp Rolling Hills (4 points)

- ☐ Hersheypark stationery (1 point)
- ☐ You on a kiddie ride (2 points)
- ☐ An employee who is 50 years old (2 points)
- ☐ The ride that's closest to 50 years old (3 points)
- ☐ Roller coaster with a maximum speed of 50 miles per hour (3 points)
- ☐ Another roller coaster with a maximum speed of 50 miles per hour (3 points)
- ☐ The 50 red lights on the retired Flying Falcon seats (5 points)
- ☐ The ride whose distance from the ground to its peak is 50 feet (5 points)

Setting the Bar High

"Holy Hershey's," Wiener said in wonderment as he took in the rainbow of looping roller coasters just beyond the main gate. The pre-entrance was bustling with families and scout troops and youth groups, all absorbed in maps and phone apps. While the Rolling Hillers waited for Cookie to grab the tickets, they probably should have been reviewing Scavenger-Hunt strategies, but instead they were gathered in a delirious huddle, mouths open like, *How did we get so lucky, and also, can we eat the sweet air?*

"WHAT A *NUTRAGEOUS* MORNING, Camp Rolling Hills!" an Ice Breakers Mints container announced. Well, it was likely a human in costume, but still. "Can I hear you say, '*NutRageous* morning'?"

"*NutRageous* morning."

"I can't *HEAR* you."

"NUTRAGEOUS MORNING."

"All right, all right!" The Ice Breakers Mints said, clapping her white-gloved hands together. "The ice has been broken! We are so *Jolly Rancher'd* to have you here with us today for a little friendly competition."

While all the teams exchanged smiles and bumps, Wiener glued his gaze to a lemonade stand. He didn't want to feel bad if Missi and Chico were exchanging smiles and bumps with only each other. But then he spotted Chico's fist held out for him to pound. Missi smiled. Wiener's heart swelled. His team was the greatest. Even though Missi and Chico might have been hoping for romantic time alone together, they weren't letting it show.

"Just a couple o' quick *refreshers* on the rules," Ice Breakers Mints said. "One: You must stick with your team at all times." She cued Cookie for a demonstration with a big cheesy finger point. Cookie group-hugged Sophie and the J-squad. "Two: Keep your wristband on." She cued Arman, who put his wrist out for band application. And then he detached his arm in her hands.

"I DIDN'T DO IT," Ice Breakers screamed, tripping over her clown shoes and collapsing onto her pillowy mint middle. Everyone began buckling with laughter—even Wiener. Except, then Arman gave Ice Breakers a helping flesh hand and said, "Not gonna lie: My ma's a cyborg," and suddenly Wiener stopped thinking the prank was so funny. First off, no one's mom is a cyborg. And second, Arman had lied. *Again.*

"Cyborg—nice one!" Ice Breakers said, clapping her gloved hands together. "So. The rules. Easy as chocolate pie?"

Easier. Wiener would come back to Camp Rolling Hills tonight and tell his li'l bro all about how he'd teamed up with the newbie and the girl who got away and led them to Scavenger Hunt victory. And it would be TRUE. Then, when TJ and the Captain reviewed the developed photos and confirmed their win, Wiener would split his Louie bagel with Max. Max would

lick the overflowing cream cheese around the edges, and say, "Holy Louie, my big brother really is epic."

"Everybody line up for your measurements," Ice Breakers announced.

Wiener flexed his bicep. "What's getting measured?"

"Height," Ice Breakers said. "Roller coasters aren't safe for the wee ones!"

Wait, whaaa? Wiener's vision started to blur from the outside in as his mind flashed to the first day of summer when Play Dough had measured his height against his brother's with a lacrosse stick. He silently recited his top favorite proverbs for comfort. One: *It's what's inside that counts.* Two: *Big things come in small packages, yo!*

"Wiener, walk," Play Dough said, bumping him into Missi's shoulder. That's right—his *nose* smushed against her *shoulder.* He was only seeing it now—Missi was a full head taller than him. *Unless* . . . Wiener looked down, expecting heels. He was met with flip-flops.

"Alright, campers," Ice Breakers said, "one at a time, stand with your back against the Hershey's Height Board. Once you get your wristlet, head on into the park!"

Wiener could see that the Board of Impending Doom for the Vertically Challenged was split into six sections, from tallest to shortest: Jolly Rancher, Twizzlers, Hershey's, Reese's, Kisses, Miniatures. From what he could tell, he would be somewhere between Hershey's and Twizzlers. With Reese's, Kisses, and Miniatures shorter than him, maybe that wasn't so bad? Right? Not so bad?

"I better be a Twizzlers," Jamie said, holding her crossed fingers in the air. "You need to be at least a Twizzlers to ride Fahrenheit!"

"What's Fahrenheit?" Wiener asked.

"It's the second-best roller coaster to the Storm Runner," Play Dough replied.

"What do you need to be to ride the Storm Runner?" Wiener asked.

"Also Twizzlers."

"Omigod, omigod," Jamie whined. "I hate being short."

Wiener studied Jamie with panic. Last summer, Jamie had been the only person in his age group who was shorter than him. But that was LAST SUMMER. Now her legs seemed longer, and her torso longer, and in general, just everything longer. So if *she* was worried, then . . .

"NEXT!" Ice Breakers called.

Jamie shuffled to the board, "omigod"-ing.

Twizzlers, Twizzlers, Twizzlers, Wiener prayed. *Please let Jamie be a Twizzlers so that I have a chance.*

"Hershey's!" Ice Breakers called, branding Jamie with a poop-brown wristlet.

NOOOOOOOOOOOO! Wiener internally screamed.

"NOOOOOOOOOOO!" Jamie externally screamed. She walked backward through the turnstile with her arms outstretched, as if she were being sucked into the park by a magnetic force. "Jenny, do something!"

"Don't freak out," Jenny said. "We'll skip the big rides and focus on the hunt."

For a split second, Wiener thought about ditching Missi and Chico for the J-squad, but then he'd be DITCHING MISSI AND CHICO FOR THE J-SQUAD. Still, spending the day watching Missi and Chico go on rides together without him would be a nightmare.

"Hey, Missi. I forget," he said shakily. "You're into carnival games and snacks and stuff, yeah?"

"Of course," she said. "Who isn't?"

"You're right—roller coasters are overrated."

"Huh? I'm OBSESSED with roller coasters. The crazier the better!"

"NEXT!" Ice Breakers called.

"That's me," Missi said, skipping to the board.

Hershey's, Hershey's, Hershey's, Wiener now prayed. Chico was taller than Missi, and Missi was tall, but maybe not tall enough?

"Twizzlers," Ice Breakers announced before Wiener was even fully aware that Missi was standing against the board. She got branded with a red wristband and practically leaped through the turnstile. "NEXT!" It was Wiener. Next was Wiener. Wiener was next.

"I gotta, um, I gotta pee," Wiener croaked.

"Go once you're inside the park," Chico said.

Not a chance. He ducked under Play Dough's arm and sprinted left and then right and then left, desperately looking past the hoards of scouts and church groups and identical T-shirts for the restrooms. *Bingo!* He cut through the clustered line of women and their kids and burst into the men's room,

locking himself in the first open stall he could find. He toilet-papered the seat cover until it was three layers thick, spritzed his travel Febreze, and squeezed the knob of his Sea-Band against the pressure point of his wrist. *Think of a plan, Wiener. Be the giant man you are.*

And then he heard a boy's voice so fresh to puberty, it sounded like a goose playing the trumpet. "Dad, I can't believe we're going HOME after only HALF an hour."

"Well, what do you want from me? Your sister's got a fever," a man replied.

The boy grunted. "How do I GET THIS off my WRIST?"

"I've got a Swiss Army knife on my keychain."

And then Wiener heard a *snip*. A glorious, hopeful *snip*. "EUREKA!" he cried.

"You all right in there, son?" the man asked, giving a rap on the stall door.

"Uh, yes, sir," Wiener replied.

The boy started to crack up, but Wiener didn't care. If the boy was taller than his changing voice suggested (they usually were), then Wiener might have a chance at the hunt, at having the most fun day with Missi and Chico—and oh, Louie, at blessing his brother with a bagel.

As soon as their water shoes squished out of the bathroom, Wiener launched himself from the stall to the garbage can. He yanked the top off. Just paper towels. Wiener would have to go rogue. He rolled his short sleeves up to his pits and fished his arm inside until he felt hard plastic. *Success!* He pulled from the can a Twizzlers wristband, hacked down the middle.

Wiener didn't carry around duct tape or magnets like Steinberg, so he just crossed his Sea-Band over the cut part of the Twizzlers band so that it would stay around his wrist. Then he wiped the beads of sweat from his forehead and jogged out of the bathroom, as casual as a con artist. He went straight to the turnstile.

"Wristbaaaand," a human in a Hershey's Kiss costume droned.

Wiener flashed his Twizzlers.

"Where's your Rocking Hills group?" the Kiss asked, incorrectly reading the very clear letters on Wiener's camp shirt.

"My fellow Rocking Hillers are in the ins, yo," Wiener replied. Behind him were about fifty singing Girl Scouts impatiently waiting to enter, and so the Kiss stepped aside. Wiener flew through the turnstile and could instantly taste freedom. The chocolate-scented air wafted into his nose and inspired him to shout, "I'M A COCOA CRUSADER!"

"You're a what?" Missi asked, smiling. He hadn't realized she was *right there*. "Oh, nothing. Just happy to get started is all. Where's my man, Chico?"

"He went to put his backpack in a locker, he said. But I'm glad you're here."

"I'm glad *you're* here."

"Cause we're not supposed to be alone—instant disqualification."

"Oh. Yeah. Right."

"Let's plan the hunt!" she said brightly. "We definitely shouldn't waste any time."

Behind her, Totle was posing with a York Peppermint Pattie mascot. Melman was in line for French fries. Steinberg was using a protractor on the back of Smelly's T-shirt.

"Agreed," Wiener said. "Let's do this."

Missi unfolded the Scavenger Hunt and they examined it together. "Hmm," she said. "There are nineteen items on the list and twenty-four photos on the camera. That means we only have five chances for mess-ups. And the first item: *The highest point in the park*. It's a five-pointer, so maybe let's tackle it first?"

"Uh, sure thing." As Missi flipped over the Scavenger Hunt to the map on the back, Wiener hoped they wouldn't discover that the highest point in the park was an upside-down rollercoaster. Especially one he'd conned his way onto—his body could very well slip through the handlebars.

"What about this tower thing?" Missi asked, thank the Lord.

Their eyes ran over the Kissing Tower's description: A CABIN CLIMBS 250 FEET, GIVING RIDERS OF ALL SIZES A PANORAMIC VIEW OF HERSHEYPARK THROUGH HERSHEY'S KISSES–SHAPED WINDOWS. A POPULAR RIDE FOR THAT SPECIAL KISS.

Wiener looked at Missi, whose freckles looked like little chocolate morsels on a plate of ketchup. "Oh. Ha," she said.

"Ha," Wiener said.

"Weird ride," Missi said.

"The kissiest. I mean, the weirdest," Wiener said. He shook his head, trying to think of a new conversation topic. "Oh! What's the status on the Pearl Quantz flute?"

Missi broke into a grin. "I'm saving up for it. If I can get to-

gether half the money, my grandparents will pay for the other half. If all goes according to plan, I'll have my dream flute before my birthday!"

"Then I expect a FaceTime performance on November twenty-third."

"Deal," Missi said. "I seriously can't wait."

"Can't wait for what?" Chico asked, suddenly appearing with a mischievous smile. And his backpack. It was bulging at the seams, too packed for the snaps to secure it.

"I thought you were locking up your bag," Missi said, stealing the words right from Wiener's mouth.

"Nah," Chico said. "Want to start with Storm Runner?"

"Sure!" Missi said, apparently forgetting all about the Kissing Tower. She held the map out to Wiener. "That work?"

Wiener glanced down and read the Storm Runner description: THIS ONE-OF-A-KIND ROLLER COASTER FEATURES THREE INVERSIONS. IT CATAPULTS RIDERS FROM ZERO TO 72 MPH WITHIN TWO SECONDS. EIGHTEEN STORIES STRAIGHT UP, STRAIGHT DOWN. JOLLY RANCHERS AND TWIZZLERS ONLY. LEVEL FIVE.

Wow-sauce. Play Dough was right. The Storm Runner *did* sound like it would be the best ride, and incredibly, there was no mention of it going upside down! But, unfortunately, it didn't seem to help with the Scavenger Hunt. He flipped the map over. "Sounds like an adventure, but maybe we should do one of the coasters that max out at fifty miles per hour. They're worth three points each."

"Hmm," Missi said, looking over Wiener's shoulder. "Yeah. You're right."

"Slow rides are for weenies," Chico said.

"It's just that the hunt is the thing that matters, you know?" Wiener said. "Let's win the hunt and *then* we can put our lives at risk, ha."

"Are you too short for Storm Runner, my Wiener?"

"Me? Too short?" Wiener flashed his Twizzlers wristband and then shoved his arms behind his back.

Missi cocked her head. "But if I'm a Twizzlers, then how're you—?"

"I'm just looking out for the team," Wiener said. "Eye on the prize."

"The prize is bread," Chico said.

Wiener looked at Missi with a knowing smile. "Right, but it's not just *any* bread. It's a *bagel* with *bacon*." He put his hand on Chico's shoulder. "Dude, we've got so much to teach you."

"Do you care about the prize?" Chico asked Missi.

"Well, actually, I'm a vegetarian, so I don't eat bacon."

"Here's a prize," Chico said. He swung his backpack to his front and pulled out a giant Hershey's Kiss in a plastic box with a red bow. It must have been ten pounds and eight million calories.

"You got this for me?" Missi asked, hugging it to her chest. "How? We only got ten dollars!"

Chico shrugged, all *No big deal*. "I have my ways."

Wiener itched with curiosity. "What are your ways?" he asked. Campers didn't have access to cold, hard cash. All of their money was funneled into Canteen cards, which Wiener suspected were a useless currency in a place like Hersheypark.

"Did your parents send you to camp with a gift card or something?"

"Nah. Free giveaways at the gift shop."

"Oh. That's random," Wiener said. But then Missi began to untie the bow on the Kiss, and Wiener decided to drop the questioning. "You know what? Let's focus."

Totle was now posing with the same York Pattie mascot, who was suddenly on a shift break—two points. Melman was arranging her French fries and mayo in the design of a 50—two points. Smelly had a formula Sharpied onto the back of his T-shirt, which would amount to Lord knows how many points.

"Where's the camera?" Wiener asked.

Chico pulled it from his jeans pocket.

Wiener examined the thing—it had been years since he'd used a disposable camera. It was kind of janky: No zoom. No flash. And the photo counter was only on thirteen when it should have been on twenty-four. "Hey, guys, I think we got a used camera."

"Yeah, I used it," Chico said.

"Wait," Wiener said. His head started to spin. "You took pictures without us?"

Chico answered with a shameless nod.

"OF WHAT?" Wiener asked, er, shouted.

"Did you find a kid on a leash?" Missi asked Chico, all hopeful, pointing to one of the Hunt items in Wiener's shaking hands. "That would be two points right there."

"I just went *click-click*," he said, miming taking a selfie.

"Oh, God," Wiener said. "You took ELEVEN SELFIES?!"

"Hey, it's okay," Missi assured Wiener. "Maybe we can double up, like, put a *Free Parking* sign and Milton S. Hershey's signature in the same shot."

"Still." Wiener rubbed his eyes with frustration. "Today's Scavenger Hunt just got a lot harder."

Chico dropped his backpack to the floor and began rummaging for something. He pulled out Hershey's Kisses stationery, which made Wiener want to gag. *Another gift for Missi?*

"My dearest Hersheypark," Chico started, writing with a Hershey's pen.

My . . . dearest . . . Wiener took another look at the Scavenger Hunt. Two-thirds down the list: *A love letter to Hershey from Camp Rolling Hills.* Directly below that: *Hersheypark stationery.* The stationery wasn't just another gift for Missi. It was a gift for their team. "Dude! This totally beats writing on a napkin! This'll be two hunt items in one shot, five points!"

"Yes, my Wiener," Chico said. "Just because I don't see the big deal about this bagel thing, doesn't mean I want to let you down." Then he pulled out Hershey's Kiss earmuffs and put them on Wiener's head. "Also for the hunt—earmuffs—two points."

Wiener threw his arms in the air and shouted: "Chico, you sly-sauce Kit Kat!"

"Uh," Chico said, cocking his head.

"Missi, you beautiful, freckle-faced Red Hot!"

"Uh," Missi said, tossing her hand over her mouth.

Wiener bit his lips shut. But before he could open them to apologize for being so awkward, Missi shouted: "YOU'RE

A WORDSMITH!" She grabbed the stationery and pen from Chico. "Keep going, Wiener, but say romantic stuff about Hersheypark. Maybe TJ and the Captain will give us extra points if it's really funny."

"Okay, okay," Wiener said, trying to think hilarious thoughts under pressure. "Hersheypark, you park your big chocolate butt over here . . . and give me a Kiss!"

"WHAT?" Missi burst, writing it down. "More!"

"You . . . NutRageously attractive cocoa bean."

"Yes!" Missi said, now giggling so hard that her handwriting went super-loopy. "My turn! How about"—she began to rap—"For my mental healthy state, candy in my mouth is great. So much sugar's worth the price. You're nice."

"Heyo!" Wiener cheered, raising the roof. "Go, Missi! Go, Missi!" She finished scribbling, then looked at Wiener for more contributions, but he was running dry on ideas.

"Chico, you try," he said.

"No thank you, my Wiener."

"Oh, come on!" Wiener pressed.

"You can do it, Chico!" Missi cried, nudging him flirtatiously with the pen.

"Okay, fine," Chico said, then gazed up in serious thought. A few seconds later, he smirked and blurted, "Hersheypark, you are getting me all choco and making me late. Get it? Choco-late?"

There was a strange silence.

"That's terrible!" Wiener said, breaking it, and the three of them got wild with giggles. The scent of Missi's hair—as sweet as sugar-dusted strawberries—shot up his nose.

"Okay, okay! It's done, you Goobers!" Missi said. "Now, sign!"

She passed the letter to Chico, who signed it "Paolo aka Chico," and then Wiener, who signed it "Wiener—hit me up: 1-800-Chocolover." Next, Wiener took out his travel cologne and gave it a spritz.

"Wait, we need a shot of this pronto!" Missi said.

"I got it," Chico said.

Missi collapsed into Wiener with a side hug, her ear smushed against his earmuff.

Chico went *click*. "Maybe another?" Wiener asked. He could stay this close to Missi for forever.

"Nah, I'm done being weird," Chico said. "Storm Runner?"

Missi released Wiener and smoothed out her frock. "Yeah, sorry," she said. "We got a little, um, into it. Storm Runner sounds great."

Wiener nodded. Their team had started strong and now deserved some classic theme-park fun. Missi and Chico made strides toward the roller coaster while Wiener jogged lightly beside them to keep up.

They headed to Pioneer Frontier where Storm Runner lived and entered a line under a canopy. They inched up slowly, but time moved quickly as they played Concentration, listing stuff in categories like colors, and songs, and TV shows. Between rounds, Wiener tried to get a peek at the roller coaster, but the canopy was blocking it.

A whole bunch of Concentration games later, Wiener felt the burning sun. The canopy was behind them. He looked up and could see a part of the Storm Runner, specifically a drop so

crazy, his stomach hurt just staring at it. Still, he leaned over a wooden line-control barrier to see more of it, and then knocked into a kid with familiar lab goggles on.

"Excuse me," Steinberg said, his eyes glued to a now-extensive equation on Smelly's back.

"Yo, Steiny," Wiener said.

"Oh, hey, Wiener. I didn't recognize you with your, uh, earmuffs."

Wiener pulled them down to his neck like Beats headphones. "Oh, yeah. Mad Scavenger points."

Steinberg blinked. Then he began to move up in line.

"Wait!" Wiener said, bringing his voice down to a whisper. "So, on a scientific scale, how likely is it that I'll survive a roller coaster that, theoretically, I'm not, you know, tall enough to ride?"

"Unlikely."

"Ha!" *Oh, Steinberg.* "Let's talk gravity."

"What about it?" Steinberg asked.

"Will it work in my favor?"

"On the incline."

"Sweet-sauce."

"And then you'll die on the decline."

"Oh. Okay. Cool. Well, it doesn't go upside down so we'll see."

"Don't do it, Wiener," Steinberg said. Then he hustled to catch up to Smelly.

Wiener wasn't entirely deterred. Steinberg was probably being overly cautious. Surely little kids snuck onto big-kid rides all the time!

A few more rounds of Concentration later, and suddenly the Storm Runner was exposed in all its terrifying glory. Wiener stared at an even bigger drop as a coaster car plummeted, its passengers screaming bloody murder.

And then he saw them loop.

And loop again.

And loop again.

Storm Runner went upside down THREE TIMES. He read the description again from the map. Three inversions. If "inversions" meant upside-down loops, then why didn't the map just say "upside-down loops"? Was this SCHOOL or an AMUSEMENT PARK?!

Wiener's worries flipped back and forth like a flapjack, until that flapjack free-fell from the pan to the kitchen floor and died. *It's time to wimp out,* Wiener surrendered. *I may be a vertically challenged loser, but I will not die as one today.* "Hey guys," he said, seconds from boarding, "I'll just hold the stuff."

"You sure?" Missi asked. "I feel bad that we made you wait all this time."

"Oh, it's nothing," Wiener said. "It's just that the last thing we need is for our stuff to get stolen. I'll catch you at the Storm Runner exit."

Chico handed Wiener the backpack. "Hey, my Wiener," he said quietly, his back to Missi. "What's in the bag stays in the bag, yeah?"

"You mean, like, don't take stuff out?"

"I mean . . ." He leaned in so close, Wiener could smell his salty gel. "Just keep it on the down low."

"The bag?"

"No. What's *inside* the bag."

"What's inside the bag?"

"NEXT GROUP ALL ABOARD!" the roller-coaster attendant called.

"My dad is super strict," Chico said. "He'll pull me out of camp without a second thought. So, you're my man, right? You got me?" He put a fist out for a pound.

Wiener balanced the heavy, now-mysterious backpack on one shoulder and hesitantly pounded him back. "I got you."

Chico sidled up to Missi in the front row. As the ride got ready to launch, it played a prerecorded sound of a heartbeat, which was only slightly louder than the one in Wiener's chest. The magnetic breaks dropped. "Now, get ready, here we go!" the ride told the riders. It took off. Wiener waved at Chico and Missi, their arms intertwined in the air. They were too into each other, the ride, and their own racing hearts to wave back.

Wiener went to open the backpack to see what in the world Chico was talking about, when he heard a lady's screechy cry: "THAT'S HIM! THAT'S HIM!"

He clutched the backpack to his stomach and scanned the crowd. He couldn't trace where the screechy lady was or who she was screeching at. Was there a famous person here? Was Milton S. Hershey in the house? Was she talking about Chico? Had she seen him on Spain's *The Voice Jr.*?!

A single glance at his sports watch got him back on task. Wiener had ninety seconds to get to the Storm Runner's exit. He inspected the roller coaster boarding area for an easy way out,

but all the entranceways said EMPLOYEES ONLY. So he wormed his way back toward the end of the line, muttering, "Excuse me, por favor" on repeat.

"HIM! THE KID! THAT'S THE BAG!" Screechy Lady screeched. He could see her now: Thinning hair. Pudgy chin. Hershey Gift Shop shirt. Pointing right at him.

Wiener didn't know where to go but he knew it was away from here. Before he could think about it too hard, he was zig-zagging through the crowd. He skidded under a man's legs, spun around a Rolo mascot, and ran and ran and ran, until a golf cart of old people appeared in his path. He dove out of the way, and as he hit the ground, the backpack burst open at the top. Its contents toppled out. There wasn't just Missi's supersized Kiss. There was a plush chocolate-bar pillow, a candy-themed notepad, a milk-chocolate baby bottle, a baby's Twizzlers onesie, Reese's Pieces magnets, a Hershey's keychain, and a pair of chandelier earrings made of glass Kisses.

Wiener stared at the pile of souvenirs in shock. What did Chico want with any of this stuff? Even if they were free, it seemed weird he would take them. Also, why were they free? *Unless* . . . Wiener went to collect it all, but he could feel the feet pounding behind him. He left the bag and the stolen stuff, slipped between two tall families, and sprinted in the opposite direction, toward the park entrance. He sprinted for several more minutes, then glanced behind him and—*BAM*—he bounced off a man-belly and fell to his butt.

"You drop something?" the man said, bending down and picking something up at Wiener's feet.

Wiener shielded his eyes from the glaring sun. There was Arman, his robot arm outstretched, holding a snipped Twizzlers wristband.

"So, why exactly were you sprinting like you were being chased by wolves?" Arman asked Wiener over bacon-cheddar-ranch fries at Tower Fries.

"I was looking for Chico and Missi," Wiener replied.

Arman narrowed his eyes. "Uh-huh. And you got separated how?"

"It's not that they left me or I left them," Wiener explained. "It's just—well, as a newbie counselor it's probably hard for you to understand the pressure of a Scavenger Hunt."

"Try me."

"How can we be expected to stick together when there's so much to conquer, to ride, to—"

"Yeah, I'm going to stop you right there."

Wiener tried to keep eye contact with Arman to show that he had nothing to hide. But then his eyes started watering, so he looked down at the mushy fries on the napkin in front of him.

"Let's try this," Arman said. "How and why did you steal a Twizzlers wristband?"

"I didn't STEAL it," Wiener answered way louder than he'd intended.

"Come on, buddy," Arman nudged. "Be honest."

"HONEST? YOU WANT *ME* TO BE HONEST?" Wiener shoved a mushy fry into his mouth. He tried to swallow, but it formed a lump at the back of his throat.

"I'm not here to get you in trouble," Arman said gently. He leaned in across the metal picnic table. "If I tell you something truthful, will you do the same?"

Wiener dropped his eyes to Arman's Terminator Arm. "It depends on what truthful thing you tell me."

"I was born like this."

Wiener blinked, confused. "You were born like what?"

Arman flexed his robot fingers. "No cheetahs. No crocodiles. No crushing boulders. I've always had a nub for an arm."

This was crazy news. Wiener thought maybe Arman's arm had gotten mangled in a workplace accident. Or a boat accident. Something more believable than fending off a family of cheetahs, but something less boring than no story at all.

"Disappointed?" Arman asked.

"A little," Wiener admitted, slurping his lemonade.

"Yeah, I get it. There's no wow factor to the real story."

Wiener cocked an eyebrow. "Is that why you lie about your arm?"

"Sort of," Arman replied. "Though 'lie' is an ugly word. I prefer the term 'armor.'"

"Armor? Like the protective metal stuff?"

"Yup," Arman said with a grin. "Growing up, I got made fun of a lot. Kids called me an alien, and I had one friend: my mom. So when we moved to the States, I decided to play around with my arm's backstory. My 'armor' brought out the cool, silly side of me, you know?"

"Did everyone believe whatever you said?" Wiener asked.

"Not a chance," Arman replied with a chuckle. "But it wasn't

about that. It was about making people laugh. Even now, when I meet new people, the wild stories make me feel more confident. People stop focusing on my arm and start focusing on me." He sighed and licked the salt from his robot fingers. "Some people are born looking different, and it's just that, for me, I found my own way of dealing with it. That make sense?"

Wiener nodded slowly, wondering if his letters to Max weren't big ugly lies, just . . . armor.

"I can see your wheels spinning," Arman said. "You ready to come clean?"

Wiener lowered his head. "Honestly? No. I can't tell you. I could make something up, but that would be the bad kind of lie. And that I don't do."

He waited for Arman to get mad, but instead he put his robot fist out for a pound. "I hear you, buddy," he said. "And I respect that. I'm giving you a *Get Out of Jail Free* card."

"Really?" Wiener asked.

"Really. But until we find your group, you're going to have to stick with me."

"Fair," Wiener said, pounding him back.

Arman cleared the table, and the two of them began walking around the park. Wiener couldn't stop thinking about Arman's armor. Like his counselor, he'd never lied to hurt someone or be mean. It's just that, sometimes, the truth stunk, and his stories made him feel a whole lot better. Awesome-sauce, even. What was the harm in that?

"Can I get your advice?" Arman asked Wiener as they tacked on to the end of a medium-long line.

"Oh, uh. Sure thing," Wiener replied.

"Do you think I should spill the beans about my arm? To the rest of the Wawels, I mean?"

To Wiener, the answer was obvious. "Nah," he said. "Your arm, your story."

Kissing Tower

"WIENER!" Missi called on repeat, pacing up and down the Midway America section of Hersheypark. When Wiener had been a no-show at the Storm Runner exit, Missi had thought he was in the bathroom or in line for lemonade. But after twenty minutes of standing around and eyeing every blue-shirted, spiky-haired kid that passed, she'd decided it was time to search for him. So far they'd hit up Founder's Way, The Hollow, Pioneer Frontier, The Boardwalk, and now, Midway America.

No Wiener.

"Ugh," Missi said. She drew in a breath. Chico, too. "WIENEEEEEER!" they shouted together.

A woman beside them ear-muffed a toddler and shuffled her away toward the Pony Parade. "Sorry," Missi mumbled after them. "It's not what you think."

"It's not like Wiener to leave us," Chico said, kicking at some littered gummy bears at his feet. "He never leaves me alone. Like a shadow he is. A weird, nice shadow."

"Well, I dunno. Maybe he's mad at us."

"Why would he be mad?"

"Um." Missi chewed her lip. She'd been contemplating that

very question for the last forty minutes, and it was seriously bumming her out. (a) Wiener could be upset that she and Chico had gone on the Storm Runner when it had nothing to do with the hunt. (b) When Wiener had decided to jump ship, he could have secretly hoped they'd do the same. Or maybe (c) Wiener was simply jealous of Chico. According to Jenny, Play Dough was jealous of Chico, and Chico hadn't even flirted with Jenny. "Maybe Wiener's just, *you know*," Missi said suggestively, "'cause of the one time we . . ."

"The one time you what?"

She looked at Chico, waiting for the Spin the Flashlight story to leap to the surface of his brain. Surely Wiener had told him. But Chico just stared back at her, clueless. "Wiener and I—" Missi cut herself off. Her cheeks were on fire. It was probably a dumb idea to out her one-off kiss with her crush's closest friend. What if she was wrong and Wiener wasn't jealous at all? "Friends have history is all," she said, trying to be as vague as possible. "I bet Wiener just wanted to score some points on the hunt and then got distracted."

"I have the camera," he said, pointing to his shorts pocket.

"Oh."

"He carries all the baggage."

"Right." Missi took a hard look at the map. "There's only one more section of the park we haven't searched." She vaguely pointed to its super-evocative name, hoping that Chico wouldn't start bouncing his eyebrows, all *I know why you want to take me there*. But he just slurped his chocolate milkshake as oblivious as could be and said, "Let's go to it."

"Cool." Map in hand and heart a'skipping, Missi led the way to Kissing Tower Hill.

They passed the Chevrolet Music Box Theatre, where a crowd was lined up to see Drumboys, the newest drummer–boy band; and the SooperDooperLooper, which, despite its name, had only one upside-down loop; and Bizzy Bees, where little kids were buzzing around in a bee-car carousel. Coming off the ride was a girl, probably eight or nine, wearing something familiar. "I have that shirt!" Missi exclaimed. On it was a sketch of a cat drinking milk from a hollow carrot. It read: I DON'T CARROT ALL. The cat's ears were blue sequins for no reason, which was the best reason when it came to cats.

"You should wear it sometime," Chico said. "I bet it looks nice on you."

Missi's lips curved into a smile. "Really?" She followed Chico's gaze, but he was staring at a different girl. She looked seventeen, and her shirt was cropped to her belly button with a moose-skull design in the middle. "Aw, shucks. I forgot to bring that shirt to camp," Missi lied. She wasn't a fan of fashion skulls, especially ones that glorified hunting. But Chico didn't need to know that.

As she and Chico neared Kissing Tower Hill, Missi noticed that they weren't talking. Chico transferred the camera into his back pocket. He jammed his hands into his front pockets. He took his hands out to clean his sunglasses' lenses with the bottom of his Rolling Hills T-shirt. He might as well have been screaming, "I'M BORED." Missi was making him bored.

"So," Missi said. Terrible conversation topics burst in her

brain like microwavable popcorn. *Ginger Pride Walk!* No. *Golden Grahams with goat's milk!* No. *Cats in heat!* God no. What would Rebecca Joy talk about? What would the kind of girl wearing a cropped moose-skull T-shirt talk about? *Oh, sweet Hershey, I'm going crazy.* "What's the craziest thing you've ever done?" she blurted out.

"Come to camp."

"Ha, no, I mean—"

"You mean *peligroso*?"

"Does that mean adventurous?"

"Once I jumped off a cliff into a waterfall even though the sign read: *PELIGRO—Danger!*"

"What—how—did you get hurt?"

Chico swept back his glossy wave of hair, exposing a scar across the top of his forehead. "Nineteen stitches." He pointed to his elbow. "Fractured." Then his ankle. "Broken."

"Triple ouch!"

"Oh, that's nada. Another time I rode my cousin's motorcycle down Avenida Diagonal, but I didn't have a permit, so I got arrested. Four hours I was in jail."

Missi giggled. Then she stopped. That wasn't funny at all. It was actually pretty reckless. Just this past autumn, her mom had hitched a ride from a motorcyclist through Indonesia, and she'd flipped off the back and landed in a three-day coma. "You know, you're lucky you didn't hurt yourself," Missi said. "Or, like, someone else. Not to be lecture-y, but yeah."

Chico shrugged. "I'm fine. Not a scratch on the bike, either."

"What did your parents do? My grandparents—I mean,

my mom—she would have kept me locked in my room for all eternity."

"My parents told me: 'Boarding school, young man. That's where you're going!' They shipped me out of the country, away from all my friends."

"Whoa. Well, do you like it there at least?"

"The teachers are nuns. The kids are brainwashed." He pouted his lips like he was sucking on a lemon. "The school is on a farm—you eat what you grow."

Missi perked up. Going to school on a farm sounded kind of awesome. She and her grandparents also ate what they grew, and it was the coolest part of living there. Well, second-coolest to all the animals. "Are there animals on the farm?" she asked.

Chico rolled his eyes. "Yup. We have to wake up early for farm duties and taking care of the chickens. They stink."

"As in they smell or taking care of them isn't fun?"

"Both. But if you like hanging out on your grandparents' farm, then maybe you would like it."

"No, you're totally right. Farms stink all around. Blech." Missi shook her head, trying not to show how weird she felt for having dissed her favorite place in the world. "Well, anyway, maybe if you prove yourself, like, show your family that you've matured, they'll let you come back home for good."

"That's what I thought, so I was on my best behavior for months. But then when I flew home for Christmas, my room had already been turned into an office. They didn't even give me a chance."

"Another ouch."

"You're lucky that you have a mom who cares."

Missi swallowed and it felt like little shards of glass. She thought about being honest with Chico and explaining that it wasn't until her mom had woken up from a coma that she'd decided to care. It took a horrible accident for Rebecca Joy to come home to meet her daughter and promise to watch her grow the rest of the way up. But would she then have to admit that she'd lied about her grandparents, and the farm, and everything? Missi stopped walking, and Chico stopped, too. Then she looked down at her calloused garden fingers and tried to think of something understanding to say.

"Hey, don't feel bad for me," Chico said. "My parents were looking for an excuse to get rid of me, and I had fun giving it to them."

"But how'd you end up at Rolling Hills?" It seemed bizarre that a bad boy from Barcelona would spend his summer in an upstate New York sleepaway camp. She imagined Rolling Hills was the opposite of a strict Swedish boarding school. "Did someone in your family go here?"

"My mom's friend went to college with Kerri Jerecki."

"Who?"

"The, uh, camp leader person."

"The Captain?"

"Yeah. My parents are staying with friends in Saratoga for the summer, which is close by. They still don't trust me. Camp is eight weeks of childsitting."

"Well, I dunno if I'd call it that," Missi said.

Chico shifted the camera to his front pocket. He jammed his hands in his back pockets. He took his hands out and cleaned his sunglasses' lenses again. He was bored, bored, bored. Except a camp trip to Hersheypark was not a time for boredom. It was a time for stomach-flipping fun.

"I have an idea," Missi said slowly, looking at Chico with a glint of mischievousness. She hoped she was giving him the look her mom gave her before they did something spontaneously adventurous like ditch school to picnic at Palisades Park. "*Truth* or *dare*?"

Chico cocked his chin. "Huh?"

Missi repeated herself. "Truth or dare?"

"Uh, dare?"

"Okay! LET'S GO!" Missi grabbed Chico's hand, and together they wove through gaggles of teens, around strollers, behind wheelchairs, in front of international tourists, and next to families posing for pictures. *Photobomb!* She felt her hair whip around her shoulders, and her dress flap against her thighs, and the heat between their hands grow hotter.

"What are we doing?" Chico asked, mid-leap over a puddle of ice cream. "Are you daring me to run?"

"You'll see!"

The last time she'd played Truth or Dare was Lauryn Hill summer. Jenny had dared Jamie to put an ice cream sandwich in their counselor's pillowcase, and then Melman had dared Missi to take it out and eat it, and then Missi had dared Slimey to wear a menstrual pad over her eye like a period pirate, and then Sophie had dared everyone to go to sleep, and the game

was over. They'd made such a mess that they'd lost Canteen privileges for three nights. *Worth. Every. Second.*

Missi stopped short in front of a food stand with a wooden sign that read CHOCOLATE SIN. She studied the menu.

"What is this place?" Chico asked.

"Hi, there," Missi addressed the woman behind the counter, dressed in a Hershey's Krackel costume. "I'll take number four." Missi forked up two bucks for a chocolate blob in a cupcake wrapper. She handed it to Chico. "Eat it."

Chico popped it in his mouth. "Huh. Crunchy. Salty."

"That was a grasshopper."

"A BUG?" Chico spit it back into the wrapper. The blob was in three saliva-covered pieces. The grasshopper's legs were jutting out. "Yuckuckuck! No!"

"Oh please, you loved it!" Missi said.

Chico laughed. "That's truth." He stepped up to the counter. "Miss Krackel, I'm going to need another bug. For free. Mine hopped out of my mouth."

Krackel rolled her eyes. "The bug's dead."

"Now it is, yes."

Missi pressed her lips together to keep from laughing. Krackel passed him a free hopper. He popped it in his mouth with an "Mmmmmmmm, gracias," and then swallowed it in two forceful bites. "Your turn, Miss Missi. Truth or dare?"

"Dare, duh!"

Now Chico took Missi's hand and led the way as they raced to a mysterious location, which turned out to be a henna stand. "My lady would like a henna on her face," he told the tatted artist.

"On my face?!" Missi cried. "It'll stain me for weeks!"

"A dare is a dare. I'll get one with you."

"How are you paying for this?"

"I told you—I have my ways."

"You really are crazy."

Missi got a small but beautiful swirly henna from her left temple to the corner of her eye, and Chico got one that danced around his forehead scar. Then Missi went to the bathroom to reapply sunscreen while Chico somehow paid, and the dares went on. She screamed random words in Spanish at the peak of the Sidewinder. He pretended to have a panic attack on the Frog Hopper kiddie ride. She bummed a half sandwich from a Twizzlers mascot on a shift break. He attempted to enter the backstage area of the Chevrolet Music Box, posing as a Drumboy.

As Missi watched him from a cotton-candy cart, she spotted the J-squad heading in his direction. *No, no, no*, she panicked. She dashed to Chico and pulled him behind a life-size cardboard cutout of the Drumboys. "Peligro," she whispered. "Danger. If the J-squad sees us without Wiener, we're toast."

"With cream cheese and bacon?"

Missi laughed. "No, like, *toast*! Like *done*! Like *game over*!"

"In that case, RUN!" They sprinted to a cluster of people in line for a ride. Then they ducked behind a woman in an enormous sunhat and a man who was the width of three Chicos. When the couple shuffled up in line, they shuffled with them. "I think we lost the scary girls," Chico said.

"You mean the J-squad?"

133

Chico nodded.

"Okay, phew." Missi glanced down at the map in her hands, trying to figure out her next dare—she was running thin on ideas. *Let yourself free-fall, baby!* she reminded herself. *Live like there's no tomorrow!* Whenever she was reluctant to skip school to hang out with her mom or go cliff jumping at Terrace Pond, Rebecca Joy would share motivational tips like that, and off they'd go on their next adventure. *Feel the thrill!* Missi flipped the map over to the hunt for inspiration. "Omigoodness!"

"What?"

"I think we actually completed most of the hunt! Oh man, I can't believe we didn't take any pictures."

"I took pictures."

"WHAT?"

Chico showed her the photo counter on the camera: one picture left.

How was Chico so sneaky? How was he so full of surprises? Being with him, she felt like she was flying, soaring, higher, faster, no crash in sight. Just then, they were ushered into an enclosed cabin and seated on a bench by a triangular window. The doors closed. Through unseen speakers, a deep voice began talking about Hersheypark's history and stats and greatest offers. The cabin began to spin.

"Pumped?" Chico asked Missi. "That's what my Wiener says a lot. 'Pumped.'"

"Yeah, I guess," she said, though she didn't know what she was supposed to be pumped about. The ride was moving slower than a sloth in molasses, making this the least exciting part of

the last two hours. "What are we on anyway?" she asked. "Is this the monorail?"

Chico just smiled.

So Missi smiled, too. Then she glanced out the window for a clue. *Holy cocoa beans, the window!* It wasn't a triangle. It was shaped like a Hershey's Kiss! She knew exactly what ride they were riding and began to tingle with joy and nerves.

Chico reached over and took her hand in his. A clam sandwich. She could feel her heart beat wildly. They continued to go up. And spin. And up. And spin. Out the window was The Chocolate Spa at The Hotel Hershey, Hershey's Chocolate World, ZooAmerica, and the town of Hershey itself. At least that's what the deep voice was saying through the speakers. Missi was just seeing rides and buildings and treetops. It reminded her of the time she and her mom climbed High Point Monument, also a tower, and looked 1,803 feet down at the world through smudgy windows. "Never again," Rebecca Joy had told her. "Never again will I take the important things in life for granted." Missi was the important thing.

Missi shifted her hand in Chico's so that their fingers interlocked. Suddenly, she wanted to tell him that he wasn't alone. She understood how painful it was to feel like you're no more special than a rescue kitten. How awful it was to feel like you're unwanted. An inconvenience. Unloved. But Missi also wanted to give him hope. If Rebecca Joy could come back into her life with all the love and warmth she'd ever wanted, then maybe his parents could, too. "Hey," she said. "Sometimes things change as quickly as a camera flash. People can surprise you in the best way."

"Like you," Chico said.

"Me?" Missi's stomach began tumbling tumbleweed-style. They were approaching the Kissing Tower's peak—250 feet in the air. The Storm Runner was a kiddie ride and the henna tattoo stand was a pinhead. The ride stopped. They'd officially reached the tallest point in the park. Chico handed Missi the camera. She pulled him in for a kissy-face selfie, and they snapped their final shot, the background the top of the world.

"Truth or Dare?" Chico asked.

Something came over Missi. She didn't want to pretend anything anymore. She was ready to open her heart, her mind, her soul. "Truth."

"Okay, then *truthfully* how would you feel if I kissed you?"

Missi's heart began slamming against its walls. She wanted to say something wild like: "I *dare* you, my Chico Nuevo," but that seemed melodramatic. And since she didn't want to waste any more time thinking, she went with her gut: a classic thumbs-up. It was the dorkiest thing Missi had done all day, but she didn't give a flying fudgsicle.

She saw herself reflected in Chico's dark-chocolate eyes. She leaned in two inches, and he leaned in, too. She could feel the heat from his cheeks. His milkshake breath made her tummy rumble. His lips locked onto hers. His tongue slipped into her mouth and went around in loops like the Sidewinder.

Missi used her tongue to spell her name in cursive, like Jenny had told her to. But what should she do with her hands? Put them around his neck? *Too much.* On his shoulders? *Yeah, but lightly.* For what felt like ten minutes, but was probably

only ten seconds, their tongues made a roller coaster alphabet soup.

As the cabin dropped from the tower's peak, Missi heard familiar cheering: *"Missi and Chico sittin' in a tree, K-I-S-S-I-N-G!"* Her stomach flung up to her throat. But in a good way. There were Jenny and Jamie, to her left, freaking out with pride: "OMIGOD, SO ROMANTICAL!" Missi didn't care that she and Chico had gotten caught without Wiener. She'd take this moment over a hundred Louie bagels.

"Thank you for riding the Kissing Tower!" said the deep voice through the speakers. "We hope you enjoy the rest of your time at Hersheypark."

Once the cabin reached the ground, Chico put his arm around Missi. As they turned around to exit, she saw Wiener, his face on the verge of crumbling. He'd been behind them the whole kissing ride.

CAMP ROCKS!

Date: July 8

Dear Customer Service at ,
Chocolate Spa,

How are you? I am feeling very upset that
you only exist outside the park gates. You should turn the park
locker room into a spa. The sinks should spout chocolate.
Camp is ??? I'm on the bus
_____.

Today we filmed Miss Chico mashing faces
on Jenny's backup celly. DON'T TELL COOKIE,.
who is not a real cookie, but my counselor
My favorite thing so far is the Jolly Rancher
pillow in the souvenir shop. I WANT IT ☹ .

My cabin is bloated .

The food is I ate 13 Kisses today, one for.
each year of my life

Mail free samples + coupons soon!
From,
Jamie
(if you do, I'll write a
sweet-sauce Yelp review after camp)

Dear Moses 'n' Sam,

Today I discovered that:
Protractor + Compass + Healthy Airways = Specialty Bagel

I wrote it all out in scientific detail on the back of Smelly's shirt, which I can't send you, so hang tight. I'll explain when I'm home. For now, let's plan a trip to Luna Park, Coney Island. I would like to test a theory about roller-coaster velocity in relation to passenger mass pre- and post-chocolate consumption.

From,
Robert Steinberg

P.S. Unfortunately, my asthma kicked in at the park, which slowed me down, so I did not win the bagel.

July 9

Dear Mrs. Garfink,

UPDATE: The mystery trip was to Hersheypark, which does revolve around food. So let's assume Play Dough (I keep doing that, LOL) BRIAN consumed more calories than a hippo.

However, I'm not mad because today he was extra-sweet. He kissed my cheek a lot of times. I'm trying to tell myself his behavior had nothing to do with the chocolate facial Jamie gave me in the cabin.

XOXO,
Jenny

8 July

Dear Little Ealing Fireflies,

Whassup, my li'l ladies? It feels strange as salami soup that I'm writing to you while you're training for the upcoming season that I won't be a part of. But, sigh, that's life. You graduate to Grade 9, you join the Big Ealings, and then you go for the big leagues. I'M NOT STRESSED ABOUT THIS AT ALL.

Delish Fact: Hersheypark is a chocolate-themed amusement park. I repeat: a *chocolate-themed* amusement park. THIS IS NOT A DRILL.

Enclosed, you'll find flattened fudge. Please send me Smarties—the American kind aren't chocolate. They taste like chalk.

Kick choco-butt, always.

#24,
Melman

Wieners Unite

Standing under a flickering porch light and a menacing full moon, Wiener gave a nervous rap on the door of Bunker Hill Cabin. He waited five silent seconds before he heard shuffling feet. Then the door creaked open and a camper in a dinosaur onesie greeted him: "Bunker Hill Cabin, how may I help you?"

"Oh, hey," Wiener whispered, peering inside. Light was streaming in from the bathroom, illuminating a bunch of undercover lumps. "Oh, sorry. Didn't realize you guys would be sleeping."

"Long day at Cooperstown."

"Right. Well, I come bearing Hershey's gifts." The kid's eyes lit up like a campfire. "For my brother." The fire died.

"Uh, actually, want some Rolos?" Wiener whipped out Max's least favorite candy from a goodie bag. "They've got caramel in 'em."

Dinosaur Onesie snatched the Rolos like a feral skunk-munk. He peeled away the wrapper and tossed two chocolates into his mouth. "Carmel geth thtuck in my night retainer," he lisped. It was only now that Wiener noticed the metal contraption eating

142

his face. "Which maketh it the perfect midnight thnack. I can wiggle my tongue and eat thtuck pieces."

"That's the perk of a retainer I guess." The kid grinned in agreement. A Play Dough in the making. "So can I come in for a sec? Didn't mean to wake you."

"Me? Ha! I wath up doing card trickth." Dinosaur Onesie stepped inside with a grand sweeping gesture toward his single bed. On his pillow were two rows of facedown cards. "It'th a really, really good trick."

"Nice." Wiener could tell that Dinosaur Onesie wanted to practice his card trick on him, an awake human, but first and foremost, he had a mission to complete. "Show me on the way out?" Dinosaur Onesie nodded enthusiastically.

Wiener walked to the bottom bunk bed by the front door, where he'd blissfully slept (and peed) five summers back. Now Max was there, spooning his stuffed giraffe, Mister Necksmith. Four years ago, Max had gotten the giraffe from Aunt Doreen for being in the ninetieth percentile for height. She'd wanted to encourage him to embrace gianthood. As if being tall was something a kid needed encouragement to embrace. As if the ability to tower over literally anyone older than ten wasn't an impossible dream of Wiener's. As if Wiener hadn't spent hours surfing the net for growth hormones and bone-stretching therapy.

"Max," Wiener whispered.

Nothing.

"Max, you up?"

Max scrunched his face and then broke into a gentle snore. Wiener sighed. Maybe it was better that Max was asleep.

If Steinberg's hypothesis on mental osmosis was valid, then Max would catch the drift of Wiener's apology anyhow. Right? Right! He took a valiant breath. "So, it's no secret I've let you down. You came to camp for an ace summer, thinking that your big brother was a king, but turns out, I'm nothing but a joker. A fool." Wiener tapped his chin trying to think about how to express the rest of what he wanted to say in a continued card analogy, but then decided he should just say it. Straight from the heart.

"Max. You're cool. Everyone knows it. You're athletic and a good dancer and really chill. And then . . . there's me. Do you know how hard it is to be your big brother? I thought that, at least at camp, I could show you I'm The Man. But then I messed everything up. I even rejected my crush and then pushed her into a relationship with the newbie, Chico, who as it turns out is a Spanish version of the Artful Dodger—you know, the pick-pocket character from *Oliver Twist*?!" Wiener whisper-chuckled. "Of course you know who I'm talking about. You were in it. You were Oliver's understudy. Because you're Max Meyer. You rock everything!" He face-palmed. "The point is, I'm sorry your big brother is just as much of a loser at camp as he is at home."

Max rolled over to face Wiener. His eyelids began flutter-ing—he was awake, he had to be. This was horrifying. The most horrifying thing there ever was. Wiener's heart began pound-ing. He could feel it in his throat. His brain. His fingers.

Max rubbed his eyes, and then they were open. "Hey, Ernie."

"Oh, hey, Max." There was a silence that felt as long as a language-arts standardized state test. "So . . . yeah." Then

another silence that felt as long as a math state test. Wiener nervously shook the goodie bag. "I don't know if you heard me rambling, but I'm just here to drop this bad boy off." He left it at the foot of Max's bed with an "Okay, peace," then stood up and walked toward the door.

"I heard what you said," Max said quietly.

Wiener stopped in his tracks. "Nice-sauce," he said dumbly, then stood there, his feet toward the cabin door and his torso twisted toward his brother, waiting for a cue to move in a direction.

"I don't think you're a loser at camp," Max said, sitting up.

"Oh," Wiener said, confused and elated and skeptical. "You don't?"

"No."

Wiener's heart sped up, feeling like a fireworks finale. He edged back to Max's bed and sat down on his toasty Batman comforter. "So, wait . . . Does this mean that you're not mad at me?"

Max shrugged. "I mean, I am a little. You lied to me, Ernie. Lying is bad. We're brothers. We shouldn't lie to each other."

"I know," Wiener said, guiltily running his fingers through Mister Necksmith's mane. "But I didn't even realize I was doing it."

"How could you not realize?" Max asked.

"It's kind of like—" Wiener took a brave breath. "Sometimes I tell stories because they make me feel better. And when I feel better about myself, I almost forget that what I'm saying isn't the total truth."

"Huh," Max said. He bit his lip. "But that's still lying, right?"

"Well, I like to think of it, like, if I tell a little lie that keeps the haters at bay, then it's okay. But if it's a big lie that hurts people, then it's not." He paused. "Does that make sense?"

"I think so . . ." Max nodded slowly and then bulged his eyes. "Oh! Yesterday a kid in another cabin came in and said I was a big baby because of Mister Necksmith, and I told him that Mister Necksmith gives me growing powers. I don't think my stuffed giraffe actually makes me taller, but it made me feel better to say that he does." He squinted his eyes in thought. "Is that like, um—what do you call it—a 'little lie'?"

"Hmmm." Wiener thought about how Arman calls his little lies "armor." "Armor" didn't fit his own magical thinking as well as it fit his counselor's, because of Wiener's name not being Arman and also the arm thing. But . . . Wiener spotted a cologne sample he'd given Max on his dresser, and it clicked. "Swagger! That's what I call it."

"Swagger?" Max asked, following Wiener's gaze to his dresser. "Like the cologne? Because it covers up stink?"

Wiener burst out giggling. "Wasn't thinking that, but sure! Little lies that cover up the stinky truth."

"So then what I said about Mister Necksmith," Max said, "was that 'Swagger'?"

"For sure," Wiener replied. "But also, you should know that loving Mister Necksmith doesn't make you a baby, Max. It makes you an endangered species advocate. Source: *Planet Earth*."

"Hey, you're right! That's so true!"

"Of course it is. You should feel awesome about it."

"Sauce," Max corrected. "Awesome-sauce."

Wiener proudly put his hand up for a high five, and Max high-fived him back.

"So you got me candy, huh?" Max asked. Wiener held the bag out and Max grabbed a Kit Kat. He unwrapped it and took a massive, crumbly bite. "Best. Night. Ever."

Wiener felt a sneaky drop of sweat drip from his eye. God, he loved his brother. He loved him so much that he wanted to belt opera and tap dance and ugly-cry and crazy-laugh—he was feeling so many feelings!—but he was curbed by a sudden beaming light in his face.

It was Fred, the Bunker Hill counselor. He was holding a heavy-duty flashlight. "Excuse me, are you supposed to be here?"

"Yup," the Meyer brothers answered in unison.

"Wrong answer."

Wiener hadn't realized this was a test. He was just okay at tests. Also, the light. It was blinding. "I was just leaving my brother a present. Sorry."

"That's fine, but it took me a half hour to get these hyper boys to bed. Swing by before bedtime in the future, yeah? Maybe Rest Hour?"

"You got it, Fred."

"It's Jeff," Max whispered.

"You got it, Jeff," Wiener said.

Jeff disappeared back into the bathroom, and Wiener and Max broke into crazy grins. Then, suddenly, Dinosaur Onesie

was beside Max, cozying up to the goodie bag. Max dumped three Hershey's Kisses into his hand.

"So, what's your take on Mister Necksmith, man?" Wiener whispered as Dinosaur Onesie devoured the chocolate.

"Is he that funny fourth-grade teacher at Lakeside Elementary?"

"The giraffe," Wiener said flatly, pointing to it cradled in Max's arms.

"I sleep with Mrs. Buckwheat," Dinosaur Onesie said. "She's a bunny. I'm not sure if giraffes and bunnies get along."

"Oh, they do now," Wiener told him. "Giraffes and bunnies are like peas in a pod."

"Nice!" Dinosaur Onesie said. "Now can I show you my card trick?"

"I'll come back tomorrow during Rest Hour," Wiener said. "Show me then?"

"Yes, sir."

Wiener went to get up, but Max pulled him back down by his shirt. "Wait!" he whispered. He peeled his fitted sheet from the corner and pointed to where, five summers ago, Wiener had Sharpie'd onto the mattress: *Wiener 4 life.* "I like that I sleep here," Max said sweetly.

"Oh, yeah?" Wiener said, grabbing a pen. He tacked on an *s* so it read: *Wieners 4 life.* "Well, I like it, too." Then he bounced out of Bunker Hill Cabin with renewed swagger.

Dear Mom,

Camp is amazing—I'm sure lots has changed since you were a camper here, but I'd bet that the vibe is just as magical as you remember it.

I have made a countdown to Visiting Day with (clean) toilet paper. Before bed, I take away one sheet. Now there are 11 sheets left, because in 11 days I'll see you. I've never been so excited about Visiting Day in my life!

Also, I have a boyfriend from Barcelona who goes to a boarding school in Sweden. He's worldly and has a wild streak, like you. ☺ You're gonna think he's a "dreamboat"—I just know it!

more ⟶

Sometimes I miss you so much that it hurts. Write me soon? Kisses to you, Grandma, Grandpa, Happy, Sleepy, Grumpy, Dopey, Bashful, Doc, and Snow White.

Love,
Missi

Dear Journal,

I am fond of our Wawel #8, Chico, but he seems to be having a hard time following the STARFISH values system. I wrote this to help him out.

S is for Sportsmanship.
Swim with a lifeguard on duty and not alone at midnight.
T is for Tolerance.
Tolerate the chipmunks. They just want to nibble on our Ritz crackers.
A is for Appreciation.
Appreciate camp—it's a magical place.
R is for Respect.
With TJ and the Captain, keep your eyes steady, not rolling.
F is for Friendship.
Stealing cake doesn't make you a good friend, but baking one does!
I is for Integrity.
One day I'll remember what this means and so will you, Chico.

S is for Sensitivity.

Camp friends are here for you no matter what.

H is for Helpfulness.

When it says you're Sweeper on the Chore Wheel, then you sweep.

I believe in you, Chico Nuevo!

Hope this helps you, friend,

Totle

Paolo Alejandro,

Your mother and I hope that you are enjoying yourself, learning new skills and making new friends. Saratoga is absolutely lovely-quaint with vineyards, antiques shops, and museums. It's the kind of place you might appreciate one day.

A few days ago your mother checked out The Hilltopper, which featured you with a black eye, mock-proposing to a redheaded girl. You might remember our ground rules: A) No fights. B) No girlfriends. We sent you to camp to stay out of trouble. Mrs. Jerecki already called us once to report that you stole a birthday cake from the infirmary freezer in the middle of the night. That is unacceptable. One more phone call from Mrs. Jerecki, and we will be pulling you from camp.

On a positive note, your mother has generously decided that if you can prove yourself for the remainder of this summer, we will consider re-enrolling you at St. Peters. No more boarding school. We only want the best for you. Please, Paolo Alejandro, want the best for yourself.

Warm regards,
Papa & Mama

HOEDOWN LINGO

A Manual for Rookies at Camp

By Fufu and Stu Stevens

Square Dance

A dance with four couples and a
caller calling the moves.

Fun Fact: Square Dancing is the official dance in nineteen states.

(States have official dances? Who knew? We did—Fufu and Stu!)

Partner

The loving guy or gal by your side in the square.

Bow to your partner. Vow to your partner. Give a cow to your partner.

Head Couples

Partners in the square facing the basketball hoops.

Use your heads, people!

Side Couples

Partners in the square facing courtside.

Use your sides, people!

Corner

Gals, it's the guy to your right. Guys, it's the gal to your left.

In my own little corner, in my own little square, I can dance however I'm told to dance.

Home
Starting position.

Home Sweet Home!

Promenade
Couples walk around the circle, holding hands.

Sweaty-palm sandwich, yum.

Grand Right
Join right hands with your partner. Pull through.
Join right hands with the next guy/girl. Pull through.
Repeat until you're home.

This move will probably end you.

Allemande Left
Dancers face their corner. Left palm on left palm.
Turn 360 degrees.

All you need is turn! All you need is turn, turn, turn. All you need is turn.

Allemande Thar
Dancers Allemande Left into a star.

*An aerial shot of this move is classic bedroom décor
for a square-dance junkie.*

Squaring Off

"HOWDY, EV'RY BOY 'N' GAL!" Fufu and Stu shouted. Missi sat up on her knees and looked around at her fellow upper campers, who were all seated on the sunny basketball court.

"Howdy, Fufu and Stu!" they shouted back. The J-squad screamed the loudest—or maybe it just felt that way because Missi was seated between them. That's right. BETWEEN THEM. Miracles like that had been happening ever since the Kissing Tower. Sure, she'd cuddle-spoon the J-squad. Of course, she'd split a Canteen pizza three ways. Obviously she'd braid together hair from their three heads, so that they could be more than "attached at the hip."

Fufu did the classic hand-to-ear gimmick.

"HOWDY!" everyone shouted again, but louder.

Then Fufu adjusted her hearing aid, tore off her pink cow-girl hat, fluffed out her fluff-tastic hair, and said into the mic, "It's a yee-haw pleasure to be here at Camp Rolling Hills in honor of your Fiftieth Anniversary celebration. Stu and I led Square Dancing here fifty years ago—that very first Rolling Hills season!—so when the Captain invited us to come up, it meant a whole lot. We just had to say yes sirree!"

Stu, in a complementary blue cowboy hat, put his arm around his partner's shoulder. "Some history for y'all: Fufu and I shared our first square dance when we were eighteen. A week later, we got hitched. A year after that, we began calling Square Dance competitions up and down and to the left and right of our blessed nation."

Fufu put a hand to her heart. "At twenty-three, Stu and I began the summer camp circuit, and we kept at it for fifty-five glorious years. We retired a decade ago to Boynton Beach, Florida, where I teach disco water aerobics and Stu grooms our Chihuahua, Deucey, for the Sunshine State's Best in Show."

"But this week and this week only," Stu said with a flashy smile, "we dusted off our lucky dancing boots to bring you the HOEDOWN OF A LIFETIME!"

The upper campers cheered. With genuine enthusiasm. For Square Dancing.

Missi's stomach began do-si-doing like wild. Square Dancing was her jam. She and her grandparents did it every Friday night at Oldwick Senior Citizen Community Center after the Line Dancing and before the apple pie was served. But she'd never imagined her love for Square Dancing would go public. With the exception of Eraser, Oldwick's thirteen-year-old potbellied pig, she'd never had a dance partner under the age of fifty-six.

"Alrighty," Fufu said, slapping her thigh. "We're gonna ease you in nice and slow with a talk-through walk-through of the

hoedown lingo. It'll sound like a lot at first, but I promise, by the time you compete at the end of the week, the lingo will feel like it's been a part of your vocabulary forever." She winked. "First off, stand on up if you've ever square-danced before!"

Missi proudly jumped to her feet and scanned the court for Chico. She hadn't seen him in two long days, so she was kind of desperate for a smile, a high five, anything from him to hold her over. The Wawel Hillers were by the bleachers. Play Dough was arranging a bandana over his mouth like a bank robber. Dover was straightening his Eagle Scout sash. Smelly was wiping his palms on his shorts. Steinberg was fixing his flip-flop. Totle was writing in his journal. Wiener was picking at his cuticles. Chico was nowhere in sight.

"Well, look at that!" Stu said, pointing at Missi and the small handful of standing Sherri and Highgate Hillers. "We've got some semi-pros on the court. I want y'all to complete my sentences. Are you ready?"

Missi "woo"-ed alongside the other "semi-pros," who were probably more like novices who'd square-danced in gym class one time. *Game on.*

"We've got head couples and—"

"Side couples!" Missi and the "semi-pros" called out.

"Boys look to your left. Girls look to your right. There you'll find your—"

"Corner!" Missi and some of the "semi-pros" called out.

"Allemande Left to an Allemande—"

"Thar!" Missi called out with one other "semi-pro."

"Dance back up you've got a—"

"STAR!" Missi shouted all alone.

As Stu hustled over to Missi with the mic, she gave the court another once-over for Chico. Still missing. It was so strange. He'd ditched Canteen last night. He'd skipped coed newcomb this morning. And now this?

"What's your name, ginger darling?" Stu asked, the mic now centimeters from her lip-glossed lips. She'd glossed them for Chico.

"Missi Snyder."

"Well, Missi Snyder, you're going to be a great asset this week." He faced the crowd. "This gal knows her stuff!"

Missi low-wattage beamed. She wished Chico had heard Stu's compliment. Where was he? Was he avoiding her? Had she kissed him wrong? Used too much tongue? Showed too much of her real weird self?

"E'rybody rise and find your squares," Fufu said. "Stu and I will be circulating to answer any questions before we start rehearsing."

Missi's cabinmates rose and joined the Wawel Hillers mid-court. They all looked at Cookie and Arman expectantly. Cookie and Arman stared back.

"Did you make squares?" Cookie asked Arman.

"I, uh—did you?" Arman asked Cookie.

Jenny pointed to the ground in front of her. "Winning square—assemble here." The twelve Wawel and Notting Hillers clumped together in a mad rush.

"So, uh," Arman started, counting the campers in the clump. "There's got to be eight to a square—four guys and four girls. You're going to have to break up." He chose not to say what everyone was thinking: There weren't enough people for two complete squares. There would be four reject campers—two guys and two girls—who'd be assigned to a loser half square, filled out by little kids or counselors. So, no one moved.

Cookie stepped forward, her fingers in her weave. "Oh my lord, can everyone just choose one partner of the opposite sex? Let's start there."

"Don't worry, Cookie!" Jenny shouted from somewhere in the center of the huddle. "I got you, girl."

"Do you? Because—I can't even see your face."

Jenny emerged from the huddle on all fours. She dusted off her knees and clapped the Wawel and Notting Hillers to attention. "Okay, people! There's no easy way to do this. Jokes—it's super-easy! All legit couples stay. That means me and Play Dough, Slimey and Smelly, Missi and—wait, where's Chico?"

"He'll be here," Missi said.

"He's not here," Wiener said at the same time.

Just then, Sophie snuck up behind Dover and hugged him around his middle. Dover froze as Sophie swayed him in her grip, prom-style. *"We're a couple,"* she sang-spoke. "I would not wish any companion in the world but you."

"Totle—translate," Dover said, the sweat beading on his forehead.

"Sophie likes you," Totle said. "She's quoting my Aunt Sheila's Pinterest board."

"I'm quoting *The Tempest*," Sophie clarified. "Act three, scene one."

Totle shrugged. "Yeah, I dunno who said it first."

"Freak cuteness," Jenny interjected. "Okay, I need one more couple!"

One more couple?! So without Chico, Missi wasn't welcome in her square? She watched Jamie jump up and down with her hand raised and her fingers wiggling. Missi took a deep breath and waited for Jenny to pick Jamie over her. Like always.

Jenny cleared her throat: "Me and Play Dough. Slimey and Smelly. Sophie and Dover. Missi and—Wiener, you'll be Missi's partner until Chico gets here."

Wait, what? Missi wanted to feel relief, but instead she felt a big pang of guilt. Jamie stopped jumping. Her arms fell to her sides. Her wiggling fingers curled into sad little balls. Wiener stuttered, "I'll, uh—no thanks. I'll be in the other square, it's coolio."

"No excuses, Chico," Jenny said.

"I'm Wiener."

"I'm calling you Chico since you're subbing for Chico, Chico."

Suddenly, Stu appeared between Jenny and Play Dough. "How's the square-making going?" he asked the group with a tip of his hat.

"Square-sauce!" Jenny squealed.

"Do you remember my gramps?" Play Dough asked Stu. "He was here fifty years ago. Bald, bad hip. Actually he probably had hair and a good hip back then."

"He sounds familiar," Stu replied.

"Classic gramps. Always making an impression."

Jenny clapped in rapid succession. "Square up, people!"

Missi found her place next to Wiener. *It's okay*, she told herself. *Chico—the real Chico—will arrive any second. And Jamie? She's a strong independent girl! She'll be fine!* Still, as Jenny arranged the couples into a perfectly symmetrical square, Missi couldn't help but say something. "Jenny," she whispered. "You don't want to include Jamie?"

"Of course I do," Jenny said, nudging Missi closer to Wiener. "It's just—ugh—you know Jamie. She's so cute at dancing when it's choreographed, but she's literally wearing her left Converse on her right foot. Do you honestly think she'd be able to follow Fufu and Stu's calls?"

"I dunno, maybe. I just thought the three of us would stick together."

"We're together."

Missi looked over at the reject half square now being filled out by a Faith Hiller, a Hamburger Hiller, Cookie, and Arman. Jamie had her hair draped over her eyes and her chin was pointed at the ground. She looked like she was going to cry. "Are we, though?"

"She's, like, three feet away. And trust me, I know Dover is only Sophie's boyfriend in her head, but Sophie would totally

excel at something as geeky as Square Dancing, so it was a strategic pick. You know?"

Missi dutifully nodded while her heart dropped.

"E'rybody get with your partner, partner," Fufu called. *"Say hello to your partner, partner."* Somehow, amid the hullabaloo, the rehearsal had begun. Missi turned to Wiener. "Hi," she said.

"Hi," he said.

They were the first words they'd shared since the Kissing Tower. Scratch that—at the Kissing Tower they'd just gaped at each other, totally mortified. Then, even though they'd sat next to each other on the traffic-y bus ride back to camp, their silence had continued. Missi had sat there holding Chico's hand, while Wiener had pretended to listen to music with non-Bluetooth headphones connected to nothing.

"Circle to the left, promenade, move it, move it."

Missi held both her hands out to Wiener, and they promenaded. His palms were sticky with sweat. Or maybe the sweat was hers. "So," she said.

"So," Wiener said.

And then they kept dancing, without speaking, for at least five minutes.

"Now the side couples take a seat to the side, while the head couples stay standing for another ride!" That meant Slimey/Smelly and Missi/Wiener would sit out while Jenny/Play Dough and Sophie/Dover kept at it. Missi watched Slimey lay her head in Smelly's lap. It looked as natural as Tom's deodorant. She glanced at Wiener, seated at least five feet

away. Their distance was as unnatural as a hormone-pumped chicken.

"Chico should be here," Wiener said out of nowhere.

Missi sprung to attention. "Do you mean he's coming, or—?"

"I mean he shouldn't stand you up."

"Ha-ha."

"What's so funny?"

Nothing was funny. Missi didn't know why she'd laughed. Maybe it was a nervous thing. Maybe it was a desperate *Please let Wiener be wrong about Chico* thing. "He's not standing me up," she told him.

Wiener shrugged. "I hope you're right."

"Look—is this about Hersheypark?" Missi asked. "Because if it is, I'm really sorry. We waited for you. And then we looked for you. I swear."

"It's fine."

"You weren't supposed to—I mean, we didn't expect you to—" Missi cut herself off before she insensitively said, "be at the Kissing Tower." Instead she said, "We didn't mean to make you feel awkward."

"Awkward?" Wiener said. "Forget awkward. I could have been arrested!"

"Wait, what? Arrested how?!"

"Now, the side couples, it's your turn, while the head couples watch and learn!"

"Is everything okay?" Slimey asked Missi and Wiener.

"Yeah," Missi lied. She rose, totally confused. Wiener

angrily brushed himself off. They stood side by side in the square, the air extra-thick between them. Stu said something about four to the middle with a *tap, tap, tap,* and Missi followed the call, using muscle memory and nothing else. Her brain was too crowded to think. She knew in her heart that her kiss with Chico had hurt Wiener, but it wasn't her fault. It wouldn't have happened had Wiener not ditched them. It wouldn't have happened had Wiener treated her like his girlfriend at the start of the summer like she thought he was going to. And what was he even talking about? How could their kiss have gotten him arrested?

"Wonderful work, y'all! Head couples back in! Let's put it all together!"

"Just be careful," Wiener mumbled as their four-person square expanded back to eight. "I know you have good values."

"I can have values and also kiss him." Missi's throat started to lump. "If you're so upset about it, maybe you shouldn't have left us." The lumps grew bigger. "Maybe you shouldn't have left me."

"Grand Right, Grand Right. Weave it in and weave it out."

Missi weaved around the square-turned-circle, grabbing hands with Play Dough and then Smelly and then Dover.

"If you're home, gimme a cheer!"

Missi was home in her starting position, but she didn't cheer. Maybe because her throat was officially a mess of lumps. Maybe because at that very moment, she spotted Chico at the back of the court. Maybe because before she was aware of what she was doing, she was skipping in his direction.

Chico tore through the crowd until he mistakenly landed at the reject square. Just as Missi reached him, the film crew lit up the scene. She felt like the romantic lead in a teen hoedown movie. "Hey, partner," she said. "I missed you." She put her hand out for his. Her throat de-lumped. "We're in the other square."

But Chico just turned his back to the cameras and said to Missi, "Nah, I'm good."

Dear Shake-It-Up Shakespeare Sisterhood,

My romance has escalated, and I refuse to wait to share my feelings. So, alas, I present to you my unsolicited sonnet about my now-maybe-boyfriend and Square Dancing partner, Dover. Here go my hormones—COUGH, COUGH—I mean my single quatrain and rhyming couplet:

Whoosh, whoosh goes his curly 'fro in the wind
Like a hot, dreamy, springy flag of war
Eagle Scout sash of honor nicely pinned
My swooning heart just fell flat to the floor.

Ben Dover, bend over, give me a kiss
Grand Right, summer love, and cherish the bliss.

Open your heart valves for me, judges,

Sophie Edgersteckin, age 14.29

July 12th

Dear Gramps,

Do you remember Square Dancing with
Fufu and Stu fifty years ago? Does
it feel like yesterday? (If you say
yes, I have a LOT OF FOLLOW-up
questions about memory and how
that's possible.) Anyway, for my
elective period, I grabbed FRUIT punch
with them in the dining hall and
when I told them more about you,
they asked, "The big guy who used
to lift his shirt over his head and do
the Crab Dance?" And I said, "That's
my gramps!"

(I'm assuming this guy is you. It
definitely seems like something you
would have done.)

A favor: I've been wearing that
bandana you mailed me. Do you have
more? Send a bunch FOR the hoedown
if you can. I'll pay you back with
the money your daughter paid me
FOR running on the treadmill before
camp.

Thank you and love you,
Brian

My darling Missi,

I regret to say that I won't be making it up to our mutual home away from home for Visiting Day. I'm writing you from the airport in Ankara, where I am waiting for my connecting flight to Istanbul.

It took something truly awful—a motorcycle accident—for me to come home. On the contrary, it took something truly beautiful—you—to inspire my return into the world. You've ignited my need to create art at a time when art is more important than ever.

I need you to know that I love you. I'm proud of you. You are a beacon of light—silly and musical and kind—and I'm forever grateful that you let me slip into your life like I'd been there all along. I don't know when I'll see you next, but I already can't wait to meet the incredible woman you'll undoubtedly become.

Dream big. Make mistakes. Never lose yourself along the way.

Your mother,
Rebecca Joy

Number One Person

"Here we go," Wiener mumbled with dread as the Line Dance song "Popcorn" began blaring through the basketball court speakers. His cabinmates raced to join their squares, but after yesterday's debacle, he had no idea which square he should even join.

He figured he'd go wherever Chico didn't—either to be Missi's partner or Jamie's—but Chico was making a pit stop at the water fountain. Wiener would just have to stand on the sidelines and wait, watching the other upper campers get in place. He spotted Fufu stretching in the corner. He checked out his cabinmates, who were reviewing moves like the do-si-do and the Grand Right.

And then his eyes landed on Missi. She was sandwiched between the J-squad, and the scene was not pretty. Jamie was crying. Jenny was rubbing her temples, like *Leave me alone.* Missi was trying to mediate. Suddenly Melman tore Jamie away with a *Feel better* noogie, and Sophie tore Jenny away with a hug. Missi was left alone between the two competing squares. Wiener watched her close her eyes, take a deep breath,

and reopen them. Then he watched her bend down to tie her shoelaces that were already perfectly tied and walk to the end of the water fountain line.

"Hey, my Wiener," Chico said from behind him.

Wiener turned around, startled. "Hey." He waited a few seconds for Chico to make a move, but he just stood there as if he had no intention of joining a square at all. "Popcorn" began speeding up, which meant it was nearing the end. Which meant the rehearsal was about to begin. Which meant Wiener would have to join a square. "Are you going to dance with Missi today?" he blurted.

Chico shrugged. "My partner is the small scary girl—the one who's crying."

"Jamie?" Wiener asked.

"Yeah."

Wiener didn't want to dance with Missi—she probably thought he was a jerk for saying bad, confusing stuff about her boyfriend. But he didn't want to dance with Jamie, either. She was wailing harder than most kids did on the last day of camp. "You'd rather dance with Jamie than your own girlfriend?" he asked Chico.

"Missi's not my girlfriend."

"Funny joke, man." But Chico wasn't laughing. In fact, he began walking toward Jamie totally straight-faced. "Missi is definitely your girlfriend," Wiener said, cutting in front of him. "I saw you kiss her, remember?"

"How do you say—*a kiss does not a girlfriend make*?"

"Oh, jeez—well, yeah, that's how you say it—but that's foul play! This is camp, Chico. There are rules! There are values! Did we not teach you STARFISH?"

"The sharp sea animal?"

"STARFISH. Sportsmanship, Tolerance—"

"Oh, the thing Totle told me about after I stole cake and did other bad stuff, yeah." Chico put his hands on Wiener's shoulders and gave them a little squeeze. "Don't worry. I will get through the summer with no more drama."

"DRAMA?" Wiener said, flinging Chico's hands off his body. "Before Missi met you, she was sweet. She played her flute over the PA during Rest Hour. She revealed everyone's inner animal—I'm a seahorse! She told cat jokes like: *Do you want to hear a cat joke? Then just kitten!*" Chico gave Wiener a blank stare. Wiener moved on: "The point is, Missi is an amazing girl, and I worry that you don't appreciate her."

"I do dumb stuff when I'm bored, especially around girls," Chico said. "And I like Missi a lot, I do, but I can't just go around doing dumb stuff anymore, okay? My dad said I was out of chances."

"No," Wiener said, a firepit of anger growing in his belly. "That's NOT okay! So, what? You're just going to break up with her?"

"She'll get the hint, I'm sure."

"You want to GHOST HER?" Wiener shouted, the fire sizzling up to his throat. "If you're going to break up with her, which I'm not saying you should do, but if you're going to do it,

you have to actually TALK TO HER. Not just ignore her until she realizes it's over. That's straight-up mean."

"I don't think it's mean," Chico said. "Missi and I had a lot of good times."

"Yeah, because you *STOLE* stuff for her."

Chico leaned in and whispered, "Chill, my Wiener."

"Chill?!" Wiener's voice cracked as if a rubber band had tightened around his neck. "You're asking *ME* to CHILL!?"

"Uh, what's going on?" Play Dough asked Wiener. He and Totle were suddenly by his side, their arms crossed like body-guards.

"Chico wants to break up with Missi but not even tell her that he's doing it."

"Burn," Totle said.

"You can't just steal Wiener's girlfriend and then break her heart in a secret way," Play Dough told Chico.

"Wiener's girlfriend?" Chico asked, his face growing as red as a watermelon. "What are you talking about?"

"Well, um," Wiener croaked.

"Wiener and Missi started dating last summer," Play Dough cut in. "They only stopped when you came along."

"Why didn't you say anything, Wiener?" Chico demanded.

"There was no point," Wiener said, taking in Chico's perfect-ly wavy hair and catalog-worthy sunglasses and glowing tan skin. "No way would she pick *me* over *you*."

"Be nicer to yourself," Totle told Wiener. "You have a very nice jawline."

"And you have very few boogers," Play Dough said.

"And you very much smell like trees," Dover added, slipping into the conversation.

"Thanks," Wiener said, sniffing himself. No one had ever complimented him on his face or nostrils or smell, and it felt sauce.

"Excuse me while I dance with Jamie," Chico announced, edging away. "If you like Missi, my Wiener, then you can go dance with her yourself. I bet she'll love your few boogers and tree smell."

"Hey," Play Dough said, stopping Chico with a hand to his chest. "When you have the greatest little thing handed to you, and by the greatest little thing I mean Wiener, you don't piss on it."

"Ew," Dover said.

"Not literally," Play Dough said. "Right, Wiener? He never pissed on you?"

"Right," Wiener affirmed.

The Wawels, minus Chico, began giggling. Wiener was giggling with them. "Guys, should I piss myself right here? Someone tell the story of Cropsy! Actually I'm not scared of Cropsy—haven't been since Bunker Hill. Tell the story of Cropsy's zombie bride, Crapsy!"

"Crapsy isn't a thing," Play Dough said.

"I know!" Wiener cried, bursting with bliss. "I made her up!"

Play Dough smacked the back of Wiener's head, which made him crack up even more.

And then, out of nowhere, Missi appeared. The giggling stopped and the guys froze. She inched closer, slowly. "Chico, can I talk to you?"

"I don't know," Chico said, followed by awkward silence.

"*Man up,*" Play Dough chanted slowly. "*Man up.*"

The Wawels, minus Wiener, joined him: "*Man up, Man UP, MAN UP!*"

Chico was rolling his eyes. Wiener was wincing apologetically.

"Um, why are you guys chanting that?" Missi asked, then stared at Chico.

"STARFISH," Totle reminded him.

"*STARFISH, STARFISH, STARFISH,*" the Wawels began chanting instead.

"Okay, okay, FINE!" Chico said, halting the chant. He looked at Missi. "I stole all the stuff at Hersheypark, and we're over." He turned to the guys. "Now are you all happy?" Then he stormed onto the basketball court and took his place beside Jamie.

Wiener looked at Missi's face, red as a cherry, and felt a prick of guilt in his chest. Her eyes began to well up, but before they spilled over, she ran past the guys and up toward Harold Hill.

"Missi, wait up!" Wiener called, racing after her.

She didn't wait. She was fast. Way faster than Wiener. Three hills later, they were half a hill apart, and Wiener watched her duck into the Nature Shack. Twenty seconds after that, at the Shack's closed door, over his own monster breathing, Wiener could hear her sobbing. He'd never heard Missi sob, let alone cry, and he felt his heart plummet. "Knock knock," he said softly, his knuckles brushing the door.

"I'm fine," Missi said in between sobs. "Really, I'm fine."

"Cool. I'm fine, too," Wiener said. "We're just two fine friends in nature." He waited. Nothing. "So, uh, wanna talk about how we're both fine?"

He listened to Missi swallow a sob with a laugh. "Fine," she said.

"Score-sauce." Wiener pushed the Shack door open and was showered with dust and woodchips. "Yikes. I see they haven't shaped up the Nature Shack yet."

"Nope." Missi was seated on a bale of hay and cuddling a bunny rabbit on her lap. Her ponytail was a mess, with the front pieces popping up like she'd been electrocuted. "They've got some animals," she said with a sniffle, nodding toward the dinky array of newts and frogs. "But they've all been brought here by kids who abducted them on hikes. This should be a place for abandoned, hurt animals who need healing, you know?"

Wiener nodded, watching the bunny paw at Missi's tie-dye T-shirt and then at her khaki shorts. Suddenly he realized that she was dressed in her normal clothes, not one of her new exotic dresses and chunky necklaces. Still, she looked just as beautiful.

Wiener found a bale of hay beside Missi and hoisted himself up. His legs dangled. "What happened to the funky clothes—like that dress from Rishikesh?" he asked.

Missi lowered her chin and pinched her T-shirt. "I retired them." Then her face turned cotton-candy pink and her eyes welled up.

"I'm sorry," he said quickly. "I didn't—um—mean to make you sadder."

"I just want to feel like I'm special to one person."

Wiener felt swallowed by her sadness. He wanted to wrap his arm around her, but his haystack was a foot too far from her shoulders. He also wanted to tell her that she was special to him, the most special-sauce, but Missi's hazel eyes stared into his, and the words dissolved in his mouth.

"I was trying to share something personal with Chico," she said, patting her shorts pocket where a folded letter was sticking out, "because, I dunno, I really liked him and was starting to trust him. I finally thought he liked me for me."

"Who wouldn't like you for you?"

She cocked an eyebrow.

"Look," Wiener said, "I'm not trying to be corny. If anything, you shouldn't like Chico for Chico. He stole stuff and then pretended he'd bought them for you!"

"I'm not mad he stole," Missi said, cool as a cucumber with ranch.

"Why—how—not?" Wiener asked, blinking in bewilderment.

"I mean, of course what he did was wrong," she said, little pebbles in her throat. "He acted like a big-time jerk. But, like me, he has a lot going on in his life. When people have a lot going on, sometimes they do things they shouldn't do."

"Okay . . ." Before Wiener could finish flipping through his mental binder of all the things he'd done these last few weeks he shouldn't have done, Missi plowed on: "Do you know what it's like to feel like you're not wanted by your own parents?"

"Maybe?" There was one time his parents opted to

celebrate their anniversary alone in a five-star restaurant *after* he'd baked them lasagna and blueberry crisp using recipes he'd taken from *MasterChef Junior*. "I know a little bit," he said.

"No, not really you don't. You were the closest friend Chico had here. Did you ever ask him about his life and family and school and situation?"

"He never seemed like he wanted to go into it." Wiener shook his head with confusion. "Wait, hold up! Are you mad at *me* for defending you to Chico?"

"No." Missi bit her bottom lip. "I dunno, it's complicated."

"What is?"

"At camp, everything's fun." Missi's voice got thin. "I think, because of that, sometimes camp friends forget to ask each other about their lives outside of the bubble." Her voice cracked on "bubble" and her chin began to quiver. "We need to be there for each other."

"What's going on with your life outside the bubble?"

A single tear slid from her eye, and then they came flying down her cheeks in threes, fours—so fast, they blurred her freckles. "It's my mom," she said. "She came back into my life this year, after not being around my whole childhood. And it was really great to spend time with her. She was supposed to come up to camp for Visiting Day, but then I got this letter." She patted her pocket where the letter was sticking out. "She's not coming. She's gone off again. I don't even know the next time I'll see her."

"I'm so sorry," Wiener said. "I had no idea."

"It's fine," Missi said, wiping her face. "I mean, it's not fine, but yeah."

Wiener didn't know what else to say so he just held out his hand. She slipped her hand in his. Then they sat in comfortable silence for a long while. "Hey," he eventually said into the quiet. "Sorry I've been acting so dumb. I think you're really awesome, Missi. You care about people. And animals. And you're funny. So. Yeah. That's what makes you special-sauce."

"Thanks." Missi chewed the inside of her cheek. "Well, you're special, too."

Wiener flexed his bicep. "People keep telling me that."

Missi giggled. "So weird." She paused. "I changed my mind about your inner animal. You're not a seahorse. You're—"

"Wait! I watch *Planet Earth*, so my brain's an animal word bank. Let's say it together."

"Ha, okay. One, two, three—"

"A stallion!" Wiener said.

"A peacock," Missi said.

They burst into laughter. Missi whistled through the gap in between her front teeth, and it was the most adorable thing he'd ever heard. Then the sixth-period bugle sounded. It was the least adorable thing he'd ever heard.

Missi rose from the hay and headed to the bunny's crate. Wiener wasn't ready for their time together to be over. He wished they could stay here through Shower Hour. That they could meet up in private every day. "Hey, I've got an idea," he said. He followed her to the crate and helped her put the bunny inside. "Let's fix up the Nature Shack."

Missi looked at him funny—like he was an actual peacock.

"Seriously," Wiener said. "Like you said, we should make this a place for the animals that need our help."

Missi's eyes turned into sparklers. "You'd really do that with me?"

"Are you kidding?" he said.

"And you're not allergic to fur or scales or whatever?"

"I could wear eight feisty cats as a boa, and I wouldn't sneeze once." Then Wiener's body betrayed him, and he sneezed twice. Missi exploded with giggles. It made him feel like The Man of Mans.

"So," she said, throwing her hands on his shoulders. They were smiling-face-to-smiling-face. "Let's meet tomorrow at Rest Hour?"

Rest Hour was now Max Time in Bunker Hill Cabin. Dinosaur Onesie, whose name was Davey but whose nickname had morphed to Dino, was teaching them a card trick that defied logic. "How about Free Play?"

"You got it."

The Big Confession

"Is this thing on?" Jenny asked, tapping a jumbo tampon like a microphone. It was eleven at night, and she was sitting on Jamie's top bunk, spotlighted by five flashlights, one in the hands of each Notting Hiller.

Missi giggled for a second, because, you know, *tampon microphone.*

"I can hear you loud and clear," Sophie said, pressing her finger to her ear like she was wearing a headset.

"Great," Jenny said. "But not so loud that Cookie will hear and then shut this operation down? Somebody check."

Missi peered out to the porch. Cookie was absorbed in a tacky romance novel. So absorbed that she seemed to have no idea her campers weren't sleeping. "All clear," she reported.

Jenny smacked her ChapSticked lips together. "So, as you all know, this is the dress rehearsal for tomorrow's confessionals."

"Confessionals?" Slimey asked. "Aren't we practicing for our interviews with the film crew? Like what we're going to say to them when they ask us what we love about Rolling Hills?"

"Correct."

"Because when you say *confessionals*, it makes me think of reality TV."

"This *is* reality," Jenny said flatly. "And we *will* be filmed."

"Also, *dress rehearsal?*" Melman asked. "I'm wearing boxers with bananas on them."

"Yes, we see that," Jenny said flatly and then made *Let's do this already!* eyes with Jamie.

Jamie dutifully complied. "Jenny Nolan of Notting Hill Cabin, what do you L-O-V-E about Rolling Hills? Please restate the question in your answer."

Jenny flipped her hair and "smized"—smiled with her eyes. "Hi, I'm Jenny. What's not to love about Rolling Hills?" She tapped her cheek in thought. "The rolling hills roll with, like, effortless beauty. The people. The facilities. The activities. All A-MAZING. So if you're a parent wondering: *Is Camp Rolling Hills right for my precious child?* Look no further. Seriously. Stop. Eyes on my eyes. This camp is the best home away from home for all the precious little ones in the world." She lowered the tampon and her head. "And . . . scene."

Missi didn't disagree with anything Jenny had just said, but she thought the whole thing sounded scripted, like a cheesy commercial, rather than a genuine outpouring from the heart. But before anyone could say a word, Sophie tossed up the open box of tampons and shouted, "Mic drop!" The purple, yellow, and orange packages flew around the cabin like confetti. Sophie skipped over to Jenny's dangling legs and gripped her ankles. "An idea: We should write together. I'm a pro at contest submissions."

"Cool, maybe," Jenny said. "But if we do coauthor something, my name will be listed first, because *J* is before *S*."

"Not if my pen name is Aurora—"

"Jamie's turn!" Jenny yanked her legs from Sophie's grasp and folded them underneath her butt.

"Um, um, um," Jamie said. "I don't know what to say yet. Someone else go next."

"I'll go," Melman said. She brought a whole fistful of tampons to her mouth. "Yo, yo, yo. The Hills is where the magic is at. Here a gal can open up."

Questionable, Missi thought. She'd wanted to open up to her cabinmates the very first day of the summer, but no one seemed to want to listen. She'd brought her mom's *I'm leaving you again* letter all the way to Square Dancing rehearsal to share it with Chico, but before she could even get that far, he'd dumped her.

"What do you mean 'open up'?" she interrupted Melman, mid-description of Color War, maybe.

"Huh? Um." Melman shook her head to rewind her thoughts. "I think I mentioned that here a gal can open up and try different sports—rock climbing, waterskiing . . ."

"Oh," Missi said, embarrassed.

"Proceed," Jenny instructed Melman.

"Great. So, basically, Color War is competitive, but at the end of the week, it's all about your friends, whether they're on Blue or White." Melman wrapped up her confessional with a "Go Blue!" and offered the bouquet of tampons to Slimey, who plucked a purple one.

"At camp, I can truly express myself as an artist. I painted my first landscape on Forest Hill, overlooking the lake. It still hangs in my bedroom at home."

At the mention of "artist" and "home," Missi's mind sprang back to her mom. Before she'd gotten her letter, Missi had thought about Rebecca Joy a few times a day, imagining just how amazing Visiting Day with her would be. Now, Rebecca Joy popped into her mind every few minutes, and Missi's happy memories with her seemed kind of messed up. Like their bike ride through Palisades Park to sketch the cliffsides. At the time that had felt like a cool, carefree adventure, but Missi had skipped school and missed her math final. Her grade had dropped a whole letter. Rebecca Joy didn't care about rules and expectations and commitment. She just did whatever she wanted, whenever she wanted, with no consideration for what was best for her daughter. What kind of mother did that?

"Missi, hello?" Jenny said.

"Huh?"

"Your turn." Jenny tossed Missi a tampon, even though there were six at her feet.

"Right on." *Right on? Who says that?* She held the tampon like a microphone. She looked at her cabinmates looking back at her, and she tried to wash away the image of her mom's long braid whooshing in the New Jersey farmland wind. "I love Rolling Hills because—" Her voice cracked. "Because—" It wasn't that she didn't know what to say. She loved camp for a million reasons—her friendships, the sports, the trips—but Rebecca Joy wasn't leaving her head, her heart, or her throat.

"Are you okay?" Melman asked.

"Yeah," Missi said.

"Is it He Who Must Not Be Named?" Jenny asked. "Because I will make a Frankenstein collage of him with Lord Voldemort."

Slimey, the biggest Harry Potter fan of them all, just shook her head.

"It's not about Chico," Missi assured Jenny, feeling little pricks behind her eyes. "I mean, I'm sad about him, but I'm sadder about something else."

"Is it Wiener? Were you, like, in love with him the entire time? IS THAT WHY YOU AND CHICO BROKE UP?"

"No," Missi croaked, though her feelings for Wiener were kind of kicking back in. "Nothing like that."

"Who do you need me to terrorize?" Sophie asked. "Because I will go guano-crazy on whoever you want. Guano is bat poop."

"No, it's—" A wave of sadness hit Missi so hard, she couldn't finish her sentence. The cabin fell quiet. The hum of the AC became the loudest sound in the room. Talking to Wiener about her mom had left her feeling so much closer to him, but talking to the girls? She didn't want to be a downer. She chewed her lip and willed herself not to break down—not here, not now.

"I'm scared," Jamie said. "I've never seen you so serious."

"Sorry," Missi said, forcing a smile.

"Don't apologize," Slimey said. "It's okay to be serious if that's where you're at, trust me. It's not good to keep stuff locked inside." Slimey untucked her locket from under her T-shirt, and without thinking, Missi reached for her mom's chunky beaded necklace. She curled her fingers around air, forgetting that

yesterday she'd shoved it in her plastic drawer set, where it would be out of sight, out of mind. *Out of mind, ha.*

Missi took a deep breath and looked at the picture of her and her mom sticky-tacked above her bed. It had felt right to tuck away the beads and retire the frocks, but taking down the Christmas photo had felt wrong, no matter how hurtful it would be to see Rebecca Joy's face multiple times a day. "Did anyone notice this picture?" she asked her cabinmates, trying not to let her voice shake too much. She scooted off her bed so they could see.

"I noticed it," Jamie said. "That girl looks a lot like you. Is she your cousin?"

"She's my mom."

The J-squad's eyes widened. Sophie's jaw unhinged. Slimey covered her mouth with her fingers. Melman dropped her soccer ball to the floor.

"But she looks so young," Sophie said, moving to Missi's bed to get a closer look. "No gray hairs or wrinkles or anything."

"She had me when she was a teenager."

"Wait, didn't she leave, like, a decade ago?" Jenny asked, climbing down from Jamie's top bunk.

Missi lit up a little. Jenny had remembered. "Yeah, I hadn't seen her in ten years."

The rest of her cabinmates made their way over. The six of them squeezed on Missi's single bed, hovering over the photo of Rebecca Joy. Missi felt her heart go heavy and bouncy all at once. She had chills, but her cheeks were burning. Suddenly she was eager to spill everything about all the excitement and

letdown her mom had brought into her life, but her throat was still partly clogged up.

"So this was taken at Christmastime?" Slimey asked.

"On Christmas," Missi said. "That's when she came home."

"Like, for good?" Jamie asked.

"Well—"

"Is she coming up for Visiting Day?" Jenny asked. "Omigod, do we get to meet her?!"

The pricks behind Missi's eyes turned into stabs, and before she could will herself to keep it together, she became a puddle of tears. Her nose got stuffed up, and her eyes began to burn, and she'd never felt so self-conscious in her life. "I—I'm—sorry," she sobbed, wiping her soggy eyes with the back of her hand.

"Stop saying sorry," Slimey said. "Cry it out!"

Missi sputtered a laugh. "Thanks, you guys. I'm fine." She expected her friends to go back to their own beds. But Jamie rubbed her back. Jenny smoothed her frizz. Slimey held her hand. She was smothered in forehead and shoulder kisses. For some silly reason, that made her cry even more.

"It's going to be okay," said Jamie.

"We love you, carrot top," said Jenny.

"There, there, thou princess of cats," said Sophie.

Finally, Missi sniffled and the waterfall of tears came to a halt. She unzipped the Hello Kitty pillowcase of her pillow and pulled out her mom's letter. "I got this from her yesterday." She unfolded it onto her lap, and all the girls' heads leaned in at once to read it. Missi's eyes were too wet and blurry to follow along, but she'd read the letter so many times, and had thought

about it so much, by now she knew it by heart. Sophie and Jenny whispered the last line: "'Dream big. Make mistakes. Never lose yourself along the way.'"

Missi felt a wave of fresh pain. She'd really wanted to introduce Rebecca Joy to her cabinmates. To show her around camp's new facilities. To have her see her daughter in her element. "So, yeah," Missi said, trying not to drown in her disappointment. "You won't be meeting her anytime soon."

"Well, if we can't meet your mom in person," Slimey said, "then maybe we can meet her through your stories."

Missi looked at her curiously. "What do you mean?"

"She means tell us everything," Jenny said.

"Oh." Missi wasn't sure that was a good idea. Certainly her cabinmates felt claustrophobic on her single bed. Surely they wanted to get back to the fun confessionals. Tonight wasn't meant to be a breaking-news special of *The Missi Show*. "It's okay," she said. "I don't want to be a wet blanket."

"Then be a dry one," Jenny said. "Can you pretty please tell us about your mom?"

"Yeah, tell us," Jamie said. "If you want to talk, then we want to hear!"

Jamie, Jenny, Slimey, Melman, and Sophie cuddled in tight, bracing themselves for story-time. "Sure," Missi said as her heart grew a size. "That would be really nice."

"So, like, where was she before Christmas?" Jenny asked. "What made her come home? Was it weird at first? What did you guys do together these last six months? Leave no juicy details out."

Missi nestled herself against her jean pillow and tried to fall back into her favorite memories with her mom—baking bean brownies, learning reflexology, strawberry picking at Battleview Orchards, and stargazing at Double Trouble State Park. But Rebecca Joy's letter was stuck in her head, and those once-sweet memories, just like the one of the Palisades Park trip, had turned sour. Missi explained how angry and hurt she was. How it wasn't fair that her mom had come back into her life just to abandon her all over again. How it made her feel like she wasn't a good-enough daughter. Like everything her mom had promised her was a lie, and how could she trust her ever again?

It was weirdly healing to be honest with her best friends. They listened and rubbed her back and squeezed her hand through the hardest parts.

Cookie tiptoed inside at 1:03 a.m., her romance novel pressed against her chest. "Are you all up?" she whispered.

"No," Sophie said. It was followed by muffled giggles.

"I'm the worst counselor." Cookie sighed. "Seriously, ladies. Bedtime. Please no one tell the Captain I neglected you."

"Wait, wait!" Jenny cried. "Can we sleep all together?"

"Like how?" Cookie asked, looking skeptically at her tangle of campers, their limbs dangling off of Missi's mattress.

"Like this." Jenny waved everyone off the bed. "Jamie and Melman, push with me." The three girls pushed Missi's single bed all the way over to Jenny's bottom bunk, while Slimey and Melman collected fallen pillows. Sophie dragged blankets over from her bed. "See? A sleepover party!" Jenny squealed. "Who's in?"

They all shot up their hands. Missi's heart had an even bigger growth spurt. She was in. Obviously. SooperDooper-Looper in.

"This work for you?" Jenny asked Cookie.

Cookie shrugged. "We already sleep in tight quarters. Do you girls have so much love that you need to go to bed on top of each other?"

"YES!" the Notting Hillers shouted in unison. Missi and the J-squad carried on: "Jinx! Double jinx! Triple jinx! Quadruple jinx!" Melman smacked the three of them with a pillow before they could say "Quintuple jinx!" Feathers exploded. Missi began laughing so hard that her front teeth whistled like a harmonica. The six of them were a contagious heap of giggles.

Twenty minutes later, once the giggles settled and their eyelids were all like, *Nope, we are closed for business*, Missi whispered: "G'night munchkins!"

Jamie nuzzled her nose in Missi's back. Sophie wiggled her butt into Missi's stomach. "G'night, Missi-face," Jenny said. Then, just like that, they fell asleep—a six-person cuddle-spoon.

July 16

Dear Grandma and Grandpa,

How are you? We have a big hoedown coming up in just a few days—yee-haw! Is there such a thing as a square that's made up of more than four pairs? It would be really cool to include my entire age group. Can you email the Captain, or fax her if that's easier, your response ASAP?

Also, the Captain checked in and told me that you're worried about me. I got Mom's letter, and it was a real blow, but in the end, I'm okay. With amazing friends by my side at camp, I can get through anything.

So excited to run into your arms on Visiting Day. Big kitty cat kisses to Happy, Sleepy, Grumpy, Dopey, Bashful, Doc, and Snow White.

Love,
Missi

P.S. I really am so lucky to have been raised by you. ☺

Paolo Alejandro,

Your mother and I have some news! Tía Gabriella has decided to marry Angelo. In just one week. Surprise! We will be cutting our summer vacation in Saratoga short and bringing you back with us to Barcelona. We will be coordinating all the details with Mrs. Jerecki. Do you need any alterations to your suit? We hope you are not too disappointed. Camp looks like it's a wonderful time.

Warm regards,
Papa & Mama

Adiós a un Hombre Nuevo
(Goodbye to a New Man)

"Left, straight, straight, keep going, STOP—THAT'S A FLAGPOLE!"

A blindfolded Wiener stopped short. "Tell me again why you pulled me from stained glass?" he asked Dover. "I was almost done with my kaleidoscope."

"A little birdie in a tree said something very true to me."

"Birds don't talk."

"Fine," Dover said. "I was in the office, browsing their DVD library, when I overheard something in Spanish. I looked up, and there was Chico, talking smack on the landline."

"Really? What did he say?"

"Actually he was pretty polite," Dover said. "But I don't want to say too much. You should hear it from the source himself."

"Can you at least tell me why I'm blindfolded?" Wiener asked. "I know we're going to Wawel Hill. I can smell our dirty laundry from here."

"Oh. I dunno. I thought it would make walking more fun."

"For you."

"Yes, for me."

Wiener tore off the blindfold, and he and Dover began jogging.

Well, more precisely, Dover began speed walking at Wiener's jogging pace because *leg-length differences*. Wiener couldn't wait to hear what was up. Maybe Chico had scored a Spanish indie film for them to screen. Maybe he'd asked his parents to send up supplies for a cabin Carnaval, Barcelona-style! Or maybe it was Chico's birthday? The guys had never asked him his birthday. That had to be it! *One whipped-cream sundae with rainbow sprinkles, please!* "I bet I know what it is," Wiener said.

"I bet you don't," Dover replied.

Now they were both running. The day after the Square Dancing fiasco, things had cooled down. Chico had apologized for his stretch of discourtesy, dishonesty, and thievery, and Play Dough had promised to never again chant *Man up* or *STAR-FISH* at him until he buckled. The guys had learned a lot more about Chico, and he had learned a lot more about the guys. For instance, Wiener now knew that Chico preferred paprika on everything from tuna fish to iceberg lettuce. Chico now knew that campers spread superbugs called lice. Things didn't get perfect overnight, but Chico did give the cabin a group singing lesson and only charged a half can of EZ Cheez.

Wiener and Dover arrived at last, sticky with sweat, at the foot of Wawel Hill Cabin. Wiener bounded up three, four, five porch steps and then stopped cold. In front of him was a tightly packed camouflage duffel. On its side, in chalk: Ramos. "Chico's leaving?"

"Yup," Dover said.

"C'mon, I thought you were dragging me here for sauce news!"

"Nope. Sour-sauce news."

Wiener anxiously climbed the last porch step and opened the cabin door. There was Chico, hovering over Wiener's bed, arranging his denim Ray-Ban sunglasses on his pillow. "Whatcha doing?"

Chico jumped backward, startled. "I, uh."

"Did they break?" Wiener asked.

Chico's lips turned up. "No, my Wiener. I feel bad for—how do you say—*throwing you shade?*"

"That's how you say it."

"So I'm throwing you my shades as a parting gift."

"Ha! What? Me?" Wiener got instantly giddy. He couldn't believe he'd get to sport Chico's Ray-Bans. They were the saucest accessory in town! Could he pull them off? Probably! Not as well as Chico, but he'd look cooler in them than he did in the pink plastic ones he'd won at Play Dough's bar mitzvah. "Thanks, man!" Wiener said. "This means a lot."

"I'm glad," Chico said, smiling.

Just as Wiener went to slip the Ray-Bans from the pillow to his eyes, the words "parting gift" sunk in, and his excitement got smothered in sadness. "Wait, so why do you have to leave?"

"I have my aunt Gabriella's wedding. She's my mom's sister. She does crazy stuff, like me. She's my favorite. The guy she's marrying is a racecar driver with a scar from his lip to his eyebrow."

"Oh," Wiener said, relieved and worried all at once. He hoped the dude was good to Gabriella. And a more cautious driver now. "But then you'll come back after the wedding?"

"I don't think so," Chico said somberly. "It's a big trip. Expensive, too."

Wiener had very little idea how much a round-trip flight from New York to Barcelona was, but one thing he did know: Camp was priceless. "Is there *anything* I can do to change your mind?"

"It's not up to me. But even if it were, it would be hard to see Missi every day and not be allowed to date her."

"What do you mean 'not allowed'?"

Chico sat on the edge of Wiener's bed. "Before camp, my parents told me I couldn't have a girlfriend here."

"But Missi's not just *any* girlfriend," Wiener protested. "It's not like she's a racecar driver with a scar on her face. She's the opposite! She's the best influence!"

"Well, I did steal stuff for her."

"That she didn't ask you to steal!"

Chico shuffled his feet. "I don't want to fight about it, my Wiener. I had to stop seeing Missi. Before we found out about my aunt Gabriella's engagement, my parents told me that if I follow their rules and get through the summer without any more trouble, I could go back to my old school in Barcelona. I could sleep in my own bed. I could go to Carnaval with my dad. I could be back home with my friends where I belong. That's a really big deal for me."

Wiener tried to imagine how he'd feel if his parents forced him to go to a boarding school in Sweden. He'd miss Max a lot, and his parents, but other than that it sounded sweet—mountainous backdrops, Ikea furniture, gender equality!

Chico was back at his bed now, packing up last-minute stuff like his hair gel and argyle socks. *Maybe I'm thinking about it all backward*, Wiener thought. Maybe Chico felt the way he would if his parents didn't let him return to Rolling Hills. A summer without camp would be miserable! He'd spend his days mowing his parents' lawn, avoiding slugs in the driveway, and watching Netflix all alone.

"So, wait," Wiener said, walking over to Chico. He helped him fold his underwear, which was also argyle. "When your parents told you that they might let you stay in Barcelona, did they know about what went down in Hersheypark?"

"No."

"Do they know about it now?"

"Yeah. I told them myself."

Wiener did a double take. Actually, it was a triple take. Which was appropriately dramatic for this sort of news.

"It's fine," Chico said, laying a hand on Wiener's shoulder. "It was time I owned up. It's the only way I'll stop doing dumb stuff. I don't want to end up in jail. Or hurting more hearts."

"Wow," Wiener said. "That's really mature of you."

Chico nodded in agreement.

"So, what did your parents say when you told them?"

"Well." Chico sighed. "They weren't happy about what I did, but they were proud I'd come to them first. As far as my future—Sweden or Barcelona—I'll have to see."

"That's great news!" Wiener jumped a little. "It's a win-win!"

"Maybe," Chico said with a smile. "You always see the best in things, my Wiener." He squatted to the floor and dug under

his bed, pulling out a glass Hershey's Kiss filled with brown liquid.

Chocolate milk? "Aw," Wiener said to be polite. "You didn't have to."

"It's for Missi. To apologize," Chico said. "It's Hershey's perfume, and no, I didn't steal it. I had a friend buy it online and ship it to me. With my own money. If that's what you were thinking."

That wasn't what he was thinking. "May I?" Wiener asked.

Chico cocked his chin and spritzed Wiener's neck. "I forgot you like to smell like a lady."

"Like a lady?!" Wiener scoffed. "If milk chocolate and nostalgia is the smell of a lady, then I'll happily smell like one for the rest of my life."

Suddenly Dover was beside them. "Yo, Wiener. Do me." Wiener had completely forgotten Dover was in the cabin. These last five minutes, he'd felt like it was just him and Chico and no one else—the definition of true bromance. Dover locked his fingers behind his head and spun. Wiener sprayed him six times. "Mmmmmmm, yum!" he cried, opening his mouth as wide as a softball. "Spritz my tongue!"

Chico stepped in with urgency. "It's not for your mouth." He worked the perfume out from Wiener's furled fingers and slipped it into its original packaging.

Just then, Arman popped his head into the cabin. "Hey, buddy, you ready?"

"You're leaving now?" Wiener asked Chico in a panic. "Like, as in this second?"

"Yes, my Wiener."

Wiener's heart began to beat wildly and sadly all at once.

Arman grabbed Chico's carry-on bag from his bed and headed back toward the porch. "Quick goodbyes, yeah? Eddie, the groundskeeper, is waiting for you in his car. You've gotta make your flight."

"Thanks, Arman. I'll be right there." Chico looked Wiener in the eyes. "Can you deliver the gift to Missi? I have a note." He rotated the Hershey's Kiss perfume package to reveal a sealed baby blue envelope taped to its side.

"Of course," Wiener said.

Dover offered Chico a handshake, which turned into a man-hug.

Wiener felt a pinch of heartbreak. He wished he could keep hanging out with the new man Chico was just starting to become. "Guys?" he said. Dover and Chico opened up their hug and put their arms around each other's shoulders. "How do you say 'New Man' in Spanish?"

"Hombre nuevo," Chico and Dover said together, then broke into matching grins.

Wiener got struck with a plan. He communicated it through rapid blinking to Dover, who blinked back. "You ready for this?" he asked him.

Dover rubbed his eyes. "If we were just playing the staring game, you lost first."

"Nope, we're sending Chico off the right way." Wiener grabbed a broom and cleared his throat. "*Now* are you with me?"

"Ohhhhh!" Dover slow-clapped with approval. "With you all the way."

"Good." Wiener turned to Chico. "Kneel, Paolo of Barcelona . . ." He pushed him down by his head. He tapped him on his right shoulder, then swept the broom over his head to the left one.

Dover whispered a blessing in Spanish. "Que tengas un viaje seguro, amigo. Translation: 'Safe travels, friend.'"

Wiener nodded to him and continued. "Arise, Hombre Nuevo!"

"Guys, I really don't—"

"Hombre!!!" they cheered over him.

Then Wiener slipped on the Ray-Bans and went in for a man-hug of his own.

Missi,

I am sorry for hurting you. You deserve better than me. You deserve the world.

I hope this perfume brings you back to our day of adventure and passion. Wear it well, my beautiful friend with the fire hair. I will think of you while across the Atlantic.

Yours,
Chico

P.S. I don't know if Wiener told you, but I bought this with my own savings.

Dearest Missi,

We hope this fax finds you well.

Your grandfather and I just spent the afternoon at Oldwick. After much debate, we have found a solution for you. Below is a diagram for a twelve-person dance—six couples arranged in a hexagon. The Captain has arranged for us to speak on the phone so we can explain how it all works.

Always remember, you are the light of our lives. You keep us young. You keep us loving. We wouldn't trade the past fourteen years for anything.

Hugs, kisses, and apple pie,
Grandma & Grandpa

Hoedown Showdown

"H-E-X-A, *HEX-A-GON!*" the Wawel and Notting Hillers cheered. Missi's stomach was doing somersaults—she was about to coach her team through a grueling competition of weaving, skipping, do-si-doing and more.

"It's time to get started!" Stu announced from a makeshift platform in front of the basketball hoop. The creamsicle sun was setting so perfectly behind him, it looked like he was being filmed for a Western and not the new camper recruitment video. He fanned himself with his cowboy hat and addressed the bleachers of lower-camp spectators. "Oo-wee, we've got some fierce competition tonight, don't you think?"

Led by the lower-camp counselors, the spectators agreed with a cheer: "H-O-E-DOWN!" It was followed by five claps. "H-O-E-DOWN!"

Fufu joined Stu on the stage. "Let's break this down," she said, nearly kissing the mic. "We've got fifteen upper-camp squares, including our ambitious group of twelve. I'm watching y'all with hawk eyes. All it takes is one dancer in a square to Grand Right to the left, or turn to his partner instead of his

corner, or sashay instead of do-si-do, and I sit the whole team down for good. You think you can survive?"

Missi grinned at her eleven hexagonmates, who were giddy with anticipation. They looked perfect for tonight's evening activity, clad in overalls, flannel shirts, and red polka-dot bandanas—courtesy of Play Dough's legendary grandpa. To take the country look to the extreme, Jenny had drawn freckles on each of their cheeks—well, except for Missi's, since hers were naturally sun-kissed with them. Like her grandma loved to say, she was born to boogie.

"Are y'all ready?" Stu asked the remaining competitors.

"Yee-haw," they dutifully shouted.

"I can't hear you."

"YEE-HAW!" they screamed.

"Hold on to your partners," Stu said. "It's going to be a bumpy ride."

Missi slipped her arm through the crook of Wiener's elbow. "Stu is about to whip out the big calls, I can feel it," she warned her group. "If you have any questions, fire away now."

"Remind me," Sophie said. "Dover and I—are we a side couple?"

"Head couple," Missi said.

"Is Totle my corner?" Jamie asked.

"No, Slimey is," Missi said. It was time for an emergency review session. "Sophie and Dover, Jenny and Play Dough, Slimey and Smelly: You're the head couples—one, three, and five. Jamie and Totle, Melman and Steinberg, me and Wiener: We're the side couples—two, four, and six. Got it?"

She was hoping for an enthusiastic "Got it!" just like the enthusiastic "Let's do it!" they'd given her when she'd proposed the hexagon configuration yesterday afternoon. But instead, she received a series of "Um"-s. Her heart dropped into her stomach.

Her team had rehearsed a full hour after breakfast, and then another hour before the hoedown, but had that been enough? Their hexagon had new starting positions, new dance arrangements, and had to—at all times—move 50 percent faster to keep up with Stu's calls. Six pairs in one shape meant they could all dance together—no cabinmate left behind!—but it was also proving to be a gigantic challenge.

The honky-tonk music kicked in through the speakers. From the bleachers, the lower campers slapped their knees and cheered. "Dance with confidence," Missi reminded her team. "All that matters is that you're home at the end of each sequence."

"And . . . off we go!" Stu called. He started simple with a ladies' chain. He called a Right and Left Thru. A half turn. A partner trade. Fufu waved down square after square.

"*Right hand out to your corner, and e'rybody say, 'Grand Right!'*"

Suddenly Dover's 'fro was in Missi's mouth. She trilled her lips free of curls and tried to assess the situation: Led by Jamie, the outer partners were weaving in the wrong direction. "Right, right," she panic-whispered at them, spinning Jamie around just before they all fell like dominos.

"There are nine teams left," Stu announced. "It's time to up the stakes from rare to well done!" The honky-tonk music

blasted louder. Stu's calls got trickier: Taps. Half Sashays. Allemande Thars. "Just look at that hexagon," he said, pointing to their Notting and Wawel team as they promenaded around the ring. The film crew lit them up. "Led by the fearless hoedown pro, Miss Missi Snyder!"

"We're on fire!" Jenny cried.

"We are?" Jamie asked.

Missi smiled at her team, skipping with determination, their braids and bandanas whipping in the air. Never in a million years did she think Square Dancing could be this fun. At Oldwick, it was festive, but no one wanted to bust a knee. Here—knees, hips, heads—they bounced like trambopoline springs!

Stu began to make calls in all the trickiest combinations: Crossover Circulations to Horseshoe Turns to Line Explosions. Fufu eliminated more crumbling squares. Their hexagon was booking it. The sweat was trickling down their faces. Their freckles were smeared like war paint. A chant broke out from the crowd: "HEX! HEX! HEX!"

Missi's legs were jelly, but wild energy was coursing through her veins and fueling her cowboy boots. She was free-falling—living on the edge, in the moment, like there was no tomorrow. As if her mom's free spirit had been in her DNA all along.

"If you're home, gimme a cheer!"

Missi was home in her starting position and so was the rest of her team. They all threw their hands up and leaped in the air. Except for Steinberg. His body wavered like he was surfing inside a canoe. "Cheer," he croaked.

"Dude, are you okay?" Play Dough asked him.

"Oh, sure. The oxygen is flowing at fifty percent."

"Only fifty percent?"

"Oh, did I say fifty? I meant fifteen."

"FIFTEEN?"

"Five," Steinberg replied. Then he stumbled backward into Arman, who shoved an inhaler into his mouth and said, "Puff, buddy!"

Steinberg puffed. He sucked in a broken breath. "Win it— without—me." Then his eyes rolled to the back of his head, and he fainted.

"He's gonna be fine, you guys," Arman assured them, scooping him up. He carried Steinberg to a golf cart at the edge of the court, and Nurse Nanette drove him off into the sunset.

"Uhhhhhh," Play Dough said. "Now what?"

The honky-tonk music cut out. Missi wanted to answer Play Dough, but she didn't have an answer, and without an answer, the panic alarms began ringing in her ears.

"Alright, Team Hex," Stu said. "You're one of three teams left. Think you can call up a friend?"

Friend? All of her friends were beside her. Missi's heart began racing at triple Cotton-Eyed Joe speed. Who could replace Steinberg? Most kids were familiar with the Square Dancing moves. But NONE of them was familiar with the hexagon modifications.

"Hurry on up, Miss Missi," Stu pressed. "Call up any camper you'd like."

Missi frantically looked around the court. The eliminated

squares were a sea of raised hands. "Me, me, me, me!" All of upper camp wanted in on the hoedown glory. The cameras were rolling. Seconds flashed by. She felt her energy, her wildness, her genetic sense of adventure drain dry. She turned to Wiener with *Help me* eyes.

Being the awesome guy he was, he was already on it, scanning the bleachers. He froze, then he spun to Missi with the news: "I've got us the perfect sub."

"ONE MINUTE BEFORE WE RESUME!" Stu called.

Wiener led Max from the bleachers to Steinberg's spot. Max was wearing a Knicks jersey, since his lower-camp square had decided to unify their appearance through sports apparel. It had looked sauce. Now, however, Max stuck out like Patrick Ewing in a group of eleven Miley Cyruses. "You're in the big leagues now, li'l bro. You ready?"

Max nodded nervously. "I'm really excited, Ernie. It's just—I've never square-danced with this many people. I don't know if I can do it."

"Sure you can," Wiener said. "Your team placed third in all of lower camp. You're a great dancer." He turned to his friends. "Right, guys?"

Play Dough tousled Max's locks. "We all saw you Electric Slide. You were more electric than an eel." He made a *zzzz* sound and did a body wave.

Max laughed, then smiled bashfully. "Maybe, but that was just me breakdancing."

"Exactly," Missi said. "If you can breakdance in the middle of a line dance, then I have faith you can hexagon dance your way through a square dance."

Wiener offered Max a thumbs-up, but the truth was, Max was right to be nervous. Breakdancing was something you could improvise. Hexagon dancing, not so much. Wiener hadn't really thought this through. "Hey, do we have time for a quick run of the dance?" he asked the group.

"THIRTY SECONDS!" Stu called.

"Yeah, not happening," Play Dough said.

Max looked at Wiener with a glint of panic in his eyes.

"Don't worry, you'll be able to follow along," Wiener told Max, trying to sound reassuring. "Melman's your partner. You two are side couple number four."

Melman fist-bumped Max. "You'll be the Victoria to my David Beckham."

"Can I be David?" Max asked.

"Nope," Melman replied. "But do you have any quick questions?"

"Yeah," Max said. "What's a hexagon?"

"It's a shape with six sides," Totle said. "Fun fact: It's my favorite shape." He stroked invisible chin hairs. "Actually, I'm thinking of an octagon."

"And how is it different from normal Square Dancing?" Max asked.

"It's not *that* different," Wiener offered.

"*Well*," Missi said.

"Ernie, what should I do?" Max pleaded.

"Um." Wiener wracked his brain for something helpful to say. He had chosen Max because (a) he was talented and (b) he had experience dancing with the guys. But the thing was, even someone as talented and experienced as Max could mess up. And then what? Max would feel like a total failure, and Wiener would feel like an irresponsible brain clog for putting him in this position.

"TEN SECONDS!" Stu called.

"But what if I make us lose?" Max panicked. "What if I do a Grand Right but go left. What if—"

"Listen, Max." Wiener put his hands on his brother's shoulders, wishing he had the perfect big-brotherly thing to say next. Then, out of nowhere, an idea hit: "It doesn't matter if it's the wrong step, as long as you act like it's the right step. You just gotta SWAGGER!"

Max's eyes widened. "Swagger?"

"Yup." Wiener grounded himself, then looked at Max with intensity. "Swagger."

Max smiled all knowingly. "Okay, yeah, I think that's something I can do."

"ALRIGHTY, FOLKS," Stu called. "SQUARE YOUR SETS!"

Team Hex tossed their hands into the middle of their huddle. "Hex on three," Missi said. "One, two . . ."

"HEX!" they cried.

The honky-tonk music ripped through the speakers. Stu launched with the toughest calls: Flutterwheel. Reverse Flutterwheel. Alamo Swing Thru. Wiener glanced at Max, his tongue

pressed up over his top lip in concentration. He was dancing like a star. Fufu waved down a Faith/Hamburger square. There were two teams left, including theirs. The crowd was going nuts: "H-O-E-DOWN! H-O-E-DOWN!"

Wiener wiped the sweat from under his bandana. Stu's calls were starting to get cryptic. *Did he cue an Ocean Wave or a Ferris Wheel? A Cloverleaf or a Teacup Chain?* The cameras were closing in. His feet were moving faster than he could think. Faster than his feet could think. Faster, faster, faster. He twirled his corner, Dover. Dover looked a lot like Slimey. He was twirling Slimey. Slimey was not his corner. *Yikes.* He was all turned around. He crashed into Play Dough and fell flat on his back. Above him were swirling stars in the shape of Patrick Ewing's face.

"Get up," Patrick said. "Team Hex needs you."

Suddenly Wiener found himself being lifted onto Patrick Ewing's back. He hugged Patrick's Knicks jersey tight as the two of them danced like electric eels.

The whole camp was cheering: *"HE'S GOT THE MOVES LIKE SWAGGER! HE'S GOT THE MOVES LIKE SWAGGER! HE'S GOT THE MOO-OO-OO-OO-OOVES LIKE SWAGGER!"*

Wiener spread his arms out over Patrick's back like he was flying, and then he landed on the cold, hard court. Looking down at him was Max. "Ernie, Ernie, Ernie!" he cried. "Are you okay?"

Wiener's brain de-fuzzed. "Yeah, I'm fine. Are you fine?" Then reality hit. He was on the ground. Not on his feet, dancing. That could only mean one thing. "I messed it up, didn't I?"

Max was grinning.

"Why are you grinning?"

"Because—just listen!"

Wiener could hear the cheering now. It infiltrated his eardrums: "WIENER BROS! WIENER BROS! WIENER BROS!"

He jolted up. Max pulled him to his feet. The crowd went wild. He waved at them. They went wilder. "I can't believe we won!" Wiener exclaimed, swinging Max round and round. "I knew we could do it, I knew it, huzzah!"

"Won?" Play Dough said, smacking the back of Wiener's head. "No, dream boy. We lost big time. Like, we lost so hard, Stu called it, 'A Legendary Crash and Burn.'"

Wiener tried to wrap his head around what that meant. "We were legendary because I swung Slimey instead of Dover, or . . . ?"

His friends broke into spastic giggles and began talking over each other so rapidly, with such excitement, that together, their stories made zero sense.

"W-w-wait!" Wiener gasped. "One person at a time!"

Missi took the lead while their team closed in, happy and heavily breathing. "So!" she said. "Dover swung Sophie, but he was supposed to swing you. You swung Slimey, but she was supposed to be *tap tap tapping* Jenny. Totle and Jamie Ocean Waved, while Play Dough and Jenny Ferris Wheeled. Half of us were in a Cloverleaf, and the other half of us were in a Teacup Chain. And then when we were supposed to freeze, Smelly sneezed. After that, we transformed into a monster blob, and Max breakdanced with insanity, carrying you on his back!"

"That's epic!" Wiener said. "I can't believe I was out for, like, ten minutes."

That triggered another wave of giggles.

"What?" Wiener asked.

"It was ten seconds tops," Missi said.

After a minute or so of cozy, sweaty group hugging, the cheering lulled and it was time to de-huddle. The girls broke off and skipped arm in arm to the front of the court to claim their second-place silicone bracelets. And the guys sprinted over to TJ to ask him about Steinberg's asthma status, and also to relay to Steinberg everything they'd just explained to Wiener.

"What a brother you've got," Play Dough said to Max, throwing his beefy arm around Max's shoulders.

And then something amazing happened. Max looked at Wiener like he was the most special man in the world. Manlier than Chico. Manlier than *Project Runway*'s Tim Gunn. Manlier than *Planet Earth*'s narrator, David Attenborough. "Yeah, my cabinmates are jealous," Max said. "I always knew I had the coolest big brother in the world. But now everyone sees it."

Play Dough nodded. "It's sauce, but not unusual, to pass out during Square Dancing—Steinberg did it—but it's next-level sauce to declare your love for, of all people, the great and retired Patrick Ewing."

Wiener laughed. "I did that?!"

"Yes," Play Dough said flatly. He looked at Max and then at Wiener. "Sometimes I can't believe you two are related."

Max and Wiener high-fived. Then Wiener performed his own rendition of Totle's Victory Dance—he pressed his knees together and flapped his arms like a chicken driving a go-cart. Max did the Worm. Play Dough cracked up, and then joined them with the Running Man.

"Alright," Fufu called from the stage. "It's officially my favorite part of the evening—LINE DANCE TIME!"

Play Dough hustled off to chat with Stu. Max ran off to hug Dino. Missi jumped up to the stage to co-lead "Cotton-Eyed Joe."

For the first time in a while, Wiener was all alone. But he wasn't lonely. His heart was fuller than his stomach after a chicken parm. He fixed Chico's Ray-Bans on top of his head and began to Grapevine.

CAMP ROCKS!

Dear Mom and Pop Meyer,

Rest assured, this summer is already hexagon-shaping up to be the greatest one we've ever had. Max and I took the hoedown to the next level. Forget liar, liar, pants on fire. It's Meyer, Meyer, dance on higher.

Catch you on the flip side. Of the camp's gates. When they let you in for Visiting Day.

Your legendary sons,
The Wiener Bros
(Ernie & Max)

The True You

Missi's smile was so big, she was pretty sure it was eating her face. Sitting on the basketball court, watching the footage from the last four weeks glow on the big white screen, she couldn't stop it if she tried. Wiener was on her left. Jamie was on her right. The rest of the Notting and Wawel Hillers were surrounding her, sharing sleeping bags and blankets, popcorn and hot chocolate, giggles and hugs.

"By the way, your outfit is very *Project Runway*," Wiener told Missi, tickling her cat ears.

"Never seen it," Missi admitted, surprising herself.

Wiener and Jenny exchanged a *We need to do something about this, STAT* look.

"So are you hosting the *PR* marathon after camp or am I?" Jenny asked.

"I'll air the first six seasons, you do the rest," Wiener replied.

"Deal."

Tonight's screening of the new camper recruitment video was set up like a real Hollywood film premiere. A red carpet made of red spray-painted cotton balls lined the back of the court. Before the screening, the Bunker and One Tree Hillers

had walked around, interviewing campers with mock-up microphones (Styrofoam balls on empty toilet paper rolls) and mock-up video cameras (cardboard boxes labeled "CRH News"). Everyone had been invited to wear their finest "you." So, in addition to the felt cat ears, Missi was sporting a T-shirt with a tortoise playing a flute, khaki shorts over kitty leggings, and the well-washed purple Crocs that Wiener had once upon a time barfed on. Her cabinmates had agreed that her outfit was purr-fect.

As the film moved from a sports montage to backward footage of campers jumping off the trambopoline, Cookie squatted beside the group. "Hey, a surprise from TJ and the Captain," she whispered. "Play Dough—your team won the Hersheypark Scavenger Hunt. Congrats, my man." She pulled a Louie bagel from a paper bag and handed it over.

"Oh, sweet Louie!" Play Dough cried, holding it up like a baby Simba. "Never change, you precious bundle of carbs."

"Put the bagel down, Wawel," a Highgate Hiller said from behind them. "We can't see."

"Sorry for being a proud parent," Play Dough scoffed. He lowered the Louie bagel, kissed it, and offered Wiener the first bite. Wiener accepted so enthusiastically, he gave himself a cream cheese 'stache.

"Oh, that reminds me!" Missi said to Wiener, whipping out the Hershey's perfume from her shorts pocket. "It was sweet of Chico to give me this, but it's cat poison. If I wear it at home, we're all in trouble."

Wiener laughed. "He definitely did not think of that."

"Nope," Missi said. "You want it?"

Wiener accepted without a single hem or haw. He sprayed all 360 degrees of his neck and sucked in the chocolate aroma. "I'm wearing this every day."

Other than Dover, who had his tongue out to catch "perfume particles," everyone brought their shirts up over their faces.

"Oh, come on," Wiener said. "You know I smell delicious."

And then, with impeccable timing, Play Dough burped, tainting the chocolate aroma with tonight's Sloppy Joes dinner. As the smell wafted around a six-foot radius, there was a collective "ewwww" groan.

Missi cut hers short. "That's us!" she blurted, squeezing Wiener's hand so hard he yelped. "Happy" underscored the footage of them nursing a fawn, a chipmunk, and a salamander back to health.

"I can't believe we fixed up the Nature Shack just in time for Visiting Day," he whispered.

"I know!" Missi replied proudly.

Some slides later, there was a *BOOM* sound effect. Then, underscored by Lennon & Maisy's cover of "Boom Clap," pictures appeared and disappeared on the screen like fireworks. The best ones were:

(a) Slimey, Melman, and Missi painting the Notting Hill's Love Shack booth;

(b) Sophie, at the carnival, meditating inside the Bouncy House;

(c) Jenny kissing her Play Dough/Shawn Mendes Franken-stein artwork;

(d) Max and Dino, holding up Mr. Necksmith and Mrs. Buckwheat in wedding apparel;

And (e) Miss Jen-Jam giving their "confessionals" to the film crew.

Missi felt Wiener and Jamie's arms collapse onto her shoulders. She spread her arms over their shoulders, too. *Oh, the love.*

Next, hoedown group shots streamed across the screen. In the Notting/Wawel one, Missi was smack in the middle, hugged tight by her hexagon. *That's us! That's me!* She was beaming like crazy now. Turns out, she was the person she wanted to be all along.

If only Rebecca Joy could see the photo, Missi thought as it dissolved into the next slide. A whole bunch of complicated feelings sloshed around in her stomach. She was excited to see her grandparents tomorrow. Every Visiting Day, they brought salad made with fresh veggies from their farm. They watched Missi do water gymnastics in the pool. They complimented her on her lanyards and stained-glass projects. Still, she was worried tomorrow would feel different. That the specialness of the day would be muddied by the fact that her mom was only there in spirit, if that's even where her wandering spirit was at all.

"Hey, are you okay?" Wiener whispered.

"Yeah, it's just that tomorrow is Visiting Day, and I was really hoping—" A lump sprouted in her throat. She swallowed it flat. "It'll be hard without my mom, you know?"

"Yeah," Wiener said. "Hey, maybe tomorrow my parents and I can eat lunch with you and your grandparents? They bring sushi."

Before Missi had a chance to respond, she got sucked back in to the film as fresh footage of the Wiener brothers filled the screen. "Tell me one thing you've learned this summer about being true to yourself," Max was saying from the red carpet, speaking into his mock-up microphone and then bringing it to Wiener's mouth.

"Well, being true to yourself as a kid can be kind of tricky," Wiener said. "We're still learning so much about who we are and trying different things. You might find that there's a version of you out there that is just as true as the one you are now." He adjusted the dandelion Scotch-taped to his pink collared shirt. "Camp is, hands down, the best place for that journey."

Missi felt her cheeks burn and her palms get a teensy bit sweaty. Still, she gave Wiener a *Well said* hand squeeze. He was so right. This summer, Missi had learned that she wasn't just one thing. She had a lot of sides to her personality—band lover, farm freak, cat girl, silly romantic, park daredevil, hoedown captain— and she bet, over time, she'd find even more. Of course it would have been special to share all that with her mom. But Missi didn't need Rebecca Joy to prove to herself that she was awesome and loved. She didn't need to be in the center of a picture to prove it, either. She just needed to look around at her amazing friends, right here, right now, and she could feel it in her bones.

"So, what do you think about tomorrow, Missi?" Wiener

pressed. "Lunch together?" He gave her a kiss on the cheek, and the warmth of it shot all the way down to her toes.

Missi gave him a double thumbs-up. "That would be all the sauce."

Acknowledgments

Some years ago, I was lucky to collaborate with the Spiegel brothers—Adam and David—on writing the musical *Camp Rolling Hills.* My friend Erica Finkel saw a workshop of the show and tossed out the idea that I write a book for middle schoolers. A few months later, I embarked on *Camp Rolling Hills:* the Book! Erica is my fairy godmother, bestie, and editor, who grew the seed of an idea into a full-fledged series. I am forever grateful. Thank you to the amazing Spiegel brothers for your inspiration and permission to nurture the world we hold so close to our hearts.

Camp has been a major part of my life and still is. I was lucky to transition from camper to counselor to upper staff at Tyler Hill Camp, where my mom was the Head of Girls' Side. Mom and Dad, thank you for introducing me to this incredible, life-changing place, for daring me to be silly and take enormous risks, and for your endless love and support. To my brother, Mike, my sister, Amy, and my sister-in-law, Deanna, who all work in the camp industry: Congrats on making a career out of the greatest cult. To my brand-new beautiful niece, Sofie, good

job starting sleepaway camp at seven months old. Excited to watch you grow up to become Color War General. I love you.

Grandma Terry, Grandma Joanie, and Grandpa Lenny—thank you for being my number-one fans. You three are the world's best.

Lauren Kasnett Nearpass, thank you for brainstorming marketing and branding and for inviting me to blog for Summer 365. I'm honored to be working with you and your incredible organization.

Jay Jacobs, thank you for conceiving the STARFISH Program and for granting me permission to reference it in the Camp Rolling Hills series. It's a brilliant values system that defined so much of my personal experience at Tyler Hill. I'm so glad I can share it.

Lexi Korologos, my teenage life coach, thank you for dishing your honest feedback.

To my brave students at Long Island City High School and Naked Angels, thank you for inspiring me every single day with your lack of inhibition. You keep my imagination fed. Special shout-out to Nancy Robles, Haidee Quizhpi, and Sebastián De la Paz for the Spanish translations!

Thank you to my friend and collaborator Elissa Brent Weissman for the blurb, for the collaborative camp-themed book events, and for always reading what I send you.

Thank you to Megan Feulner at Sterling Lord Literistic and to my theatrical literary agent at Creative Artists Agency, Ally Shuster, who's always such a fierce advocate of my work.

Susan Van Metre, Erica Finkel (again and again), and the whole brilliant team at Abrams: Pam, Samantha, Kyle, Rebecca, Mary, Elisa, Tessa, and Jenny, thank you for helping this story reach all the campers and wannabe campers out there. And illustrator Melissa Manwill, so happy to be collaborating with you and your character sketches. They're perfection.

My camp friends. My campers. My counselors. My co-counselors. The camps: Twin Oaks, Crestwood, Summit, Tyler Hill, A.C.T., Oxbridge. You have made me who I am today and provided me with the heart and experience to write this series.

My partner-in-crime, Tim Borecky, thank you for lending me your wisdom and dramaturgy every time I cornered you to read you chapters. I appreciate your indulging my characters as if they are our friends. You, too, have moves like swagger.

To all the camp people out there, enjoy the adventure and the s'mores. Don't be afraid to think outside the square.

Collect them all!